28. Dec '95

THE SEARCH FOR LEE HARVEY OSWALD

THE SEARCH FOR

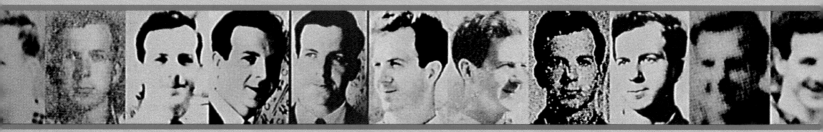

A Comprehensive Photographic Record

LEE HARVEY OSWALD

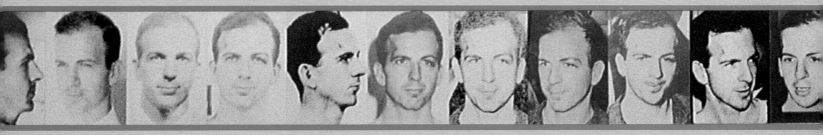

ROBERT J. GRODEN

PENGUIN
STUDIO

PENGUIN STUDIO BOOKS
Published by the Penguin Group
Penguin Books USA Inc., 375 Hudson Street, New York, New York 10014, U.S.A.
Penguin Books Ltd, 27 Wrights Lane, London W8 5TZ, England
Penguin Books Australia Ltd, Ringwood, Victoria, Australia
Penguin Books Canada Ltd, 10 Alcorn Avenue, Toronto, Ontario, Canada M4V 3B2
Penguin Books (N.Z.) Ltd, 182-190 Wairau Road, Auckland 10, New Zealand

Penguin Books Ltd, Registered Offices: Harmondsworth, Middlesex, England

First published in 1995 by Viking Penguin, a division of Penguin Books USA Inc.

1 3 5 7 9 10 8 6 4 2

Text copyright © 1995 Robert J. Groden
Introduction copyright © 1995 Cyril H. Wecht

Photograph credits appear on page 262.
CIP data available
ISBN 0-670-85867-6

Printed and bound in the U.S.A. by R.R. Donnelley & Sons Company

DEDICATION

This book is primarily dedicated to my family who have supported my work at enormous physical, emotional, and financial cost.

For their concern and unselfish assistance, I also dedicate this book to my closest friends: Wilma Franck, Marshal Evans, Marc and Cheryl Fruchtman, Mo Weitzman, Leo McCormick, Mike Frankel, and Frank and Evelyn Troxell. In addition, this book is for Rob, John and Mike-what this country and I owe you can never be repaid.

I offer a special thanks to an unsung hero of the Kennedy case, Roger Feinman. It is my hope that his decades of devotion to finding the truth, righting wrongs, and seeking justice may someday be appreciated by this country.

I also dedicate this book to the memory of Augusta R. Groden, Charles B. Groden, Milton E. Franck, Sylvia Meagher, Larry Howard, and the hundreds of innocent witnesses of the Kennedy assassination who happened to be in the wrong place at the wrong time and paid with their lives.

Finally for Marina, June and Rachel-may all the truth be known...soon!

ACKNOWLEDGMENTS

I would like to thank my editor, Marie Timell, who devoted countless hours, many of those her own time, to the completion of this volume, and Michael Fragnito, Publisher of Viking Studio Books, for his support of my work and his dedication to bringing it to the public.

Many thanks to: Robert Buckley and his crew, especially Pam Stevenson, at Buckley's Photo Lab; Dorothy Price and Terri Wilson, David Starks at DSP Video; Don Petty and Jack Balderson at Allied Film & Video; Steve Franko and Mark Revord at Video Post; Matthew Bradley at Penguin USA; Diane Raymond, Daniel Thompson, and Billie Campbell.

In appreciation of their generosity in providing photographs, their cooperation and their help, my thanks goes to: Marina Oswald Porter and Ken Porter, Dr. Cyril H. Wecht, Dr. Charles Crenshaw, J. Gary Shaw, Lennie Mather, J.R. Gach, Edward Chiarini, Stuart L. Reed, Jr., John B. Ciravolo, Jr., John H. Depew, Barry Sheehy, Robert Tanenbaum, Kevin McCarthy, Dr. Robert McClelland, and Ron Lewis.

I also extend my thanks to those critics of the official fiction about the assassination who have helped me with this book: Jack White, Jerry Policoff, Larry Ray Harris, Jan Stevens, Peggy Robohm, Larry & Daryll Ann Howard, Beverly Oliver & Charles Massagee, Wallace Milam, Jim Lesar, Mary Ferrell, Rick Nelson, John Armstrong, Jim Marrs, Tom Miller, Al Navis, Mark Crouch, John Judge, Dave Medzorian, Chris Sharrett, Richard E. Sprague, David Scheim, Carl Oglesby, Harvey Yazijian, Penn & Elaine Jones, Harold and Lil Weisberg, Vincent Salandria, Brad Kizzia, Aubrey Rike, Paul O'Connor, Floyd Riebe, Dr. James Fetzer, Dr. Doug DeSalles, Dr. David Mantik, Dr. Gary Aguilar, Dr. Randolph Robertson, Belita Nelson, Martin Shackelford, Walt Brown, Craig Roberts, Jean Hill, Andy & Linda Winiarczyk, Henry Hurt, Cindy Smolovik, Mike Blackwell, Tom Blackwell, Richard Bartholomew, Robert Chapman, Dave Tucker, Allen Stone, Earl Golz, Julia Sanders, Kelly Hatcher, Lovita Irby, Robert Saltzman, Kelly Creech, Rex and Rebecca Dean, and Gordon Smith.

— Robert Groden, October, 1995

INTRODUCTION

Unresolved and controversial murders are not rare occurrences. Substantial differences of opinion among highly competent, experienced forensic scientists in the analysis and interpretation of physical evidence in homicide cases are not unusual in our adversarial system either. In the great majority of cases, conflicts arise because the initial scene investigation or the medicolegal autopsy was not handled adequately and skillfully. Sometimes, there may be deliberate obfuscation of key circumstances by the criminal conspirators or conversely, by biased law enforcement officials that prevents a definitive and valid unraveling of the apparent mystery. After all, murders are committed by human beings, who are capable of committing any kind of act, from noble to abominable, from gracious to reprehensible, from saintly to egregious. Of course, the same spectrum of behavior may be manifested by official investigators and government agents who are charged with the responsibility of solving murders.

Unfortunately, the worst of both extremes of such human conduct came together in one of the most important murders of modern times, the assassination of President John F. Kennedy on Friday, November 22, 1963, in Dallas, Texas. The level of evil and cunning manifested by the planners and perpetrators of the deed were soon to be paralleled by the incompetence of those charged with the responsibility of solving the crime—from the autopsy pathologists to the special blue-ribbon panel appointed by President Lyndon B. Johnson. We are still attempting to learn exactly what happened thirty-two years ago. Who orchestrated the killing of President Kennedy, why was he assassinated, and how has the government managed to cover up the truth from the earliest moments following the shooting?

When one considers how much investigative time and effort, personal fortitude and courage, professional experience and expertise, and financial expenditure have been directed to the solution of the political crime of the century, it is disappointing to have to acknowledge that we still do not have clear and definitive answers to critical questions more than three decades later. However, we are getting closer to cutting through the morass of governmental obstacles, misrepresentations, and outright lies in our effort to repudiate the Warren Commission Report and arrive at the truth. The work done by thousands of intelligent private citizens is beginning to force a wedge in the stone wall of falsehood and silence created by some governmental agencies, a stance, regrettably, that has been defended and accepted by almost all the key members of our country's news media establishment.

Among the most knowledgeable and respected JFK assassination critic-researchers over the past thirty years is Robert J. Groden, the collector and author of the photographs and text that follow. Bob Groden has long been recognized as one of the foremost experts and authorities in photographic analysis and interpretation in the JFK case. Thee handsome volume he has compiled is undoubtedly the best and most complete photobiography of the officially alleged sole assassin that anyone, including the Warren Commission, the FBI, and the United States Congress, has assembled. His book will serve to educate the uninitiated, further inform those who have studied the case to some degree, and solidify the conclusions of the most veteran Warren Commission Report critics. The diagrams, document reproductions, and thorough analysis that Bob Groden has incorporated here should help clarify the important events and highlights of the Kennedy assassination while dispelling the confusion and historical inconsistency surrounding Lee Harvey Oswald initially created by the government and perpetuated by self-appointed syco-

phants and apologists for the Warren Commission Report, the news media hierarchy, and a spate of opportunistic authors. If a picture is worth a thousand words, then Bob Groden has created an encyclopedia in *The Search for Lee Harvey Oswald.* Readers will see who the real Oswald was and draw their own conclusions regarding what role, if any, he played in the JFK assassination.

The ongoing release of previously withheld documents from the confidential files of the CIA, FBI, and various other governmental agencies that was mandated by the U. S. Congress, and which is being handled under the aegis of the Assassination Records Review Board, has already resulted in significant new disclosures. With hundreds of thousands more pages of such materials still to be revealed, there is a justifiable basis for guarded optimism about the eventual resolution of the murder of an American president in our lifetime.

If Oswald had not been gunned down by Jack Ruby in the basement of the Dallas Public Safety Building on the morning of Sunday, November 24, 1963 (while in police custody), would he ever have gone to trial? Keep in mind that it was the Warren Court, the Supreme Court under Chief Justice Earl Warren, that crafted revolutionary changes in criminal law procedures in the 1960s with their rulings in *Miranda, Gideon, Escobedo,* and other cases. Oswald

was interrogated without the presence or counseling of an attorney from Friday afternoon, November 22, following his arrest in the Texas Theatre, until his death two days later. Is it conceivable that what came to be known as the "Miranda" warning might have emerged a few years earlier as the "Oswald" warning? A fascinating thought, indeed! And if Oswald had gone to trial, what would we have learned about the facts behind the assassination of President Kennedy? How much did Oswald know about the killing, and how much could we have adduced from whatever information he would have provided in sworn testimony in an open courtroom, represented by experienced and highly competent attorneys?

Of one thing we can be certain. If Oswald had lived, we would not have had to labor for the past thirty-two years under the heavy mantle of the collective misrepresentations, lies, deliberate omissions, and contrived scenarios like the scientifically ridiculous "single bullet theory." The truth would have emerged long ago, to the ultimate benefit of our country.

Since we cannot undo history, we can only strive to retroactively learn the truth through diligent, painstaking research and investigation. That is the purpose of honest writing. That is the value of this excellent book and the proud accomplishment of Robert J. Groden.

Cyril H. Wecht, M.D., J.D.

Past President, American
Academy of Forensic Sciences

Past President, American
College of Legal Medicine

Clinical Adjunct Associate
Professor of Pathology,
University of Pittsburgh
School of Medicine

Adjunct Professor of Law,
Duquesne University School of Law

CONTENTS

PREFACE

On September 24, 1964, President Lyndon Baines Johnson received an 888-page book from the Chief Justice of the United States, Earl Warren. An original copy of *The Report of the President's Commission on the Assassination of President John F. Kennedy*, better known as the Warren Report, it pronounced its verdict for history: Lee Harvey Oswald, a twenty-four-year-old malcontent, ex-marine, former defector to Russia, and member of the left-wing Fair Play for Cuba Committee, had, alone and unassisted, assassinated the thirty-fifth president of the United States, John F. Kennedy, on November 22, 1963; Oswald had fired three bullets from a cheap, defective World War II Italian surplus Mannlicher-Carcano rifle with a hopelessly misaligned telescopic sight. He fired, according to the Warren Report, from the easternmost window on the sixth floor on the southern face of the Texas School Book Depository, where he was employed as an order filler. Oswald was himself shot to death two days after the Kennedy assassination by fifty-two-year-old Dallas nightclub owner and self-styled lone avenger Jack Ruby. There would be no trial, and the rights and benefits normally afforded a defendant would not apply to Lee Oswald. His civil rights would not be protected in death any more than they had been in the closing days of his life.

On November 23, the day after the Kennedy assassination, FBI Director J. Edgar Hoover phoned President Johnson and told him, "The evidence that they have [against Oswald] at the present time is not very, very strong. . . . The case as it stands now isn't strong enough to be able to get a conviction." The next day, two hours after Oswald was silenced and could no longer defend himself, Hoover put in another call to Johnson and voiced a deep apprehension: "The thing I am most concerned about, is having something issued so we can convince the public that Oswald is the real assassin." (Anthony Summers, *Vanity Fair*, December 1994)

Late in 1993, while lecturing at Harvard University, I was speaking with a man and his wife. She was noticeably pregnant, and the father-to-be told me that if the baby was a girl he was going to name her after Lee Harvey Oswald. "Leigh?" I asked. "No. Patsy," he answered.

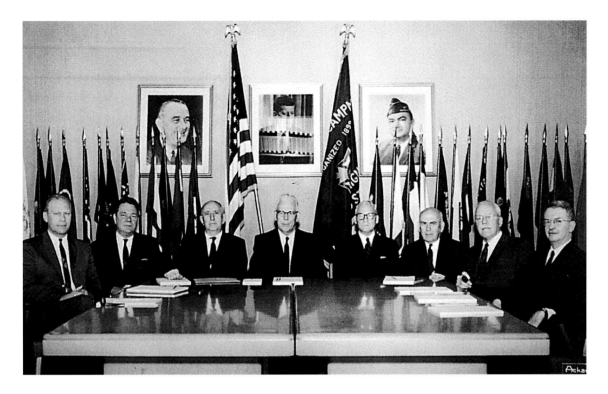

Left: **The Warren Commission's mandate was to stop the rumors of a conspiracy, not to find the truth. Did they know they were creating a cover-up?**

The exchange occurred fully three decades after the murder. The public's awareness of the probable innocence of the designated patsy in the assassination of President John F. Kennedy continues to grow. This despite the concerted efforts of the U.S. government, the news media, and government-supported revisionist authors to reinflate the myth of the lone assassin and attack the legitimate critics of the Warren Report.

During those three decades of doubt and unanswered questions, a small army of researchers and investigators has kept the issue of the assassination alive and have made it difficult for the conspirators in the assassination of President Kennedy and the murder of Lee Oswald, and in the cover-ups that followed, to feel at ease with the official fictional cover story of Lee Harvey Oswald as the lone assassin.

The hard line of the Warren Report—one man, one gun, three shots—is no longer accepted by the vast majority of the American public, but the vast majority of the press still backs the fairy tale of Lee Oswald as a lone nut assassin. Bolstered by information presented in books such as Gerald Posner's *Case*

Closed (1993) and Jim Moore's *Conspiracy of One* (1990), which whitewashes the failure of the press to adequately question and investigate what Lee Oswald himself called the official press "dispatches," the news media continue to ignore the thousands of pieces of solid evidence that prove conspiracy far beyond any reasonable doubt.

The government case against Lee Oswald was never solid. None of its "evidence" could have stood up to cross-examination. A trial is an adversarial procedure in which both sides argue the merits of the evidence. No trial could be allowed since the case against Oswald would not have prevailed in court. Lee had to be eliminated post haste before he broke his silence.

In my previous book, *The Killing of a President* (Viking Studio Books, 1993), I presented six hundred photographs of the assassination of President Kennedy and the events surrounding it, and proved that a conspiracy existed. I do not repeat that body of information here. Let there be no doubt. There was a conspiracy to kill President Kennedy. The size of the conspiracy remains unknown, but whether it involved

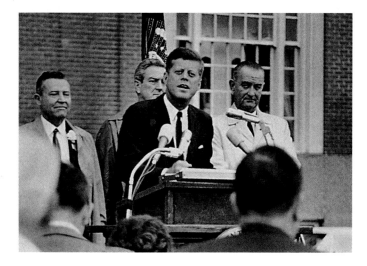

Left: **President Kennedy gave a speech at the Hotel Texas in Fort Worth on the morning of November 22, 1963. He then spoke to the Fort Worth Chamber of Commerce before flying to Dallas.**

2,000 people or only two people, it was still a conspiracy. Was Lee Oswald involved in that conspiracy? Probably not. The Warren Commission in 1964, and the Select Committee on Assassinations of the United States House of Representatives in 1979, could not (or would not) find any conspiratorial links between Oswald and any other group or individual. If we are to believe that portion of their investigation, then the conspiracy could not have involved Oswald.

In this book, I attempt to give dimension to the image of the man who was accused of the crime of the century. I track Lee Oswald's life through the use of photographs and documents that will place him in a new light. Also, I examine the intriguing possibility that more than one person may have used the identity of Lee Oswald and that J. Edgar Hoover was aware of and concerned about this.

We will see that a large amount of the exculpatory evidence that might have helped Lee Oswald was never examined by the police or the press. We will also see that Lee Oswald may have been very different from the image presented to us after the assassination.

As Marina Oswald, his wife, told me, "Lee was no angel." My goal is not to present him as one. However, it would be a gross injustice to history and to the memories of both Lee Oswald and John Kennedy to allow the false image of Oswald that has been constructed to stand unchallenged.

May all the truth be known . . . soon!

Robert J. Groden

THE SEARCH FOR LEE HARVEY OSWALD

Office of **Recorder of Births, Marriages and Deaths**
PARISH OF ORLEANS
MUNICIPAL OFFICE BUILDING, CARONDELET AND LAFAYETTE STREETS No. 17034

This is to Certify, that ___LEE HARVEY OSWALD___
lawful Son of ___ROBERT E. LEE OSWALD (DEC___
and ___MARGUERITE CLAVERIE___ was born on
the 18TH day of OCTOBER 1939, and registered in Book
No. 207 Folio 1321, on the 25TH day of OCTOBER 1939

P. Henry Lanauze
DEPUTY RECORDER.

KEEP THIS FOR FUTURE REFERENCE

Left: Lee Oswald's birth certificate from
New Orleans, dated October 18, 1939.

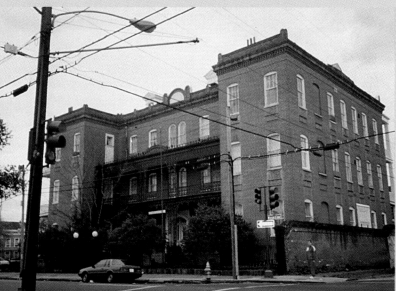

Above: The Old French Hospital in New Orleans,
where Lee Oswald was born.

Left: Lee at two years of age
in New Orleans, 1941.

1

AN ABNORMAL CHILDHOOD

Lee Harvey Oswald's childhood has been presented by armchair psychologists as the stereotypical breeding ground for a sociopath. He was a fatherless child whose mother was often absent and who grew up all too aware that money was scarce. Troubling? Of course. But the description could fit the childhoods of thousands of people.

While it is probably true that Lee's search for a father figure allowed several individuals and agencies to gain control of his destiny, there is no evidence that the search led him to be a presidential assassin. It is far more likely that his trust in certain individuals and organizations led to his entrapment as the designated patsy in the Kennedy assassination.

Lee Harvey Oswald, the alleged murderer of President John F. Kennedy and Dallas Police Officer J. D. Tippit, was born at the Old French Hospital in New Orleans on October 18, 1939. The baby was named Lee after his father, Robert Edward Lee Oswald, a life insurance agent and premium collector, who in turn had been named after the Civil War General Robert E. Lee. Robert E. Lee Oswald had died of a heart attack at the age of forty-five, two months before Lee's birth. Lee was the third child of Marguerite Claverie Oswald. Robert and Marguerite had been married since July 19, 1933. Lee's older brother, Robert, had been born in New Orleans on April 7, 1934. The boys also had a half-brother, John Edward Pic, born in 1931, the result of their mother's previous marriage at age twenty-two to Edward John Pic. Marguerite and Edward Pic were married in 1929. Marguerite was three months' pregnant and stated that Pic did not want the child. The marriage lasted only until 1930.

The death of her husband after six years of marriage was devastating to Marguerite. She was on her own with an eight-year-old and a five-year-old, and she was seven months' pregnant. Robert Oswald Sr. had provided income and security that were now gone. Coping with her new reality was a massive strain. To generate income, she rented out her home and moved into a cheaper apartment with the three boys.

Marguerite was a clinging and possessive mother but was cold to her sons as well. Her lack of warmth and affection created problems for all of them. Shortly after Lee's birth, Robert and John were shipped off to a strict Catholic boarding school, the Infant Jesus College Home, in Algiers, Louisiana.

The Early Years

When Lee was born, the family lived in an unsavory section of the French Quarter in New Orleans, known as Exchange Alley, an area saturated with bars, strip joints, and gambling dens under the control of organized crime.

Marguerite went to work as a saleswomen around the time of Lee's second birthday. Her sister, Lillian Murret, and others often babysat for Lee. Marguerite moved the family more than once and seemed burdened by the demands of motherhood. On December 26, 1942, when Lee was three years and two months old, Marguerite put him into the Evangelical Lutheran Bethlehem Orphan Asylum. John and Robert had been placed there the previous year. "I took the children home on weekends, but I couldn't look after them and work, too," she later said. Each of her sons was to join the military at a young age.

There were many gaps in the record of Lee Harvey Oswald's childhood. Then, in 1979, the House Select Committee on Assassinations published a great deal of the hidden story of his early life in New Orleans.

Following his birth, his mother's sister Lillian and her husband, Charles "Dutz" Murret, often played the role of a surrogate family for Lee. Dutz Murret was a bookmaker in New Orleans and worked for mob boss Carlos Marcello, at the time one of the most powerful crime leaders in the United States. Dutz's brother, John "Moose" Murret, had been seen with Marcello by New Orleans police. Marcello's closest business associate was Santos Trafficante, who ran Marcello's narcotics and gambling empires in Cuba and the American Southeast. Dutz Murret was basically a drone in Marcello's New Orleans operation.

After the death of Lee's father, Murret frequently acted as matchmaker for Marguerite and, over the years, introduced her to several men. Two suitors, Clem Sehrt and Raoul Sere, were attorneys allegedly connected to the Marcello crime family, and a third, Sam Termine, was reputed to be a chauffeur for Marcello. These men, as well as Murret himself, were Lee's early father figures. Almost from the dawn of Lee's awareness, he was exposed to organized crime.

Above: **Lee and his dog.**

Left: **The application for Lee to enter Evangelical Lutheran Bethlehem Orphan Asylum, dated December 26, 1942.**

Right: On a fishing trip, young Lee holding a catch, date unknown.

Above: The request to release Lee from the Orphan Asylum, dated January 29, 1944.

Right: Lee at age five in Fort Worth in 1944.

Elementary School

In 1944, when Lee was five, Marguerite met an industrial engineer named Edwin A. Ekdahl. They were married in May 1945. Robert Oswald remembers, "All of us liked Mr. Ekdahl, but I think Lee loved him most of all." John Pic states, "Lee found in him the father he never had."

Marguerite and Edwin drove to Massachusetts so his family could meet his new bride. When the honeymoon trip ended, the Ekdahls moved into a small house on the south side of Fort Worth in Benbrook, Texas, and Lee was removed from the orphanage and joined them. John Pic and Robert Oswald were shipped off to the Chamberlain-Hunt Military Academy in Port Gibson, Mississippi, to attend military school, which Ekdahl apparently paid for.

Lee started attending first grade at Benbrook Common School in Fort Worth. His elementary school years were filled with a great deal of upheaval as the result of the emotional turmoil in Marguerite's life. The Ekdahls separated for several months in the summer of 1946. Marguerite moved to Covington, Louisiana, taking Lee with her. While there, he was enrolled in his second school, also for the first grade, Covington Elementary. Five months later, Marguerite reconciled with Ekdahl and moved back to Fort Worth.

Lee didn't start elementary school again until January of 1947, when he was seven years old. He enrolled in the first grade at the Lily B. Clayton School in Fort Worth, his third first-grade class in two years. At Clayton he earned As and Bs on his report card, and finally moved on to the second grade. He was a year older than his classmates, who respected the advantage his age gave him and the fact that he was taller than them. His former classmate from the second grade, Phil Vinson, remembered him well: "No one in our class was a close friend of Lee's, yet all of the boys seemed to look up to him. During recess pe-

Left: **Mr. and Mrs. Edwin Ekdahl, shortly after their marriage, in 1945.**

Marguerite and Ed Ekdahl had started fighting almost immediately after their marriage. She felt that he was cheating on her and was determined to prove it. During the summer of 1947, Marguerite brought John, who was by then fifteen years old, and one of his buddies for a ride to where she thought Ekdahl and his girlfriend were. Pretending to be a Western Union messenger, John's friend rang the bell. When the door opened, Marguerite forced her way inside and found Ekdahl with the girlfriend, who was wearing a negligee.

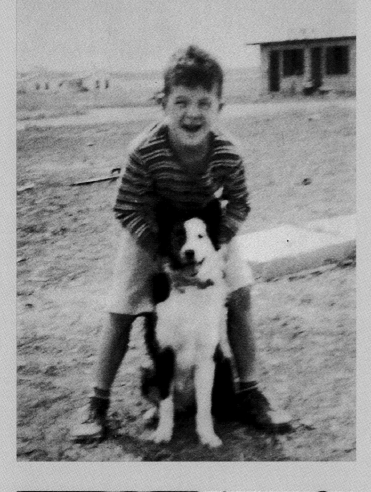

Left: Lee with his collie, Lady.

Above: Lee on his tricycle, date unknown.

Left: Lee, age eight, in Fort Worth when he was in the second grade in 1947.

AN ABNORMAL CHILDHOOD 7

Two doors away from the Oswalds lived accountant Cecil Simmons. Mr. Simmons recalled, "I'll tell you the way I got acquainted with that little squirt. I came home from work one day and picked up the phone. It was dead. I figured what the hell, so I asked into the receiver if anyone was on the phone. A kid's voice says, 'You're goddamn right there's someone on the line.' This stopped me for a minute, then I asked the kid if he'd mind releasing the line. So he says to me, 'I'll release it when I'm damn good and ready.' Well, naturally I was a little burned. I asked my wife who was on our party line and she said it was the Oswalds. I knew them slightly. Every single night Marguerite would get off the bus at my corner and walk across my lawn. Well, this night I stopped her and told her what had happened. She asked me to quote exactly what was said and I did. She said, 'I don't believe Lee would say anything like that.' Then Lee walked up and said, 'What's the matter, Mother?' She told him that I had accused him of using profanity on the telephone. She asked him what about it and he denied it. So then she said, 'I guess you must be mistaken, Mr. Simmons.' I know damn well it was him. There wasn't anyone else in the house at that time, I found that out later. And that was my first and last contact with Lee Oswald." (*Life* magazine, February 21, 1964)

Left: A class photograph shows Lee, front row and center, at age eleven in the fifth grade, Forth Worth.

Opposite Below: The schoolyard at Ridglea West Elementary School where Lee (arrow points to him) and other students spent recess. Lee attended Ridglea longer than any other school.

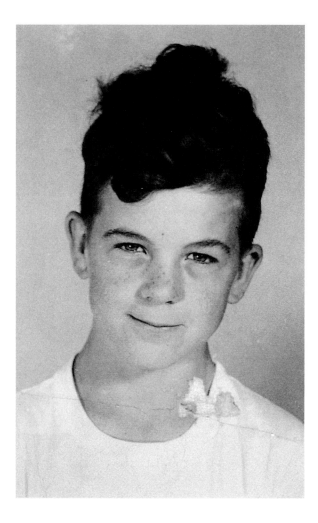

Above: **Lee in Fort Worth in 1949.**

riods, the boys would form into what we called 'gangs' and engage in friendly wrestling matches or games of touch football. According to our code, being in Lee's gang was a high honor. Lee chose those to serve with him on the grade school playground. In class, he remained quiet."

The Ekdahls permanently separated in January of 1948, and Lee changed schools in March. Marguerite enrolled Lee in the George Clark Elementary School, also on the south side of Fort Worth. He completed the second grade at Clark and was promoted to the third grade. Marguerite's marriage to Ekdahl ended in divorce after barely three years.

Marguerite had filed for the divorce, but Ekdahl also filed suit. In his complaint, he started that Marguerite nagged him and constantly argued about money. During the hearings, he stated that she once threw a bottle at his head and that she had struck and scratched him. The jury granted the divorce in June of 1948, and Marguerite was granted $1,500.00. Ed Ekdahl died of a heart attack soon after.

With Ekdahl gone, John and Robert had to leave the military academy. John, fifteen, observed that they were "back down in the lower class." Marguerite

Left: A closeup of Lee Oswald from his fifth-grade class photograph, 1951.

Right: Lee at age twelve was the tallest boy in the sixth grade.

went back to using Oswald as her official last name and used her $1,500.00 divorce settlement to pay her legal fees and to buy a small one-story frame house at 7408 South Ewing Avenue in the Ridglea section of Forth Worth, near Benbrook. The Oswalds lived there for the next four years. John Pic and Robert Oswald slept on the porch, and Lee and his mother slept together in her bedroom. This unorthodox arrangement lasted until Lee was almost eleven years of age. Marguerite apparently pushed John and Robert to join the military to make life easier for her financially, and they were quick to leave home.

Lee apparently was very unhappy. Neighbors remember him as touchy and short-tempered. Hiram Conway, who lived three houses down the block, recalled, "He seemed antisocial to me. I thought he was vicious with the other children. He would become quite angry at very little provocation. I saw him chuck things at other kids several times." Mrs. Conway remembered, "I don't think he was anything but a high-tempered kid. He was a cute little boy with curly hair and a good build. The family all called him Lee-Boy."

Lee was enrolled in the fourth grade in September of 1949 at Ridglea West Elementary School. Mrs. Clyde Livingston, his first teacher there, took an interest in him. "Lee left an empty home in the morning, went home to an empty home at lunch, and returned to an empty home at night. I once asked him if his mother left a lunch for him. He said, 'No, but I can open a can of soup as well as anyone.'"

He failed spelling, an early indication of what appears, in retrospect, to have been dyslexia. One report card reveals four As, three Cs, and the balance Bs. His marks for the year overall were lower. Although he passed spelling, the As were gone, leaving Bs and Cs. He took an I.Q. test and scored 103.

In 1949, Lee gave Mrs. Livingston a Collie puppy for a Christmas present. It was from a litter delivered to Lady, his family dog. Mrs. Livingston remembered, "He really loved that mother dog. He would check on her at home every day. After he had given me the little puppy, he'd come over on weekends to see how it was getting along. But I had a feeling he wasn't coming by just to see the dog. He'd stay around and talk.

He was friendly enough, but not particularly talkative.

"He wasn't a hostile child, not even stubborn. He was good-humored but quiet. He was interested in a little girl in the class, Nancy Kuklies. Lee was rather messy and I put him next to Nancy in class. He became a lot neater. He slicked his hair down and kept his desk neater than he had. She'd say something to him if he didn't. But the romance didn't last long. Another boy interested Nancy."

Richard Warren Garrett was Lee's classmate and probably his closest friend at this time. Garrett remembered, "He used to play ball with me and Pat O'Connor almost every day. We ran around together. And Lee was the dominant one among the three of us. He was larger, I remember, and tougher. But he wasn't particularly eager to fight all the time. One time the fad was to hold your breath until you passed out. Lee really liked that."

Lee's grades continued to fall. By the time he was in the fifth grade, he got two Ds, failing in the Fort Worth school district, for spelling and mathematics. He also got two Cs; the rest were Bs.

Bill Leverich was another of Lee's classmates at Ridglea West Elementary School. Mr. Leverich said, "I remember that he'd scoot his desk chair across the floor to the pencil sharpener, just to get attention, of course. The kids would snicker and the teacher would get mad."

It is reported that Lee had caught the attention of the fifth- and sixth-grade girls as well. One of his female classmates reminisced, "He had muscles—he was strong." One girl liked Lee so much that when he was walking home with another girl, the first girl asked Lee if he would give her a kiss. Lee said he would if he could kiss the other girl as well. He got to kiss both of them.

One of Lee's former classmates, Mrs. Pat Davenport Baum of Fort Worth, recalled that he once wrote her a love letter and got angry when she rejected him. "Oh, how he hated me for that. He didn't speak to me at all for a long time." Lee "walked real proud. But he never wore Levis, he wore some other type of jeans, which looked cheaper."

Another classmate, Monroe Davis, spoke of how Lee once beat him after school. "He fought dirty, pinching and biting, but he would have licked me anyway." Toward the end of the fight, Marguerite arrived, and "She was laughing. She was real proud of him."

John Pic turned eighteen on January 17, 1950. Anxious to leave home, on January 25 he enlisted in the U.S. Coast Guard. Robert Oswald followed suit by joining the marines in July of 1952.

In June 1952, Lee finished the sixth grade at Ridglea West. He was almost thirteen years old. Tall and athletically built for twelve, he found it increasingly difficult to maintain friendly relationships with other people and seemed to look for arguments. Despite his social problems, moodiness, and declining school grades, the three years he spent at Ridglea West were among the most stable of his life.

Below: **Lee, approximately age twelve, possibly Fort Worth, 1952.**

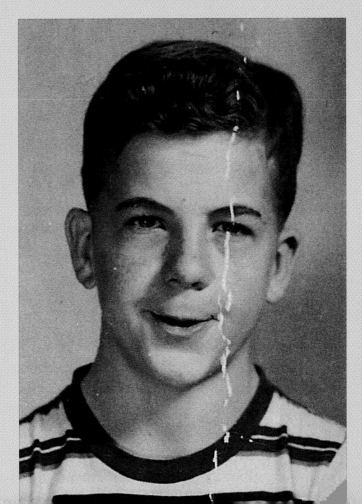

Taken during the period that Marguerite and Lee lived in New York, this photograph shows Lee at the zoo, one of his favorite places to spend time when he skipped school.

2

A TROUBLED TEENAGER

New York

By August 1952, both John and Robert were in the military. To be closer to her eldest son, Marguerite decided that she and Lee would move to New York City, where John Pic was stationed. She also felt that the possibility of a better financial situation was greater in New York. This move was to deeply affect and alter Lee's life. The Coast Guard had stationed John Pic on Ellis Island, but he lived in Manhattan with his in-laws. Marguerite and Lee simply showed up one day in early September. Upon their unannounced arrival, they promptly moved in with John, his wife, Margaret Dorothy (Marge) Fuhrman Pic, and their baby, John Edward Pic Jr., who had been born on May 14. John and Marge were living with Marge's parents in their apartment at 325 East Ninety-second Street. At the time, Marge's parents were on vacation.

John took leave from the Coast Guard to spend some time with his youngest sibling. He took Lee on the Staten Island Ferry, to the Museum of Natural History, and to other sights that would interest a thirteen-year-old boy.

Marguerite registered Lee at Trinity Evangelical Lutheran School in Manhattan, where he began the seventh grade. But the living arrangement with the Pics would prove to be a problem since Marguerite did not get along with Marge. Marguerite made no efforts to find employment or her own home. Moreover, Lee's behavior left a bit to be desired. These tensions culminated, finally, one afternoon, in a fight between Marguerite and the Pics. It seems that Lee pulled a pocket knife on Marge when she asked him to turn down the volume on the television. By late September, Lee and his mother had moved into their own one-room basement apartment at 1455 Sheridan Avenue in the Bronx, and Marguerite had started working for a Lerner's dress store.

Truancy

Along with the move to the Bronx, after just three weeks at Trinity, Lee transferred to Junior High School 117. He was barely passing his classes. His report card reveals that his teachers rated him satisfactory in courtesy and effort but unsatisfactory in cooperation, dependability, and self-control.

Lee was given a second I.Q. test, the Wechsler Intelligence Scale for Children, and he scored 118. This placed him in the "upper range of bright normal intelligence." He also scored above average on reading and mathematics exams. But he was a chronic truant. His record of attendance at J.H.S. 117 was poor. He was absent 47 days between October 1952 and January 1953. He preferred the Bronx Zoo to school. Because he was caught by a truant officer at the zoo, he had to appear in the New York Children's Court.

Marguerite and Lee had moved once more, in March of 1953, to another apartment in the Bronx, at 825 East 179 Street. Marguerite was now working at Martin's Department Store in Brooklyn. She was earning $45.00 per week, with Wednesdays and Sundays off. To get to work, she had to travel from the Bronx through Manhattan and into Brooklyn. Because of the long commute, she left the house very early in the morning and returned home late in the evening.

When the Oswalds moved, Lee transferred to Junior High School 44 on Columbus Avenue and Seventy-sixth Street in Manhattan, his third school in seven months. With no one to oversee him, he simply didn't show up at his new school, preferring to learn about the wonders of the subterranean world of the New York subway system, visit museums, read, and watch television. When he was caught playing hooky at the Bronx Zoo, he was sent to the New York City Youth House for Boys, a way station for troubled children, to be observed for six weeks.

Lee entered Youth House for Boys on April 16, 1953, and was examined for emotional and physical problems. His psychiatric examinations were given and evaluated by Irving Sokolow, a staff psychologist, and Dr. Renatus Hartogs, chief psychiatrist at the facility. After the assassination, Hartogs was approached by the press in New York and presented with questions about the mind of an assassin. His answers never reflected the fact that he himself had observed Lee professionally a decade earlier. He never once mentioned that Lee had been his patient. Why? Because he didn't really remember Lee at all. In fact, Hartogs admittedly "reconstructed" his memories for the Warren Commission from a "conference" held at some unspecified date in which Lee had been discussed.

He described Lee for the Warren Commission as a "tense, withdrawn, and evasive boy, who dislikes intensely talking about himself and his feelings. Lee is a youngster with superior mental endowments, functioning presently in the right-normal range of mental efficiency. His abstract thinking capability and his vocabulary are well-developed. No retardation in school subjects could be found despite truancy."

The results of his testing showed Lee to have no neurological problems or psychoses, but it was determined that he had "personality pattern disturbance with schizoid features and passive-aggressive tendencies." The Warren Report states, "Lee has to be seen as an emotionally quite disturbed youngster who suffers the impact of really existing emotional deprivation, lack of affection, absence of family life and rejection by a self-involved and conflicted mother."

Irving Sokolow reported that Lee was " a somewhat insecure youngster, exhibiting much inclination for warm and satisfying relationships to others. . . . He exhibits some difficulty in relationships to the maternal figure suggesting more anxiety in this area than in any other." (Warren Commission)

Lee was also seen by social worker Evelyn Strickman, who observed a "rather pleasant, appealing quality about this emotionally starved, affectionless youngster, which grows as one speaks to him." (Warren Commission) Ms. Strickman added that Lee's interests were limited to watching

television, notably his favorite show, "I Led Three Lives"—an observation confirmed by Marguerite—and reading magazines. His only goal was to join the marines, following in the footsteps of his brother Robert.

When Lee was released from Youth House on probation on May 7, 1953, it was strongly recommended that Marguerite look into the Big Brothers in the hope of helping Lee cope with New York and his problems. Robert Oswald came to visit his family in

John Carro, a thirty-six-year-old probation officer from Children's Court in the Bronx, was assigned to the case and contacted Lee. They talked at Officer Carro's office. Lee was a "friendly, likable boy who portrays very little emotion . . . much of Lee's difficulties seem to stem from his inability to adapt himself to the change of environment and the change of economic status of his family." Recalled Officer Carro, "My job was to find out his background, his attitude toward school, the attitude of his parents, whether there were any illnesses or extenuating circumstances and so on. I found him to be a small, bright . . . boy. I asked him why he was staying out of school and he said he thought school was a waste of time, that he wasn't learning anything there anyway." Lee also told Officer Carro that the other kids teased him for his southern drawl and his dungarees.

"I asked him what his hobbies were, and he said he used to collect stamps but didn't do that any more. He said he liked horseback riding and said he wanted to go into the marines. But, he said, most of all he just liked to be by himself and do things by himself. He would get up in the morning and watch television all day. There was no one else at home. The mother worked. He didn't have any friends, and he didn't seem to miss having any friends. He never said anything to me about reading. It didn't seem abnormal to him to stay home and do nothing, but it was.

"In my report, I indicated this was a potentially dangerous situation, dangerous to his personality. When you get a thirteen-year-old kid who withdraws into his own world, whose only company is fantasy, who wants no friends, who has no father figure, whose mother doesn't seem to relate either, then you've got trouble. I recommended placement for Oswald. I thought of a place like Berkshire Farm in Canaan [New York] or Children's Village at Dobbs Ferry [New York]. They have cottages for the kids there, and psychiatric treatment, as well as follow-up therapy. I definitely thought that would help this boy.

"I had the feeling that his mother was completely ineffectual, that she was detached and noninvolved. She kept saying that Lee wasn't any problem, and she didn't understand what the fuss was all about. She wanted to go back to Texas or Louisiana but said she didn't have the money.

"Finally I remember telling Lee, 'It's either school or commitment.' He said, 'In that case, I'll go back to school.' His mother refused to take him to a court-attached psychiatric clinic. She said that he was attending school by that time and there was no reason for going to the clinic. Lee's behavior was slightly disruptive at school.

"In January 1954, I wrote to Mrs. Oswald, asking her to come into my office and bring the boy. The letter came back, 'Moved. Left No Forwarding Address.'" (Report of John Carro re: Lee Oswald. The Warren Commission.)

New York, and Lee acted as a guide for his older brother.

When he returned to J.H.S. 44 after his evaluation at Youth House, his work and attendance improved. According to his mother, that fall, he was elected president of his eighth-grade class. This seems rather strange, since class elections are invariable popularity contests, and a bitter, friendless loner such as Lee would not stand a chance of raising the necessary votes. It is worth noting that the Warren Commission was able to locate and interview friends of Lee's from both Fort Worth and New Orleans but none from New York. Lee's improvement was marred by an incident in October of 1953. He refused to salute the American flag and was termed "unruly." The action was reported to his probation officer and noted in his record.

Lee's interest in politics began around this time, when he was handed a pamphlet by an old woman on a Bronx street corner one afternoon. The pamphlet was a protest against the persecution and execution of Julius and Ethel Rosenberg, then believed by many to have been framed for espionage. The pamphlet had been printed by the Communist Party, but it struck a sympathetic chord in the already alienated teenager. The authorities and legend makers wish us to accept that at that instant, Lee was magically transformed into the model of a Marxist youth.

Below Left: **Edward Voebel, Lee's closest boyhood friend in New Orleans.**

Lee's time in New York ended in 1954, when Marguerite pulled him out of junior high school to move back to New Orleans. Ignoring orders from the court and advice from the psychologist, unfazed by Lee's truancy, and complaining that her normal son was being treated like a criminal, Marguerite left for New Orleans with Lee on January 10, 1954, before his probation had expired.

Marguerite later spoke negatively of the sixteen months they spent in New York. "It was a very, very sad story. Mr. John Carro told him, 'Lee, you'll have to report to me every week.' I said, 'Mr. Carro, my son is not going to report to you. He's no criminal. He's given his word that it's not going to happen again. The first time he doesn't keep his word, then he'll report to you.' I was not going to have a boy of that age and caliber going to a probation officer."

Below Right: **Lee in his ninth-grade classroom at Beauregard Junior High School, New Orleans, 1955, subsequent to his return from New York.**

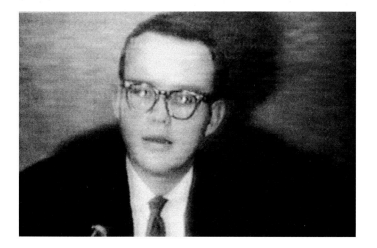

Back to New Orleans

Marguerite wrote to John Pic, "We are back in New Orleans and happy to be back. Lee is his self again after the ordeal in New York. It was almost a tragedy, but a little love and patience did the trick." She and Lee moved in with Lillian and Dutz Murret at their house at 757 French Street.

Within a few days of their return, Lee entered the eighth-grade class at Beauregard Junior High School in New Orleans. It was his ninth school in a ten-year period. At Beauregard, his truancy abated, but "Pinkie Lee" started to espouse the teachings of Karl Marx and subscribed to several Marxist publications.

Marguerite rented an apartment on St. Mary Street that belonged to a childhood friend, Myrtle Evans. The apartment was in a different school district than Beauregard, but Marguerite did not inform the school; apparently she wanted her son to stay there because he was doing well.

As was typical, in the spring of 1954 Marguerite had a fight with Mrs. Evans, and the Oswalds then moved to an apartment at 126 Exchange Place in May. From Exchange Place, located in New Orleans's French Quarter, Lee had to take a long streetcar ride up Canal Street to school.

Robert Oswald remembers, "Nobody ever saw Lee pick a fight, but anyone who picked on him was in for a real scrape. . . . One day Lee was attacked by a group of white boys who saw him sit down in the Negro section of the bus. New Orleans buses were still segregated at that time, but Lee didn't know it, or, having lived in New York, he had forgotten. Several boys jumped on Lee and started punching him. People who saw the fight said that Lee seemed unafraid. His fists flew in all directions, but he was outnumbered and thoroughly beaten up."

Before he graduated from Beauregard's eighth grade in 1954, Lee filled out a personal history form. He stated that he had two brothers but neglected to give their names. He said he was Lutheran. He listed his hobbies as reading and outdoor sports, football in

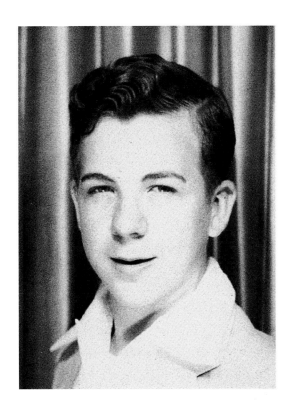

Right: Lee, circa 1955. He was nearly sixteen at this time.

particular. For his future Lee said he wanted to join a military service or become a draftsman. As far as his school subjects went, Lee said he liked civics best and art least. He was then supposed to name two friends. He entered two names but erased them.

Compared with the New York period, Lee's attendance at Beauregard improved drastically; he missed only seven days in the 1954–1955 school year. However, his grades were below average and he was having even more problems with his classmates. One of them remembered, "He fought with a lot of guys, I don't remember him friends with anyone." The view of him as a loner had begun when Marguerite brought him to New York, at the age of thirteen; it was to remain with him for the rest of his life.

One of Lee's few friends was Beauregard classmate Edward Voebel. Lee and Ed Voebel shot pool and threw darts in a poolroom in the French Quarter near the Oswalds' apartment. Voebel recalled, "One day he showed me a toy pistol, and he asked me if it looked real. I told him it didn't. Then some time later, he said he knew where he could get a real pistol, but would have to steal it from a pawn shop. I talked him out of it." (*Life* magazine, February 21, 1964)

The Civil Air Patrol

The summer of 1955 in New Orleans changed the course of Lee's life forever. He was between the ninth and tenth grades when he and Edward Voebel were invited to twice-weekly meetings of the student aviation organization of the Civil Air Patrol (CAP) at Lakefront Airport by schoolmate Frederick O'Sullivan. Lee was so enthusiastic about the organization that he got a newspaper route to earn money for a uniform. His commander was Captain David William Ferrie, a pilot, rabid anticommunist, right-wing fanatic, and suspected homosexual pedophile.

Ferrie was born in Cleveland, Ohio, on March 28, 1918. He was raised as a devout Roman Catholic and attended St. Mary's Seminary in Cleveland, preparing

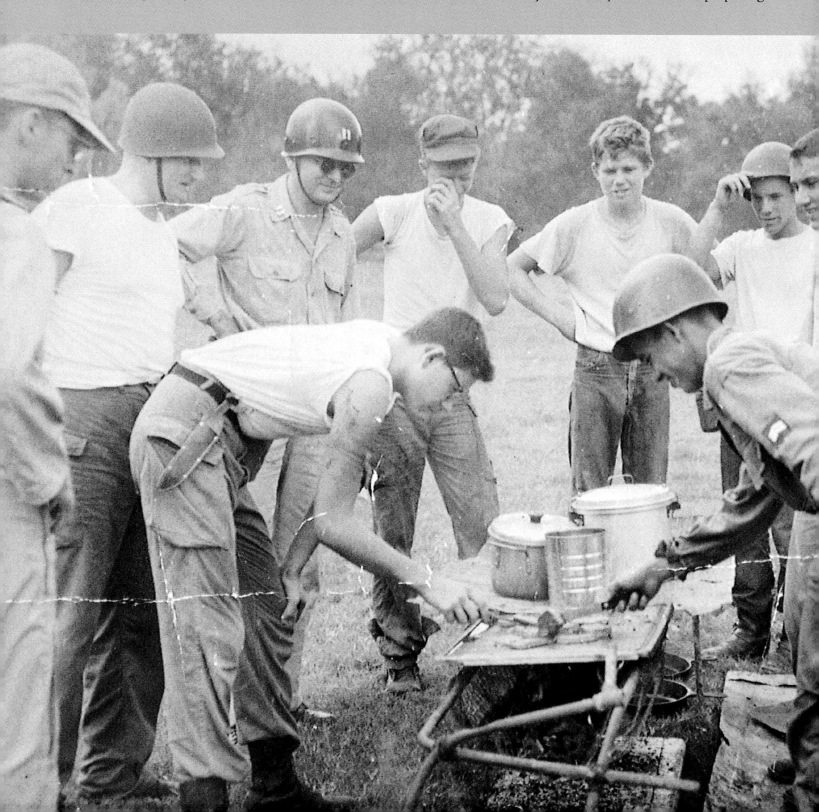

Left: David William Ferrie's passport photo. He had a disease called *alopecia praecox,* which causes total baldness. As a reuslt, he wore a toupee and painted on his "eyebrows."

Right: Lee dressed in his Civil Air Patrol (CAP) uniform, July 1955.

Left: This photograph of a CAP picnic in the summer of 1955 shows Lee and David Ferrie together. Ferrie is second from the left, while Lee is at the far right.

to enter the priesthood. After two years, however, he left and went to Baldwin-Wallace College in Berea, Ohio, where he obtained his bachelor of arts degree. He again attempted to become a priest, by enrolling in St. Charles Seminary, Carthagena, Ohio, but once again he failed.

His interest shifted to aviation, and he received his pilot's license in 1944. He taught aeronautics at the Benedictine High School in Cleveland from the fall of 1944 through the spring of 1948. He moved to New Orleans in the early 1950s, qualified for com-

mercial pilot accreditation, and worked briefly for Eastern Airlines before becoming commander of a Civil Air Patrol unit first at Lakefront Airport and then at Moisant Airport.

Ferrie's appearance was nothing short of weird. He had a disease known as *alopecia praecox*, which left him with no body hair, so he wore a red mohair wig, which he glued on, and he painted eyebrows on his hairless face. His hobby was cancer research. He turned his apartment into a laboratory of sorts, and kept as many as several hundred laboratory mice as subjects of his experiments.

It has been said that Ferrie exercised control over people much as Jim Jones would in Jonestown years later. He was also an amateur hypnotist. In late 1955 he was dismissd from the Civil Air Patrol when it was discovered that he had been having nude drinking parties with some of the boys. He had been fired by Eastern Airlines for a similar reason. Ferrie's homosexuality became public knowledge in 1961. According to Paris Flammonde in *The Oswald Affair* (1969), Ferrie was arrested for committing a "crime against nature" and "indecent behavior with juveniles" in Jefferson Parish, Louisiana.

Although Warren Commission apologists have lied to the public for decades and falsely stated that Lee

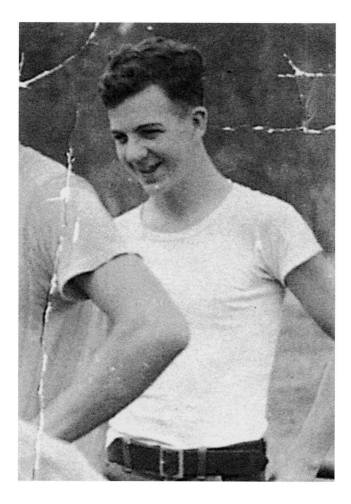

Left: **A close-up of David Ferrie from the CAP picnic photograph.**

Right: **Lee Oswald in a close-up from the CAP picnic photograph.**

and David Ferrie never met while in the Civil Air Patrol, at least three witnesses have confirmed being in the presence of the two at the same time. There are also two photographs of Lee and Ferrie together. Former CAP lieutenant Jerry Paradis told journalists Anthony and Robbyn Summers, "They were undoubtedly in that unit together. I was a lieutenant coinciding with the months Oswald was a recruit. . . . I recall him as a very quiet, serious young man. . . . David Ferrie was sort of the scoutmaster." Marguerite spoke of a uniformed recruiting officer (Ferrie?) who had tried to get Lee to join the marines while he was still in the CAP. The man visited their apartment and tried to get her to allow Lee to enlist while he was underage. An authentic marine recruiter would never have attempted to have a mother break the law.

Lee and Dave Ferrie would meet again eight years later in the summer of 1963. There is no evidence that the two had met or maintained a relationship of any kind between the summer of 1955 and the summer of 1963. The sole exception to this is a rumor that Ferrie had piloted Lee Oswald to Cuba sometime in 1959.

Ferrie died on February 22, 1967, as he was being indicted as a co-conspirator in the Kennedy assassination by New Orleans District Attorney Jim Garrison.

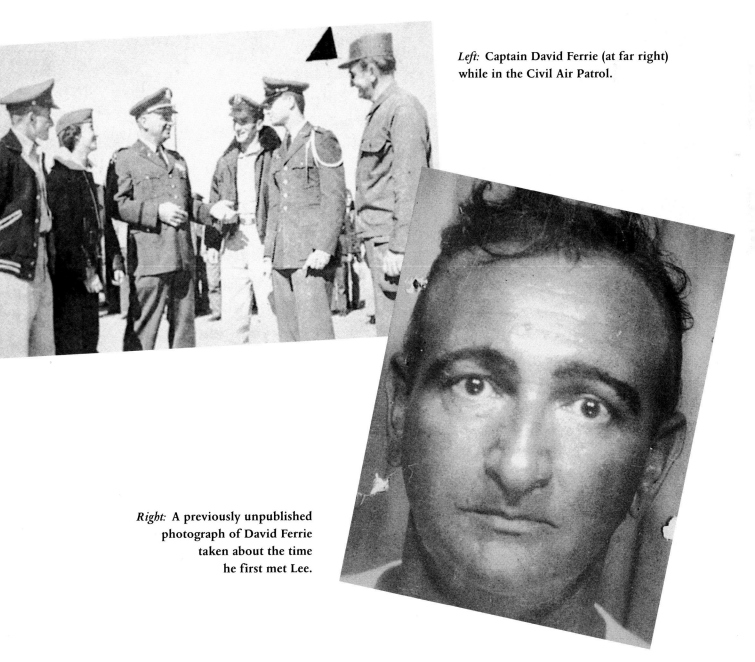

Left: **Captain David Ferrie (at far right) while in the Civil Air Patrol.**

Right: **A previously unpublished photograph of David Ferrie taken about the time he first met Lee.**

The High School Dropout

In September of 1955, as he neared his sixteenth birthday, Lee took achievement tests upon entering Warren Easton High School. His better-than-average scores were 88 in reading and 85 in vocabulary, while his math, English, and science scores were somewhat lower. He stayed at Easton for just under a month. Marguerite wrote a letter to the high school on October 7, 1955, stating that Lee would have to withdraw from school because they were relocating to San Diego. The purpose of this blatant lie was to allow Lee to enlist, underage, in the Marine Corps. Lee did try to enlist, but his age was discovered and he was rejected.

In fact, Lee and Marguerite remained in New Orleans through late summer 1956. Lee never did return to Warren Easton High School but began to spend massive amounts of time at local libraries. He spent the whole next year reading as he waited for his seventeenth birthday so that he could enlist. He would be the only marine who had memorized both the complete Marine Corps manual and Karl Marx's *Das Kapital*. Marguerite later stated, "He was bored and restless in school. He used to come home and say 'I already know all the stuff they're teaching. Why bother with that?' Then he'd go off to the library." Although Lee was an avid reader, there were still

Above: **Lee at age seventeen with a friend in high school. He barely attended the high schools in which he was enrolled.**

signs of possible dyslexia (he misspelled his own and his mother's names, for example). The disability could explain his school problems and his trouble maintaining steady employment in the years to come.

If Lee was really reading the teachings of Karl Marx, why would he be anxious to serve a government he would, of necessity, despise? The strong desire to enlist just doesn't fit the profile.

In November 1955 he found work as a messenger for the Gerard F. Tujague Forwarding Company near the docks of the Mississippi River, but he quit in January 1956. According to the Warren Commission, he then went to work for the J. R. Michaels Company, quit, and took another job as a runner for the Pfisterer dental laboratory in New Orleans. He read whenever he had a chance.

Marguerite recalled, "He brought home books on Marxism and socialism, but I didn't worry. You can't protect your children from everything, just try to help them see things in the right way. Besides, if those books are so bad, why are they there where any child can get hold of them?"

Left: **Stripling High School, Fort Worth. Lee attended school there, but both the Warren Commission and the FBI chose not to report this. Why?**

Fort Worth and the Budding Communist

Marguerite and Lee moved back to Fort Worth in August of 1956, and Lee enrolled in Arlington Heights High School. The antisocial behavior he had exhibited in New York continued. He ran into his old grammer school friend Richard Warren Garrett in school one day. Later Garrett recalled, "He walked up to me in the hall at school, I remember I had to look down to talk to him, and it seemed strange, because he had been the tallest, the dominant member of our group in grammer school. He looked like he was just lost. He was very different from the way I remembered him. He seemed to have no personality at all. He couldn't express himself well. He just hadn't turned into somebody. He hadn't turned into anybody. I've read where people say he was a loner. Well, he wasn't in the sixth grade but he sure was in high school."

Lee turned seventeen on October 18, 1956. He was now old enough to enlist in the marines. He told Marguerite that he was going to drop out of high school: "I just want to do something different." It has been suggested that Lee joined the marines to get away from the domination of Marguerite. There were far less drastic ways for him to accomplish that goal. He never had a problem being on his own. He has practically raised himself, and, ultimately, he was to go to Russia on his own. Did someone or something else convince him to enlist?

Above and Left:
Letter from Lee requesting information from the Socialist Party written in October of 1956, together with a request form for information Lee had filled out.

Lee tried out for the B football team at Arlington Heights. The B team was made up of players who were not good enough to make the varsity team. After practice, the players were supposed to run at high speed for a short distance. Lee refused to run with the other team members, telling the assistant coach, Nick Ruggieri, that it was a free country and he didn't have to run if he didn't feel like it. Ruggieri told Lee "that if he wanted to play, he had to finish practice with the sprint, just like the others. He gave me the same answer. I told him to hand in his cleats."

It would certainly seem that someone with such strong problems with authority would stay as far away from the military as possible. So why did Lee enlist?

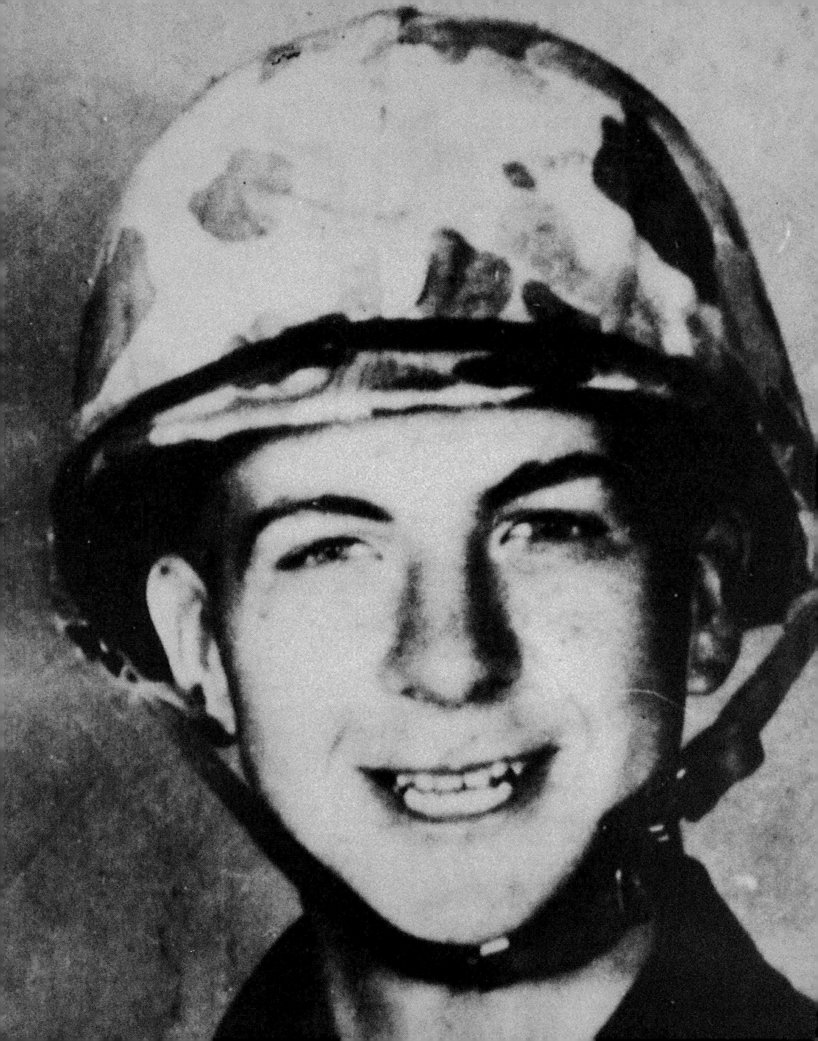

3

THE MARXIST MARINE

There are many contradictory issues regarding Lee's military career, just as, later in his life, there were times when he seemed to be in more than one place at the same time. People allegedly spent time with him in places where he ostensibly wasn't supposed to be. Other questions exist. Was it the marines that taught Lee to speak fluent Russian? Did they loan him out to the Office of Naval Intelligence, Central Intelligence Agency, Defence Intelligence Agency, or some other organization that turned him into some kind of operative? We may never know.

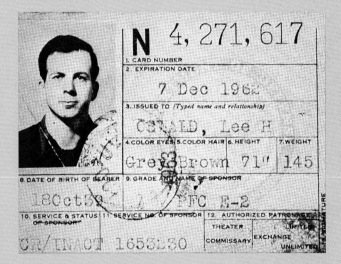

Above: Lee's Marine Corps I.D. card. Note that his height is listed as five feet, eleven inches.

Left: Lee in a marine helmet, April 1959, in Santa Ana, California, shortly before his discharge.

Training

Lee Oswald finally joined the marines on October 24, 1956, six days past his birthday. He went to Dallas and enlisted for three years. He was assigned to Platoon 2060, Second Training Battalion, San Diego, California, on October 26, 1956, for boot camp; to basic training until January 1957; and to Camp Pendleton for advanced infantry (combat) training (AIT). While in San Diego, his reputation as a poor shot with his M-1 rifle gave Private Lee Oswald the nickname "Shitbird" from other marines. Nonetheless he got along fairly well at this point.

On March 15 he was sent to the Air Frame and Power Plant (A&P) School in Jacksonville, Florida, to be trained as a mechanic. He is also listed as attending radar school and the Naval Air Technical Training Center while in Jacksonville. Basically, he was trained as an operator in aviation electronics, which required him to learn how to maintain and repair aircraft electronics systems on the ground and airborne.

On May 2, 1957, he was promoted to private first class. Two days later, on May 4, he was sent to Keesler Air Force Base in Biloxi, Mississippi, to learn aircraft surveillance. He was in the top ten of his radar operator class at Keesler, where was called "Ozzie the Rabbit" by his comrades. He remained in Biloxi until July 16 and was transferred to Aviation Electronics School in Memphis, Tennessee, where he was trained as an aviation electronics operator until September 1957. Lee's official Marine Corps records,

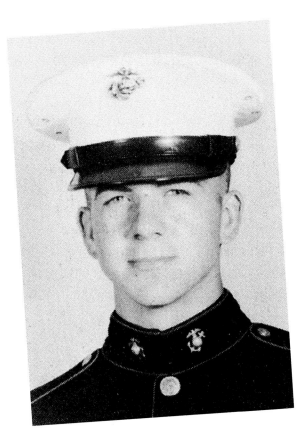

however, state that he was in El Toro, California, from July 17 until August 21. There is then a gap from August 22 until September 11.

It was an inordinate amount of training in a very short period of time. The above record comes from conflicting official sources and raises the possibility that more than one Lee Harvey Oswald existed and that they were being trained simultaneously by the marines and/or others.

It was suspected by several assassination researchers that, early on in Oswald's marine career, someone started to impersonate him. The man, or men, used the names Lee Harvey Oswald, Harvey Lee Oswald, and Alek James Hidell. These researchers believe that Hidell or one of the others took over the identity of Lee Harvey Oswald as a U.S. or Soviet intelligence agent for the rest of his life. One might then believe that the real Oswald was given another identity—as in the witness protection program—or was either held prisoner or killed. It has been suggested that one or more "Oswalds" could have been switched while Lee was in the marines, perhaps while he was being transferred between duty stations. This could explain why marine records show that Lee was 5´11´´ when he enlisted but only 5´9´´ when he was discharged.

Fellow Marine Allen R. Felde, who was also seventeen, was in boot camp, AIT, A&P, and aviation school with Lee. He recalled that Lee "continually discussed politics[,] in which topic none of the young marines had any interest. Oswald was an argumentative type of person and would frequently take the opposite side of an argument just for the sake of a debate. Oswald was not popular with the other recruits, and his company was avoided if possible."

Mr. Felde told the FBI that Lee continually wrote to United States senators about issues in which he believed strongly. Felde remembered that Lee expressed a dislike for wealthy people and that he championed the cause of the working man. Lee spoke of his dissatisfaction with Presidents Eisenhower and Truman and said that he had been opposed to U.S. involvement in the Korean War since a million men had been killed but nothing had been accomplished.

Felde told the FBI something that should have raised many questions: "At the time that the eight-man squad was assigned to Camp Pendleton and was permitted to take their first weekend leave, the entire group took a taxi cab to Tijuana, Mexico, at which point Oswald left the squad and was seen again only when the squad returned to Camp Pendleton." Felde said this was also true of at least four weekend leaves that the men took in Los Angeles. Oswald would ride with the group to Los Angeles in a bus but would leave the rest of the men at the bus depot and not be observed again until they returned to base. (Michael Benson, *Who's Who in the JFK Assassination*, 1993)

What was his purpose? Did he meet someone? The answers to these key questions may never be known, but they might help us find out who killed President Kennedy.

Right: **This photo of Lee against a height chart was taken when he entered the marines. Note, first, that here his height is five feet, nine inches, and, second, that the length of his head appears to be thirteen inches long.**

Mysterious Marine

As reported by several of his fellow marines, Oswald spent most of his personal time away from the others. Much of the time, nobody knew his whereabouts or activities. Allen Felde recalled that Oswald often read in marine base libraries or in his quarters. At Camp Pendleton and while training in Jacksonville and Memphis, Oswald was often observed with a brown leatherette-covered book with gold, Old English–type letters about 250 pages thick, and a small blue book of about 100 pages. Felde did not know the contents of these books. He stated that although he had been on the rifle range with Oswald, he could not recall if he was a good shot or not. Felde described Oswald as being a good talker and having an excellent vocabulary.

He remembers that Lee "was pretty hard to understand. I remember him as quiet, serious and trying to find himself. The rest of us used to wrestle and horse

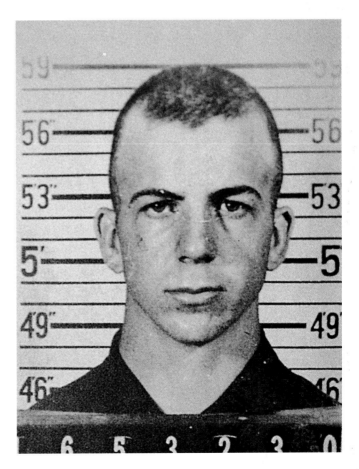

around, but he would have his bunk in the corner and would stay there reading a book . He didn't have any friends." (Warren Commission Exhibit 1662)

Lee's section chief at Pendleton, Donald Goodwin, recalled, "He was such a hothead I was glad when he was finally shipped out for radar training. He was always having beefs with the guys. Never could figure out what it was about, really. Just to get into a fight and vent his emotions, I suppose."

Lee's Marine Corps marksmanship record shows that he was a fair to poor shot. On one course he was ranked as a sharpshooter, with a score of 212, at distances between 200 and 500 yards. (Those scoring 190 to 209 qualified as marksmen; 210 to 219, sharpshooters; 220 to 250, experts.) Firing on another course, on May 6, 1959, he just barely qualified as marksman, with a score of 191. He used the standard M-1 rifle on both ranges.

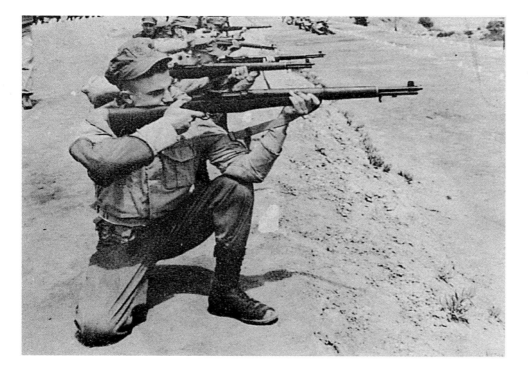

Left: **A photo of Oswald during Marine Corps rifle training. He was considered a poor shot.**

In light of his connection with David Ferrie, we cannot overlook an issue that relates to Lee at this point in time. At Keesler AFB, fellow marine Daniel Powers thought that Lee was a homosexual, stating, "He had a lot of feminine characteristics." Marine David Christie kept his distance from Lee because he thought Lee was a homosexual. It was reported that Lee allegedly went to a transvestite club/bar in Yamato, Japan, and that he went to The Flamingo, a gay bar in Tijuana, Mexico, on one occasion while stationed in California. For the record, there is absolutely no evidence that Lee Oswald was homosexual. A woman named Rose Cheramie made the statement to a policeman in November 1963 in Louisiana that Lee and her boss, Jack Ruby, were "bedmates." There is no proof of this either.

Japan

Lee shipped out to Japan on the USS *Bexar* from San Francisco on August 22, 1957. The ship stopped in Hawaii, and Lee went ashore and sent Marguerite a postcard: "Well, only one day here but I have been having lots of fun. 12 more days to Japan. Love, Lee."

The *Bexar* docked at Yokosuka, Japan, a naval port close to Tokyo. Lee was to serve with the First Marine Air Control Wing at Atsugi Naval Air Station, thirty-five miles southwest of Tokyo. He was assigned to the most sensitive U.S. intelligence presence in the Pacific. Atsugi had the largest CIA installation in the area, used for chemical, biological, and psychological experiments in which military men unwittingly acted as guinea pigs. (*Who's Who in the JFK Assassination* and Tom Miller, *The Assassination Please Almanac*, 1977))

He became part of Marine Air Control Squadron One, "MACS-1," nicknamed Coffee Mill. The job of the squadron of 100 to 150 men was to operate electronic and communications equipment for surveillance, aircraft identification, and fighter direction. They also gave navigational assistance to U.S. and Japanese airplanes. Lee worked each day as a radar operator in the high-security radar "bubble," observing flight patterns of, among other craft, top-secret U-2 reconnaissance (spy) planes, which made intelligence flights over the Soviet Union.

Late in the year he became very vocal about reading communist, Marxist and socialist literature, not exactly everyday reading material for a U.S. Marine. Many students of the assassination believe that at this point Os-

wald began training in counterintelligence and that Marxism was a cover. The possibility remains that he might have been a true believer in Marxism, but it would still be some time before he became adamant about his own alleged socialist beliefs; until now he had confined himself largely to conversation about the content of his reading.

Marguerite and social worker Evelyn Strickman, as we have seen, stated that Lee's favorite television show had been "I Led Three Lives," which ran from May 1953 through the middle of 1956. The show was about Herbert A. Philbrick, an FBI agent who had infiltrated the Communist Party for nine years and was a counterspy for the FBI. Lee's brother Robert stated that Lee never missed a single episode of the show. Was Lee following in the footsteps of his role model, Herb Philbrick?

Two weeks prior to enlisting in the marines, Lee had written a letter to the Young People's Socialist League of the Socialist Party of America, asking for literature and information. Considering this, he was treated in an amazingly cavalier fashion by the Marine Corps. From reports and testimony given to the Warren Commission, we find an apparently clear record of his supposed beliefs. He made it known that he subscribed to and read socialist publications. In spite of such proclamations, he was given a "confidential" military clearance, higher than his own commanding officer—a level of clearance required for his position as a radar operator.

At Atsugi, Oswald's fellow marines began calling him Comrade Oswaldskovich, because he read Russian-language periodicals and appeared to be teaching himself the Russian language, but the marines never removed his security clearance.

Left: **Lee, age eighteen, posed for this photograph at the U. S. Naval Base in Atsugi, Japan.**

CIA Mind Control

Atsugi was more than just the air base from which U-2 spy flights originated. According to Edward J. Epstein and Michael Benson, it was also one of the headquarters of a CIA mind-control program code-named MK/ULTRA, which used LSD, mescaline, and other mind-altering substances to give the authorities control over chosen subjects. The drugs limited subjects' capability to resist authority and question the morality or justification of orders given. (*Who's Who in the JFK Assassination*) Given Lee's history of emotional problems and his behavior, it seems that he was the perfect candidate for this type of testing.

In October 1963, a man entered the office of New Orleans Assistant District Attorney Edward Gillen. The visitor asked Gillen if he knew anything about the legality of importing a new drug known as LSD into the United States. The stranger said that he had a source for LSD and wanted to know if it might be illegal to sell it. In 1963, one of the only known sources for LSD was the CIA. The agency had been experimenting with LSD in its program known as Project Artichoke, which was in fact the CIA's first "Manchurian Candidate" experiment in 1951. The CIA performed experiments at two overseas military installations in the 1960s. One of these was Atsugi Air Base, where the agency regularly fed mescaline, sodium pentothol, depressants, amphetamines, and LSD to off-duty U.S. Marines both on base and at local bars.

One of these marine guinea pigs stated, "It was pretty weird. I'm eighteen at the time, and chasing all the whores in town, and these CIA guys are buying my drinks and paying for the whores and giving me a whole lot of drinks with lots of weird drugs in them. Pretty soon all the shadows are moving around, we're in this bar, see, and samurais are everywhere, and I started to see skeletons and things. My mind just started boiling over, going about a thousand miles a minute. I'm sure there are going to be some little old ladies who're gonna be surprised that illegal drugs like heroin and LSD were freely used by government agents. But, that's just the way it was."

Like 99 percent of the American public, Assistant D. A. Gillen had no concept that any of this was going on, and on that afternoon in October 1963 he thought the visitor was a crank. However, while watching television the day after the assassination, Gillen was startled to see that Lee Oswald had been arrested and charged as the murderer of President Kennedy. Lee Oswald was the same man who had visited him the previous month.

Below: **Lee during Marine Corps field training.**

The Queen Bee

"I remember him as being very quiet, but wild when he was drunk," recalled Peter Cassisi, a member of Oswald's squadron. "We used to call him 'Private Oswald,' just to needle him. He was that kind of guy. He'd go on a spurt every once in a while, and wake up the barracks when he came back. But he was mostly by himself, and never showed up at any of the squadron parties." (*Life* magazine, February 21, 1964)

Lee's socialist proclamations were getting more obvious at this point. Around the summer of 1957, he started spending off-duty hours with Japanese prostitutes and bar girls. He later claimed that he was involved with a Japanese communist cell at this time. (Edward Jay Epstein, *Legend*, 1978)

To fellow marines, he said he was learning the Russian language with a Eurasian girlfriend, a hostess at the Queen Bee bar in Tokyo. She was said to be so beautiful that they joked she was out of his league; in fact, they were astounded she would pay any attention to him. A single date with a Queen Bee hostess could easily cost up to $100.00. Lee was earning less than $85.00 per month. He dated her frequently. Fellow marine Zack Stout remembered, "He was really crazy about her."

Many officers went to the Queen Bee, and a large amount of information flowed from the mouths of intoxicated military personnel there. Stout recalled, "You could always find out where you were going [to be shipped] from a bar girl before you would on the base." Considering Lee's rather vocal Marxist rhetoric, it is possible that some of his "girlfriends" were testing the validity of his words. Naval intelligence believed that the hostesses from the Queen Bee were gathering information for the enemy. It is possible that Lee was paid money, and/or dates, for information by someone (his girlfriend?) at the Queen Bee. There is a probable connection between this situation and Lee's contracting a venereal disease "in the line of duty" at this time.

A few ex-marines remember Lee occasionally getting drunk. If true, this was the only time in his life he ever drank. Almost all of the people who knew him before he went in the service, and after, including his future wife, Marina, recall that he was a nondrinker.

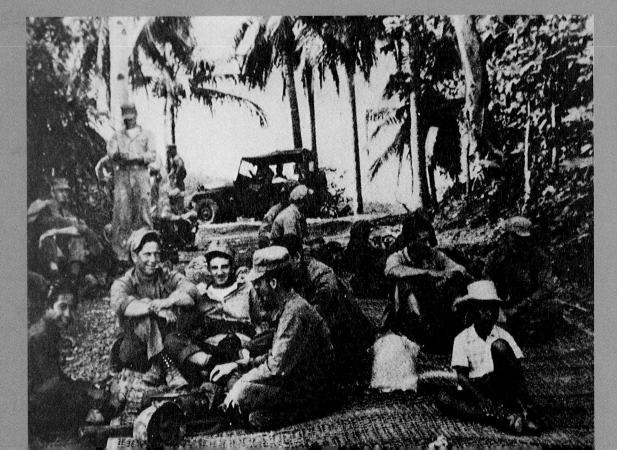

Left: **A group of marines in Corregidor, Philippines, February 1958. Lee is in profile at center.**

31

Court-martial

Oswald was court-martialed twice in 1958. The first time was on April 11, when he was convicted of violating Article 92 of the Universal Code of Military Justice (UCMJ) for possession of an unauthorized, unregistered personal firearm, a silver-plated, two-shot, .22 caliber derringer pistol, with which he had "accidentally" shot himself in the arm the previous October. The court-martial was postponed until the

unit returned to Atsugi from an imminent Pacific tour so that Lee could ship out with his unit. The question of whether or not the 1957 shooting was an accident is still unanswered.

Lee's marine squadron had been given orders to leave Atsugi, and he may have shot himself to get a transfer to prevent leaving with his unit. The planned tour of the Pacific included the Philippines; among the stops was Corregidor. To let Lee know that he was not getting away with anything, the marines (guilty until proven innocent) put him on permanent K.P. (kitchen duty) for the next three months. Since he was being punished for the crime before he was even court-martialed, he was justifiably angry.

MACS-1 was ordered to leave on the USS *Terrell County* and landed at Subic Bay in the Philippines in January 1958. The squadron set up camp near Cubi Point Air Base.

Left: **Movie star John Wayne appears in the foreground of this photograph taken in Corregidor, where he was shooting the film *The Barbarian and the Geisha*, in January 1958. It was a coincidence that the photo also shows Lee Oswald in the mess hall doorway.**

On January 15, 1958, USMC Private Martin Schrand was shot to death while on guard duty. Schrand was found lying in a pool of blood by fellow marine James R. "Bud" Persons, who was also on guard duty. Schrand had been shot under the right arm with his own shotgun. The shotgun's barrel was longer than the length of Schrand's arm, so it could not have been suicide. The death was ruled accidental, the assumption being that Schrand *had* dropped the shotgun and had been hit when it went off. The likelihood of murder was squelched by the marines. Although there is not the slightest bit of evidence that Lee could have been involved, whispered rumors have been circulated for years that he might have been implicated in some way. As pointed out by Anthony Summers, if Lee *had* been involved, this could have been held against him and used to control him. In fact, the Office of Naval Intelligence did investigate Lee for possible involvement in Schrand's death. Marine Donald Camarata states that at the time there was a rumor that Lee had been somehow responsible for Schrand's death.

Lee's squadron returned to Atsugi in March 1958, and he underwent his April 11 court-martial for the possession of the derringer and the self-inflicted gunshot wound. The penalty? He was lowered in rank from private first class to private and fined $25.00 per month for two months; some of his privileges were taken away, and he was given twenty days' confinement at hard labor, but the confinement was suspended.

Lee's second court-martial occurred two months later, after he talked back to Technical Sergeant Miguel Rodriguez, a noncommissioned officer, when they were both off-duty. He attempted to pick a fight with Rodriguez at the enlisted men's club at Atsugi. A few nights later, at the Bluebird Café, he once again encountered Rodriguez and poured a drink on him. The military police stopped the fight before it really began, and Rodriguez swore out a complaint against

Right: Sergeant Miguel Rodriguez, with whom Lee picked a fight in Japan. This led to Oswald's second court-martial and a time in the brig.

Above: Lee's sick call record for July 12, 1958. Note the entry: "Bleeding from rectum." Was Lee attacked while in the brig? Considering the next entry (at left), it is plausible.

Left: The record of Lee's first court-martial on April 11, 1958.

Right: Lee's health record for September 16, 1958. Note the entry: "Gonococcus...in the line of duty." Could this be related to the sick call record of July 12?

33

Lee. This was his second offense, and for the second time he was reduced in rank from private first class to private. He was also sentenced to twenty-eight days in the brig, beginning July 27, 1958, and fined $55.00.

The two incidents created more time when Oswald was out of contact with other marines. In spite of the light sentences, he appeared angry and stated to fellow marine radar operator Joe Macedo, "I've seen enough of a democratic society here in MACS-1. When I get out I'm going to try something else." (*Legend*)

Lee and his unit were sent to Taiwan (Formosa) on September 14, 1958. One night soon after arriving, Lee was on guard duty around midnight. He shot his M-1 rifle four or five times into the trees near his post. When his commanding officer, Lieutenant Charles R. Rhodes, a fellow southerner from South Carolina, finally found him, Lee was on the ground and slumped against a tree, "shaking and crying," his rifle lying across his lap. He was sent back to Japan by military plane on October 5 for "medical treatment" and recuperation. On October 6, twelve days before his nineteenth birthday, he was transferred out of MACS-1, put on general duty, and shipped 400 miles away to Iwakuni Air Base. He was shipped back home to the United States on November 2.

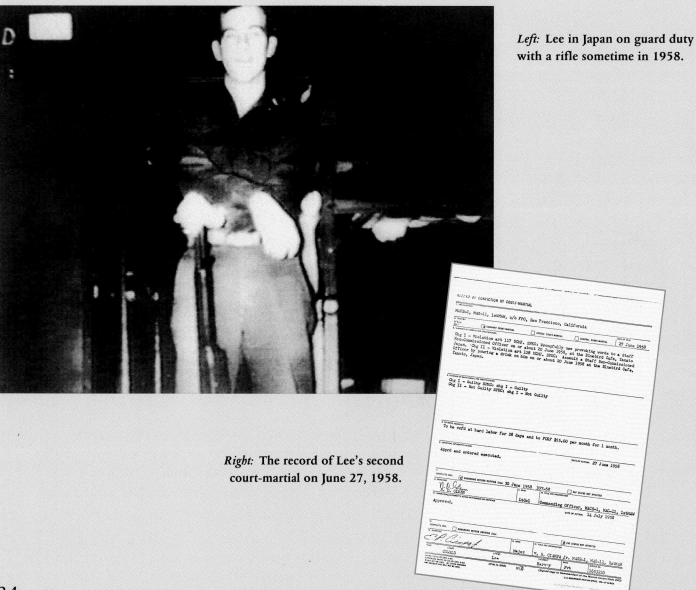

Left: **Lee in Japan on guard duty with a rifle sometime in 1958.**

Right: **The record of Lee's second court-martial on June 27, 1958.**

El Toro

Lee traveled back home on the USS *Barrett*, which sailed from Yokosuka, Japan, on the two-week voyage to San Francisco. He spent one month's leave in Fort Worth with Marguerite and Robert.

He was reassigned to the Third Marine Air Wing, Air Control Squadron Nine, at the El Toro marine base near Santa Ana, California, and reported there on December 21. It was at El Toro that Lee began drawing a significant amount of attention to himself by advertising himself as a Marxist. Until this point, his political leanings had remained in the background. Now they were most blatantly obvious.

Officially, we are told that Lee attempted to enroll in a military language school by taking a Russian language test on February 25, 1959, but he failed the test and did not qualify. We are told that he had begun to study Russian on his own. This was in all probability not true. Why would the marines test his Russian language proficiency if they had not been the ones who were training him in Russian? Notwithstanding the allegedly low test scores, his proficiency in Russian makes it appear that he was being trained professionally and intensively by the Office of Naval Intelligence (ONI)—if not by the ONI, then by someone else within the alphabet soup of U.S. military intelligence or by the marines themselves.

On the same day, February 25, Lee applied to Albert Schweitzer College in Churwalden, Switzerland, a private school that offered a program in "world problems," religion, philosophy, languages, and sociology. He told them that he had studied the Russian language for a year. On March 9, 1959, Private Lee Oswald was promoted to private first class for the second time, and on March 23 he received his High School General Educational Development (GED) certificate from the United States Armed Forces Institute (USAFI). On June 19, 1959, he sent a $25.00 enrollment deposit to Schweitzer—his last contact with the college.

It was the early 1960s. The stench of McCarthyism was still heavy in the air, and nowhere was it stronger than on military bases. We find an ultra-right-wing military and, in the middle of it, sticking out like the proverbial (red-leftist) sore thumb, Lee Harvey Oswald. Lee professes his adored Marxism so loudly that his fellow marines call him Comrade Oswaldskovich. He responds that he likes his life as a spy for the Russians. This unique posture is completely overlooked by all marine superiors. Lee Oswald, in spite of two courts-martial and professed Marxist leanings, kept his high-level security clearance throughout his Marine Corps career.

Lieutenant John E. Donovan was Lee's commanding officer at El Toro. He recalled that Lee was of "higher intelligence" than the average enlisted man and was seventh in his class of thirty radar operators. "Lee Harvey Oswald was dependable and very calm under periods of pressure," Donovan recalled. "He read most of the time, histories, magazines, books on government and a Russian newspaper he used to get. He spent a lot of time studying the Russian language. There were no pocketbooks or comics for him."

Donovan called Lee "an officer-baiter" and a troublemaker. "He would ask officers to explain some obscure situation in foreign affairs, just to show off his superior knowledge. He seemed to be in revolt against any kind of authority." Donovan explained that Lee played end on the squadron football team until he was dismissed "because he kept talking back in the huddle." The quarterback was a captain. (*Life* magazine, February 21, 1964)

Discharge

Although his enlistment in the marines would not be over until December 7, 1959 (two years from the date of his induction and adding the "bad time" penalty for the two offenses), Lee applied for, and received, an early hardship discharge on August 17, 1959, claiming that his mother was sick and needed him. While working in a department store in Fort Worth, she was injured on December 5, 1958 (nine months prior to Lee's discharge request), when a box of glass jars fell and hit her head and injured her nose. She was confined to her bed for six months, and the lost income and medical bills quickly depleted her meager savings. On January 9, 1959, a doctor in Fort Worth stated that he "could not go along with the alleged injury for compensation purposes," but the Fort Worth Accident Review Board awarded her $934.00. Marguerite stated, "I didn't want to tell Lee and worry him, but finally I wrote." Lee first learned of his mother's nose injury in July 1959. At this time, he took a one-month leave from the marines to visit her.

Again, the accident had occurred the previous December 5, and Marguerite had completely recovered months before Lee applied for the early discharge. (His brothers Robert and John stated that it was unlikely that he could have helped their mother in any case.)

On September 4, 1959, Lee was informed that his early discharge was approved and that he would be released on September 11.

Left: **Oswald's Marine Corps ring and I.D. bracelet. He seemed to wear the two items constantly, as they appear in many of the photographs taken of him.**

Below: Lee's Marine Corps
discharge document.

Above: Oswald's Selective Service
registration card. It was found in his
wallet when he was arrested for the
assassination of President Kennedy.

Right: The photograph in
Oswald's first passport.

4

THE COUNTERFEIT DEFECTOR

The problem with tracing Lee Oswald in the Soviet Union is that none of the information regarding his activities there can be confirmed. For more than twenty years, the main source of information was the "historic diary" he kept. Because of the work of the House Select Committee on Assassinations at the end of the 1970s, the authenticity of the diary is now officially in question. Many experts feel that Oswald did not write it at all, while others believe that he did compose it but that it was written in one or two sittings rather than daily, as the events occurred. Other sources of information on Lee include Marina Oswald, whom Lee met and married while in the Soviet Union, and Yuri Nosenko, a former KGB agent, living in the Soviet Union at the time, who had defected to the United States.

Discrepancies exist in the official version of Oswald's travels. For example, he allegedly took airplanes at times when there were no airline flights. Unbelievably, he received his visa at the Russian consulate in Helsinki, Finland, in forty-eight hours, when a week was the normal minimum waiting period. The usual amount of red tape did not seem to exist for Lee Oswald. The Soviet consul to Finland in Helsinki was Gregory Golub, who may well have been a KGB agent. It is believed that Oswald went directly through Golub, which backs the allegation that someone was behind his "defection."

One of the most intriguing questions relating to Lee Oswald is: What was the true motivation behind his defection? Was the defection his own idea, or was he following someone else's program? Given his activities in the military and the fact that he never "got around" to renouncing his U.S. citizenship, it is more than likely that the defection was a sham, designed to convince the Soviets that he was sincere by offering them U-2 spy plane and radar information as strong bait. If he was sent there, what was his mission?

Preparing for Defection

On September 4, 1959, seven days prior to his departure from El Toro, Lee applied for a passport so that he could attend Albert Schweitzer College and the University of Turku in Finland. The marines never questioned how this would help his ailing mother. The passport was issued in Louisiana on September 10. When Lee was discharged from the marines the following day, he received $219.00 in separation and travel pay and signed a statement that read, "I shall not hereafter in any manner reveal or divulge to any person any information affecting the National Defense, Classified, Top-Secret, Secret, or Confidential, of which I gained knowledge during my employment . . ." He would violate this oath a month and a half later, halfway around the world.

Lee's discharge was originally classified as honorable, but it was downgraded to "undesirable" on September 13, 1960, after he defected to the Soviet Union.

Lee traveled to Texas, arriving at his mother's apartment in Fort Worth on September 14. Ashamed of what she perceived to be her own ill-health and financial condition, she would later say, "Of all my sorrow, I don't think I will ever forget the shame I felt when my boy entered that small place with a sick mother. In the morning, he said, 'Mother, my mind is made up. I want to get on a ship and travel. I'll see a lot and it's good work.'" Lee closed out his bank account, $203.00, gave Marguerite $100.00, and kept the rest. Despite her difficult circumstances, Lee had spent only three nights with his mother.

It is believed that he had been able to save up to $1,600.00 from his Marine Corps salary, which he used to leave. On September 17 he departed for New Orleans, the first leg in his defection. He made travel arrangements through Travel Consultants, a New Orleans travel agency. (This was the same travel agency used by businessman Clay Lavergne Shaw, who years

Right: **The validations in Lee's passport showing dates of his entry into and exit from France and England.**

Marguerite received a letter from Lee sent from the Liberty Hotel and postmarked New Orleans. "Well, I have booked passage on a ship to Europe, I would of had to sooner or later and I think it's best I go now. Just remember that above all else that my values are different from Robert's or yours. It is difficult to tell you how I feel. Just remember this is what I must do. I did not tell you about my plans because you could not be expected to understand."

later would be charged as a co-conspirator in the Kennedy assassination.) Lee paid $220.75 for his ticket. On September 20, 1959, he left aboard the SS *Marion Lykes*, a freighter, which went from New Orleans to Le Havre, France. The voyage took sixteen days. Lee was one of only four passengers. He arrived in France on October 8.

Following Oswald's arrival in France on October 8, he apparently traveled to England; his passport was stamped October 9 in London. From there he went to Helsinki, arriving October 10 at 11:30 p.m. Within the next six days he appeared in Stockholm, Sweden, but he subsequently returned to Helsinki.

The Warren Report and CIA documents revealed that the only direct London-to-Helsinki flight was Finn Air #852, arriving at 11:33 p.m.—which would not have allowed Lee enough time to get through customs and check into the Torni Hotel within twenty-seven minutes of his arrival, when he did in fact check in. This raises a legitimate question as to the actual means of transportation utilized by Lee to arrive in Finland.

Lee's stay in Helsinki, first at the Torni Hotel and then at the Klaus Kurki Hotel, lasted from October 10 through October 15. On the fourteenth he received a visa to visit the Soviet Union. U.S. State Department official John A. McVickar, then stationed at the U.S. Embassy in Moscow, later said that only "knowledgeable" travelers to Russia came through Helsinki. Lee's passport was stamped and he departed Finland by train on October 15, arriving in Moscow later the same day.

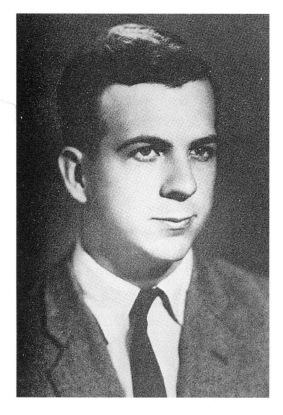

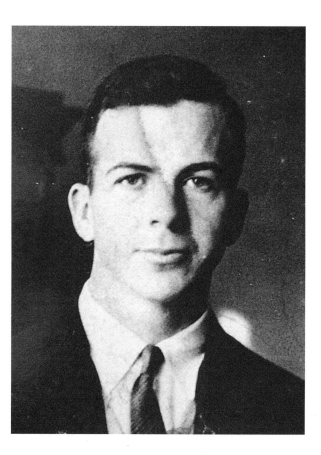

Left: **Lee when he arrived in Russia. This photograph was taken for press releases.**

Right: **Lee at the Hotel Berlin in October 1959. This became known as the "Moscow defection photo" and it ran in the American newspapers.**

MOSCOW

A guide for Intourist, the Soviet tourist agency, Rima Shirokova, escorted Lee from the Moscow railroad station on October 16 to the Hotel Berlin. Lee told her that he was a student. Because he had first stated to the Soviets in Helsinki that he had come to visit Russia only as a tourist, he received a six-day tourist visa.

He proceeded to write a letter to the Supreme Soviet asking for Soviet citizenship. While waiting for a response, he was interviewed on October 18 or 19 on a Soviet radio broadcast and made anti-American statements.

Below Left: **A message from the American embassy in Moscow to the Department of the Navy. What words followed "...former Marine and..."? Could it have been "Agent of the Central Intelligence Agency"?**

The Soviets refused Lee's request for citizenship and informed him that his six-day tourist visa had expired and that he had two hours in which to leave Russia. An entry in his diary states that he went back to his room at the Hotel Berlin and slashed his left wrist, attempting suicide over the rejection by his newly adopted country. The action was discovered by Rima Shirokova, who, it was originally reported, found him unconscious on the floor of his room; later (in 1993) she reported that she had actually found him in his bathtub. She saw that

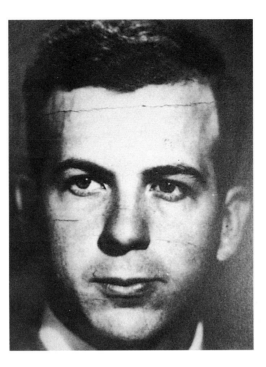

Left: **A photograph of Lee at the time he attempted to defect.**

Below Right: **The bathtub at the Hotel Berlin where Lee "attempted suicide."**

he was bleeding from his wrist and called for help, and Lee was taken by ambulance to Botkinskaya Hospital, where he received emergency treatment and five stitches. He remained in the hospital for three days in the psychiatric ward and four days in the somatic ward, for observation, before being discharged. The "suicide" attempt disrupted his deportation from Russia. The Russians apparently feared there might be an international incident if an American killed himself or died in the Soviet Union.

Upon his release from the hospital, on October 28, Lee checked out of the Hotel Berlin and into the Metropole Hotel. Later that day he was contacted by the hotel registration office, asking if he still was interested in obtaining Soviet citizenship. He responded that he was and was told that he would not have an answer for several days. Three days later, on October 31, after two and a half weeks in Moscow, he took a taxi to the American embassy, threw his passport down on a desk, and stated to Richard E. Snyder, the second secretary and senior consular official, "I've made up my mind, I'm through." He declared that he had applied for Soviet citizenship and stated that he wished to "dissolve his American citizenship." Along with the passport was a note:

"I Lee Harvey Oswald do hereby request that my present citizenship in the United States of America be revoked.

I have entered the Soviet Union for the express purpose of applying for citizenship in the Soviet Union, through the means of naturalization.

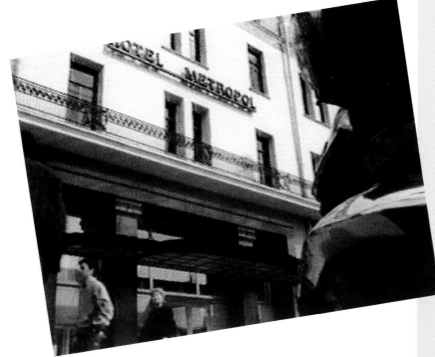

Below: **The Hotel Metropole in Moscow, where Lee stayed upon his discharge from a Soviet hospital following his suicide attempt.**

There is a challenge to the authenticity of Oswald's diary. In a letter to his brother Robert and in interviews with UPI reporter Aline Mosby on November 8 and 13, 1959, Oswald said he had been told by the Soviets that he had been given permission to remain in Russia (resident alien status). Contrary to this, in his diary, he wrote that he did not learn until as late as November 16 that he had temporarily obtained permission to remain in Russia.

In mid-November Lee was interviewed by Priscilla Johnson at her hotel in Moscow. Johnson's name later showed up on a list of U.S. State Department employees, and it has been alleged for many years that she was working for the CIA. If she was, we can only wonder if she was one of Lee's CIA contacts or perhaps one of his controllers in the Soviet Union.

My request for citizenship is now pending before the Supreme Soviet of the U.S.S.R.

I take these steps for political reasons. My request for the revoking of my American citizenship is made only after the longest and most serious considerations.

I affirm that my allegiance is to the Union of Soviet Socialist Republics."

(signed) Lee H. Oswald

In discussing his decision, Lee told Snyder that he had been a U.S. Marine and that he possessed military secrets the Russians would want. Obviously wishing to stop Oswald, Snyder told him that he could not dissolve his U.S. citizenship until the following Monday. The bureaucratic red tape forced Lee to wait.

Richard Snyder was responsible for monitoring Soviet response to U-2 spy flights. With his personal knowledge of the U-2 program, he must have perceived quickly that Lee and his knowledge would have been a threat to U.S. security and a propaganda asset for the Russians. In spite of this, Lee was simply released by the embassy and given a residence visa by Moscow, without being debriefed by the CIA or the KGB. Why?

In the next few days Lee gave interviews to correspondents for both major wire services, United Press International and the Associated Press, and to several other reporters. He spoke of his love of communism and stated that he did not wish to end up in poverty under a capitalist system of government.

On November 1 he was interviewed by Aline Mosby, a correspondent for United Press International, at the Hotel Metropole. Mosby got the impression that Lee was "a person very determined, but unsure of himself, naive and emotionally unbalanced." Lee stated that he had "indoctrinated himself" in Marxism and that he sympathized "with niggers." He told her, "I will never return to the United States for any reason. I am a Marxist. I became interested at about the age of 15. I've seen poor niggers, being a

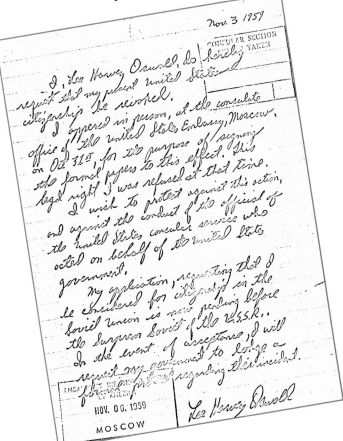

Below: Lee's request to have his U. S. citizenship revoked.

Below: Lee's second request to revoke his U. S. citizenship.

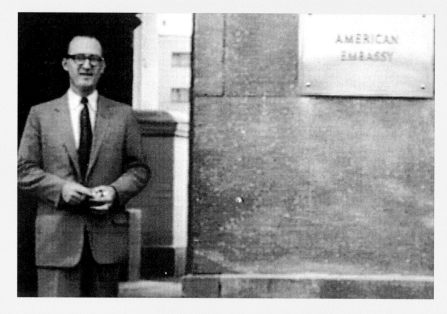

southern boy, and that was a lesson. People hate because they're told to hate, like school kids. It's the fashion to hate people in the United States."

In America, many newspapers carried the stories and portions of Lee's interviews. Only then did Marguerite learn what had become of her son. A newspaper reporter had called her late in October and told her that her son had defected to the Soviet Union. Marguerite later recalled, "I told them they were crazy, but I learned it was true. I couldn't understand it." Lee had just celebrated his twentieth birthday.

Marguerite had the premonition that Lee was actually an undercover agent for the United States and that this entire story was simply a cover. This was a charge she would repeat thousands of times until her death, of cancer, in January 1982. The government went to extremes to dismiss her charge as groundless; however, it is more than likely that she was correct in her assumption.

In 1994 Anthony and Robbyn Summers uncovered a previously unknown witness to Lee's visit to the American embassy. The official version of Lee's visit reports him as never going beyond the ground-floor consular office. However, Joan Hallett, the widow of the assistant naval attaché, who was a receptionist employed by the embassy, clearly remembers his visit. She remembers Richard Snyder and the embassy security officer escorting Lee upstairs to the secured working floors, where the ambassador and the military, political, and economic officers were located. A casual visitor or even a high-profile character, as Lee has been portrayed, would never be allowed into such a secured area. The chances of a defector being allowed anywhere near any of the upper floors is inconceiv-

Below: Lee in Moscow.

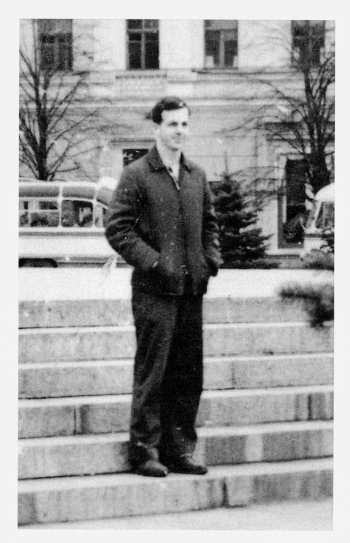

able unless he were actively involved in U.S. espionage or on official business. Hallett herself had never been allowed on any of the upper floors. She observed Lee at the embassy "several times" during 1959.

Richard Snyder's stall had worked. Oswald never formally renounced his U.S. citizenship. This may well have been the plan from the beginning. The ability to return to the United States still available to him, he was now left with an official "easy out" should he ever change his mind about remaining in Russia.

Above: **The article written by Aline Mosby based on her interview with Lee Oswald in the Soviet Union.**

Below: **The residency permit issued to Lee and dated January 4, 1960, by the Soviet government, which permitted him to stay in the USSR for one year.**

Right: **"Moscow, November 22, 1959, Lee Harvey Oswald." This inscription is from Lee's Russian-English dictionary.**

Minsk

Oswald was summoned on January 4, 1960, to the Soviet Passport Office, where he was told that he was being relocated to Minsk, an industrial town nearly five hundred miles southwest of Moscow. He arrived there January 7 and was greeted by the mayor on the following day. He was given a rent-free apartment and a job at the Belorussian Radio and Television Factory. His pay was the equivalent of $60.00 per month. Curiously, he was paid nearly as much as the foreman of the factory. He was also given a generous subsidy by the Soviet Red Cross.

Based on declassified Soviet files, we know that Lee lived very well for a year and went out with several women, nearly all KGB-controlled government agents assigned to monitor his activities. Many of his Russian friends, both men and women, called him "Alik," a far more Russian-sounding name than Lee, which sounded Chinese to the Russians. Lee would later allegedly use Alik as part of the alias Alik James Hidell.

Left: **The outside of Lee's apartment house in Minsk.**

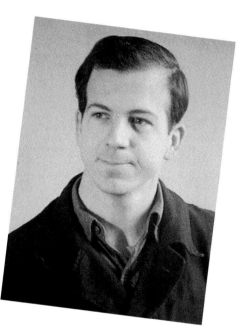

Right: **Lee in Minsk at the radio factory where he worked in 1959.**

Above: **The living room of Lee's Minsk apartment.**

Below: **Oswald at the factory with some of his co-workers.**

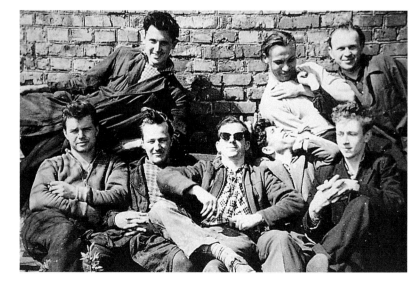

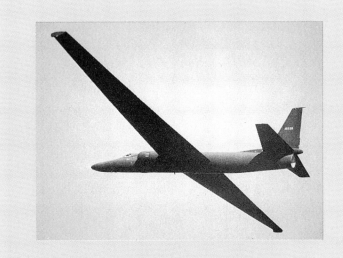

Above: The U-2 spy plane. A U-2 plane piloted by Francis Gary Powers was shot down during Lee's stay in the Soviet Union. Did the Soviets learn of U-2 missions from Lee?

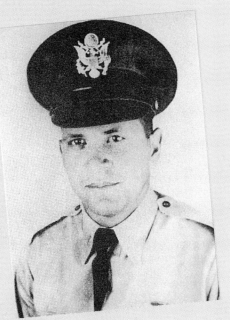

Right: Francis Gary Powers.

On May 1, 1960, a U-2 spy plane piloted by Francis Gary Powers was shot down by the Soviets while photographing Soviet military installations. The United States first denied that it was on a spy mission but later conceded that it was. This major incident is curiously absent from Lee's "historic diary," even though he had certainly been aware of and perhaps even involved in the missions in Atsugi. Powers, who survived the crash, believed that it was information from Lee that gave the Soviets the ability to find the U-2 and shoot it down. Beyond question, the Russians would have talked to Lee about this incident. Officially, and unbelievably, they claimed that they never did.

On May 5 Soviet Premier Nikita Khrushchev angrily announced that the U-2 had been downed four days earlier, on the first. On May 14 the Big Four Summit Meeting in Paris began, with the United States, England, France, and the Soviet Union participating. The premise of the conference was on shaky ground. The right-wing hawks in the United States government, the leadership of America's intelligence agencies, and the Soviets all wanted the cold war to continue. There is a very strong likelihood that Lee's defection was designed to provide the fertilizer to allow the Soviets an excuse to end the talks. This is exactly what did happen. On May 17, 1960, the peace talks fell apart. Khrushchev cited the U-2 incident and referred to America's "aggressive actions." If this was Lee Oswald's mission, it succeeded.

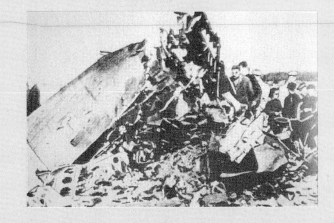

Left: The wreck of Powers's plane.

From January through May 1960, Lee studied Russian with an Intourist teacher in Minsk and dated a woman named Ella German. The official version of his life in the Soviet Union describes him as infatuated with Ella. One of the reasons attributed to his subsequent desire to return to the United States was the disillusionment that resulted from her rejection of him and his offer of marriage.

A 1960 entry in Lee's diary states, "I am starting to reconsider my desire about staying. The work is drab. The money I get has nowhere to be spent. No nightclubs or bowling alleys. No places of recreation except the trade union dances. I have had enough." The entry seems to be the start of repatriation and may also have been intended to show the beginning of Lee's dissatisfaction and frustration.

In January 1961 the Soviet Passport Office once again called Lee in and asked him whether he still desired Soviet citizenship. He said no but indicated that he would like to remain for another year.

The American embassy received a letter from Lee on February 13, 1961. It had been sent from Minsk on February 5. Lee stated his desire to return to the United States. Richard Snyder answered back, stating that Oswald would have to come to the American embassy in person. On March 5 Lee wrote Snyder that he would not be permitted to leave Minsk without official permission. The letter did not arrive in Moscow until March 20. The Warren Report concluded that, because it took more than two weeks to be delivered, the Russian authorities must have intercepted this second letter.

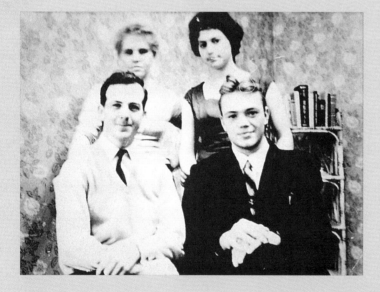

Left: Lee's birthday party in Minsk, October 18, 1960. Rosa Kuznetsova (left), Ella German, and Pavel Golovachev. Ella was one of Lee's girlfriends. He once proposed marriage to her, but she turned him down.

Right: Lee, fishing, with the Zigers.

Above: Lee (right) with his friend Eleanora Ziger's sister Anita in Minsk.

48

Above: Lee tending to a campfire on a picnic with the Zigers.

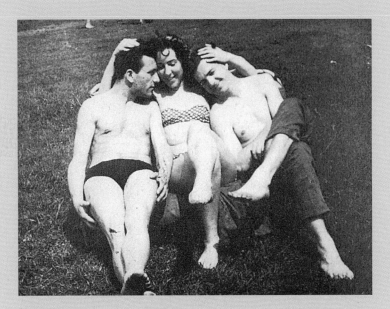

Above: Lee with Eleanora Ziger and one of her boyfriends in the summer of 1960.

Above: Lee's Soviet hunting license.

Above: Ironically, Lee wrote to the former secretary of the navy, John Connally, from Minsk on January 30, 1961, in an attempt to upgrade his marine discharge.

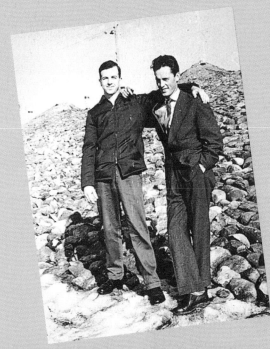

Left: The man on the right with Lee in this photograph was known as Alfred of Cuba.

THE COUNTERFEIT DEFECTOR **49**

Marina

It was during this time period that Oswald met nineteen-year-old Marina Nikolayevna Prusakova, at a dance at the Palace of Culture for Professional Workers in Minsk. Marina was born on July 17, 1941, in Severodvinsk in the Archangel Region in the northernmost area of Russia. Her mother, Klavdia Vasilievna Prusakova, had died in 1957; like Lee, she had never known her father. Marina had lived for a while with her stepfather, Alexander Ivanovich Medvedev, but did not get along well with him. She had attended a pharmacy school in Leningrad between 1955 and 1959 and, at the age of eighteen, moved to Minsk to live with her uncle, Ilya Vasilyevich Prusakov, and his wife. The Prusakovs had no children of their own. According to Marina, her uncle was a colonel in the Minsk Ministry of Internal Affairs (MVD), the agency that controlled the Soviet secret police. His title would actually translate to minister of domestic affairs, or the Russian equivalent of an FBI agent. It has often been alledged that he was a KGB agent, but Marina strongly denies this.

Lee asked Marina to marry him in early April 1961. By April 20 they filed an intent-to-marry notice, and on April 27 they received the permission necessary for a Soviet national to marry a foreigner. They were married on April 30, 1961, at 11:00 A.M.

Marina testified before the Warren Commission that when she and Lee married, he had never mentioned to her that he was planning to leave the Soviet Union. She was not aware that he would be able to return to the United States. However, the Oswalds were making plans to travel to America by the end of May 1961. The Oswald diary has an entry stating that Lee didn't tell Marina they were going to go to America until the end of June, but the American embassy in Moscow received a letter from Lee on May 25 stating he wanted a guarantee that he would not be prosecuted for treason or other crimes when he returned home.

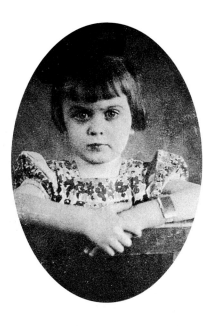

Right: **Marina at age 3 in Murmansk, USSR.**

Above: **Marina, twelve years old, is at the bottom left in this class photo, in Leningrad.**

Left: **Marina at fourteen near Leningrad.**

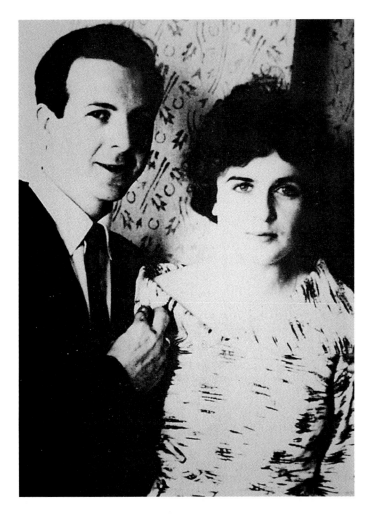

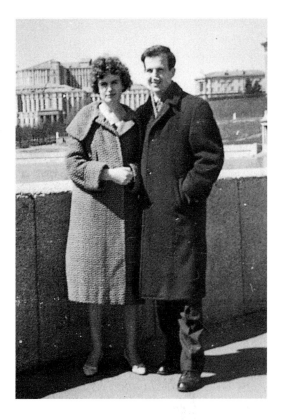

Right: Lee and Marina on the second day of their marriage in front of the opera house (right) in Minsk.

Right: Lee's wedding portrait.

Above: Lee and Marina on their wedding day, April 30, 1961.

Below Right: Lee at age twenty-one with Marina in the early summer of 1961 in Minsk on the balcony of their apartment.

Below Left: The Palace of Culture in Minsk, where Lee and Marina first met at a dance.

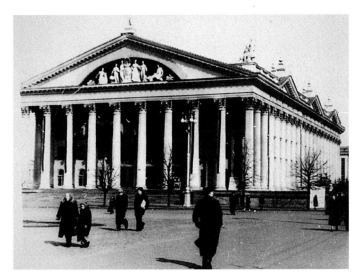

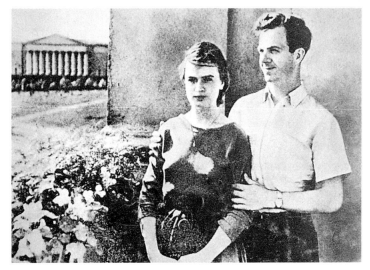

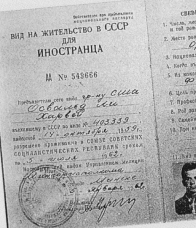

Right: Lee carried this photograph of Marina in his wallet; it was probably one of his favorites.

Left: Lee's new residency permit, showing that he is now married.

Below: A close-up of Lee from the tourist photos in Minsk.

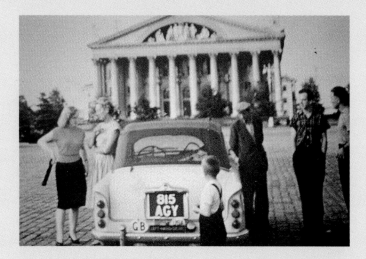

Above: A photo of Lee (far right, in plaid shirt) accidentally taken with a group of U. S. tourists in Minsk, 1961.

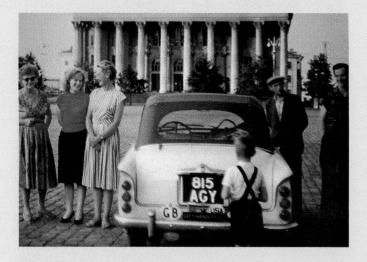

Above: A second photo of Lee with U. S. tourists. These pictures were soon in CIA files.

Left: A formal portrait of Lee taken in the summer of 1961.

When Lee tried to enlist at the age of sixteen, the marines realized that the birth certificate he had presented was a fake and sent him away, but a false birth certificate now existed. After Lee defected to Russia, J. Edgar Hoover personally sent a letter to the State Department voicing fear of the "[p]ossibility that an impostor is using Oswald's birth certificate." When Lee returned from Minsk without his birth certificate—and it never did reappear—the Office of Naval Intelligence, the Department of State, and the FBI all expressed concern. Yet the Warren Commission was never told of these concerns. Warren Commission Counsel W. David Slawson has stated, "I don't know where the impostor notion would have led us . . . but the point is we didn't know about it. And why not? It could conceivably have been something related to the CIA . . . a general CIA effort to take out everything that reflected on them may have covered this up."

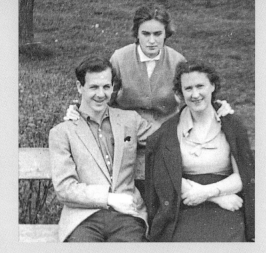

Left: Lee and Marina with her Aunt Luba in Minsk, early fall, 1961.

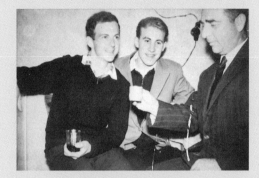

Left: A friend of Lee's and Marina's named Anatole, and Alexander Ziger.

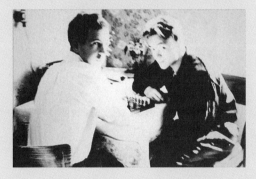

Left: Pavel Golovachev, on the right, was Lee's best friend in Minsk.

Left: A KGB surveillance photograph of Lee, possibly with Pavel, in 1961.

Right: A KGB surveillance photograph of Marina.

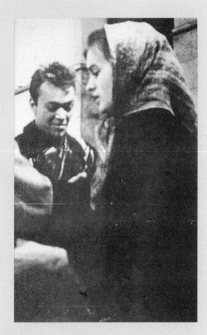

Left: Another KGB photograph of Lee. The KGB kept Lee under constant surveillance.

Preparing to Leave

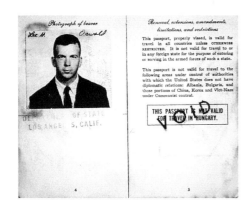

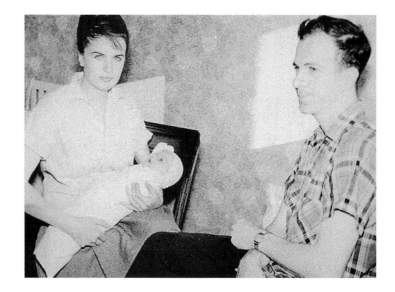

Above left: Lee's passport was returned to him in July of 1961 by the U. S. embassy.

Above Right: Marina, June and Lee in their Minsk apartment in 1962.

Left: The letter of response to Lee in Minsk from John Connally, February 23, 1962.

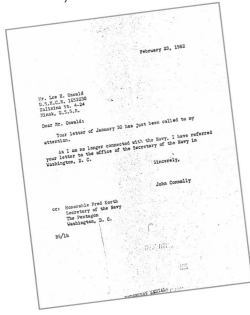

Below: Lee holding newborn baby June in the Minsk apartment.

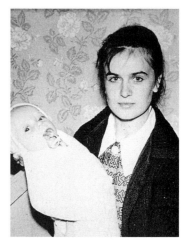

Above: Marina with the baby.

Below: June Oswald's picture was added to Lee's passport on May 24, 1962.

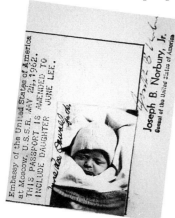

Right: A group photo taken as the Zigers see Lee, Marina, and June off to America at the Minsk railway station.

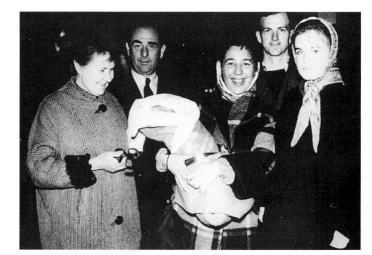

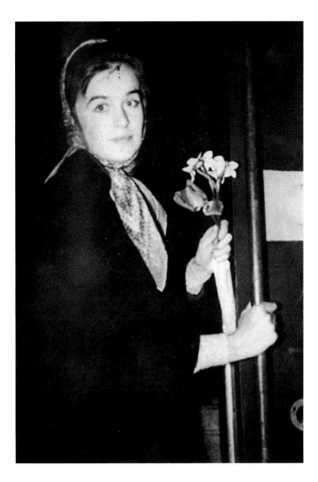

Left: Marina, obviously nervous and frightened to leave her homeland, at the railroad station in Minsk boarding the train to leave Russia.

Left: Lee, on the train, happy to be returning home after two and a half years in Russia.

Above: Lee contemplates his return to America.

Right: Lee and Marina aboard the train.

5

THE HOMECOMING

Arranging for Lee's return to America was a nightmare. Most of the problems arose from Marina's troubles getting a visa. She was also pregnant with their first child. While they were still living in Minsk, on February 15, 1962, their daughter, June Lee Oswald, was born.

On June 1, 1962, Lee, Marina, and June Lee left by train for the Netherlands. They departed Holland on the SS *Maasdam* on June 4 and arrived in Hoboken, New Jersey, on June 13. The Oswald family was met, not by the Immigration and Naturalization Service or the State Department, but by Spas T. Raiken, from Traveler's Aid in New York City. Raiken was secretary general of the American Friends of the Anti-Bolshevik Nations, Inc., an ultra-right-wing organization. Why a right-wing group would help someone who was visibly pro-Marxist like Lee is a great mystery. The Oswalds spent a night in a Times Square hotel in New York City. The New York Department of Welfare lent them some money. The next day, June 14, they flew to Fort Worth, after Lee's brother Robert wired him the money for the trip.

How was it that Lee was not charged with treason? He had defected to a communist country and had pos-

sibly divulged military secrets, usually grounds for imprisonment or even execution; but he was not even charged. Moreover, the State Department had lent him $435.71 to come back to America. Although Lee was never officially able to afford it, the money was later repaid, conceivably by one of the U.S. intelligence agencies.

On January 20, 1964, two months following the assassination of President Kennedy, KGB agent Yuri Nosenko defected to the United States. He informed the CIA that he had controlled the Oswald case in Russia. Nosenko was put through 1,277 days, nearly four years, of living hell in solitary confinement (formally referred to as intense interrogation) by James Jesus Angleton, CIA chief of counterintelligence. Oswald, on the other hand, was formally ignored by the powers that be and was only briefly interviewed by the FBI upon his return.

Fort Worth

The Oswalds traveled to Fort Worth because Lee's brother Robert, who lived and worked there, had sent Lee a letter, while Lee was still in Russia, inviting the family to move in with him. The FBI spoke to Lee, for the first time that we are aware of, on June 26, 1962. Although they reported that he was "arrogant" during the questioning, Lee himself felt that the interview went "just fine."

Lee, Marina, and June stayed at Robert's for approximately a month. In mid-July they moved in with Marguerite at 1501 West Seventh Street. Lee and Marguerite didn't get along well, and in August the family moved to a one-bedroom apartment of their own at 2703 Mercedes Street. The apartment was in poor shape, sparsely furnished and run down. The rent was $59.50 per month. They remained until October 9.

From July 17 until October 9, 1962, Lee was employed as a sheet-metal worker for the Louv-R-Pak division of the Leslie Welding Company in Fort Worth at an hourly wage of $1.25. Apparently he made no friends there. He attempted to publish an article about his life in Russia; he had always wanted to be a writer, and this, he hoped, would be his big chance. No publisher, it seems, was interested.

At this time, Lee and his family started to bond with some of the Russian-speaking community around Dallas and Fort Worth, an ethnically centered group with language, politics, and nationalist pride as their common ground. A great many members of the community were fond of Marina and feared for her safety. They correctly believed that Lee was abusing her. When she appeared with a black eye, several of her friends advised her to leave him. But Marina was not an American citizen, spoke very little English (Lee actively discouraged her from learning it), had a baby to care for, and had no money of her own. Because she was afraid of being sent back to the Soviet Union, she put up with Lee's abuse.

On August 16, 1962, the FBI interrogated Lee again, this time in the rear seat of a car in front of his Mercedes Street home. The questioning pretty much followed the same lines as the first session. Lee stated that he had not attempted to become a Soviet citizen and that he had never knowingly spoken to anyone from the KGB. He displayed open antagonism toward the agents questioning him.

The Oswalds decided to move to Dallas in October. While Lee went there to look for work, Marina moved with June to the home of Mrs. Elena Hall in Fort Worth. Hall was of Russian descent but had been born in Iran. Marina and June stayed with her until Lee found employment.

Left: **Lee took this picture of Marina and June in Poland on the way to America.**

Right: **Marguerite sent this picture to Lee in Russia. This is how she looked upon his return.**

George DeMohrenschildt

One of the few émigrés who got along with Lee was fifty-one-year-old George Sergei DeMohrenschildt, a White Russian who had arrived in the United States in May 1938. DeMohrenschildt was a geologist who had been involved in intelligence activities for several years. While in Europe before emigrating, it is said that he had backed Nazi efforts to overthrow Joseph Stalin. It is also widely believed that DeMohrenschildt worked directly for the Nazis. He was pathologically afraid of Israeli retaliation near the end of his life.

DeMohrenschildt had been suspected of being a spy after he fled to the United States, and he was involved with the CIA in Guatemala during the training for the Bay of Pigs invasion. During the time of the Kennedy assassination, he was living in Haiti, working for Dallas oil billionaire Clint Murchison. Ironically, this mysterious character, closer to Lee Os-wald than most, was also close to Jacqueline Kennedy, who referred to him as "Uncle George." DeMohrenschildt had been engaged to her Aunt Michele and had once nearly married her mother, Janet Auchincloss, dating her at the time she was divorcing Jackie's father. Edie Beale, Jackie's cousin, stated, "We all knew George. He was a regular visitor. As a child, Jackie played on the lawn with Uncle George."

Lee and Marina were still living in Fort Worth when they were first visited by DeMohrenschildt, on October 7, 1962. He suggested that since most of their Russian-speaking friends lived in and around Dallas, they should consider moving there. Lee took his advice.

When Lee was arrested after the assassination on November 21, 1963, George DeMohrenschildt came to his defense, stating that he owned a Beretta automatic pistol and not the Smith & Wesson revolver the Dallas police claim he had at the time of his arrest. DeMohrenschildt's personal history raises many questions about his real connections to Lee.

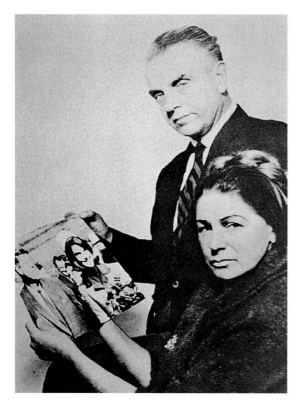

Left: **George and Jeanne DeMohrenschildt, friends of the Oswalds. He was the mysterious man who encouraged Lee to move to Dallas.**

Right: **George DeMohrenschildt.**

Dallas

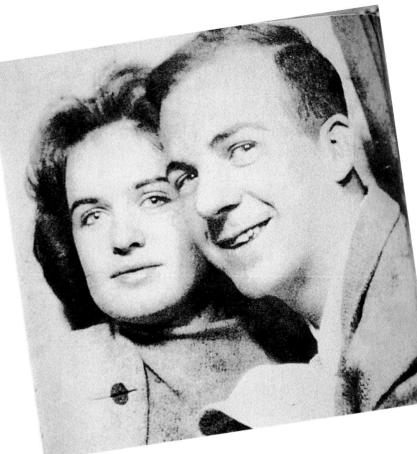

Above: **A photo booth portrait taken at the Greyhound bus station in Dallas, Thanksgiving Day, November 22, 1962, exactly one year to the day before the assassination.**

Lee finally found a job at Jaggars-Chiles-Stovall, a graphic arts company in downtown Dallas. Part of JCS's business was classified government photographic and print work. Considering Lee's military and Marxist background, JCS should have been the last place to want to hire him. However, on October 11, 1962, he was taken on as a photoprint trainee at $1.35 per hour. While Lee was employed there, the company worked on secret, classified maps of the Soviet Union, Cuba, and China for U.S. Army intelligence. How could he pass the security checks?

Lee stayed at the Dallas YMCA from October 15 through October 19. Nobody knows where he spent nights during the two-week period at the end of October. On November 3 he rented an apartment at 605 Elsbeth Street, in the Oak Cliff section of Dallas.

Marina moved in with him, but their relationship was as poor as ever, and after a few days she took June to live with Russian-speaking friends. Lee pleaded with her to return, however, and she and the baby eventually did so.

In November Robert Oswald invited Lee and their half-brother John Pic and their families to his home for Thanksgiving dinner. Lee would not see Robert Oswald again until one year later, after the assassination; it was the last time he would ever see John Pic.

Lee was especially vocal while at Jaggars-Chiles-Stovall about his apparent Marxist sympathies. He subscribed to Marxist publications, printed a free poster for *The Militant*, a socialist newspaper, on company equipment, and corresponded with the American Communist Party.

Left: **George DeMohrenschildt was quoted as saying that the CIA got in touch with him and asked him to maintain contact with Lee.**

Changes

On January 27, 1963, someone, possibly Lee, mail-ordered a Smith & Wesson .38 revolver (Commando model number 1905, serial number V510210) from Seaport Traders, Inc., located at 1221 South Grand in Los Angeles, California. The purchaser used the name A. J. Hidell, to whom it was shipped. The price of the handgun was $29.95. Originally, it had a standard five-inch barrel, but L. M. Johnson, of Van Nuys, California, modified the gun by cutting down the barrel to two and a quarter inches and rechambering it to accept .38 special ammunition as opposed to .38 standard ammunition. On March 12, 1963, someone ordered a Mannlicher-Carcano bolt-action rifle from Klein's Sporting Goods in Chicago under the name A. Hidell. Both firearms were shipped to a post office box, number 2915, in Dallas, which, we have been told, had been rented by Lee Oswald. Even though the order dates for the revolver and the rifle were a month and a half apart, both weapons arrived in Dal-las at the post office box on March 20. Had the weapons been bought in Dallas, they could not have been traced; however, mail delivery insured that they could be and that the orders could be linked to Lee. After the assassination, when Lee was arrested, he repeatedly denied that he had ever owned a rifle.

Lee and his family moved from 605 Elsbeth Street on March 3, 1963. They rented a second-floor apart-

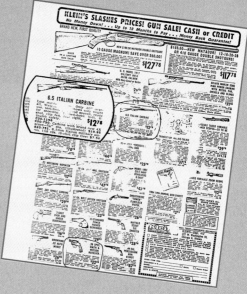

Right: **The advertisement for the Mannlicher-Carcano rifle from Klein's Sporting Goods in Chicago.**

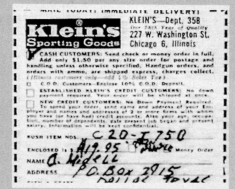

Left: **The order coupon for the Mannlicher-Carcano.**

Below: **The money order used to pay for the Mannlicher-Carcano. The handwriting appears to be the same as that on the revolver order form**

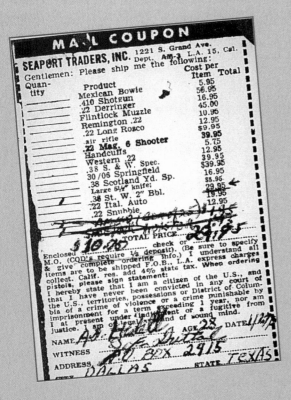

Left: **The order form for the Smith & Wesson .38 revolver that was said to belong to Lee, dated January 27, 1963.**

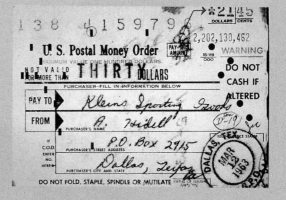

ment at 214 West Neely Street, a few blocks away. Just prior to moving to Neely Street, Marina had learned that she was expecting their second child. It was the rear of this house that was the background in the infamous and seemingly incriminating "backyard photographs" of Lee holding weapons and socialist publications that the government claims were taken by Marina. (See chapter 8.) The photos, analyzed by experts from around the world, have been labeled as fakes.

Lee was fired from Jaggars-Chiles-Stovall on April 6, 1963. He was charged with incompetence. Robert Stovall, one of the owners of the company, refused to give Lee a positive review when queried as a reference for another job the following October. He stated that he was bothered by Lee's communist leanings.

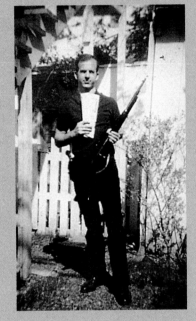

Left: One of a set of three photographs that are the only evidence linking Lee Oswald to the handgun and rifle. The question remains whether this is truly a photograph of Lee.

Above: A *New York Times* article about another rifle owned by a man using the name Oswald. Gunsmith Dial Ryder was hired by someone to mount a telescopic sight on a rifle. The Mannlicher-Carcano, however, when shipped from Chicago to its purchaser in Dallas already had the telescopic sight installed on it.

Below: Lee and Marina moved to 214 West Neely Street in March 1963 and lived there until May 1.

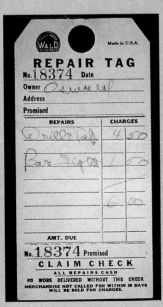

Left: The work tag for mounting the rifle scope. Whose rifle was this and who used the name Oswald to request the work?

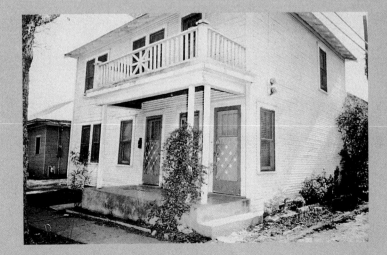

The Walker Incident

At about 9:00 p.m. on April 10, 1963, someone took a shot at Major-General Edwin A. Walker, a former U.S. Army officer who had been forced to resign from service by an order initiated by President Kennedy on April 17, 1961. Walker was relieved of his command of the Twenty-fourth Infantry Division in Germany because of his ultra-right-wing political beliefs and the propaganda he force-fed soldiers. The would-be assassin had rested a rifle on the top of a fence behind Walker's home and fired a shot through a window. The bullet narrowly missed. It is believed by many that the Walker incident was pre-fabricated drama set up by some of his followers to gain sympathy for his cause by making him an almost-martyr.

At the time of the shooting, Dallas authorities thought that the assassination attempt against Walker was the result of a conspiracy involving a few participants. Witnesses saw a group of suspicious men near the house before the shot was fired. There were no suspects in the case, however, until, after Lee was himself murdered. Marina reported that Lee had told her that he had fired the shots. Marina stated that Lee had also planned on shooting former Vice President Richard M. Nixon. These statements, the fact that Lee beat Marina, and the backyard photographs represent the sum total of "evidence" of Oswald's violent nature. The Warren Commission claimed that there was additional evidence to indicate that Lee was involved in the Walker shooting: a ballistics match identification of the bullet found in the Walker home with the Mannlicher-Carcano rifle Lee might have owned. That report is a lie. The Walker bullet did not come from the Mannlicher-Carcano. General Walker got a very good look at the bullet the night of the shooting. He stated that the bullet, or at least what was left of it, bore no resemblance to photographs of

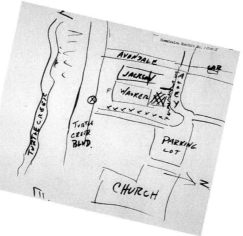

Right: A drawing of Major-General Edwin A. Walker's property by Walker aide Robert A. Surrey, who, incidentally, detested John F. Kennedy.

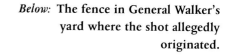

Below: The fence in General Walker's yard where the shot allegedly originated.

Left: Walker a few hours after a shot was fired at him in April 1963.

Right: Walker's house in Dallas at about the time of the shooting.

Above: The point of impact in the window frame, which deflected the bullet, saving Walker's life.

Above: The bullet said to have been fired at Walker. He later stated that this was not the same bullet as the one taken from his home after the shooting.

Above: The bullet hole in the wall in Walker's living room. The bullet struck here after deflecting off the window frame.

Below: A police picture of the photograph before the license plate was punched out.

Below: A photograph of Walker's house allegedly found among Oswald's possessions. Originally, when the photo was found, the car's license plate in the picture was intact. Later, the license plate was poked out to hide the owner's identity.

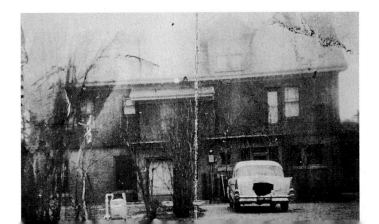

Warren Commission Exhibit 399, the so-called magic bullet allegedly fired from the Carcano.

After the Kennedy assassination, a photograph of General Walker's home, taken from the alley behind his house with a car parked in the driveway, was allegedly found among Lee's possessions. By the time the photo was turned over to the Warren Commission by the FBI, a hole had been pushed through it right in the spot where the license plate on the car had been, rendering the car unidentifiable. (It was not Walker's.) A separate photograph, taken by the Dallas police, shows many of Lee's possessions laid out on the floor of police headquarters, including the photograph of the Walker home with no hole, but from such a great distance that you can't make out the number on the license plate. The hole had clearly been punched through the photograph to protect the identity of the owner of the car.

A note to Marina from Lee was also discovered. It gave her instructions for what she should do if Lee was "captured," but it doesn't say at what. The note seems to have been written by Lee. Witnesses' reports of the group of suspicious men near General Walker's home on the evening of the shooting apparently were never seriously considered by the Warren Commission, and the Walker shooting, too, was ascribed to a "lone nut."

Marina was in a frightening position when Lee was arrested after the assassination. Although she has told this author that she wasn't specifically threatened with deportation by the government, she knew that she could easily be deported if she didn't cooperate fully with the FBI and the Warren Commission.

Since a wife cannot be made to testify against her husband, none of Marina Oswald's testimony or statements would have been admissible in court had Oswald gone to trial. Absent that testimony, the case for Lee's involvement in the Kennedy assassination or the Walker shooting falls apart. It is highly unlikely that Lee was the assailant in the Walker shooting. Indeed, as targets, President Kennedy and General Walker were at opposite ends of the political spectrum.

6

THE RETURN TO
NEW ORLEANS, 1963

Above: **The Reily Coffee Company, where Lee worked in New Orleans.**

At the end of April 1963, after a period of unemployment in Dallas, Lee went to New Orleans, Louisiana, by bus to try to find work. Marina and June moved in with Ruth Paine, an American friend of Marina's who spoke fluent Russian. She lived with her husband, Michael, at 2515 West Fifth Street in Irving, Texas, a suburb of Dallas.

Upon arriving at the New Orleans bus station Lee phoned his mother's sister Lillian to see if he could stay with her and his Uncle Dutz until he could find his own place. Dutz Murret was still employed by Carlos Marcello, by then one of President Kennedy's most bitter and powerful enemies. Lillian Murret, who had not been informed that Lee had returned from the Soviet Union and knew nothing of Lee's marriage to Marina or of the baby, agreed to have him stay.

Lee's reported activities in and around New Orleans in the summer of 1963, and the motivation for them, are some of the most questionable of his life. To this day, more questions remain as to his actions in New Orleans, Clinton, and Jackson, Louisiana, than there are answers. His connections, direct and indirect, were with some of the most violent people in the United States. If he was designated as the patsy in the conspiracy to kill the president, the final decision was probably made in New Orleans.

Reunion

On May 9, 1963, Lee was hired by the William B. Reily Coffee Company at 640 Magazine Street as a maintenance man for $1.50 an hour. On his job application, he listed as a reference Sergeant Robert Hidell.

The job at the Reily Coffee Company may well have been a cover to allow Lee to participate in other endeavors. A witness said that he never seemed to do any work at Reily. He was not a lazy person. His interests and activities and his diligence in seeking employment prove this. Interestingly, four of his co-workers at Reily, Emmet Barbee, John Branyon, Alfred Claude, and Dante Marachini, left Reily within a few weeks after Lee quit; all four went to work for NASA.

Myrtle Evans, a woman whom Lee had known as a child, helped him to find a house to rent. The day he started work at Reily, he rented an apartment at 4907 Magazine Street for $65.00 per month. He called Marina in Irving and asked her to come to New Orleans. Marina agreed. "Daddy loves us," Marina told baby June.

Lee moved to the Magazine Street apartment on May 10, and Marina and June, who had been driven to New Orleans by Ruth Paine, moved in on the eleventh. Ruth stayed in New Orleans for a few days and arrived home in Irving on May 14.

Right: The Crescent City Garage, where Lee hung out in his spare time with his friend Adrian Alba.

Left: Ron Lewis, Lee's closest friend in New Orleans.

Right: The list of books Lee borrowed from a library in New Orleans.

CARD SHOWS RETURN DATE	TITLE	AUTHOR	DATE WOULD HAVE BEEN CHECKED OUT
7/1/63	"Soviet Potentials"	GEORGE B. CRESSEY	6/17/63
7/1/63	"What We Must Know About Communism"	HARRY BOMERO OVERSTREET	6/17/63
7/24/63	"Russia Under Khrushchev"	ALEXANDER WERTH	7/10/63
7/15/63	"Portrait of A President"	JOHN F. KENNEDY / WILLIAM MANCHESTER	7/1/63
6/15/63	"The Huey Long Murder Case"	HERMANN B. DEUTSCH	6/1/63
5/5/63	"Portrait of A Revolutionary: Mao Tse-Tung"	ROBERT PAYNE	5/22/63
6/15/63	"The Berlin Wall"	DEAN and DAVID HELLER	6/1/63
7/1/63	"This Is My Philosophy"	Edited by WHIT BURNETT	6/17/63
9/23/63	"The Bridge Over the River Kwai"	PIERRE BOULLE	9/9/63
8/13/63	"The Hittite"	NOEL B. GERSON	7/30/63
7/19/63	"The Blue Nile"	ALAN MOOREHEAD	7/15/63
7/20/63	"One Day In The Life of Ivan Denisovich"	ALEXANDER SOLZHENITSYN	7/6/63
9/23/63	"Ben-Hur"	LEWIS WALLACE	9/9/63
7/29/63	"Profiles In Courage"	JOHN F. KENNEDY	7/15/63
7/12/63	"A Fall of Moondust"	A. C. CLARKE	6/28/63
7/20/63	"Hornblower and The Hotspur"	C. S. FORESTER	7/6/63
6/26/63	"Conflict"	ROBERT LECKIE	6/12/63

CARD SHOWS RETURN DATE	TITLE	AUTHOR	DATE WOULD HAVE BEEN CHECKED OUT
10/3/63	"Goldfinger"	IAN FLEMING	9/19/63
7/8/63	"Thunderball"	"	6/24/63
10/3/63	"Moonraker"	"	9/19/63
9/5/63	"From Russia With Love"	"	8/22/63
10/3/63	"Ape And Essence"	ALDOUS HUXLEY	9/19/63
10/3/63	"Brave New World"	"	9/19/63
9/5/63	"The Sixth Galaxy Reader"	H. L. GOLD	8/22/63
9/5/63	"Portals of Tomorrow"	AUGUST DERLETH	8/22/63
8/13/63	"Mind Partner"	Edited by H. L. GOLD	7/30/63
8/1/63	"Five Spy Novels"	Selected by HOWARD HAYCRAFT	7/18/63
9/23/63	"Big Book of Science Fiction"	GROFF CONKLIN	9/9/63
7/24/63	"The Hugo Winners"	Edited by ISAAC ASIMOV	7/10/63
8/22/63	"The Worlds of Clifford Simak"	CLIFFORD SIMAK	8/8/63
8/19/63	"The Expert Dreamers"	Edited by FREDERIK POHL	8/5/63
8/14/63	"Nine Tomorrows"	ISAAC ASIMOV	7/31/63
8/26/63	"The Treasury of Science Fiction Classics"	Edited by HAROLD KUEBLER	8/12/63
8/14/63	"Everyday Life in Ancient Rome"	F. R. COWELL	7/31/63

The Fair Play for Cuba Committee

In May and June 1963 Lee became involved with a New York City–based pro-Castro organization called the Fair Play for Cuba Committee. He opened up his own chapter of the FPCC in New Orleans, listing himself as officer; he was also the chapter's only member. An A. J. Hidell, listed as officer, probably did not exist. It has never been made clear what the correct pronunciation of this name is. Did it rhyme with Rydell or Fidel, as Marina Oswald suspected? In any case, the name appears often in Lee's life after his return from the Soviet Union. Indeed, while in the Marine Corps he had known a man, Rene Heindel, who was nicknamed Hidell. Heindel was living in New Orleans in the summer of 1963 when Lee, or someone else, was using his nickname. If Lee Oswald was indeed framed as the assassin of President Kennedy, the Alek J. Hidell alias was used to connect him to the post office box to which were mailed both of the weapons that the FBI claimed were used to commit the murders of President Kennedy and Dallas Police Officer J. D. Tippit.

On June 4, 1963, one thousand FPCC propaganda leaflets were ordered from the Jones Printing Company. The order identifies the purchaser as Lee Osborne. Just as there was no Alik James Hidell, there was no Lee Osborne either. However, since Lee clearly intended to distribute the leaflets using his own name, why would he order them under an alias?

In June he was on the streets of New Orleans passing out the leaflets. Hand-stamped on the first batch was the address 544 Camp Street. All later handouts bore either his Magazine Street address or post office box number 30016. His own post office box number, however, was 30061. The last two numbers listed for the post office box on the leaflets were reversed. Was this a mistake? Was Lee truly dyslexic? Can we believe, if he was, that he never noticed the mistake?

Or did he not really want to be bothered with undesirable positive responses to his leaflets? There is a strong possibility that he did not want new recruits and was only doing this highly visible, and photographed, labor to help build his pro-Castro cover story. Like the central character of "I Led Three Lives," he was now playing the part of a stereotypical communist to the hilt. He twice nailed pro-Castro signs on a neighbor's house, and he loudly criticized a New Orleans singer for singing "Castro, that bastro."

Left: **Lee's second passport photo, taken June 23, 1963. The passport listed his height as five feet, eleven inches.**

Below: **Lee wrote to V. T. Lee of the Fair Play for Cuba Committee from New Orleans stating that he wanted to join.**

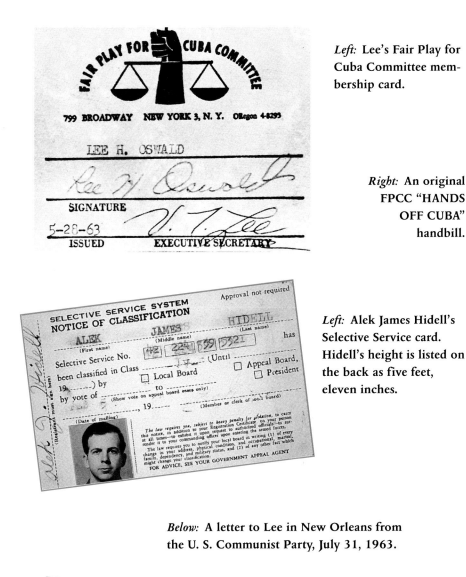

Left: Lee's Fair Play for Cuba Committee membership card.

Right: An original FPCC "HANDS OFF CUBA" handbill.

Left: Alek James Hidell's Selective Service card. Hidell's height is listed on the back as five feet, eleven inches.

Below: A letter to Lee in New Orleans from the U. S. Communist Party, July 31, 1963.

HANDS OFF CUBA!

Join the Fair Play for Cuba Committee

NEW ORLEANS CHARTER MEMBER BRANCH

Free Literature, Lectures

LOCATION:

V. T. Lee Exhibit #4

62-109060-1845

EVERYONE WELCOME!

Above: The membership card of the New Orleans chapter of the Fair Play for Cuba Committee.

Left: The $9.89 bill for printing 1,000 Fair Play for Cuba Committee handbills, June 4, 1963.

Guy Banister and David Ferrie

The address initially stamped on the FPCC leaflets, 544 Camp Street, was the Newman Building—also the address of intelligence operative and former FBI agent Guy Banister, the former special agent in charge of the Chicago office of the FBI. Banister was now running his own private detective firm, Banister and Associates. He worked with David Ferrie, who had been Oswald's superior in the Civil Air Patrol in the summer of 1955. For decades, Kennedy assassination researchers have suspected that Ferrie was responsible for recruiting Lee Oswald into a life of spying and undercover work. Ferrie had been a pilot for the CIA and a private investigator for Carlos Marcello, as had been Ferrie's boss, Guy Banister.

Recall that, politically, David Ferrie was a rabid conservative and anti-communist. Lee was observed meeting with both Guy Banister and David Ferrie during the summer of 1963. As anticommunists, why were the two men apparently unconcerned about Lee's activities? It certainly seems that they knew, or suspected, that his procommunist activities were a front. Was Lee working for Banister, or with him?

Left: The corner of Lafayette and Camp Streets in downtown New Orleans.

Right: Guy Banister was not only anticommunist and anti-Castro but the ultra-right-wing former chief of the Chicago FBI office.

Below: Lee had stamped the 544 Camp Street address on the first batch of FPCC handbills.

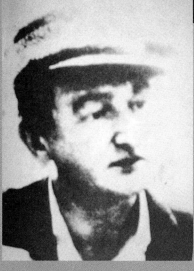

Left: David Ferrie in a relaxed moment.

Right: FPCC pamphlet listing the address as 544 Camp St., the same building where Guy Banister's office was located. Banister was an anti-Castroite who operated a private detective firm.

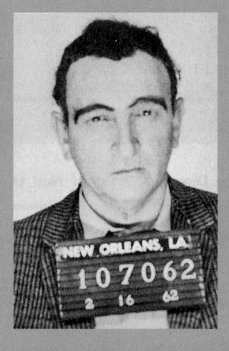

Above: David Ferrie.

Left: This building, known as the Newman building, seems to have been the center for both pro- and anti-Castro activities in New Orleans. It had two entrances, one on Camp Street and one on Lafayette Street. This is the view of 544 Camp (arrow).

Below Left: Guy Banister. Was he "running" Lee as an agent? If so, for whom?

Below Right: Lee was seen with Guy Banister at 544 Camp Street by several witnesses.

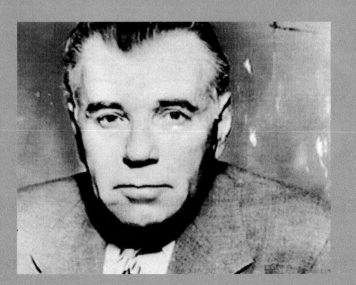

Return to Russia

In early June, Lee started again to talk of returning to the Soviet Union. Back on February 14, while still living in Texas, just after Marina had told Lee that she was pregnant with their second child, he had forced her to write to the Soviet embassy, asking to return to the Soviet Union. She was not happy with his treatment of her but truly liked America and wanted to stay. She had no desire to return to Russia, especially not alone. This time Lee spoke of the whole family returning together. The request he had Marina write pleaded that the application be expedited so that they could be there before their child, due in four months, was born. On July 8, Lee had Marina write to the Soviet embassy again to see what was taking so long. She expressed impatience with the red tape and requested that they receive quicker service.

Lee's job at Reily lasted until July 19, when he was fired for laziness. It was then that he began talking about going to Cuba.

Left: **Carlos Bringuier, an anti-Castro Cuban, who fought with Lee on Canal Street.**

Carlos Bringuier

On August 5, 1963, Lee entered a store, the Costa Roca, managed by anti-Castro Cuban exile leader Dr. Carlos Jose Bringuier, a close associate of another anti-Castro leader, Sergio Arcacha Smith, leader of the anti-Castro Cuban Revolutionary Front. Smith's office was also in the Newman Building. Lee and Bringuier spoke of the unofficial war against Fidel Castro. Four days before this meeting, the FBI had mounted a surprise raid on the Cuban exile base on the north shore of Lake Pontchartrain just north of New Orleans. Lee told Bringuier that he was a sympathizer and that they were fellow soldiers in the fight to overthrow Castro. He told Carlos of his Marine Corps training, lent him his marine manual, and offered to help train the exile guerrillas for projected attacks against Castro's Cuba. Bringuier still has Lee's *Guidebook for Marines* in his possession. (*Who Was Lee Harvey Oswald*, television documentary produced by WGBH-TV, Boston, 1993)

The FBI and the Warren Commission decided that this was a devious cover acted out by Lee to deceive Bringuier and his friends. However, Lee's reported statements might well have reflected his true feelings, given that the FPCC activities may have been the real cover story. We may never know for sure.

Above: **Lee's *Guidebook for Marines*, which he gave to Carlos Bringuier with the offer to help train his men.**

Under Arrest

On Friday, August 9, Lee was standing on Canal Street in New Orleans, wearing a VIVA FIDEL signboard and handing out FPCC leaflets that read HANDS OFF CUBA! join the fair play for cuba committee, when Carlos Bringuier, twenty-nine, and some of his associates, including Miguel Mariano Cruz Enriquez, eighteen, and Celso Macario Hernandez, forty-seven, approached him. Bringuier cursed and shouted at Lee. Lee smiled and offered his hand in a sarcastic gesture of camaraderie. Carlos threatened to hit him, to which Lee responded by dropping his arms. "O.K. Carlos," he said, "if you want to hit me, hit me." Carlos hit him in the face. Lee refused to hit back. The police soon arrived, and Lee and the others were placed under arrest for disturbing the peace. One of the arresting officers, Frank Hayward, stated that Lee appeared enthusiastic about the arrest. The incident added weight to the story that Lee was a communist sympathizer and would look good as part of his record as a pro-Castroite. It has always seemed curiously convenient that two eight-millimeter cameras were on hand to shoot the arrest of Lee and the anti-Castro Cubans.

Lee was in jail for only one night before being bailed out by Emile Bruneau, an associate not only of Carlos Marcello and Nofio Pecora but of Lee's Uncle Dutz Murret. While Lee was in jail he did something quite odd. The official record states that he asked to see an FBI agent. FBI Special Agent John Lester Quigley showed up and he got his wish.

As reported by W. R. Morris and R. B. Cutler in their book *Alias Oswald* (1985), a man claiming to be a former agent of both the FBI and the CIA, Harry Dean, later stated, "This was unusual. Unless the person in custody reveals that he has important information regarding a crime that has been or is about to be committed, or the FBI is familiar with the subject who has been arrested, the agency is not going to send an agent to talk to an individual who has been thrown into jail for simply disturbing the peace. The

Above: **Lee on Canal Street, August 9, 1963. He is wearing a placard stating "VIVA FIDEL."**

Above: **Lee complaining to the police that Carlos Bringuier and his friends had torn up his FPCC handbills.**

Right: **Celso M. Hernandez, one of the anti-Castro Cubans who argued with Lee on Canal Street.**

FBI knew that Oswald was an agent and that he wanted to talk to another operative so he could turn over the information he had garnered. This is why an agent was sent to the New Orleans jail." (W. R. Morris and R. B. Cutler, *Alias Oswald*, 1985)

The FBI, via Quigley, may have used the arrest as their chance to interview, or debrief, Lee. The interview, or debriefing, lasted for an hour and a half. Agent Quigley should normally have placed his notes from the interview in an office file on Lee. Instead, he burned the notes. One can only wonder if the still powerful and well-connected "ex"-FBI agent Guy Banister had arranged the note burning. If we adhere to the official Warren Commission story that Lee was an unstable communist sympathizer, he would have wanted to stay as far away as possible from the FBI, not call them.

Lieutenant Francis Martello, deputy commander of the New Orleans Police Intelligence Division, interviewed Lee upon learning his Soviet history from his cousin, Joyce Murret O'Brien. Lee told him that he was a Marxist and had gone to Russia but that "it stunk." Contradicting himself, he then stated that he was planning on going back to the USSR.

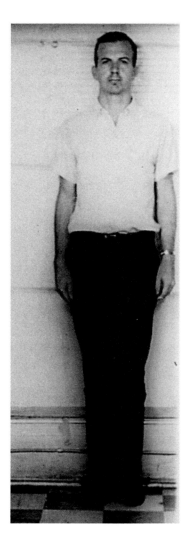

Right: New Orleans police photo showing Lee under arrest. The height chart shows him as five feet, eight inches tall in shoes.

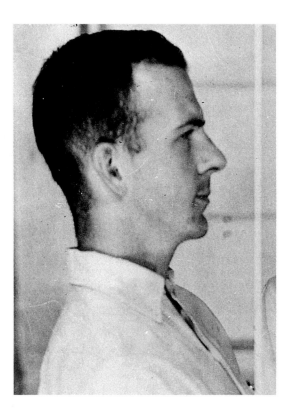

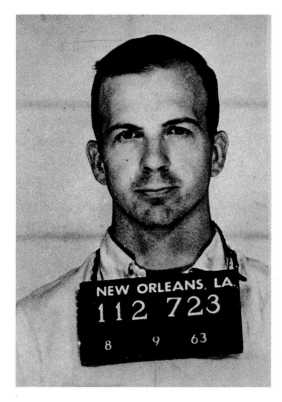

Left: The mug shots taken of Lee after his arrest in...

Right: ...New Orleans, August 9, 1963.

Exposure

On Monday, August 12, 1963, Lee and Carlos Bringuier appeared in Second Municipal Court at 1:00 p.m. The charges were dismissed against Bringuier, and Lee was fined $10.00. Marina Oswald confirmed that Lee actually wanted to be arrested. He wanted the exposure. He wanted to get the publicity as a pro-Castroite. She referred to this as "self-advertising." Marina was right, but the question still remains: Why?

Lee was back handing out his Fair Play for Cuba Committee flyers on the streets of New Orleans on August 16. He had hired three men to help with distribution: odd, since he was nearly without funds for himself and his family. They stood in front of the International Trade Mart, whose director, Clay Shaw, would be charged with conspiracy to assassinate President Kennedy four years later by New Orleans District Attorney Jim Garrison. Somebody (probably Lee himself or, possibly, Carlos Bringuier) called WDSU-TV and other members of the New Orleans news media to announce that he was distributing the pro-Castro literature. More self-advertising. That evening's television news broadcast his activity, and the resulting bad publicity made it nearly impossible for him to obtain employment.

Below: Lee after his court hearing in New Orleans for disturbing the peace. He was fined $10.00.

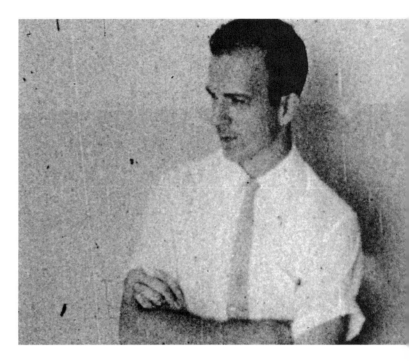

Below: Lee leaves the police station after his release in New Orleans.

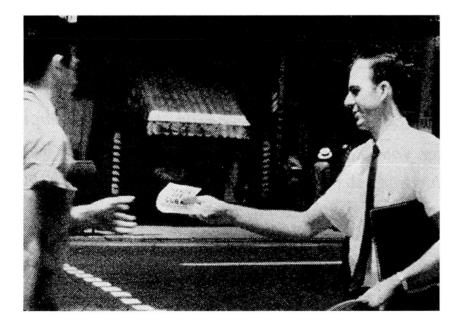

Left: Lee gives away FPCC handbills by the Trade Mart on August 16, 1963. Someone alerted the media so that Lee's activities that day were filmed.

On the morning of August 17, Lee received a visitor at his apartment on Magazine Street, a stranger named William Kirk Stuckey, host of the program *Latin Listening Post* on WDSU radio. Stuckey did a thirty-seven-minute interview with Lee, but the news director, John Corporon, considered the interview to be far too one-sided and cut out more than half an hour of tape. When the interview aired, it was four and a half minutes long. Lee argued the case for supporting Fidel Castro extremely well and impressed Stuckey with his eloquence.

Stuckey subsequently had a visit from an FBI agent, who informed him of Oswald's defection. Stuckey decided to organize a debate between Lee and Carlos Bringuier. He also invited Edward Scannell Butler, a well-known anticommunist propagandist. The debate, on a program called *Conversation Carte Blanche*, aired August 21. From the start, Lee was attacked by both Bringuier and Butler, but he held his own so well that Butler later said Lee had the attributes, if not the training, of a highly competent agitator. Afterward Stuckey invited Lee out to a bar in the French Quarter, and they spoke for most of the night of the pros and cons of living in the Soviet Union. Lee told Stuckey that he had left Russia because it had gone soft on communism, and that Cuba was the only remaining revolutionary country.

Above: Lee and one of the men he hired to pass out FPCC handbills by the New Orleans Trade Mart.

Above: Lee in front of the entrance to the International Trade Mart, which was run by Clay Shaw. Shaw was later indicted by New Orleans district attorney Jim Garrison on the charge that he conspired to assassinate the president.

Left: Doctored transcript of Lee's interview for the evening news about his views on communism. He actually said, "I *was* under the protection of the..." The doctored transcript, which is what the Warren Commission released, reads "was not."

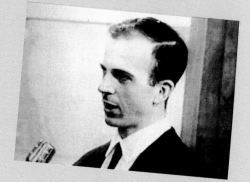

Right: Lee while being interviewed.

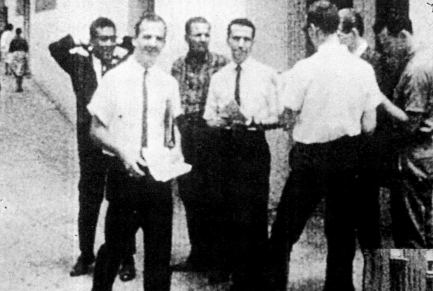

Left: The other men in white shirts were hired by Lee to hand out the FPCC handbills.

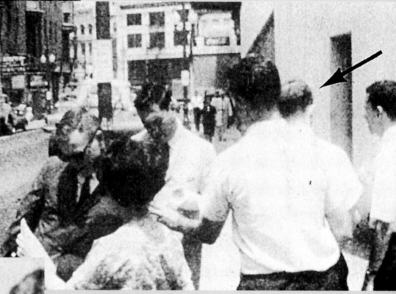

Right: The arrow points to Lee. In the background is Clay Shaw, walking toward him.

Left: Lee looks up toward Shaw who, is now approaching the side entrance to the Trade Mart.

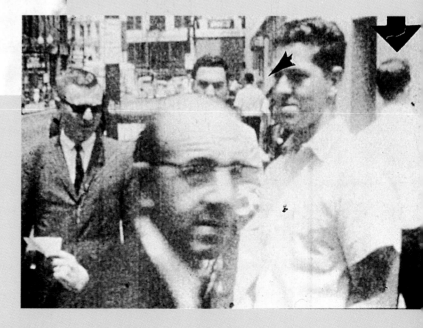

Right: Shaw enters the building and Lee, right, starts to walk toward the same entrance.

In late August/early September 1963, Lee, David Ferrie, and Clay Shaw took a short trip to both Clinton and Jackson, Louisiana. Clinton is the county seat of East Feliciana Parish; that summer it had been chosen by the Congress of Racial Equality (CORE) for a voter rights campaign.

Lee first appeared in Jackson looking for a job at East Louisiana State Hospital, an institution for the mentally insane. He was told that he needed to be a resident to get the job and that the best way to show residency was

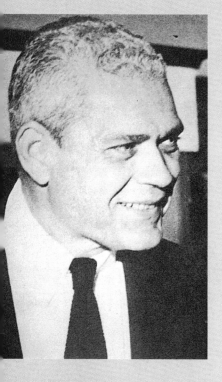

to become a registered voter. He registered in Clinton under his own name, producing his Marine Corps discharge papers as identification. The incident is well-remembered because Lee was the only white man registering. Several witnesses later told investigators that Lee was accompanied by two older men whom they identified as Clay Shaw and David Ferrie. These witnesses established a positive link between Lee Oswald and both Shaw and Ferrie less than three months before the assassination.

The fact of the registration was not disclosed to the public until 1967 and was uncovered during the Garrison investigation. The House Select Committee on Assassinations conducted their own investigation between 1976 and 1978. They confirmed that the Clinton and Jackson witnesses were both "credible and significant."

Above: Shaw's denial of any association with Ferrie proves him a liar. Why would he take the risk of being caught in a lie unless he had a bigger secret to hide?

Above: Clay Shaw, who lied under oath about knowing both David Ferrie and Lee Oswald. Shaw would use the alias Clay Bertrand.

Tony Summers discovered a new perspective on Lee's New Orleans adventures, which he published in 1979 in his book *Conspiracy.* Summers reexamined the original Jim Garrison evidence. Centering his attention on the anti-Castro circus at 544 Camp Street, he discovered the rumor that Guy Banister had used several young men to infiltrate pro-Castro groups.

Summers found two brothers, Allen and Daniel Campbell, who, like Lee, were ex-marines. They had both been employed by Banister for infiltration purposes.

Daniel Campbell said that he had been at Camp Street the day of the fight between Lee and Carlos Bringuier. Later, Lee came back to the office at 544 Camp Street and used Campbell's telephone to make a call. Allen backed Daniel's story.

Left and Above Right: Photographs taken around 1949 show Clay Shaw and David Ferrie together at a social gathering. From variations in their appearance, these photos may be from different occasions.

Allen Campbell said that he had been with Guy Banister when they ran into Lee handing out his FPCC leaflets in front of Clay Shaw's offices at the International Trade Mart. Allen assumed that the violently anti-Castroite Banister would be infuriated at this sort of pro-Castro demonstration but was amazed when Banister simply smiled at the sight of Lee.

Summers went to Delphine Roberts, who had been Guy Banister's private secretary and mistress during this period. Roberts confirmed that Lee had worked for Banister during the summer of 1963. She further stated the idea for Lee's Fair Play for Cuba Committee chapter had been dreamed up by both Oswald and Banister one afternoon at Guy's office. Roberts even remembered the exact day, earlier that summer, when Lee had first arrived at 544 Camp Street seeking investigative work, and she stated that Lee was working for Banister in an undercover capacity. When Delphine and Banister came across Lee with some of his pro-Castro propaganda, she expected her boss to explode with anger, but instead he told her, "Don't worry, he's with us." However, Banister was furious when he found out that Lee had foolishly stamped Banister's 544 Camp Street address on his FPCC leaflets.

In spite of his many years as someone with (or apparently with) sympathies antithetical to his country, Lee Oswald's name was never placed in the FBI's Security Index, a file the bureau maintains on those people it feels are a threat to national security. If there was only one name on the list, it should have been the name of Lee Harvey Oswald. During the period from 1976 to 1978, the House Assassinations Committee questioned seventeen FBI agents, supervisors, and senior officials as to why Lee was not listed in the Security index. Not one felt that he should have been. Why? According to Harry Dean, "Mr. Oswald wasn't in the Security Index because the FBI officials knew that he was working to preserve security, not hinder it."

Left: A comparison of Ferrie in a mug shot and from the photograph at the bottom of the previous page.

Right: Louisiana Highway 19 North where it crosses Route 10. Turn left for Jackson or right for Clinton. Shaw and Ferrie drove Lee here ostensibly to find work.

Right: East Louisiana State Mental Hospital, where Lee attempted to find employment.

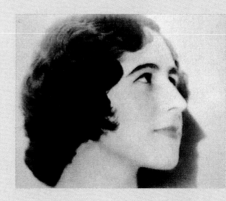

Left: Delphine Roberts, Banister's secretary and mistress, saw Banister and Lee together several times.

Russia via Cuba via Mexico

Lee was prepared to go to Cuba. He had absorbed the tenets of communism, or at least effectively created the veneer of a communist sympathizer: propagandizing for the FPCC; television and radio shows; news stories; the fight with Carlos Bringuier; the arrest; and spending his own money for the cause.

He put together a résumé to present to the Cuban Embassy that touted the above points. He mentioned his Marine Corps career, his time in the Soviet Union, and all of his pro-Castro activities in New Orleans, especially the FPCC items.

He sent letters to both *The Militant* and *The Daily Worker*, telling them that he would soon be moving to New York. Of course, the FBI intercepted the letters. This may have been what Lee had in mind. In reality, he was heading south. His destination was Mexico (or so we are told).

Ruth Paine had written to Marina and invited her to come back to Irving in September and stay as long as she wanted. The invitation was really designed so that Marina would be with Ruth when the new baby was born. Ruth assured her not to worry about money, that her husband Michael was in a position to take care of her and would be happy to help. Ruth came to New Orleans to pick up Marina and June, and they left for the return trip to Irving on September 23. The day after they left, Lee was, by all appearances, on his way to Mexico City by bus.

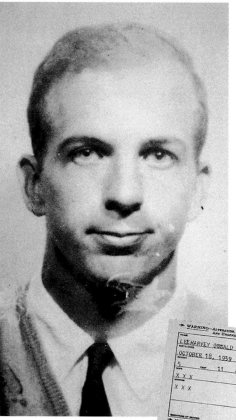

Left: **A photograph of Lee in New Orleans taken in September 1963.**

Right: **Lee's second passport, which he was issued in the record time of twenty-four hours.**

Right: **Silvia Odio, who claims that she met with either Lee or an Oswald impostor and two Cubans in Dallas.**

Left: Loran E. Hall is believed to be "Leopoldo."

Left: Lawrence J. Howard Jr. is believed to be "Angelo."

Left: The Warren Commission believed that it was this man, Billy Seymour, who was the Oswald impostor who used the name Leon Oswald.

On September 25, a man using the name Leon and two other men tried to infiltrate an anti-Castro Cuban exile group in Dallas. The three appeared in the evening at the home of twenty-six-year-old Cuban refugee Silvia Odio and her seventeen-year-old sister, Annie. Odio's father was in a Cuban prison for attempting to assassinate Fidel Castro the previous year. The three men said that they were from the anti-Castro underground and were friends and associates of Odio's father. Two of the men were dark-skinned Latinos and the third man was an American in his early twenties. The first Latin man called himself Leopoldo and told her, in Spanish, "We wanted you to meet this American. His name is Leon Oswald." Odio was told that Leon was an ex-marine and an expert with a rifle who wanted to be introduced to her friends in the Cuban underground. The second Latino man was called Angelo. The entire conversation was in Spanish, and Leon, standing silently with an odd grin, apparently did not understand a word of it. Odio asked for time to think about helping the men and to check out their legitimacy. As they were departing, Leopoldo told her that they would be going to Mexico soon.

The next day, Leopoldo called Odio and asked her what she thought about Leon Oswald, the American in the trio. "I didn't think anything," she answered. He told her that Leon was "*loco*" and could probably be utilized to assassinate Fidel Castro if they could just get him to Cuba, and in contact with the underground leadership. He again stated that Leon was an "expert shot." (House Select Committee on Assassinations)

7

LEE "HENRY" OSWALD

IN MEXICO CITY

In September, Lee (or someone impersonating him) left New Orleans for Mexico City with Lee's "portfolio" to renounce Lee's American citizenship, again, and to try to return to Russia via Cuba. (Or was it really a mission to infiltrate Cuban intelligence or perhaps even to kill Fidel Castro?)

There is no tangible proof that Lee ever went to Mexico City. Nobody really knows where he went. There is far more evidence that one or more impostors and not the genuine Lee Oswald actually went to Mexico. The issue of who actually visited Mexico from September 26 through October 3, 1963, is absolutely critical.

Lee, or someone using his name, crossed the border by way of Continental Trailways bus at Nuevo Laredo, Texas, and called attention to "Lee Harvey Oswald" by stating to another passenger that he was going to Cuba via Mexico since it wasn't legal to go there from America.

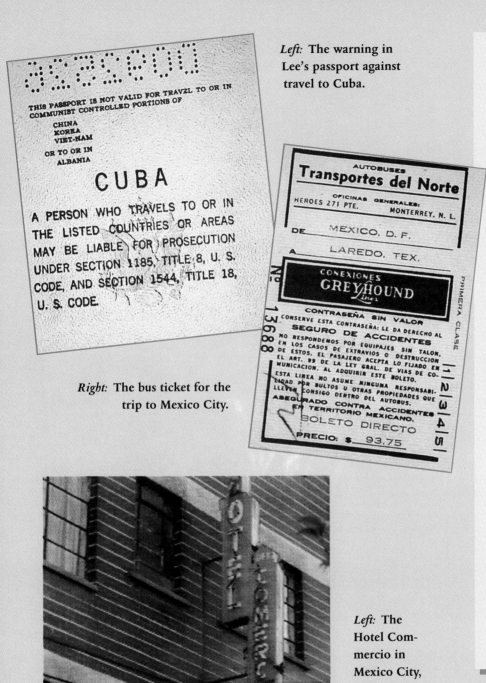

Left: The warning in Lee's passport against travel to Cuba.

Right: The bus ticket for the trip to Mexico City.

Left: The Hotel Commercio in Mexico City, where "Lee Oswald" stayed.

Rather than Mexico, Oswald may have gone to Florida. Recent developments have indicated that, in Florida, he was escorted by intelligence types. An electronics expert named John Martino who was an associate of the mobster Santos Trafficante later told *Newsday* reporter John Cummings that he had met Lee Oswald in Miami "several weeks before the assassination." According to Cummings, "He [Martino] said an FBI agent named Connors asked him to come to a boat docked in Biscayne Bay, and introduced him to Oswald by name. The impression John got was that Oswald didn't know his ass from his elbow, didn't know what he was involved in. He [Martino] thought the agent wanted him to meet Oswald because John was involved in anti-Communist activity, and Oswald was someone this agent was running."

After a two-day journey, on Friday, September 27, at 10:00 a.m., the bus reached Mexico City. "Oswald" registered at the Hotel Comercio under the name O. H. Lee. After checking in and dropping off his two suitcases, he went first to the Russian and then to the Cuban embassy. At the latter he spoke with Silvia Tirado de Duran. He said that he desired to visit Cuba en route to the Soviet Union. He stated that he was "a friend of the Cuban revolution" and handed over the assembled portfolio listing the history of "Lee Harvey Oswald"'s life over the past several years. Duran, although Mexican, supported Castro and was influenced by the documents. She told him to come back with passport photos.

He went back to the Soviet embassy and returned to the Cuban embassy that afternoon with the pho-

tographs. Duran told him that she had called the Soviet embassy and had found out that his transit visa could not be completed until he was given a Soviet entry visa, which could take up to four months to arrange since permission from the Ministry of Foreign Relations in Moscow would be required. Angered by the red tape, he demanded to talk to Duran's superior and spoke to the consul, Eusebio Azcue. He argued with Azcue, who declined to expedite the visa to allow him to depart for Cuba. All the months of setting up the background posture as a pro-Castroite and the work for the Fair Play for Cuba Committee didn't mean a thing to Havana.

The next day, Saturday, September 28, he returned to the Cuban embassy, but it was closed. He left and once again returned to the Russian embassy and there suggested that the Soviet embassy in Washington, D.C., be contacted to straighten out the problem. When he left, the Soviet embassy contacted the KGB in Moscow for a decision on whether he should be given an instant visa.

He had to wait in Mexico City for three days for an answer. Nobody knows what he was doing, where he went, or who he met with during that time.

On Tuesday, October 1, he returned to the Cuban embassy to try one last time for a Cuban transit visa. He asked Silvia Duran to call the Soviet embassy. She placed the call and gave him the phone. He spoke in Russian to Ivan Obyedkov, a guard at the embassy. The guard, who knew nothing about him, wanted to know who he had spoken to at the Soviet embassy over the last few days. He told Obyedkov that he had seen "Comrade Kostikov" on September 28. Obyedkov told him that he should perhaps see Kostikov in person. "I'll be right over," he replied, and left the Cuban embassy with a tall "Cuban" man headed in the direction of the Soviet embassy. (*Legend*)

On October 2, O. H. Lee checked out of the Hotel Comercio and caught a cab at 8:30 a.m. to board a Transporte del Norte bus for Dallas.

Above: **The front gate of the Cuban embassy in Mexico City.**

Above: **Silvia Duran, the secretary at the Cuban consulate in Mexico City who dealt with "Oswald."**

Right: **Eusebio Azcue, the Cuban consul in Mexico City when Lee was alleged to have been there.**

The CIA and the False Oswald

The CIA's concern over the activities of the Mexico City "Oswald" became more pronounced from the moment "Oswald" mentioned "Comrade Kostikov" on the phone at the Cuban embassy. The Mexico City CIA station routinely monitored and tape recorded all phone calls between the Cuban and Soviet embassies; thus they had intercepted the calls relating to Oswald, as well as the October 1 conversation with Obyedkov about Kostikov. The fact that Kostikov was handling the Oswald case should have brought the entire intelligence apparatus of the Western world to its collective feet. Valery Vladimirovich Kostikov was a high-level intelligence officer within the KGB. His specialty was managing the missions of deep-cover Soviet secret agents in America. He has also been identified as being a member of Department 13, the KGB's sabotage and assassination squad.

Washington finally, on October 10, gave orders to Winston Scott, the CIA's Mexico City station chief, to inform the FBI office in Mexico City, the Immigration and Naturalization Service, and the U.S. Embassy about "Oswald"'s meeting with the Soviet embassy. The CIA is not authorized to investigate the actions of United States citizens overseas unless there is a "special request," so the CIA, according to its own files on Lee Oswald, "did nothing future on the case" other than to respond to an October 23 request from the Office of Naval Intelligence for a photograph of Oswald for an I.D. check. This happened a month *prior* to the assassination.

Above: **Eusebio Azcue.**

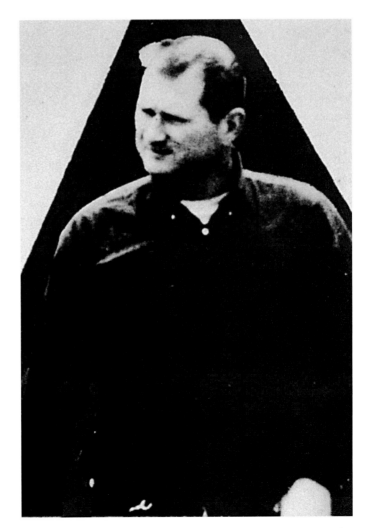

Right: **One of the many CIA surveillance photos taken of a man that the CIA believed to be Lee Oswald. This is the only photo among many that the CIA gave to the Warren Commission.**

There is a strong probability that the entire story of Lee Oswald's trip to Mexico City is a fabrication. The Mexico City Oswald was adamant in his desire to obtain a visa to visit Cuba in order to return to the Soviet Union—behavior not consistent with the statements of a man who was evidently happy to have returned to his country.

After the assassination, during the Warren Commission proceedings, the commission and the FBI asked the CIA to turn over whatever information they had on Lee Harvey Oswald. The Mexico City station file that the CIA produced was for a "Lee Henry [emphasis added] Oswald, born on 18 October 1939 in New Orleans. . . . A former U.S. Marine, who defected to the Soviet Union in October 1959 and later made arrangements with the U.S. Embassy in Moscow to return . . ." Hidden CIA telephoto cameras had photographed everyone entering and leaving the Soviet embassy. The CIA checked their photo files and found a series of photographs of the man they identified as Lee Oswald; he was about thirty-five years old and heavily built, while the real Lee was not yet twenty-four and slim. The Mexico City Oswald bore no resemblance to the real Lee Oswald.

CIA tape recordings of the Mexico City Oswald conversing with a Soviet official capture a man with only the slightest knowledge of the Russian language. Interpreters who transcribed the tapes for the CIA stated that the man spoke with a broken Russian accent. The real Lee spoke fluent Russian. The CIA has stated that these tapes had all been routinely erased soon after they were recorded. It is suspected that the CIA still had at least one, and probably more, of the eight "Oswald tapes" long after the assassination. At least two Warren Commission lawyers, David Slawson and William Coleman, heard some of the recordings several months after the assassination. The CIA played the recordings for them. It wasn't Lee's voice on the tape.

Eusebio Azcue, who testified before the House Assassinations Committee in 1978, described a man with different characteristics from the man who would be arrested in Dallas in just under two months.

Supporters of the Warren Report point out that the photographs Silvia Duran had attached to Lee's visa application were in fact of Lee. We have been told that he left the embassy, went out to a photo booth, and returned with the photographs. In fact, the photographs had been taken of Lee in New Orleans in September prior to the trip to Mexico City.

Interestingly, there were several positive identifications of Lee Oswald in the United States during the time he was supposed to have been in Mexico City. If he didn't really travel to Mexico City (and he said he didn't when he was under arrest), someone with enough power and money to pull it off succeeded in making it look as if he had. If the Mexico City story is a fraud, it gives massive credibility to Lee's statements that he was "just a patsy" and destroys the myth of the lone assassin.

Below: **The building that housed the CIA photo observation post.**

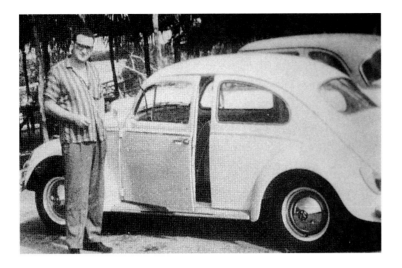

Above: Valery Kostikov, a KGB officer who may have met with "Oswald" at the Soviet embassy in Mexico City.

After he had returned to Dallas, Lee allegedly wrote the Soviet embassy in Washington, D.C., a letter, which was intercepted by the FBI. (Who said they weren't interested in Lee before the assassination?) The letter read, "I was unable to remain in Mexico indefinitely because of my Mexican visa restriction. I could not take a chance on requesting a new visa unless I used my real name so I returned to the United States. Had I been able to reach the Soviet Embassy in Havana as planned, the embassy there would have had time to complete our business." What this "business" was has never been explained.

Left: The "original" of "Lee"'s application to travel to Cuba. The picture on the visa application is the photo that was taken in New Orleans in September.

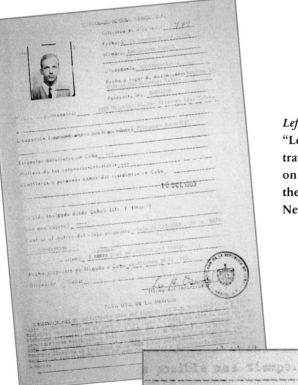

Right: Detail of the signature and embassy stamp from the original application. The signature is clearly not his.

Above: A copy of a different application to travel to Cuba. This signature appears more like Lee's.

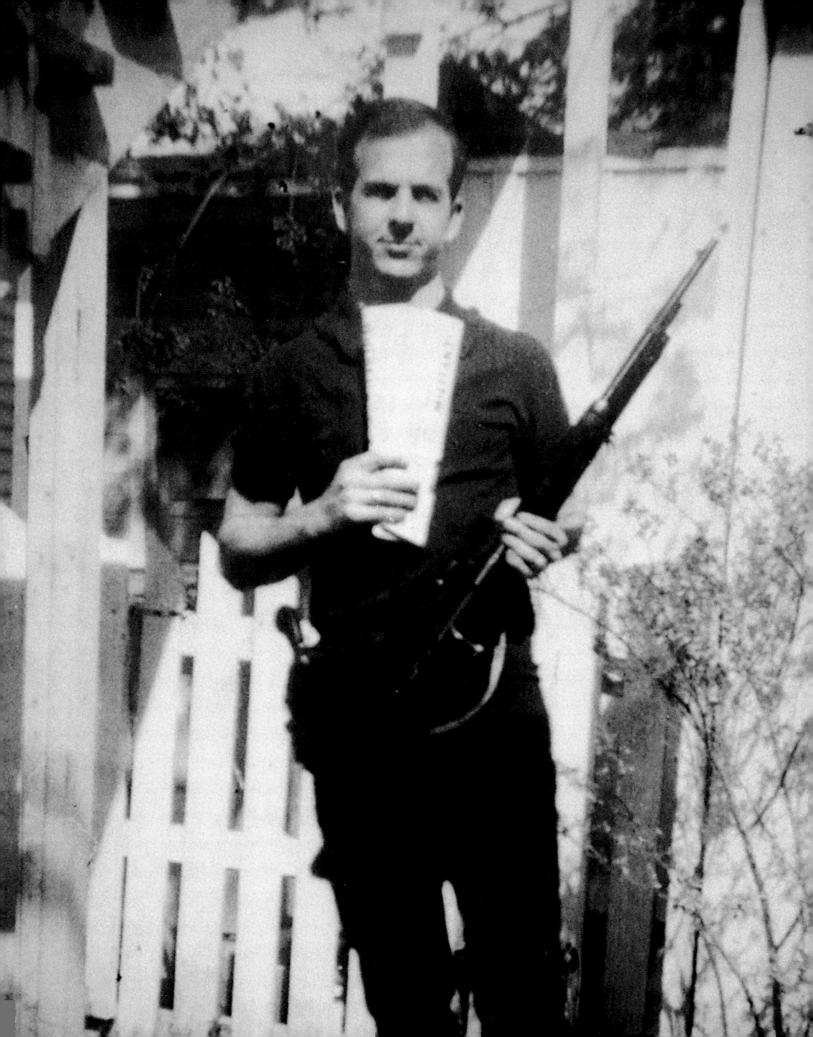

8

SETTING UP THE PATSY

After the CIA's botched invasion of Cuba at the Bay of Pigs in April of 1961, several high-ranking members of the CIA were fired by the president, including Major-General Charles P. Cabell, the brother of Earle Cabell, mayor of Dallas at the time of the assassination. Even the CIA's most experienced director, Richard Helms, would call the CIA's handling of the invasion "harebrained." President Kennedy asked Ted Sorensen, his special counsel, "How could I have been so stupid to let them [the CIA] go ahead [with the invasion]?" (Tony Summers, *Vanity Fair*, December 1994)

In October 1962, as a result of the Cuban missile crisis, President Kennedy agreed to stop the CIA's "secret war" against Fidel Castro—training Cuban exile troops for a second planned invasion of Cuba. The troops included men who were Bay of Pigs veterans and who blamed Kennedy for the failure of the first invasion. However, the CIA hierarchy refused to abide by the agreement and continued to train Cuban exiles at training camps on the north shore of Lake Pontchartrain, on No Name Key in Florida, and in Guatemala in preparation for a second invasion. Guy Banister, David Ferrie, and many others from the 544 Camp Street crowd were actively involved in the training.

When the president found out that his orders had been disobeyed by the CIA, he sent in the FBI and the Miami police to break up the training camps. Arrests were made, and arms and ammunition were confiscated. At this point, the Cuban exiles and their supporters, such as Guy Banister and David Ferrie, hated JFK perhaps as much as or more than they hated Fidel Castro.

The CIA, who had been running the operation, and the anti-Castro Cubans, who already hated President Kennedy after the Bay of Pigs fiasco, now grew enraged. They saw Kennedy as a traitor to their cause. Ranking members of the CIA felt that the president was a threat to the agency's very existence. The final straw was JFK's plan to withdraw CIA-controlled U.S. advisors from Vietnam.

The ultra right wing felt that the president was a communist who was selling America down the drain to the worldwide communist conspiracy, and they wanted the communists (Castro) out of the Western Hemisphere. They detested the president's stand on civil rights and his support of integration.

Also involved in the planning and training for a possible invasion of Cuba and/or an assassination attempt against Castro were mobsters Johnny Roselli, Sam "Momo" Giancana, Santos Trafficante, and Carlos Marcello, who had openly threatened Attorney General Robert Kennedy's life. Robert Kennedy was applying considerable pressure on the mob through his war on organized crime; and President Kennedy's backing off from an invastion infuriated the mob as well. They wanted to regain control of the gambling, gaming, and prostitution interests that they had lost when Castro had thrown them out of Cuba after his takeover. The execution of the president was the mob's golden opportunity to rid itself of several of its enemies at the same time. With the president gone, Robert Kennedy would have no power since the next

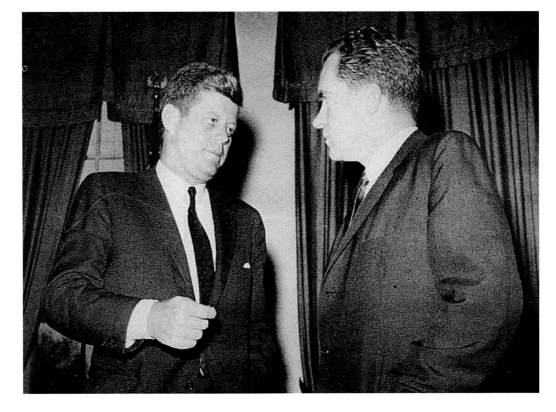

Right: **Former President Nixon, a Watergate conspirator, could not remember where he was during the assassination. Years later he would be pardoned for "all crimes" by Warren Commission member Gerald Ford.**

president, Lyndon Johnson, hated him and would not support the war against the mob; and the assassination could be blamed on Fidel Castro.

How to pin the president's death on Castro? Simple. Have a pro-Castroite accused as the assassin. The perfect candidate for "designated patsy" was Lee Harvey Oswald.

In all likelihood, the CIA kept Oswald on as an inactive agent, as perhaps they had been since his defection to the USSR. In September 1962, he went to work for the FBI as a $200-per-month informant (Warren Commission executive session, January 27, 1964, p. 129). But on what or whom could he inform? One possibility is that he was supposed to observe the White Russian community in and around Dallas, which included the late George DeMohrenschildt.

A very probable scenario is that in mid-1963 Lee Oswald was reactivated by the CIA and sent to New Orleans to create a pro-Castro cover by starting the New Orleans chapter of the Fair Play for Cuba Committee. It appears at this point that CIA agent payroll number 110669 (Oswald; Texas Attorney General, Waggoner Carr) had been ordered by his superiors to furnish himself with a pro-Castro cover in order to enable him to enter Cuba by way of Mexico City, possibly in order to infiltrate Cuban intelligence, or perhaps to try to assassinate Castro. Possibly, those members of the CIA involved in the Kennedy assassination plot were setting Oswald up as "the missing link," the connection between Fidel Castro and the assassination.

Using both Oswald himself and look-alike second Oswalds, frequently giving little care to coordinating the two, the CIA manufactured incidents to build up Oswald's image, or "legend," as an antisocial and violent loner and a supporter of Fidel Castro.

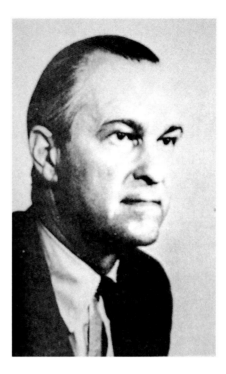

Above: **Richard Helms, CIA deputy director, never told the Warren Commission about CIA-backed death plots against Fidel Castro.**

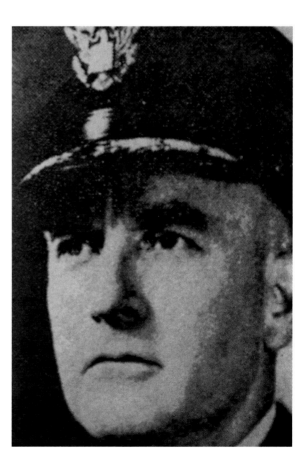

Right: **General Charles Cabell was fired from the CIA by President Kennedy after the failure of the Bay of Pigs invasion.**

The Backyard Photographs

Among the evidence used to indict Oswald and portray his "violent nature" were two photographs (Warren Commission Exhibits 133A and 133B) supposedly showing him with a rifle, a pistol, and two socialist newspapers. They are the only evidence linking him to the weapons said to have been used in the Kennedy assassination and the killing of J. D. Tippit. The photographs, reportedly "found" soon after the assassination in Ruth Paine's garage, where Marina Oswald was living with daughters June and Rachel, are obviously fraudulent. (Someone else stood in Oswald's Neely Street backyard and Lee's face was superimposed onto the other man's body.) There are better than a dozen ways to prove that the photographs do not depict an actual occasion, that Lee could not have posed for them, and that they were manufactured prior to the assassination. In proving that these photos are fake, one proves that Lee Oswald was set up well in advance of the assassination as "the patsy." The most alarming aspect of the backyard photos is that they were created to frame Oswald before the crime was committed and planted among Oswald's possessions *before* the murder took place. This and the sophisticated work required to create the photos in the first place could not have been done by amateurs.

Marina Oswald stated that in March 1963, she took a photograph of her husband in the Neely Street backyard. Later, presented with two such pictures, she stated that she had never seen the results of her photography after the session and that she must have taken two snapshots. The Warren Report volumes contain both of these pictures, and a reconstruction photograph of a policeman in a business suit in a pose similar, but not identical, to those of the two "Oswald" photographs.

Nobody gave much thought to this until early in 1976, when, during its probe into CIA involvement in the assassination and cover-up, the Schweiker-Hart

Below Left and Right: **These two photographs (W. C. Exhibits 133B and 133A) were found together with their corresponding negatives in the garage of Ruth Paine.**

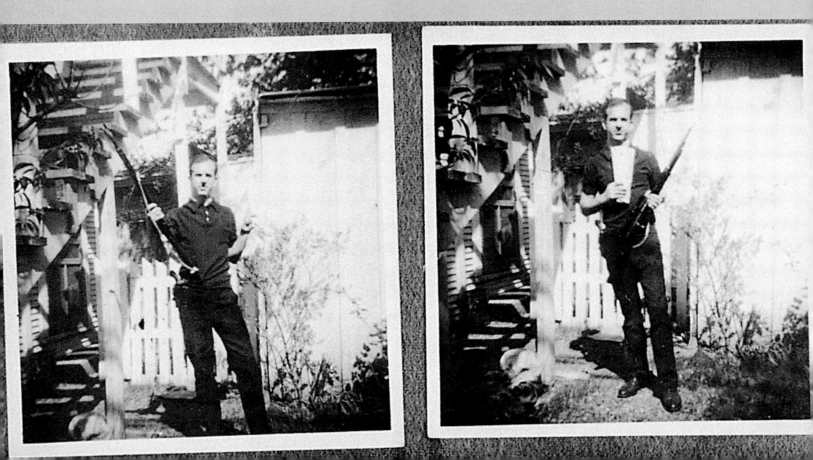

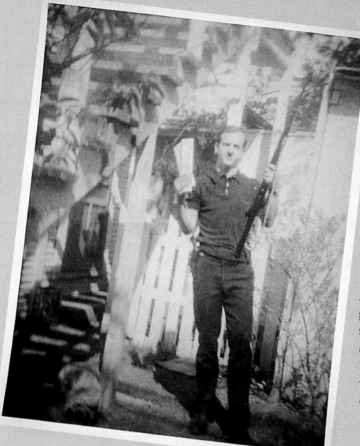

Left: This third photograph was also allegedly found, but was held aside by police officer Roscoe White. This would have been designated CE-133-C.

Above: Lee's Imperial Reflex camera, which was used to make the backyard photographs.

Below Left: The position of the police officer in the official re-creation was obviously based on CE-133-C, which the police never *officially* had as a guide. Obviously they did have it. It was never turned over to the Warren Commission.

Below Right: The FBI claimed that the edge faults on the interior of Lee's camera were unique, and that the patterns of edge faults and scratches on the negatives prove that the camera produced the photographs.

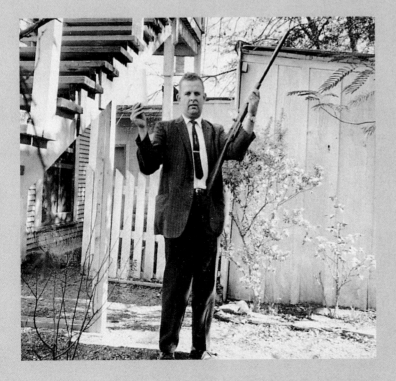

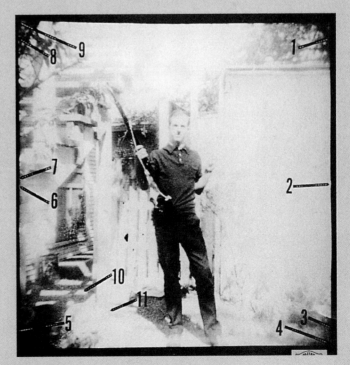

Subcommittee, a Senate investigative body that hired private investigators, ran across yet a third photograph. Marina originally had said that she had taken only one photograph. Then, when shown two, she said that she may have taken two. But now we have three.

The reconstruction photograph published in the Warren Commission volumes presents the exact pose as in this third missing photo. In other words, when creating the reconstruction, the police must have had the third photo all along. Because the third photo is the one that is most obviously a fake, and because of Marina's bombshell testimony that she took only one photograph, the third photo was never released, but, clearly in error, the reconstruction was.

Two Dallas policemen, Roscoe White and Rusty Livingston, kept unauthorized copies of the third photograph for themselves. Imagine the conspirators' horror when they discovered that two prints of the rejected third composite photograph had been appropriated and had reappeared.

The Imperial Reflex camera that Oswald owned and with which the backyard photos ostensibly were taken is little more than a plastic toy. The edges of the picture area of the negatives have flaws and faults, and the camera itself creates faint scratches on the film negatives that are assumed to be unique to each camera, although they may not be. It would be important to establish a link between the camera and the negatives in order to prove the authenticity of the photographs. The only negative ever turned over to the Warren Commission was Exhibit 133B, since someone within the Dallas police department had stolen the other (Exhibit 133A) after Dallas Police Detective Richard S. Stovall created the "Stovall-A" print from it (Exhibit 134).

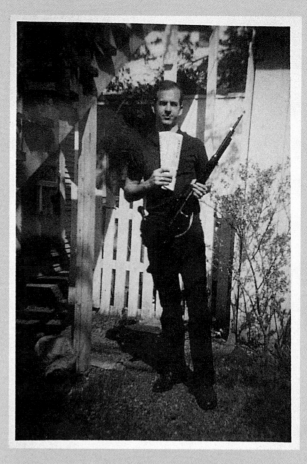

Above: **CE-133-A/STOVALL, a vertically cropped 5″x 8″ variation of the full square CE-133-A print.**

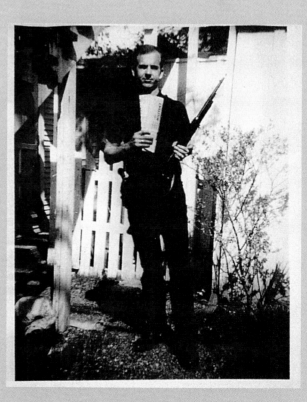

Right: **CE-134 is a print made from the original CE-133-A negative by the Dallas police department. The print of CE-134 proves that the authorities did have the CE-133-A negative and then "lost" it.**

Right: The only hint that the print is a copy is the dark edge. The "original" back-yard photos have a dark edge as well, indicating they could be copies.

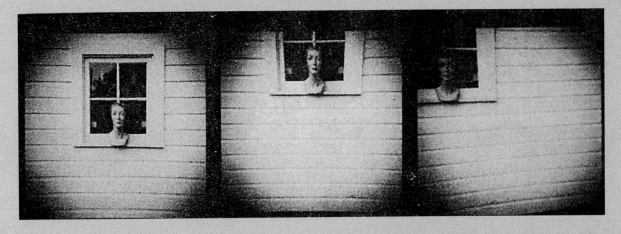

Below Right: A unique copy of CE-133-A, given to the HSCA by Jeanne DeMohrenschildt. Note the black border instead of the white edge. This was produced by placing the negative in an oversized glass negative carrier in order to print it. This was almost too convenient for the House Assassinations Committee. They now had the only existing image of CE-133-A that included the edge faults, thereby enabling them to link it to Lee's camera.

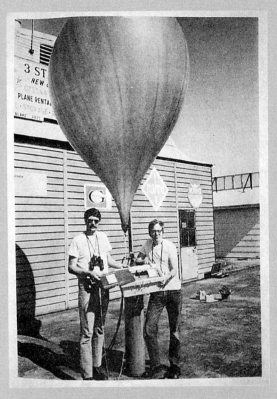

Left: The HSCA duplicated this picture by photographing it using Lee's camera to see if the camera could be used as a copy camera.

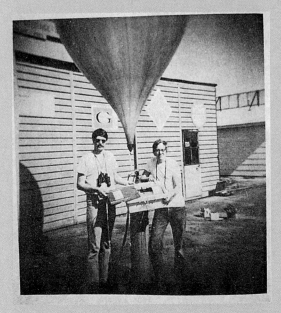

Left: The result proves that Lee's camera can easily produce copies as acceptable as originals.

Right: The reverse side of the DeMohrenschildt CE-133-A print reads "Hunter of Fascists Ha-Ha-Ha!!!"

The House Assassinations Committee's Photographic Panel confirmed the FBI's conclusion that, based on the characteristics of the negatives, at least two of the three surviving backyard photographs were indeed taken with Lee's Imperial Reflex camera. When I was staff photographic consultant to the Committee, I requested the photographic panel to establish whether or not Lee's camera could be used as a copy camera, creating counterfeit "original negatives." The panel ran tests and produced photographs proving that the fixed-focus camera can be (and, in my opinion, was) used to make copy negatives with a four-power supplementary proxar lens. This is akin to a telephoto lens and is placed over the exist-ing lens for closer focus. Lee's camera could have been used to take a picture of a photograph, conceivably doctored in any fashion, and the resulting negative of the photograph of a photograph would appear to be the original negative of the altered photo.

This is how a connection was established between the camera and Exhibit 133B. Since the negative for Exhibit 133A was missing, it became necessary to find evidence of the link. This "evidence" materialized from a totally unexpected source, George DeMohrenschildt.

On April 1, 1977, Jeanne DeMohrenschildt lent the House Assassinations Committee a unique, and previously unknown, print of Exhibit 133A, which had been produced in an oversized glass negative carrier. The print conveniently reproduced the edges of

Left: **Marina endured hours of questioning and interviews following the assassination. Often her statements were manipulated by the authorities.**

Below: **This photograph with the "Ghost of Lee Oswald" was created by the Dallas police. But when and why?**

Above: **The backyard at Neely Street in 1963.**

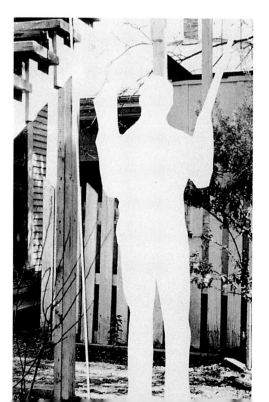

Right: **In the photographs that Marina says she really took, she was standing at the foot of the stairs aiming east. The background in the genuine photographs would have been this short fence by the alley.**

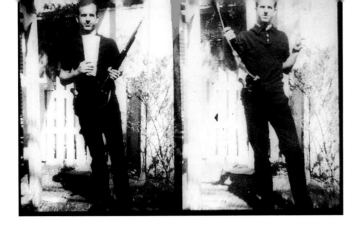

Above: The ratio of the rifle length to the man in the photographs changes in each picture, indicating fakery.

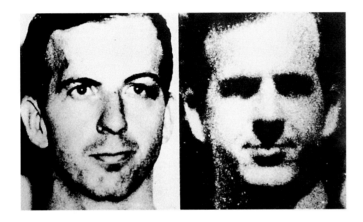

Above: Lee had a pointed chin with a cleft. The man in the picture had a square chin and no cleft.

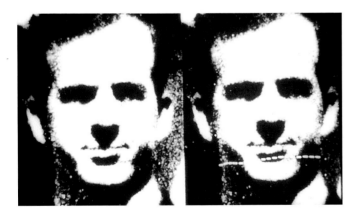

Above: The crop line through the chin is quite apparent. The House Assassinations Committee claimed that Lee had chin acne and that this is what we are seeing in the photographs.

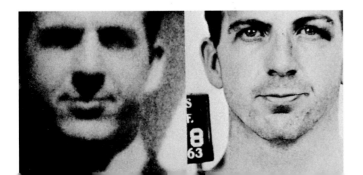

the picture area on what was presumably the original negative. It is the only known existing photographic entity showing the image of Exhibit 133A and the camera mask area at the same time. If this slightly too convenient discovery was the cake, then the icing was the writing on the reverse side, which read:

> To my friend George
> from
> Lee Oswald
> 5/IV/63

Also written on the reverse side of the photograph, in Russian, were the words:

> Hunter of
> Fascists
> Ha-Ha-Ha!!!

Jeanne DeMohrenschildt told the House Committee that she and George had found the photograph in February 1967 while unpacking belongings they had put in storage before leaving for Haiti in May of 1963.

The House panel was able to link the Imperial Reflex to Exhibit 133A based on the "new evidence" showing the unique edges. However, in this case as well, Lee's camera could have been used to create a photograph of a photograph.

All of this becomes moot since these are not the pictures Marina did take. Marina has told this author that when she took the pictures, she was standing by the stairs. Since the stairs were behind her, they could not possibly appear in the photographs.

The backyard photographs are a powerful argument that Lee was framed prior to the assassination.

Left: Lee's mug shot, right, shows the pointed chin with the cleft. The backyard chin is square.

9
BEFORE THE ASSASSINATION

Return to Dallas

Upon Lee's return to Dallas on October 3, 1963, he checked into the YMCA, where he had stayed from October 15 to October 19, 1962. On Friday, October 4, he applied for a job at the Padgett Printing Company. His application was turned down when Jaggars-Chiles-Stovall refused to give him a positive job reference. He went to visit Marina and June at Ruth Paine's home in Irving that afternoon, spent the weekend with them, and returned to Dallas on Monday, October 7.

Above: **The rooming house at 1026 North Beckley, where Lee lived at the time of the assassination.**

Right: The dressing table from Lee's room.

Below: Lee's room was a fishbowl with four windows comprising an entire wall. It makes sense that he would have wanted to hang curtains for privacy.

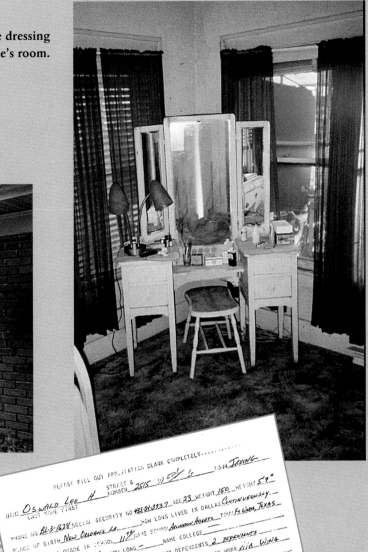

Above: Lee's bed from the rooming house at 1026 North Beckley.

Above: The original job application for the Texas School Book Depository, filled out by Lee Oswald on October 15, 1963.

He rented a room at the home of Mary Bledsoe at 621 Marsalis Street for $7.00 per week. Bledsoe would later become a witness for the Warren Commission, testifying about her encounter with her former tenant on a downtown bus during his "escape" following the assassination. Lee stayed at Bledsoe's house for only one week. She didn't like him and would not allow him to stay there any longer. He spent the weekend at the Paine home and on October 14 rented a room (really not much more than a closet) from Gladys Johnson at 1026 North Beckley Avenue in the Oak Cliff section of Dallas under the alias O. H. Lee. He was paying $8.00 per week for the space.

It was on that fateful day, Monday, October 14, that Ruth Paine told her neighbor, Linnie Mae Randle, that Lee needed to find a job. Randle mentioned that her brother, Buell Wesley Frazier, who lived with her, was working in downtown Dallas at the Texas School Book Depository and suggested that Lee apply there. Paine called Roy S. Truly, superintendent of the book depository, and told him about Lee. Truly advised her that Lee should stop by the depository in person to fill out an employment application and for a job interview. Lee made a good impression and was hired as an order filler. He started work on Wednesday, October 16, at $1.25 per hour.

Each weekend, he visited Marina and June at Ruth Paine's house, hitching rides there and back from Buell Frazier. On October 20, Marina gave birth to their second daughter, Audrey Marina Rachel Oswald.

On November 1, Oswald rented Dallas post office box 6225 at the Terminal

Right: **The Paine house in Irving, Texas, where Oswald spent the night before the assassination.**

Above: **Lee wrote this mysterious letter to a so far unidentified Mr. Hunt. Might it have been Dallas oilman H. L.Hunt, who hated President Kennedy? Or perhaps it was Watergate felon E. Howard Hunt? What is the meaning of the note?**

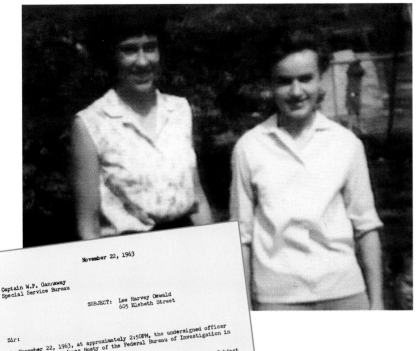

Left: **Ruth Paine and Marina Oswald remained at home after Lee left for work.**

On or about Tuesday, November 12, 1963, ten days before the assassination, Lee hand delivered a note to the Dallas FBI office at 1114 Commerce Street. The note was in an unsealed envelope for Agent James P. Hosty. Lee asked Nanny Fenner, the receptionist, to give the letter to Hosty, since Hosty was out to lunch. Upon returning from lunch, Hosty received the note. He claims that the note read something to the effect, "If you have anything you want to learn about me, come talk to me directly. If you don't cease bothering my wife, I will take the appropriate action and report this to the proper authorities." He also claims that the note was neither dated nor signed.

According to Hosty, he told his boss, Dallas Special Agent-in-Charge J. Gordon Shanklin, about the note on the afternoon of the assassination. When Lee was murdered two days later, Shanklin summoned Hosty to his office and told him, "Oswald is dead now. There can be no trial. Here, get rid of this." Hosty testified that he then tore up the note and flushed it down a toilet.

While it is true that Hosty had visited Marina at Ruth Paine's home on several occasions, it is almost impossible to believe the officially described contents of the note. It is far more likely that the note was a warning to the FBI that the assassination was going to take place.

Left: **FBI agent James Hosty was told by his boss, J. Gordon Shanklin, to destroy the note Lee had given him prior to the assassination. Hosty tore it up and flushed it down a toilet.**

November 22, 1963

Captain W.P. Gannaway
Special Service Bureau

 SUBJECT: Lee Harvey Oswald
 605 Elsbeth Street

Sir:

On November 22, 1963, at approximately 2:50PM, the undersigned officer met Special Agent James Hosty of the Federal Bureau of Investigation in the basement of the City Hall.

At that time Special Agent Hosty related to this officer that the Subject was a member of the Communist Party, and that he was residing in Dallas.

The Subject was arrested for the murder of Officer J.D. Tippit and is a prime suspect in the assassination of President Kennedy.

The information regarding the Subject's affiliation with the Communist Party is the first information this officer has received from the Federal Bureau of Investigation regarding same.

Agent Hosty further stated that the Federal Bureau of Investigation was aware of the Subject and that they had information that this Subject was capable of committing the assassination of President Kennedy.

 Respectfully submitted,

 Jack Revill, Lieutenant
 Criminal Intelligence Section

Sworn to and subscribed before me, this the 7th day of April, 1964.

 FRANCES BOCK
 Notary, Dallas County, Dallas, Texas

Below: **The Paines' garage, where the rifle was allegedly stored and the backyard photos were "found."**

Annex Building, which was located on the south side of Dealey Plaza, directly across from the Texas School Book Depository. On the application he stated that the box would be used for mail for both the Fair Play for Cuba Committee and the American Civil Liberties Union.

On Thursday, November 21, 1963, the day before the assassination, Lee asked Buell Frazier to drive him to visit Marina in Irving. It was the first time he had altered his travel pattern; he normally went home on weeknights to his room at 1026 North Beckley Avenue and went to Irving only on Fridays. It was also the first time that he hadn't telephoned Marina beforehand to let her know he was coming. Buell later testified that Lee told him he needed to pick up curtain rods for his room in Oak Cliff. Lee and Marina had a fight that evening. Marina found out that Lee was using the alias O. H. Lee, was upset about it, and wanted to know why. Lee went to bed early that night. In the morning, he left money as usual for Marina and, apparently still angry about the fight the previous evening, placed his wedding ring in a teacup on a dresser in her bedroom—the first time he had

done so. He then walked to the Randal home on the next corner to meet Buell Frazier for the ride to the depository.

Both Frazier and Linnie Mae Randle saw Lee carrying a "long and bulky package," which they said he placed on the back seat of Buell's car. Although we have no way of verifying it, since tapes of his interrogation have never been released, we are told that during his questioning after the assassination, Lee denied having carried any package, other than his lunch, to work that day. Frazier says that Oswald told him the package contained the curtain rods that they had spoken about Thursday afternoon. Both Frazier and Randle were certain that the contents of the package were far too short to have been a rifle, even if it had been broken down into its component parts. No one else saw Lee with any kind of package that morning. There are two photographs, taken in the rooming house that afternoon, showing the housekeeper at 1026 North Beckley Avenue, Earlene Roberts, supervising a man hanging curtain rods in Lee's room. When Lee left the depository after the assassination, he probably took the curtain rods with him.

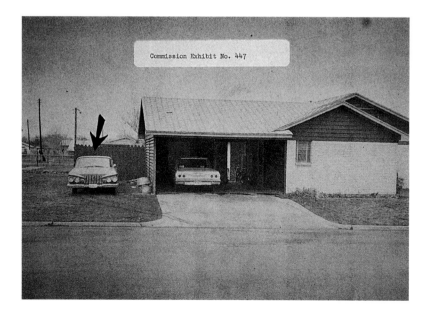

Above: **Buell Wesley Frazier's car at the Randle home. This was the starting point of the car trip to the depository on the day of the assassination.**

Below Right: **A re-creation by Linnie Mae Randle for the Warren Commission of her view from the kitchen window. It was from here that she observed Lee approach her home carrying a package.**

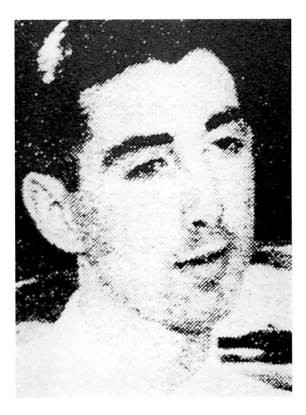

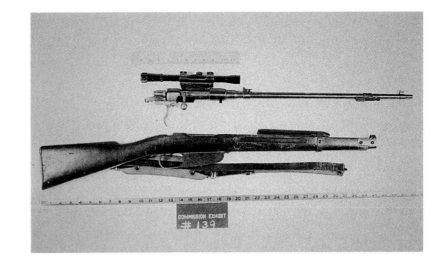

Left: Buell Frazier, Linnie Mae Randle's brother, gave Lee a ride both to Irving the evening previous to and to work the day of the assassination.

Above: Even broken down into its component parts, the Carcano is far longer than the package that Lee was seen carrying.

Below: The Texas School Book Depository, where Lee worked as an order filler.

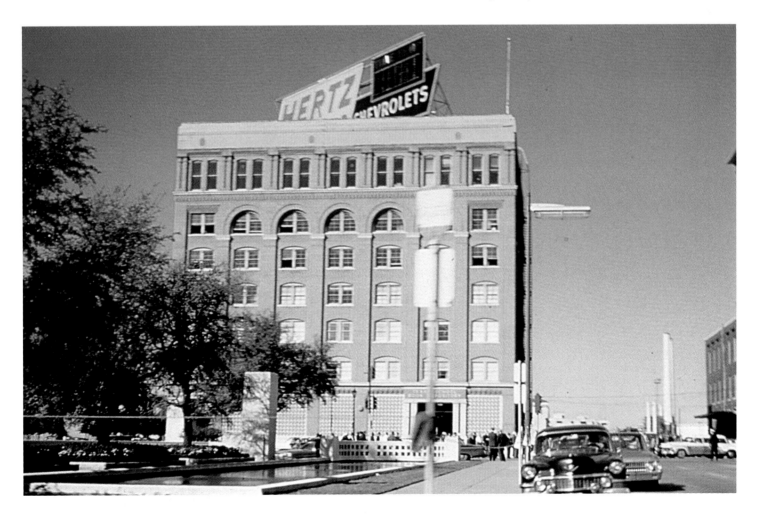

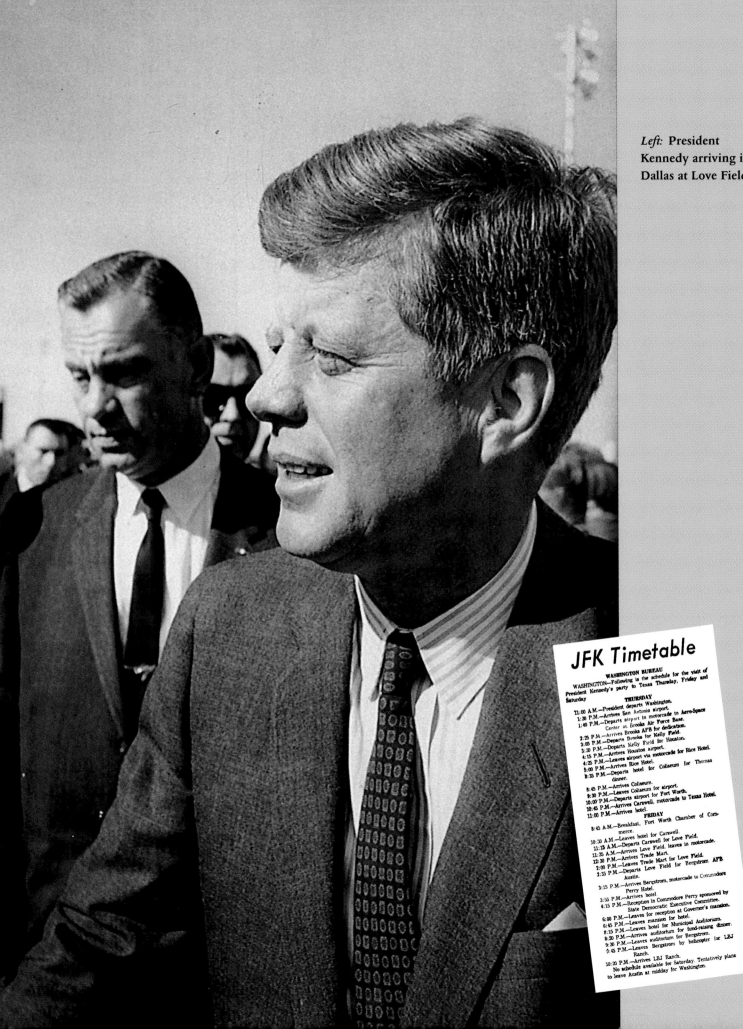

Left: President Kennedy arriving in Dallas at Love Field.

JFK Timetable

WASHINGTON BUREAU

WASHINGTON—Following is the schedule for the visit of President Kennedy's party to Texas Thursday, Friday and Saturday.

THURSDAY

11:00 A.M.—President departs Washington.
1:30 P.M.—Arrives San Antonio airport.
1:40 P.M.—Departs airport in motorcade to Aero-Space Center at Brooks Air Force Base.
2:25 P.M.—Arrives Brooks AFB for dedication.
3:05 P.M.—Departs Brooks for Kelly Field.
3:30 P.M.—Departs Kelly Field for Houston.
4:15 P.M.—Arrives Houston airport.
4:25 P.M.—Leaves airport via motorcade for Rice Hotel.
5:00 P.M.—Arrives Rice Hotel.
8:35 P.M.—Departs hotel for Coliseum for Thomas dinner.
8:45 P.M.—Arrives Coliseum.
9:30 P.M.—Leaves Coliseum for airport.
10:00 P.M.—Departs airport for Fort Worth.
10:45 P.M.—Arrives Carswell, motorcade to Texas Hotel.
11:00 P.M.—Arrives hotel.

FRIDAY

8:45 A.M.—Breakfast, Fort Worth Chamber of Commerce.
10:30 A.M.—Leaves hotel for Carswell.
11:15 A.M.—Departs Carswell for Love Field.
11:35 A.M.—Arrives Love Field, leaves in motorcade.
12:30 P.M.—Arrives Trade Mart.
2:00 P.M.—Leaves Trade Mart for Love Field.
2:35 P.M.—Departs Love Field for Bergstrom AFB Austin.
3:15 P.M.—Arrives Bergstrom, motorcade to Commodore Perry Hotel.
3:55 P.M.—Arrives hotel.
4:15 P.M.—Reception in Commodore Perry sponsored by State Democratic Executive Committee.
6:00 P.M.—Leaves for reception at Governor's mansion.
6:45 P.M.—Leaves mansion for hotel.
8:15 P.M.—Leaves hotel for Municipal Auditorium.
8:20 P.M.—Arrives auditorium for fund-raising dinner.
9:30 P.M.—Leaves auditorium for Bergstrom.
9:45 P.M.—Leaves Bergstrom by helicopter for LBJ Ranch.
10:20 P.M.—Arrives LBJ Ranch.

No schedule available for Saturday. Tentatively plans to leave Austin at midday for Washington.

10

THE ASSASSINATION

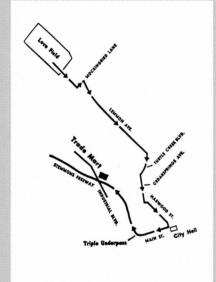

Above: The route of the motorcade published in the *Dallas Morning News* on November 22. The actual route, which zig-zagged through Dealey Plaza, was unplanned and quite different.

Opposite: The timetable for the President's Texas trip. The motorcade was running about six minutes late because the President stopped to shake hands with people at the airport.

On the day of President Kennedy's visit to Dallas, November 22, the *Dallas Morning News* published the planned route of the presidential motorcade. At about noon, as the presidential limousine turned from Harwood Street to Main Street, the activity in Dealey Plaza was electric. The anticipation of seeing the president and first lady was universal and grew in intensity with each passing moment. Dressmaker Abraham Zapruder climbed up on a short pedestal and exposed a few frames of film of some people with his Bell and Howell eight-millimeter movie camera. Other amateur filmmakers and photographers were at the ready throughout the plaza. Main Street was packed eight to twelve deep with cheering onlookers. The motorcade worked its way down Main Street heading for Houston Street, the beginning of the plaza.

Standing alone at the northeast corner of the plaza was the Texas School Book Depository, a massive red monolith soon to become one of the most famous buildings in the world.

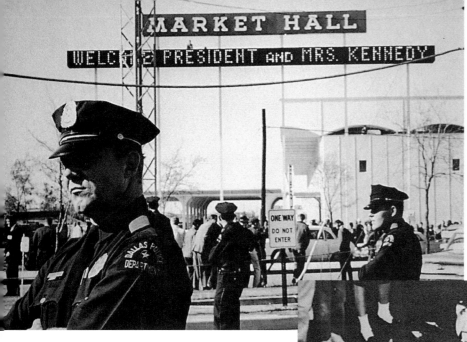

Left: The Market Hall, one of the buildings comprising the Trade Mart, where President Kennedy was to give a fund-raising speech at a luncheon in his honor.

Right: The presidential limousine and its occupants.

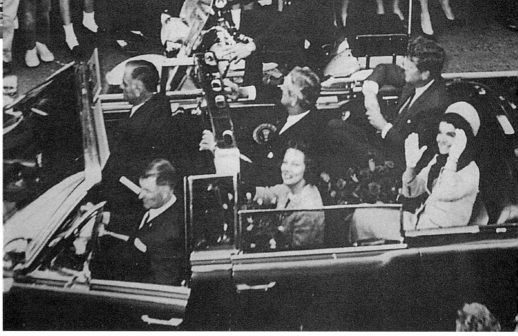

Right: The motorcade turns from Harwood onto Main. Note Secret Service Agent Clint Hill on the rear bumper of the Lincoln.

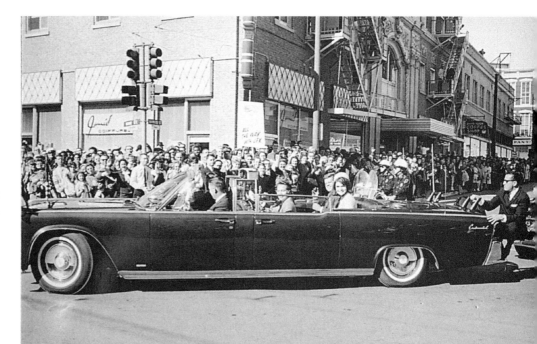

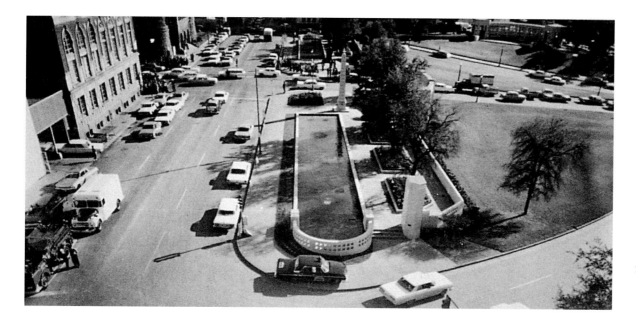

Left: The view from the sixth-floor window of the Texas School Book Depository. The perfect shot for a lone assassin would have been from this direction as the car approached. Why wasn't it fired from here?

Below: The Texas School Book Depository.

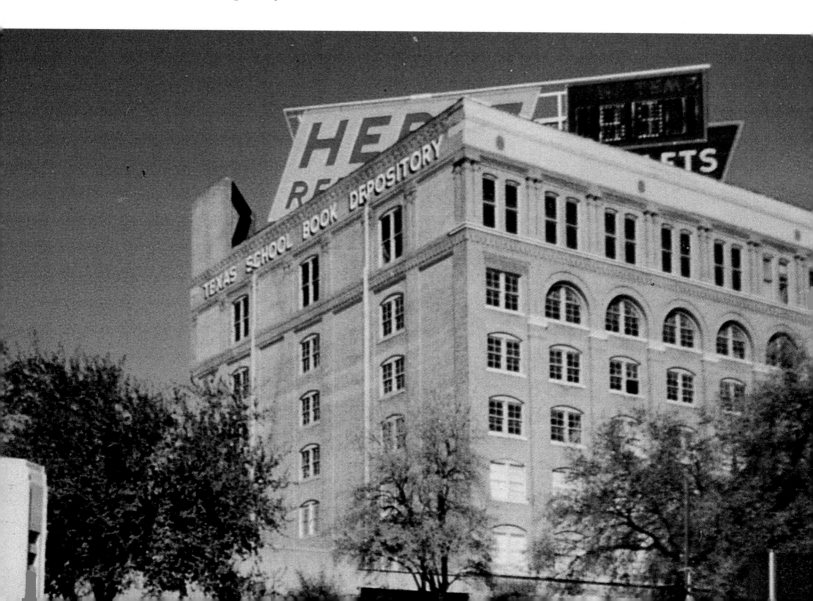

Inside the Depository

Because of the presidential motorcade, most of the employees of the depository were outside the building, lining Elm and Houston Streets. Some remained inside, looking out the windows of the building. Elsie Dorman, who suffered vertigo, stood at a closed window on the fourth floor and placed her eight-millimeter movie camera up to a windowpane, waiting for the limousine to negotiate the ninety-degree right-hand turn from Main onto Houston.

On the fifth floor, finishing a short recreational smoke, Bonnie Ray Williams, Harold Norman, and James Jarman positioned themselves in the three easternmost windows immediately below the so-called sniper's nest on the sixth floor. Williams had just been on the sixth floor, where he ate his lunch of chicken and a Dr. Pepper less than forty feet from the sniper's nest. He saw and heard no one anywhere near the area in the ten to twelve minutes he was there.

Jarman had just come up from the lunchroom on the first floor, where Lee had been eating his lunch. Lee had seen Jarman and another co-worker in the lunchroom and told the Dallas police this fact while under interrogation after his arrest; Jarman, however, had not noticed Lee. Lee remained in the lunchroom for some time and then went up to the second-floor snackroom to buy a Coke and possibly wait for an incoming phone call. There he was seen by a co-worker, Carolyn Arnold, at least as late as 12:15 and probably later. The switchboard for all incoming calls to the building was located in the room directly across the hall from the snackroom. Lee was waiting for something on the second floor. He was seen there just minutes before the shooting and was still there when he was seen by Dallas Police Officer Marrion Baker and book depository superintendent Roy Truly, his boss, as little as seventy-two seconds after the final shot was fired. He was in exactly the same spot. He had not moved. It is very likely that Lee was indeed waiting for a phone call. He may have been told to expect a call at that time. In fact, he may even have received a call. We may never know. The published schedule showed that the motorcade was due to pass through Dealey Plaza at 12:25. It seems illogical that the alleged assassin would be casually hanging around the second floor just minutes before the expected arrival time of the intended target—especially with the sniper's nest four floors and the diagonal length of the building away.

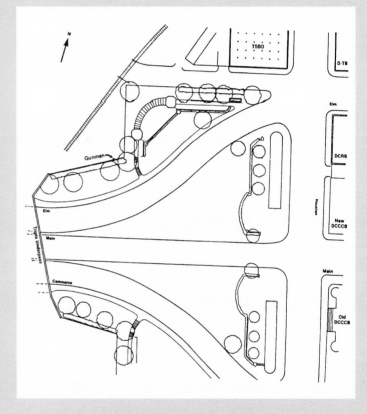

Above: **A map of Dealey Plaza, the site of the assassination, showing the likely location of the gunman who fired the fatal shot at President Kennedy.**

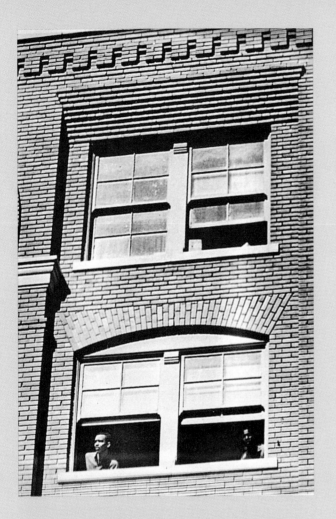

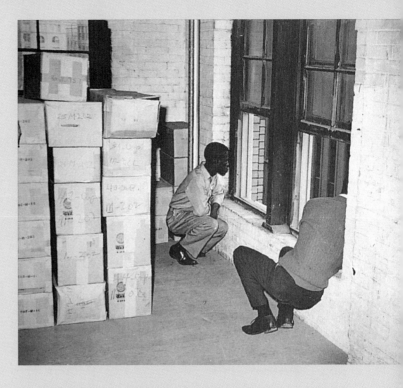

Above: Harold Norman and Bonnie Ray Williams in the positions they occupied on the fifth floor during the shooting.

Above: The sixth-floor window as seen from the vantage point of the motorcade about fifteen seconds after the last shot was fired. Bonnie Ray Williams and Harold Norman are on the floor below.

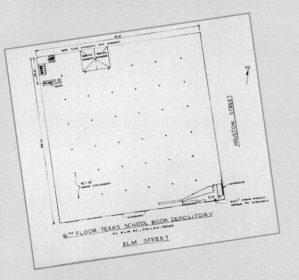

Right: On the fourth floor, Elsie Dorman prepares to film the motorcade.

Above: The floor plan of the sixth floor of the book depository, and the "sniper's nest" at lower right.

The Shooting

Had there been only one assassin, whether or not it was Lee, the perfect shot would have been when the limousine was on Houston Street, heading north toward the book depository. The view was totally unobstructed. As the car was approaching the shooter, the target would have been getting larger in the rifle scope. The car and the target were moving slowly to make the turn onto Elm Street moments later. The rifle would not have to project out of the window, risking disclosure of the gunman. Finally, the sun would not be glaring into the eyes of the gunman.

Instead we are told the lone assassin chose to shoot just after the car had disappeared behind a live oak tree and had begun to speed up, making the target smaller and smaller. He waited until the bright Texas sun was glaring and reflecting directly into his eyes. He waited for the possibility that Secret Service agents might jump onto the running boards on the rear of the car, thus blocking the view from the window.

The only reason for the assassin to wait was that there was at least one other assassin waiting on the grassy knoll to the right front of the motorcade and probably another elsewhere within Dealey Plaza; probably there were two or more other assassins. The best way to assure success would be to catch the president in a crossfire. This is exactly what happened.

Because the medical, witness, ballistic, and acoustic evidence has been so corrupted by the official investigations, there is no way to be certain exactly how many shots were fired in total. The minimum number of shots were the four that struck the president, but that requires ignoring the evidence of shots that missed. One shot struck the president in the front of the neck, just below the Adam's apple. One entered the back, six inches below the shoulder line and just to the right of the spinal column. One shot went to the rear of his head. And there was a shot that entered the right temple from the direction of the grassy knoll. One or both of the head shots could have been fatal. Then there were two shots that struck Texas Governor John Connally—one to his back by the right armpit, and another to his right wrist, which ended up in his left thigh. Finally, consider the four or five shots that missed the occupants of the car completely. One caused a minor wound to the cheek of a bystander, James Tague; another struck the inside frame of the front windshield of the limousine, above the passenger-side sun visor; three or four hit different areas of the ground in the plaza.

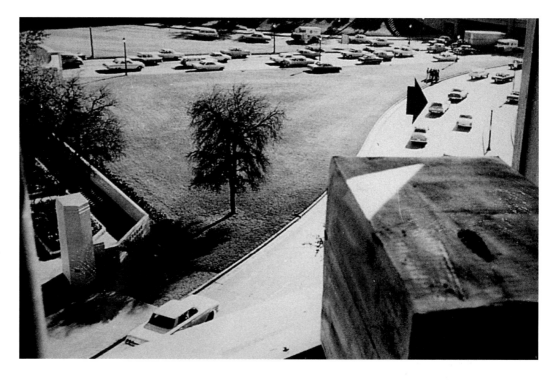

Right: **The view down Elm Street from the sixth-floor window. The midday sun would have been glaring off the street into the eyes of whoever fired from the sixth floor. The presidential limousine would have been at the approximate location of the arrow shown.**

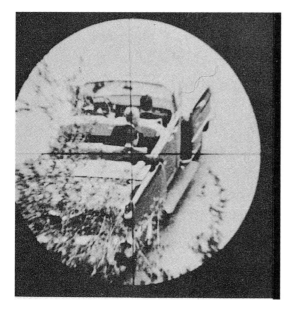

Above: Considering the location of the nonfatal wounds in both President Kennedy and Governor Connally, a single bullet from the sniper's nest could not have hit both men, negating the single bullet theory. This can be seen in the above reenactment created by the government in 1964.

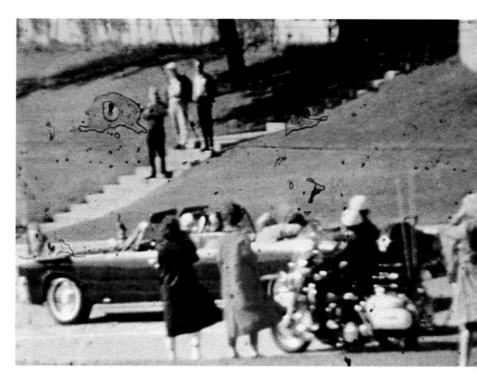

Above: The moment of the fatal head shot(s).

Below: A second man peers from the west end window of the sixth floor, fifteen seconds after the shooting.

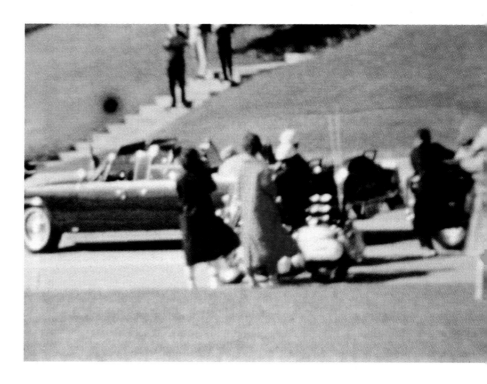

Above: Secret Service Agent Clint Hill jumps onto the rear of the president's car after the shooting.

The Warren Commission recognized only three shots as having been fired. It ignored the additional shots and misrepresented the location and nature of the wounds of the president by promoting the notion that a single bullet was responsible for the back and neck wounds as well as Governor Connally's wounds.

As the shots were fired, construction worker Howard Leslie Brennan was sitting on a cement wall across Elm Street from the book depository. He claimed that he looked up and saw someone through the dirty, half-closed sixth-floor depository window, more than 130 feet away and with the bright afternoon sun reflecting in his eyes. Brennan, who needed glasses but was not wearing them, said he saw a man in his early thirties, with a fair complexion, who was slender and neat—possibly 5′10″. The man was standing up and resting against the left windowsill, with a gun to his right shoulder, holding the gun with his left hand and taking positive aim. Brennan also stated that he saw the assassin fire the last shot. That night, Brennan failed to make a positive identification of Lee. When questioned about this while testifying for the Warren Commission, he stated that he feared for the safety of his family and himself if he were to identify Lee as the assassin. Perhaps he feared retaliation from Lee's "commie" friends. (At this time, Oswald's political leanings had not yet been announced.) Brennan was the only witness to "identify" Lee as the assassin.

It cannot be repeated often enough. Lee had no motive to kill the president. Warren Commission apologists claim that he was looking for his spot in history. Then why did he deny committing the crime? Why did he make no impassioned political statement?

Right: **Howard Leslie Brennan sitting on a wall across from the Texas School Book Depository.**

As late as the summer of 1964, as the Warren Report was already being written, Robert Oswald got a phone call from the Warren Commission to see if he could shed some light on the issue of a motive. Approximately eight months into their investigation, they still could not find a motive for the man they insisted had committed the crime. At least a dozen witnesses had told the Warren Commission that Lee had admired President Kennedy. When Lee had been arrested in New Orleans in August, he had told a policeman that he liked the president. Only a month prior to the assassination, he had said that President Kennedy was doing "a real fine job, a real good job." A Warren Commission counsel stated, "We ducked the question of motive."

The shots were fired, the president was killed, Governor Connally was seriously wounded, bystander James Tague was slightly injured, and history was changed forever.

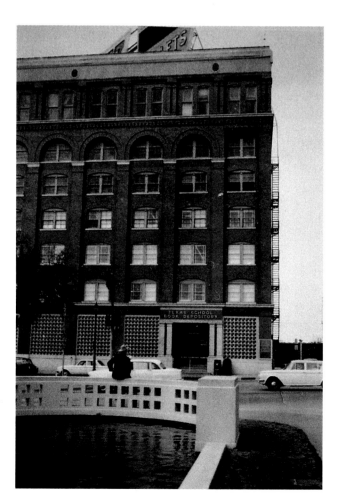

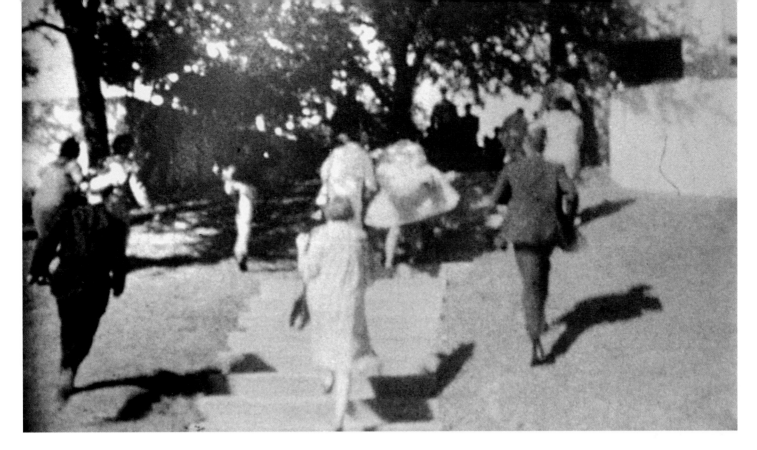

Above: Hundreds of witnesses chased an assassin up the grassy knoll moments after the final shot. By the time they reached the parking lot, he was either gone or had blended into the crowd.

Below: Brennan on the wall where he was sitting when he claimed that he saw the assassin in the sixth-floor window. This picture was taken from book depository doorway. Could one definitively identify an assassin from this distance?

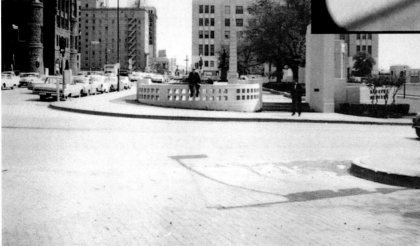

Above: The sixth-floor window thirty seconds after the shooting. Someone is still there. Lee was seen on the second floor forty-two seconds after the assassination. It would have been impossible for him to get to the second floor in time if this were him.

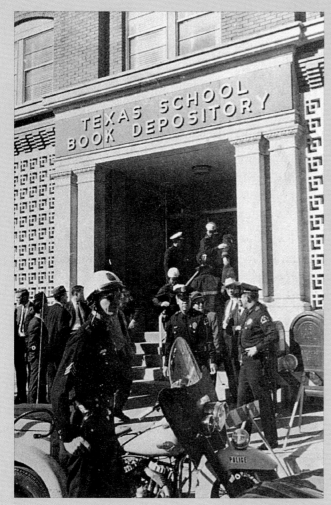

Right: As the police approached the sniper's nest, they found the window half open, with boxes stacked for a gun rest.

Above: The doorway of the Texas School Book Depository as police officers seal off the building.

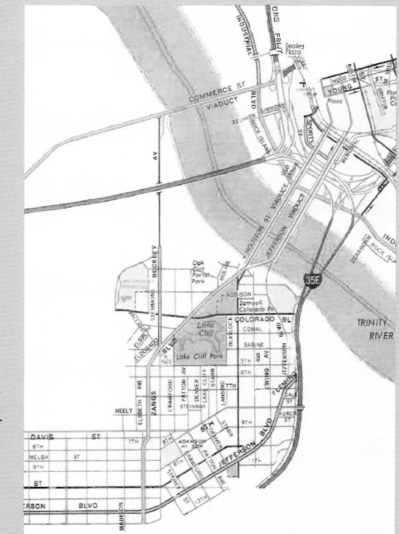

Right: The map shows the area in Dallas where the events of November 22 occurred.

11
AFTER THE ASSASSINATION

Leaving the Depository

Within seconds of the shooting, Officer Marrion Baker ran into the book depository; he had noticed pigeons flying away from the roof of the building at the moment of the gunshots. Baker encountered Roy Truly, who identified himself. The two men ran toward the upper floors. When they reached the second floor, Baker noticed Lee calmly standing by the soda machine in the snackroom, stuck his service revolver in Lee's abdomen, and asked Truly if Lee belonged there. Truly said that Lee indeed worked for him, and the two men continued up to the sixth floor. Truly later stated in his testimony that Lee was told, then, that the president had been shot. Lee did not rush away. He bought a bottle of soda, and, rather than running out the back stairway, which was just a few feet away, he calmly walked through the room with the telephone switchboard to the front of the building and down the front stairs to the first floor.

Five to ten minutes after the shooting, and as he was about to leave the building, he bumped into newsman Robert MacNeil. MacNeil had jumped out of one of the press cars and had run up the grassy knoll with a crowd that was chasing a suspected assassin. He had been photographed on the knoll where the stockade fence meets the overpass several minutes after the assassination. After observing the situation on the knoll, he had walked back up Elm Street to the entrance of the depository, where, upon entering, he asked Lee if he knew where he could find a telephone. Lee told MacNeil to check inside.

When Lee got to the street, he spoke to his supervisor, Bill Shelley, who told him that work would be suspended for the rest of the day because the president had been shot. It is possible that, at this point, Lee went back into the depository to pick up his package of curtain rods, then left for the day.

Below: **This photograph was taken several minutes after the assassination. Newsman Robert MacNeil is standing in the crowd by the overpass and looking over his shoulder. He later left the knoll and went to the book depository, where he ran into Lee leaving the building. This shatters the fiction that Lee raced out of the building within three minutes of the shooting. It was a minimum of five to six minutes and probably as much as ten minutes before he left the building.**

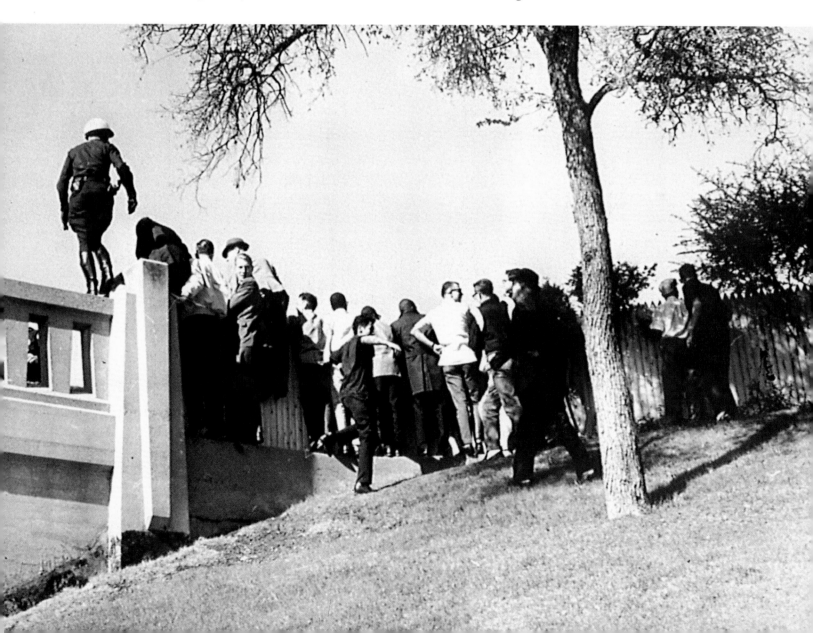

Above Left: The assassin was supposed to have raced around thousands of book cartons to the far end of the sixth floor,...

Above Right: ...wiped his fingerprints off the rifle before hiding it, and raced down four flights of stairs to the second floor. All of this in as little as seventy-two seconds.

Above Left: While Lee was buying a soda in the second floor lunch room, officers Marrion Baker and Roy Truly rushed in and confronted a calm and not at all out of breath Lee. Truly identified him to Baker and the two men left Lee and ran upstairs.

Above Right: After Lee bought his soda, he went into the office where the depository's switchboard was located and he was seen by co-worker Elizabeth Reid. He walked across the office and then down to the first floor, where he spoke to newsman Robert MacNeil.

Collecting the Evidence

Above Left: The official version of the gun-rest box positions.

Above Right: An alternate version of the position of the boxes in the sniper's nest. Which version was correct?

Above: The rifle, in the place where it was discovered, lying between boxes diagonally across the building from the sniper's nest.

Right: The "sniper's nest", the easternmost sixth floor window in the Book Depository. The "nest" refers to the row of boxes that were stacked to conceal the gunman. Only a single palm print of Oswald's was found on any of the boxes. How could he have erected the nest without leaving more prints?

Left: This other rifle, described as a British Enfield, was found in the depository. It's not a Carcano.

Above: The scope of the rifle that was found was so misaligned, the FBI had to add three shims, just to test-fire it. The misalignment would certainly have impaired the sniper's success.

Left: A rifle is taken from the book depository by Lieutenant Day.

Below: "MADE ITALY" is clearly stamped on the Carcano, but all three deputy sheriffs who found it said it was a German Mauser.

Right: The magic bullet that, according to the Warren Report, caused seven separate wounds and broke two dense bones, yet remained intact.

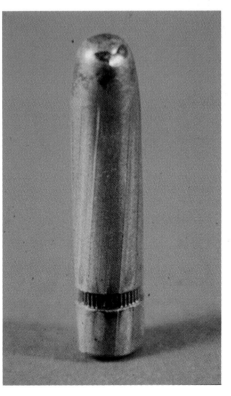

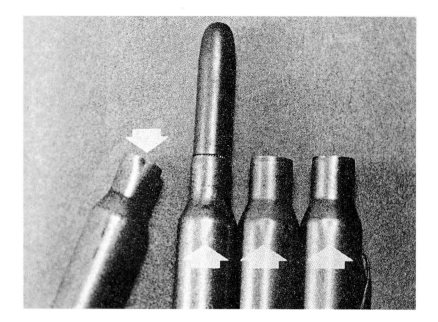

Above: The shells found on the sixth floor of the depository and the live bullet found in the rifle. One shell's dent shows that the rifle jammed during the shooting. This would have severely slowed down the firing time—if the shell was even fired from the rifle. The same shell has no chambering mark, meaning it may never have been in the rifle. The other three have chambering marks.

Deputy Sheriff Roger Craig, who was standing across Elm Street and to the southwest of the book depository, disagreed with the official story. For many years and until the time of his death, he maintained that Lee didn't leave the building until fifteen minutes after the assassination and that he got into a green Rambler station wagon. The car picked him up on Elm Street and headed west through the triple railroad underpass.

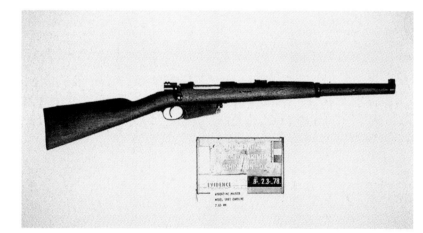

Left: A 7.65-millimeter Mauser, like the one found and reported by deputy sheriffs Seymour Weitzman, Eugene Boone, and Roger Craig.

Above Right: The mysterious cartridge clip that appeared in the Warren Commission report as evidence yet was never in any evidence inventory. No report ever mentioned anyone finding a clip. The rifle cannot be fired without a clip. The clip is automatically ejected from the rifle when the last bullet is chambered. It falls to the floor. It cannot remain in the rifle. Moreover, a clip holds six bullets, yet just three shells and one bullet were found.

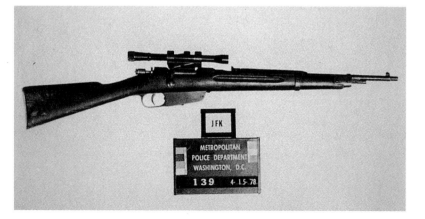

Left: The Mannlicher-Carcano rifle, 6.5-millimeter, serial No. C2766.

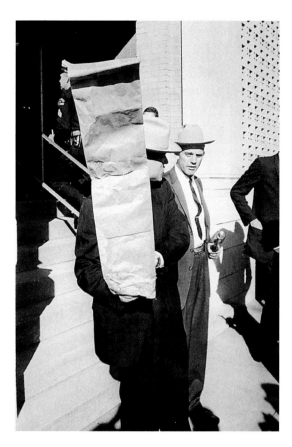

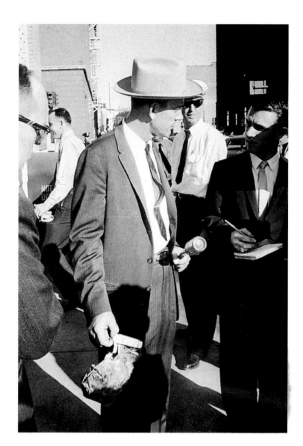

Left: The bag in which the rifle was concealed was allegedly found in the sniper's nest. Not a single drop of gun oil was found on the bag, the contours of which didn't match the Carcano. Here the bag is being removed from the depository by police officers.

Right: The lunch bag and Dr. Pepper bottle were considered evidence, but they weren't Lee's.

Above Left: Deputy Sheriff Eugene Boone's report of finding a 7.65-millimeter Mauser rifle, not a 6.5-millimeter Carcano.

Above Right: The FBI reported that the wrapping paper and tape used to make the rifle bag came from the table on the left in the book depository. Did Oswald really make the bag the night before the assassination? Buell Frazier did not report Oswald as possessing the bag when Oswald rode with Frazier to Irving the night before the assassination.

The "Getaway"

Lee, we are told, walked seven blocks east up Elm Street and boarded a Marsalis Street bus at the corner of Elm Street and Murphy. The bus was heading westward, in the direction of the depository building. Several assassination researchers feel that, since Lee took the Marsalis Street bus, he may not have been going home but to another destination. The Marsalis Street bus could bring him no closer than seven blocks from his rooming house at 1026 North Beckley Avenue, while the Beckley Avenue bus would have dropped him off in front of the rooming house. It is interesting to note that Jack Ruby's apartment, at 323 South Ewing Street in Oak Cliff, was two short blocks from Marsalis Avenue. By coincidence, Mary Bledsoe, Lee's former landlady from his first week in Dallas in early October, was on the bus and recognized him. Cecil McWatters, the driver of the bus, handed Lee a Lakewood-Marsalis transfer with the date November 22, 1963. The transfer was found in Lee's pocket after his arrest.

Left: **Lee left the depository through the glass main entrance door to the street where he spoke to his supervisor, Bill Shelley, for a few minutes before heading east on Elm Street.**

Above Right: **He was aboard the bus when this previously unpublished photograph was taken.**

Above: McWatters's bus was stuck in traffic on Elm St. This photograph is published here for the first time.

Left: Lee walked east to a bus stop, where he boarded a bus driven by Cecil McWatters.

The bus was soon stuck in the traffic around Dealey Plaza, and Lee got off after only two blocks, at the corner of Elm and Lamar Streets. Mary Bledsoe and Cecil McWatters later identified him in a police lineup. (McWatters was honest enough to admit that, because Oswald had cuts and bruises all over his face, and since he was the only one wearing a torn and dirty T-shirt, while all of the others wore button-down dress shirts and were clean-shaven, the lineup was conducted in an unfair manner.) Lee had been on the bus for about four minutes.

From Elm and Lamar, he walked two blocks south to the Greyhound bus station at Commerce and Lamar, two blocks from Dealey Plaza, and got into the front seat of a taxi driven by William Whaley. Whaley's testimony to the Warren Commission indicated that Lee did not appear to be at all nervous or in a hurry. He even offered to give the cab to a woman, who refused his offer.

Whaley entered the start of the cab ride as 12:30 p.m. in his logbook. The time of the assassination was 12:30:30. Whaley later stated that he sometimes rounded off the entry times in his logbook to the nearest quarter-hour. The start of the ride must have been closer to 12:30 than 12:45.

Below: **Lee asked for a transfer and departed the bus.**

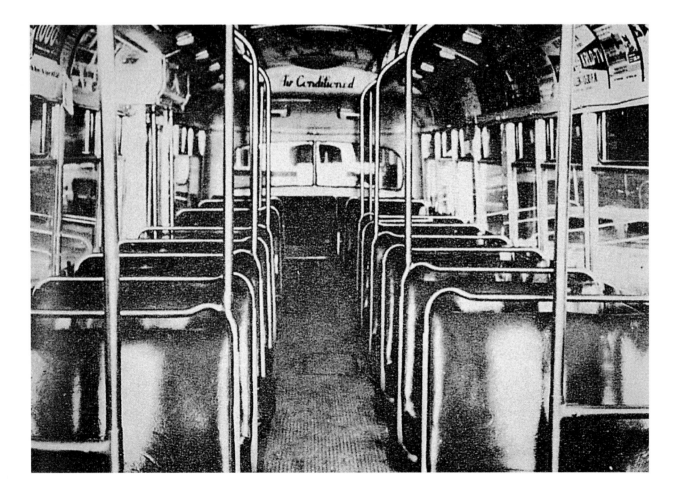

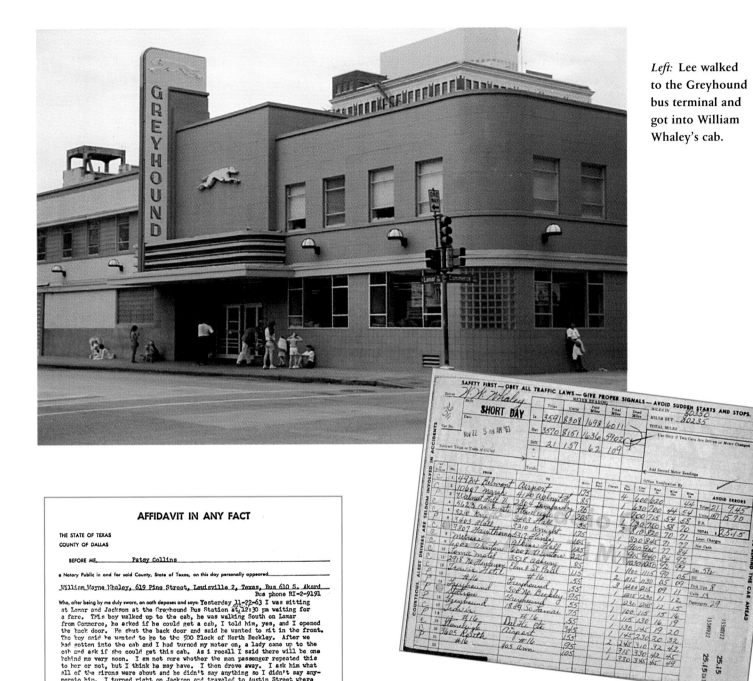

Left: Lee walked to the Greyhound bus terminal and got into William Whaley's cab.

Above Right: Whaley's log showed Lee was fare #14. The fare was 95 cents, and the trip was from 12:30 to 12:45 pm.

Left: Whaley's affidavit describes Lee's behavior and states that Lee tipped him a nickel.

Whaley let Lee off in Oak Cliff, twenty feet north of the northwest corner of the intersection of North Beckley Avenue and Neely Street, on the 700 block of North Beckley. Earlene Roberts later told the authorities that "Mr. Lee," as she knew him, arrived at the rooming house at about 1:00 p.m. Roberts was watching television news reports of the assassination. She said to Oswald, "Isn't that terrible about the president?" According to Roberts, Oswald barely replied. He went directly to his room but stayed for only three or four minutes. When he emerged, he was wearing a jacket, which, she said, he was zipping up. At 68 degrees, the weather was actually too warm for a jacket. Lee had come from the depository in a white T-shirt, leaving his jacket in the building. Since he was wearing an overshirt when he was arrested, it could have been the overshirt and not a jacket that Roberts saw.

During the time that Lee was in his room, Roberts observed that a police squad car pulled up in front of the rooming house. She noticed what appeared to be two uniformed officers in the car. The driver honked twice and then drove off.

Lee left the rooming house at about 1:04 p.m. When Roberts last saw him, he was standing at the bus stop in front of her house at the intersection of Beckley and Zang Boulevard. Ten minutes later, Officer J. D. Tippit was shot to death east of the corner of Tenth Street and Patton Avenue, nearly a mile from the rooming house but only three-tenths of a mile from Jack Ruby's apartment.

Left: **Upon his arrival at North Beckley, Lee went to his closet and retrieved either a jacket or an overshirt.**

Right: **The Warren Report states that Oswald picked up this .38 revolver.**

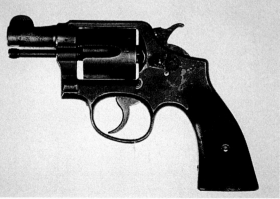

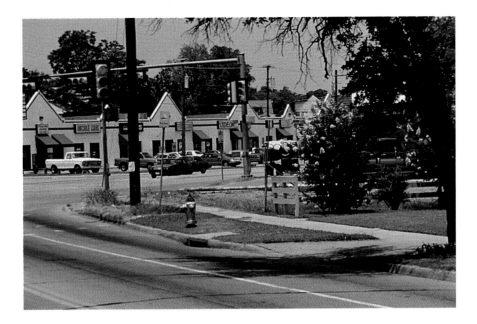

Left: Lee left the rooming house and calmly walked to the corner, where he was seen waiting by the north-bound bus stop.

Right: While Lee was still in the rooming house, a police car drove up, stopped, and the horn sounded. Housekeeper Earlene Roberts looked out the window, saw the car and what she thought were two officers. The car could have been Tippit's; the spare uniform in the window might have appeared to be a second officer.

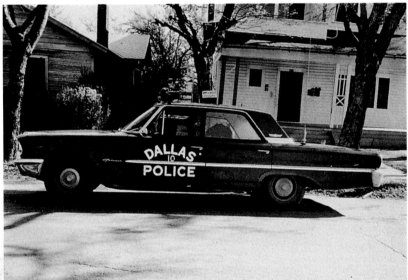

Left: Roberts's view of the corner bus stop where she saw Lee standing after he left her house. What was he waiting for?

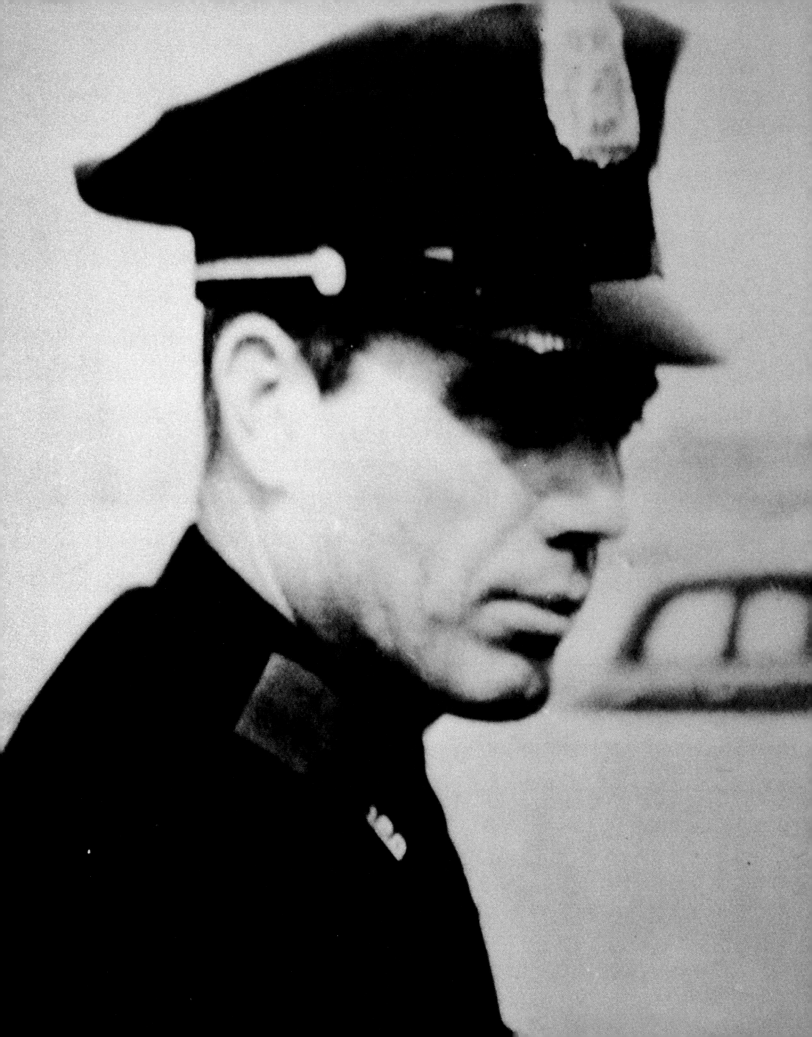

12
THE TIPPIT SHOOTING

Above: The corner of Tenth Street and Patton Avenue, where the shooting occurred.

It was approximately forty minutes after the assassination that Officer J. D. Tippit was killed, in what may well have been an unrelated incident, several miles from the assassination site. The Dallas police, the FBI, and the Warren Commission all drew the unsupported conclusion that Oswald had shot him. He was actually arrested for the murder of Tippit, not for killing the president. It is possible that Tippit was killed by someone whose intention was to implicate Lee in the president's assassination.

Left: **Dallas Police Officer J.D. Tippit.**

Based on the evidence, Oswald simply could not have killed Tippit. To begin with, Tippit was shot with an automatic pistol. (As mentioned earlier, the handgun that was alleged to belong to Lee was a Smith & Wesson revolver that had been rechambered to hold .38 special ammunition.) The bullet shells found at the scene of the shooting do not fit Lee's gun. Many of the witnesses to the Tippit killing did not identify Lee as the killer in a police lineup when first asked but changed their minds later. The only eyewitness who positively and immediately identified him was Helen Louise Markham, but her identification was extremely irresolute. All the witnesses who eventually identified Lee recognized him as the man they had seen fleeing the scene, not actually committing the crime. Of paramount importance is the inescapable fact that Oswald couldn't have had enough time to go from his rooming house to the scene of the Tippit shooting by the time the shooting took place.

The evidence supporting Lee's involvement in the Tippit killing included a revolver allegedly in his possession when he was arrested, four recovered

Above Left: Officer Tippit approached a pedestrian walking on Tenth Street just past Patton Avenue (Re-creation)

Above Right: Tippit spoke to the pedestrian through the small vent window. (Re-creation)

Above Left: The assailant drew his gun and fired three times across the hood of Tippit's squad car. (Re-creation)

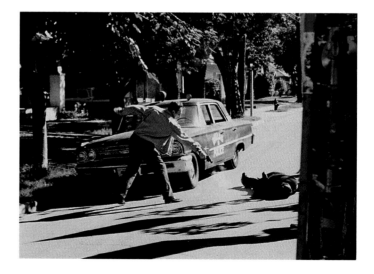

Above Right: The killer walked around the rear of the car, then went back up to the front, stood over Tippit, and fired a fourth shot into his head. (Re-creation)

spent bullets, four empty bullet shells, and a light-colored jacket. It was the evidence upon which the Warren Commission based its case, claiming that since Oswald killed Tippet, he must have killed President Kennedy. Using that logic, if it can be shown that Lee couldn't have killed Tippit, we can conclude that he didn't shoot the president, either. Although there isn't a shred of evidence that actually links the Tippit killing to the Kennedy assassination, the Warren Commission irrevocably tied the two murders to each other. We'll examine the Tippit evidence in detail.

Below: **The murder of Officer Tippit remains one of the great unsolved mysteries of the Kennedy case.**

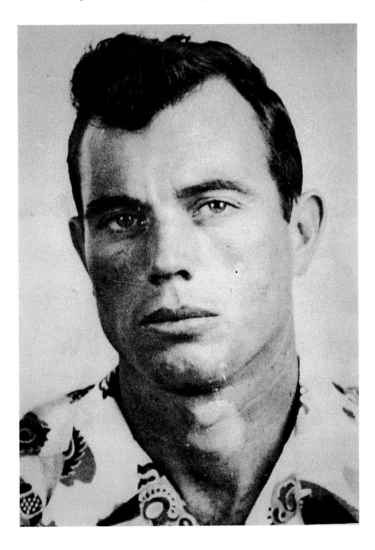

The Murder

A short time before he was murdered, Officer Tippit stopped by the Top Ten Record Shop at 338 West Jefferson Boulevard, according to both Lewis Cortinas, a store employee, and the store owner, W. R. Stark. Tippit made an argumentative telephone call. Cortinas did not know whom Tippit was talking to.

Shortly before his murder, Tippit had been driving his patrol car, number ten, heading east on Tenth Street. Soon after passing Patton Avenue, he came upon a pedestrian heading west—in the direction of Lee's rooming house, not away from it. (The official Warren Commission version of the events states that the assailant was walking east on Tenth Street. However, several witnesses claimed that he was walking west.) Twenty-seven yards east of the intersection, Tippit pulled up to the man and stopped to talk to him. He got out of his car on the driver's side and walked toward the front of the vehicle. As he reached the driver's-side front corner of the car, the assailant pulled out a handgun and fired three times across the hood. Tippit tried to pull his service revolver but fell to the ground, landing on top of his gun.

The assailant began to move away, staying on the passenger side of the car and walking toward the rear. He stopped and passed behind the trunk of the car and walked up to Tippit, lying in front of the car, and fired a fourth shot into his head at point-blank range, killing him instantly. He then walked rapidly west to the corner of Patton Avenue, proceeded south on Patton, and crossed over to the west side of the street, heading for Jefferson Boulevard.

The results of the autopsy, performed by Dr. Earl Rose, showed that Officer Tippit was shot four times. The final shot entered the head at the right temple. The other three shots entered Tippit's chest. Lottie Thompson, the supervising nurse at the autopsy, stated that Tippit had been "shot five times." This contradicts the autopsy, which clearly states four shots.

The Tippit Witnesses

Had Oswald been tried for the Tippit murder, the witnesses in the case would have provided very weak testimony, especially upon cross-examination. Not one of the witnesses to the murder picked Lee as the killer. Most gave descriptions of people, clothing, and actions totally different from the official version of the crime.

Acquilla Clemons, who was sitting on the porch of a house on the north side of Tenth Street, four houses west of Patton Avenue, was never called as a witness before the Warren Commission. She claims that she saw two men talking to Officer Tippit a moment prior to his being shot. One of the men shot

Tippit, then each man escaped in a different direction. Clemons said that the gunman was "kind of a short guy and kind of heavy." The second man was tall and thin and was wearing khaki pants and a white shirt. She said that neither of the assailants in the shooting was Lee and added that people from the police department told her to keep her mouth shut about what she saw because she "might get hurt."

Helen Louise Markham was the Warren Commission's star witness to the shooting. At the time of the murder, she was standing at the northwest corner of Tenth Street and Patton, near the stop for her usual bus to the Eat Well restaurant on Main Street, where she worked as a waitress. Markham witnessed the murder and picked Oswald out of a police lineup but

Left: **A map of the Tippit killing site.**

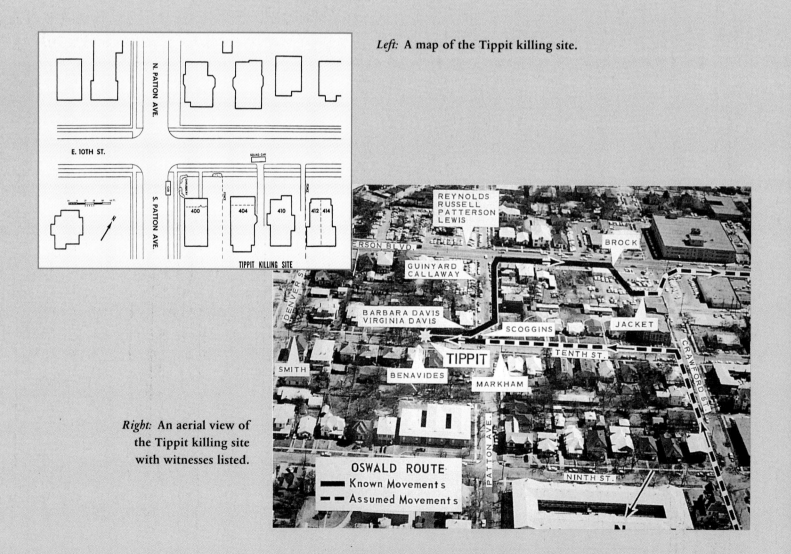

Right: **An aerial view of the Tippit killing site with witnesses listed.**

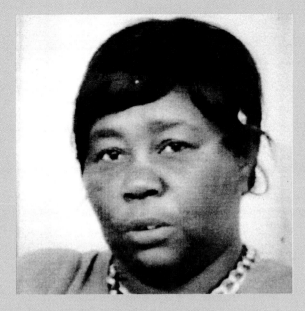

Above: Tippit killing witness Acquilla Clemons was ignored by the Warren Commission. She saw two men attack Officer Tippit.

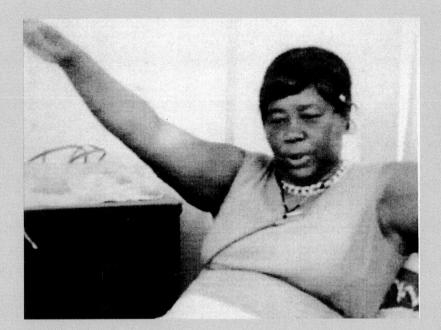

Below: Clemons stated that after the shooting, both men ran off in different directions.

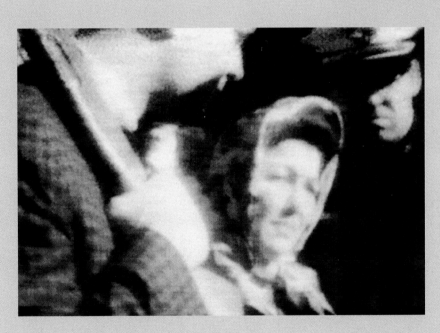

Above: Helen Markham is questioned by the police at the scene of the shooting.

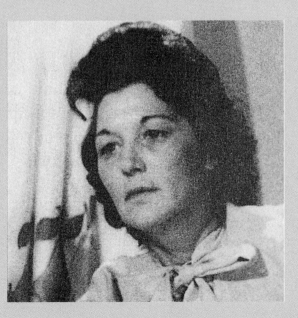

Right: Helen Markham, the Warren Commission's star witness to the Tippit killing.

was hysterical as she did so. Later, she argued with Warren Commission Senior Counsel Joseph Ball about which person she had actually selected. Ball referred to her as "an utter screwball" in an interview in 1964. Initially, she described the killer as short and somewhat on the heavy side, with slightly bushy hair.

Domingo Benavides was driving a pickup truck down Tenth Street at the time of the killing. Benavides played a number of roles in the events of the day. First, he and T. F. Bowley, another bystander, used Officer Tippit's car radio to call for help. Second, Benavides found several bullet shells, which he turned over to the police. Although he witnessed the shooting, he reported that he heard only three shots. Benavides never identified Lee in a lineup. Lee died before the police brought him in to do so.

No other witnesses saw the murder; they only saw the killer as he fled the scene. After running south on Patton to Jefferson Boulevard, the killer turned right and headed west. As he passed a parking lot by a gas station, he allegedly discarded his jacket.

Inside their home on Tenth Street, Barbara and Virginia Davis ran to the front door when they heard shots and Helen Markham's screams. They witnessed someone cutting across their front lawn. Later, the Davises also discovered spent bullets on their property. They identified Lee in a lineup but, like other witnesses to do so, only after seeing his photograph on television. Again, they could only identify him as the man who, in the briefest of moments, they had seen running across their yard.

William Scoggins was sitting in his taxi at the corner of Tenth and Patton but did not hear the shooting. As the assailant fled, he passed by Scoggins's cab, and Scoggins heard him mutter, "Poor damn cop" or "Poor dumb cop." Scoggins was one of those who testified that the assailant had initially

Left: A view of Tippit's police cruiser from Helen Markham's location. (Re-creation)

been heading west on Tenth (toward Oswald's rooming house), not east. William Arthur Smith, on the corner of Denver and East Tenth, also testified that the assailant had been heading west. Scoggins identified Lee in a police lineup that evening.

Warren Reynolds was also one of the people to see a man fleeing the scene of the murder. Reynolds was on the South side of Jefferson Boulevard east of Patton Avenue in a used car lot. Initially, Reynolds stated that the man he saw was not Oswald. On January 23, 1964, Reynolds was shot in the head. A man named Darrell Garner was arrested for the shooting, but Betty Mooney MacDonald, who had worked for Jack Ruby, gave Garner an alibi. MacDonald was then arrested for fighting with her roommate; the roommate was not arrested. MacDonald was found hanged in her jail cell. Reynolds, miraculously recovering from the gunshot wound, then changed his story and identified Lee as the man he had seen.

Above: The view from inside William Scoggins's cab was blocked by the foliage in the front yard of the Davises' home.

Above: The assailant ran across the Davis sisters' yard and past Bill Scoggins's cab. Scoggins's cab can be seen from the site of the Tippit killing position.

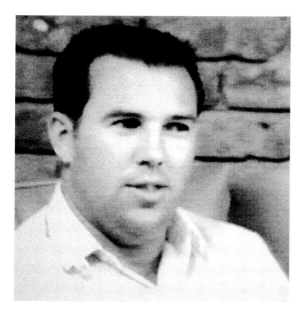

Above: Initially, witness Warren Reynolds would not identify Lee as the Tippit killer.

The Time of
the Murder

No one really knows the exact moment of the shooting of J. D. Tippit. The Warren Commission concluded that it was just before 1:16 p.m. It was critical for the commission to set the time of the shooting as late as possible, because if Tippit was shot before 1:16, it would have been impossible for Lee to have made it from his rooming house to the scene of the shooting quickly enough to have committed the murder.

The Warren Commission endorsed the testimony of Earlene Roberts: that Lee reached the rooming house at about 1:00 p.m., "in unusual haste." How accurate was her testimony? She stated that Lee entered the house after a friend phoned to tell her that the president had been shot. The first televised announcement came at 12:58:32 p.m. (Central Standard Time) on NBC-TV. Roberts turned the television on, and, as we have seen, was watching it when Lee came in. She exclaimed, "Oh, you are in a hurry." She stated that Lee didn't respond, but went to his room and stayed for a maximum of three to four minutes. Lee came into the rooming house in shirt sleeves, but when he left he was, she said, wearing "a jacket." After Lee left, Roberts looked out of her front window and saw him standing near the bus stop in front of the house on the east side of Beckley Avenue, apparently waiting for a bus heading *north*. This does not jibe with the fact that, if he had gotten on that bus, it would have taken him away from the location of the Tippit murder, not toward it.

The Warren Report states, "Oswald was next seen about nine-tenths of a mile away at the southeast corner of 10th Street and Patton Avenue, moments before the Tippit shooting." It also states that the shooting took place at about 1:16 p.m., the time that a private citizen reported the shooting over Tippit's squad car radio. (The commission states that the radio call was made by Domingo Benavides, who "stopped and waited in the truck until the gunman ran to the corner," then "reported the killing of Patrolman Tippit at about 1:16 p.m.")

This official version of the events contains two distinct inconsistencies. First, if Domingo Benavides had "waited" for the killer to leave the scene of the shooting before making the radio call, the shooting must have occurred prior to 1:16 p.m. Second, Benavides never even made the call in the first place. The call was made by T. F. Bowley. The commission members were aware of Bowley's role, but he was never called as a witness. According to Jim Marrs in his book *Crossfire* (1989), on February 18, 1986, Bowley stated that he "was driving past the scene to pick up my daughter from school to go on holiday." As he got to the Tippit shooting site, he looked at his watch. It was only 1:10 p.m.

The Warren Commission allowed Lee from shortly after 1:00 p.m. until 1:16 p.m. to travel nine-tenths of a mile from North Beckley at Zang to Tenth and Patton. They postulated that if he had "walked at a brisk pace," he could have made it. But taking Earlene Roberts's testimony that Lee left two to three minutes after 1:00 p.m. and Domingo Benavides's statements that the shooting took place at approximately 1:14 p.m., the Warren Commission's sixteen minutes is reduced to ten or eleven minutes. If Bowley's statement is considered, the time available is reduced to six or seven minutes—making it virtually impossible for Lee Oswald to have killed Officer Tippit.

One potential problem with the Bowley watch scenario is the possibility that Bowley's watch might have been running slow, and we need corroboration from other witnesses that the shooting occurred at 1:10 p.m. Assassination researcher Dave Perry observes that there are two witnesses who provide such corroboration, Domingo Benavides and Helen Louise Markham.

First there is Benavides's statement that he waited in his pickup truck for a few minutes until the killer left the scene. Benavides then ran to the squad car,

Left: In reenactment, Ted Callaway stands on the spot from which he saw someone, probably the Tippit killer, sprint by.

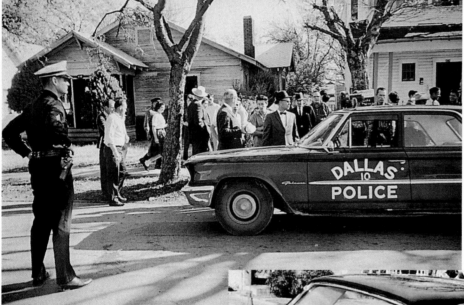

Left: Officer Tippit's patrol car parked at the murder scene on Tenth Street, east of Patton Avenue.

Right: Tippit's patrol car with a spare uniform hanging in the rear window. The passenger-side windows are rolled up.

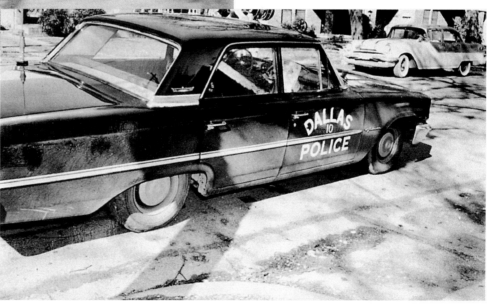

where he could not make the radio work and waited for Bowley to make the call. By the time Bowley finally made the call, it was, according to the police radio log, 1:18 p.m. The direct quote from the transcript of the police's dictabelt recording of the call is as follows: "1:18 p.m. Go ahead citizen using the police radio." The citizen then said, "We've had a shooting here."

However, the Warren Commission was originally given an edited transcript by the police. After many requests, they finally obtained the unedited transcript, which revealed that the 1:18 p.m. broadcast was made earlier, at 1:16 p.m. Therefore, the shooting probably occurred at 1:14 p.m. at the latest.

Second, Helen Louise Markham, when questioned about the time at which she observed the Tippit murder, answered, "I wouldn't be afraid to bet it wasn't six or seven minutes after one." Even after maneuvering by the Warren Commission, this key witness never could confirm the time of the shooting as 1:16 p.m. The Warren Report states, "Her description and that of other eyewitnesses led to the police broadcast at 1:22 p.m." (This was the time of the police broadcast of the notification of Tippit's shooting.) No one on the Warren Commission ever questioned Markham about how she reached her conclusion about the time.

Why was Markham at Tenth and Patton in the first place? She was walking to a bus stop to catch her usual bus to go to work. Markham should have been

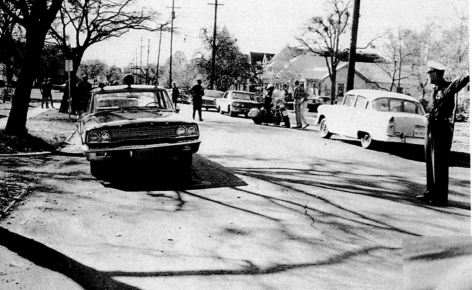

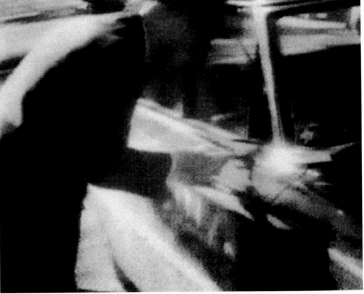

Left: **The Dallas police seal off the Tippit shooting scene.**

Right: **Dusting for fingerprints on Officer Tippit's car. No prints were ever found.**

asked whether she was on time to catch the bus, which was due at 1:12 p.m.

Markham waited "for traffic to pass" before crossing Tenth Street to the bus stop. The "traffic" consisted of Domingo Benavides's pickup truck and a red Ford Falcon driven by witness Jack Tatum, both heading west on Tenth Street, and Officer Tippit's patrol car, heading east. The bus stop was located at the northeast corner of Jefferson Boulevard and Patton Street, one block away. The distance between the two points, Tenth Street at Patton and Jefferson Boulevard at Patton, was approximately 475 feet. Walking at a normal gait, it would have taken Helen Markham one minute and twenty-five seconds to reach the bus stop. She would need to have been at Tenth and Patton *prior* to 1:10 p.m., and to have crossed Tenth Street without stopping, to have caught the 1:12 bus. Since the Warren Commission believed and stated that she had waited for traffic, she had to have arrived at Tenth Street *before* 1:10, the exact time shown on Bowley's watch. (This also permits the time required for Benavides to have waited for the gunman to leave.) The most probable time of the Tippit shooting is then 1:10 or 1:11.

Earlene Roberts testified that Lee left the house between 1:04 and 1:05. Allow that it would take Lee thirty seconds to get to the corner bus stop, where he was seen standing still and facing in the opposite direction; he would have to have traveled nine-tenths of a mile in only four or five minutes. The average runner, in training, will take seven to nine minutes to run a mile. During their investigation, the authorities conducted a complete house-to-house inquiry on Beckley Avenue. Not a single witness saw Lee or anyone running, jogging, or hurrying. No testimony or statements show that the killer had been in a hurry before the shooting. In fact, Helen Markham saw the police car approach the suspect *slowly* from the rear. Thus established, the time frame of six or seven minutes makes it clear that Lee could not have killed Officer Tippit.

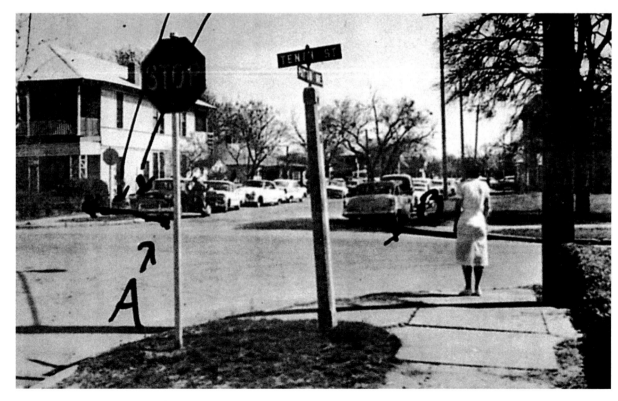

Left: **Helen Markham shows the position at Tenth and Patton from which she viewed the Tippit killing. (Re-creation)**

The Handgun

Lee was arrested at the Texas Theatre, with, we are told, a revolver tucked away in the waistband of his slacks. Later designated Warren Commission Exhibit 143, it had been purchased from Seaport Traders, Inc., in California and sent by mail to A. J. Hidell at P.O. Box 2915, Dallas, Texas, on March 20, 1963. It was a Smith & Wesson .38 special two-inch Commando model revolver and cost $29.95.

Connecting the weapon supposedly taken from Lee to the shooting of Tippit is problematic. A radio broadcast by Sergeant Gerald Hill, one of the first policemen to arrive at the scene of the Tippit murder, was transmitted as follows: "The shell at the scene indicates that the suspect is armed with an automatic [emphasis added] .38 rather than a pistol." The handgun allegedly taken from Lee at the time of his arrest was a .38 revolver, not an automatic. Sergeant Hill made his critical statement after Officer J. M. Poe, another officer on the scene, showed him a Winston cigarette package containing three empty bullet shells, which Domingo Benavides had turned over to him after the shooting. Ammunition for a revolver is not interchangeable with ammunition for an automatic, and the shells on either type of ammunition are clearly marked—".38 spl." (special for revolvers) or ".38 auto." (automatic).

In the afternoon after the shooting of Officer Tippit, two empty shells had been found in bushes at the corner of Tenth and Patton near the edge of the Davises' property. Based on the statements of Officers Poe and Hill, we have three shells turned over to Hill by Domingo Benavides. Virginia and Barbara Davis each found an empty shell on the ground near their house. These two shells were also turned over to the police. This gives us a total of five shells. But the Warren Commission had their ballistics expert, Joseph D. Nicol, examine "the four cartridge cases found near the site of the homicide." The Warren Report states, "The examination and testimony of the experts enabled the Commission to conclude that five shots may have been fired, even though only four bullets were recovered." What became of the fifth bullet shell?

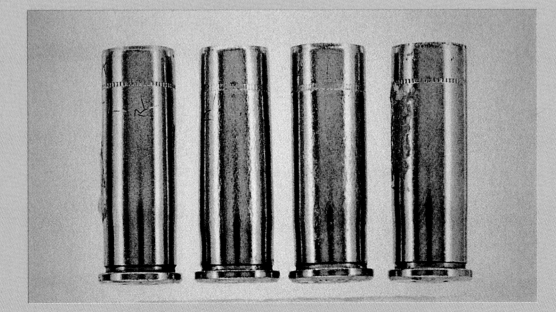

Left: **The four bullet shells that are now claimed to be the ones found at the Tippit killing scene.**

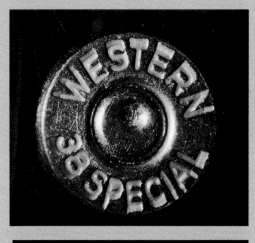

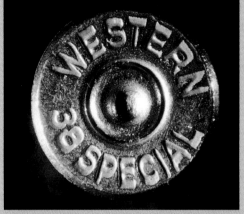

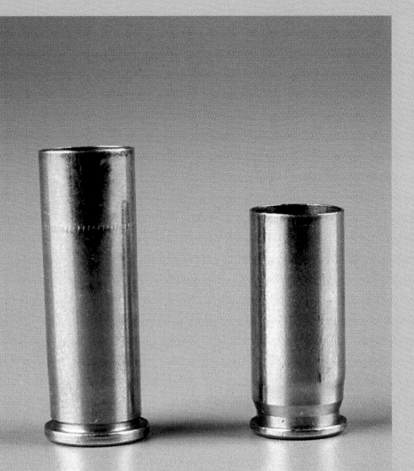

Above: The physical difference between the bullet shells for a revolver (left) and an automatic pistol (right).

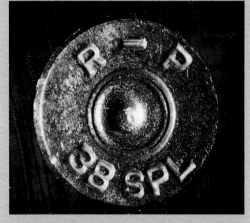

Right: The four shells. Two are from Westerns, and two are from Remington-Peterses. The bullets were three of one and one of the other.

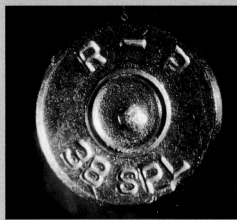

There is a strong probability that the Warren Commission never received the *original* shells from the Dallas police in the first place. Sergeant Hill told Officer Poe to keep the chain of evidence small by marking the shells for evidence and then turning them over to the crime lab or to homicide. Poe scribed his initials on the shells. When he was later asked to identify the shells, those he was shown were not initialed. In fact, no one—not Poe, Hill, the Davises, or Domingo Benavides—could identify the shells shown to them as the same ones they had found at the scene of the Tippit shooting.

Four bullets were removed from Tippit's body at Parkland Hospital. They were given to the Dallas police and then turned over to the FBI. Cortland Cunningham, an FBI firearms expert, reported, "The bullet, [FBI Exhibit] Q-13 [also Warren Commission Exhibit 602], from Officer Tippett [*sic*] is so badly mutilated that there are not sufficient individual microscopic characteristics present for identification purposes." Cunningham wrote that this was the "only bullet that was recovered." He testified to the Warren Commission that the police gave the FBI only one bullet. The FBI then contacted the police and "found" the other three bullets in police files. The Warren Commission, and in particular commission member Congressman Hale Boggs, expressed distress over the gross negligence shown in not turning over this vital evidence.

Even after Cunningham had examined all four bullets, he found them "slightly smaller than the barrel of the pistol which had fired them. This caused the bullets to have an erratic passage through the barrel and impressed upon the lead of the bullets inconsistent individual characteristics which made identification impossible."

On the other hand, Joseph Nicol found that one of the bullets recovered from Tippit's body "was fired from the same weapon that fired the test bullets [Oswald's alleged gun] to the exclusion of all other weapons." The disparity between the conclusions of Cunningham and Nicol was never resolved by the Warren Commission.

A further confusion is that, of the four shells admitted into evidence, two were Winchester/Westerns and two were Remington/Peterses. Of the four bullets, however, three were Winchester/Westerns and only one was a Remington/Peters. In the final analysis, we have five empty bullet shells found at the scene. At least three were from an automatic pistol

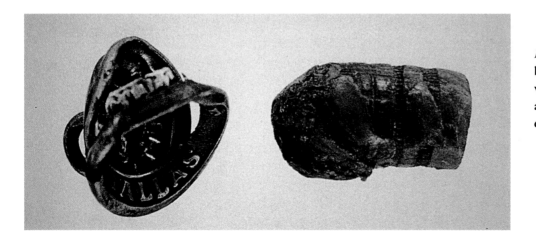

Left: **This bullet struck the button shown here, which was on Tippit's uniform, and both became slightly embedded in his skin.**

and were not capable of being fired by the weapon that was placed in evidence as Lee Oswald's. We also have five bullets: four in Dallas police files and one kicked out of the ambulance by Kinsley. Finally, at the time that the gun was confiscated from Lee Oswald at the Texas Theatre, according to Hill, all six chambers were loaded with a mixture of Winchester/Western and Remington/Peters live bullets. However, the Warren Commission was only presented with four live bullets. What happened to the other two? Were they fired in order to "create" shells or bullets?

Eddie Kinsley was the assistant to Clayton Butler, the ambulance driver who picked up the body of Officer Tippit at the shooting site. Kinsley stated, "I kicked one of the bullets out of my ambulance that went into his [jacket] button, that wasn't even counted as one of the shots. I kicked it out of the ambulance onto the parking lot of Methodist Hospital. It didn't go in the body. The first shot hit him in the temple. And then the next one hit him in the chest and in the stomach. And this one that they missed hit him in the button and it fell off the ambulance still in this button. And I would give a million dollars if I had never kicked that thing out, and kept it instead." (Interview by Dave Perry)

Right: **This is one of the three bullets that was removed from Officer Tippit's body.**

The Jacket

A light-colored jacket discarded by the gunman near the Tippit shooting site has never been conclusively linked to Oswald. Authorities have never been able to trace laundry marks on the jacket to him despite attempts to do so. Officially, Police Captain W.R. Westbrook found the jacket lying under one of the rear tires of a 1954 Oldsmobile in space 17 of a parking lot behind Ballew's Texaco Gas and Service Station near Crawford Street and Jefferson Boulevard. Westbrook later identified it for the Warren Commission (who had designated it Exhibit 162), testifying that "some officer, I feel sure it was an officer, I still can't be positive, pointed this jacket out to me." Westbrook testified that he had not found it himself; the Dallas police radio log shows that an Officer 279 mentioned a jacket he believed to have been dropped in the parking lot behind the service station by the suspect.

Officer 279's transmission was made at about 1:25 p.m.; Captain Westbrook was not at the scene until at least 1:40 p.m. Officer 279 has never been identified.

Only six of the sixteen witnesses who were called to make statements in the Tippit shooting were shown Exhibit 162. All of them saw J. D. Tippit's killer prior to his jacket being removed. One of the witnesses was never closer than 400 feet from the suspect. Examining each of the original jacket descriptions made by the witnesses, we should be reminded that the commission referred to Exhibit 162 as light beige.

- Ted Callaway said the killer's jacket was more tan than Exhibit 162.
- Domingo Benavides said the jacket was light beige.
- Barbara Davis said the killer wore a black coat.
- Helen Markham said the killer's jacket was darker than Exhibit 162.

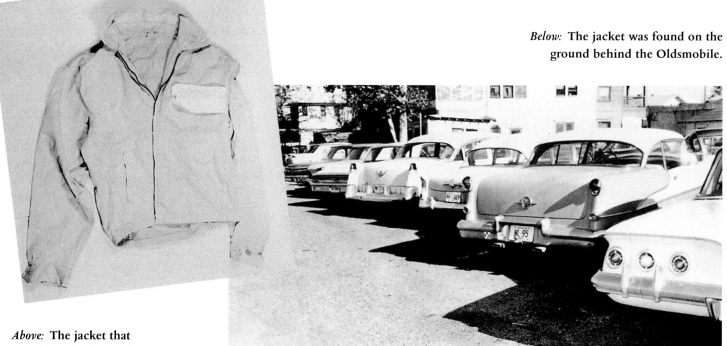

Below: **The jacket was found on the ground behind the Oldsmobile.**

Above: **The jacket that was allegedly dropped by the killer of Officer Tippit.**

- Warren Reynolds said the man had a jacket that was bluish.
- William Scoggins said the jacket was darker than Exhibit 162.

Since the descriptions of the overgarment worn by the subject vary so greatly from witness to witness, we cannot conclude that the jacket that was found belonged to the assailant. In fact, the only reason the jacket was connected to Lee in the first place was that Earlene Roberts testified that he left her house with one and that when he was arrested he didn't have one. Suppose the overshirt that Lee was wearing at the time of his arrest, not a jacket, was what Roberts saw him putting on. On that basis there is no connection between the Tippit killer and Oswald.

Above: The parking lot behind the Texaco gas station where the jacket was found.

Below: Officer Tippit's widow, Marie, and their children, Brenda Kay, Allen, and Curtis.

Right: Fellow officers were pallbearers for Officer Tippit, who was given a hero's funeral.

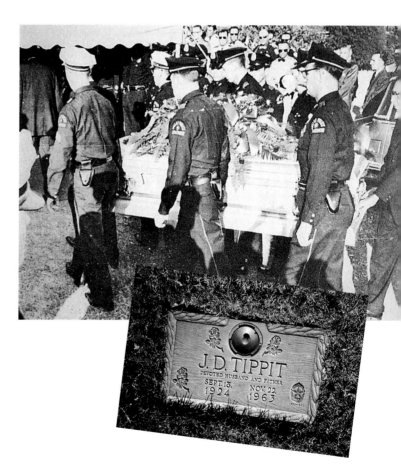

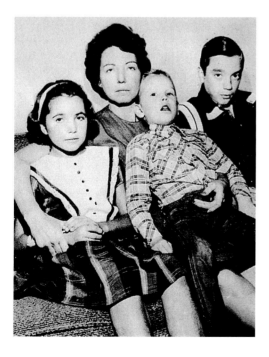

Above Right: J. D. Tippit's gravemarker at Laurel Land Cemetery in Dallas.

Left: The Texas Theatre in the Oak Cliff section of Dallas, where Lee was arrested.

13
UNDER ARREST

The Texas Theatre

After dropping the jacket, the killer continued west on Jefferson Boulevard, stopping briefly in the entrance vestibule to a Hardy's shoe store. He was spotted acting in a suspicious manner by shoe salesman Johnny Calvin Brewer. Brewer, who had seen the assailant about one week earlier as a customer, recalled, "This guy was the biggest pain in the ass I ever had in the store. He had to try on every style we carried and in the end, he didn't buy anything.

Right: **The distance between the Hardy shoe store and the Texas Theatre.**

"The police cars were racing up and down Jefferson with their sirens blasting and it appeared to me that this guy was hiding from them. He waited until there was a break in the activity and then he headed west until he got to the Texas Theatre. I left the store and followed him to the theater, and asked the lady who sold the tickets, Julia Postal, if she had sold a ticket to the guy. She said that she hadn't and I told her the guy must have snuck in and that she should call the police. [Mr. Brewer did not actually see Lee go through the doors and into the theater.] I went into the theater and spoke to Butch Burroughs [the assistant manager]. He told me that the guy who had come in had gone up to the balcony. I went up to the balcony to have a look. It was dark up there and I couldn't see anyone, so I went back downstairs and told Butch to keep his eyes on the front exit. I went to the back door and waited for the police to arrive. I heard some noise outside in the back alley and opened the door. A cop grabbed my arm and threw me up against the door. Cops started to frisk me, boy was I scared, and I told them that I was the one who had Julia Postal call them and that the man they wanted was still in the theater. They brought me back in and we walked out on the stage in front of the screen. The movie never stopped running, but someone turned up the house lights and I pointed to a guy who was sitting near the back of the theater, about three rows from the rear, and to my left. The police

Below: **The Texas Theatre shortly after November 22, 1963.**

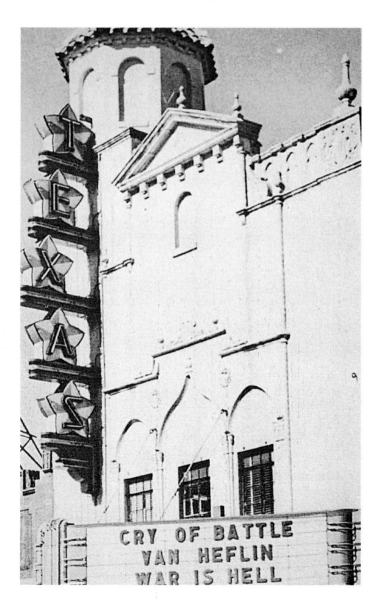

Above: **Hardy Shoe Store employee John Calvin Brewer led the police to the Texas Theatre and Lee Oswald.**

Left: The ticket booth in front of the Texas Theatre. Lee was alleged to have snuck past the booth and ticket salesperson Julia Postal and into the theater without paying.

Below: Julia Postal did not see Lee or anyone else sneak into the theater.

Left: The lobby of the Texas Theatre. John Brewer followed either Lee or an impostor to this point and then lost him.

started walking up the aisle from the front of the theater telling everyone they passed to leave and get out of the way until they got to the man I had pointed out to them."

John Brewer's story matches the official version, but Warren "Butch" Burroughs, a reliable eyewitness, places Lee Oswald in the Texas Theatre by as early as 1:00 p.m., approximately ten minutes *before* the Tippit shooting. Burroughs saw Lee from the candy counter between 1:00—when the first movie, *Cry of Battle*, started—and 1:08. According to Butch, "He went up into the balcony." If Lee had gone straight down Zang Boulevard by car or bus to Jefferson Boulevard, he could easily have made it to the Texas Theatre before 1:08. At 1:15, Lee came downstairs and Butch sold him some popcorn. Lee then went into the theater on the ground level and sat next to a pregnant woman. Several minutes later, the woman got up and went upstairs to the ladies' rest room. Butch did not see her leave and never saw her again.

Butch Burroughs's recollections are confirmed by another witness, eighteen-year-old Jack Davis. Davis had gone to see the double feature (the second movie was *War Is Hell*) and sat down in the right-rear of the theater. As the opening credits for *Cry of Battle* were ending at a few minutes past one, Lee startled Davis by squeezing by him and sitting down next to him in a theater with nine hundred seats and fewer than twenty patrons. Lee said nothing to him and after a few minutes got up and moved across the aisle and sat down next to another person. He got up again at 1:15 to buy his popcorn. Davis then saw Lee enter the center section of the theater from the far side.

Burroughs and Davis agreed that the police arrived at the theater about twenty minutes after the popcorn purchase. As Lee was being dragged out of the theater, Davis heard him shout, "I protest this police brutality."

The evidence shows Lee did not have enough time to reach Tenth and Patton on foot in the first place. Moreover, witnesses place him in the Texas Theatre at the time of the Tippit shooting. Four questions come to mind: Who really shot J. D. Tippit? Why was he shot? Who was the person who looked like Lee Oswald that John Brewer saw enter the theater at about 1:35?

Finally, if Lee could have traveled the ten blocks between his rooming house at 1026 North Beckley and the Tippit murder site in five to ten minutes, why would it supposedly take him half an hour to get from the shooting site at Tenth and Patton to the Texas Theatre, at 231 West Jefferson Boulevard, a distance of only seven blocks?

Right: **The alley exit door of the theater. John Brewer let the police in through this door.**

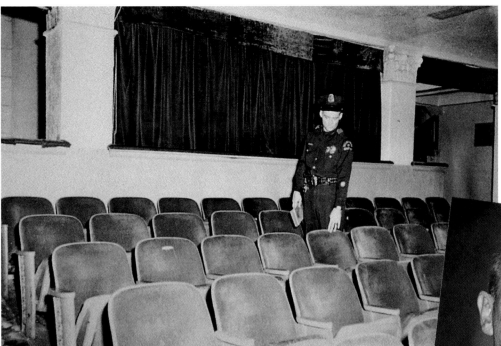

Left: A policeman points out the seat in which Lee was supposed to have been sitting.

Right: Texas Theatre manager "Butch" Burroughs claimed that he saw Lee in the theater at a time too early for Lee to have shot Tippit.

Right: Zang Boulevard at Jefferson Boulevard. Lee would have gotten off the bus one block from the Texas Theatre.

The Arrest

John Brewer pointed out to the police where Lee was sitting. The police, however, did not go directly toward him; rather, they slowly started at the front of the theater as if waiting for him to try to escape. After several minutes, they reached where he was seated. Officer Maurice "Nick" McDonald approached him and told him to stand. Oswald stood up and shouted, "Well, this is it." He hauled off and floored Officer McDonald with one punch to the face, allegedly drew a revolver from the waistband of his slacks, pulled the trigger, and fired at McDonald point-blank. McDonald reached out for the gun, and the webbing between his thumb and forefinger slid between the firing pin and the bullet shell, prevent-

ing the primer from being struck and saving his life. Other police officers jumped into the fray, and Lee was subdued. He shouted that he was not resisting arrest and screamed, "Police brutality."

At the time of Oswald's arrest, John Brewer heard at least one of the arresting officers shout, "Kill the president, will you?" However, at this point the police had no reason to suspect Oswald's involvement in the assassination. Any members of the Dallas police drawing a connection between Lee and the assassination at this point must have been part of the conspiracy. It would be half an hour before he was even a suspect in the murder of the president and ten more hours before he was charged in that crime.

Only two of the people in the theater audience were ever questioned by the Warren Commission.

Below: The police gather at the theater in a show of force. This to arrest a man for sneaking in without paying?

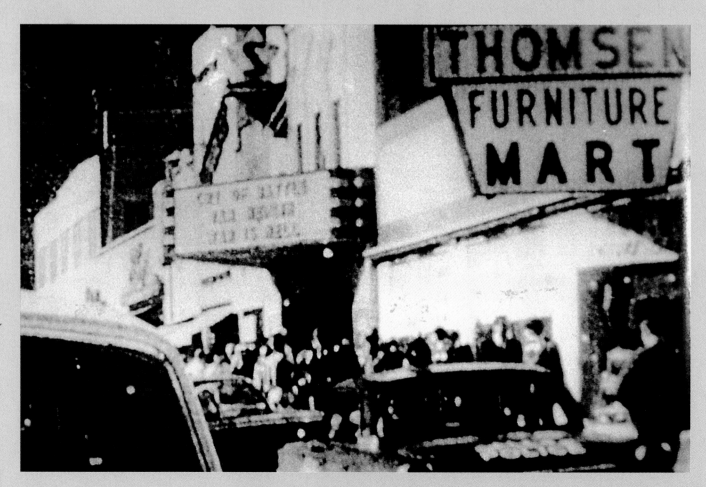

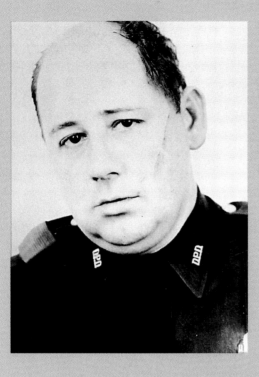

Left: Dallas Police Officer Maurice "Nick" McDonald, who scuffled with and arrested Lee.

Below: The .38 revolver alleged to have been taken from Lee at the Texas Theatre.

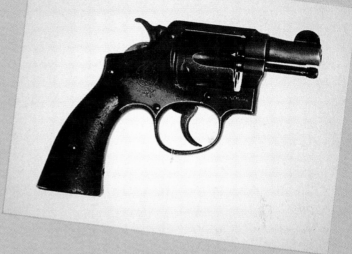

Below: Lee is wrestled to the ground, screaming, "I am not resisting arrest."

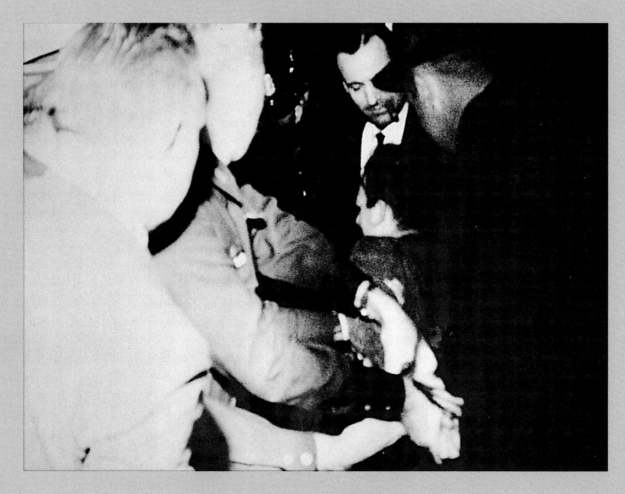

George Applin, who had been sitting six rows from the rear of the theater when the lights came on and the arrest began, testified in 1964, "There is one thing puzzling me. . . . And I don't even know if it has any bearing on the case, but there was one guy sitting in the back row right where I was standing at, and I said to him, I said, 'Buddy, you'd better move. There is a gun.' And he says—just sat there. He was back like this. Just like this. Just watching. . . . I don't think he could have seen the show. Just sitting there like this, just looking at me."

Applin told the Warren Commission that he didn't know who the man in the theater on November 22 was. But he did know who he was two days after the assassination. In 1979, he confessed to the *Dallas Morning News* that he in fact had recognized the man who had been in the theater as Jack Ruby. "I was afraid. . . . I'm a pretty nervous guy anyway. . . . after I saw that magazine where all those people had come up dead, it kind of made me keep a low profile. . . . Ruby was sitting down just watching them. And when Oswald pulled the gun and snapped it at [Officer McDonald's] head and missed and the darn thing wouldn't fire, that's when I tapped him [Ruby] on the shoulder and told him he had better move because those guns were waving around. He just turned around and looked at me. Then he turned around and started watching them."

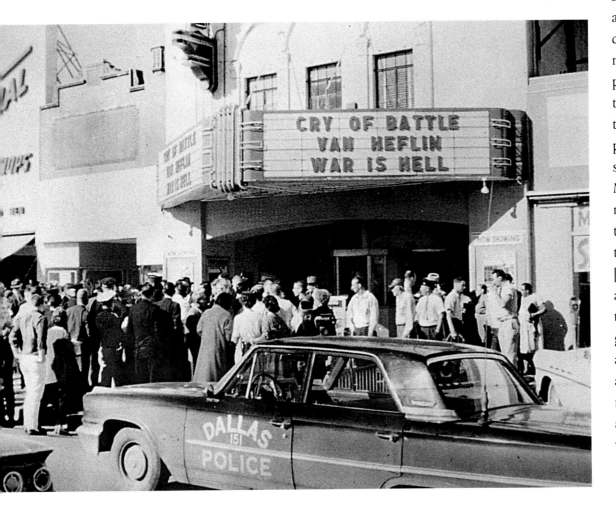

Above: **A crowd, attracted by the police cars, gathers in front of the theater.**

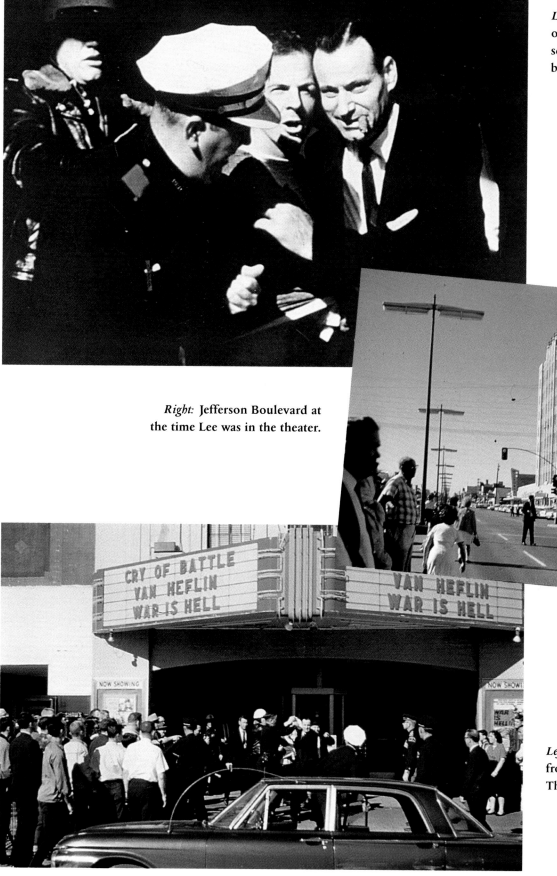

Left: Lee is dragged out of the theater, screaming, "Police brutality."

Right: Jefferson Boulevard at the time Lee was in the theater.

Left: Lee is pulled from the Texas Theatre.

Applin learned who Jack Ruby was when his picture was published two days after Lee's murder. Did Lee go to the Texas Theatre to meet Jack Ruby? Or someone else? Was he set up by a double who led the authorities to the theater? Was Lee supposed to be shot while trying to escape? By the police? Or by Ruby?

The official record reports that Lee entered the theater at 1:45 p.m. and that by 1:51 he was under arrest, was placed in the back seat of a police car, and was being driven to the police station on Main Street in downtown Dallas. He was fingerprinted by Lieutenant K. P. Knight, and formal arrest photos were taken.

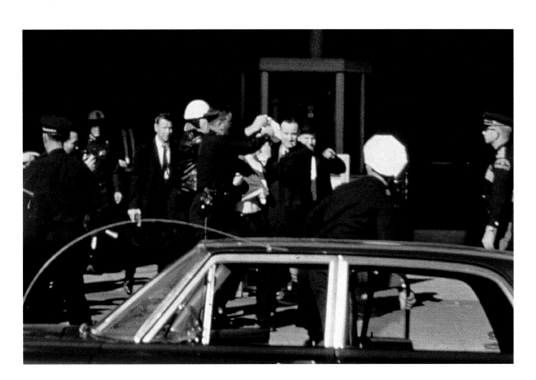

Left: Note the revolver, later said to be Lee's, in the hand of the detective, as Lee is dragged to the waiting police car.

Right: At least one policeman had already accused Lee of shooting the president, although there was no link between Lee and the assassination.

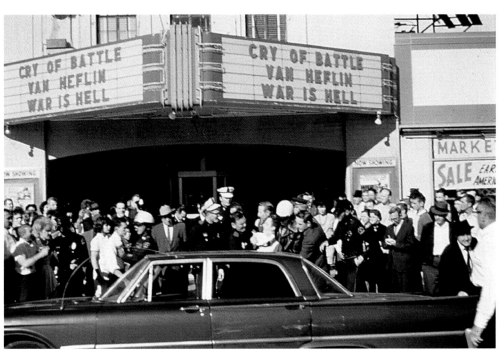

The original homicide report on the Tippit murder read, "Suspect was later arrested in the *balcony* [emphasis added] of the Texas Theatre at 231 W. Jefferson." This of course contradicts the fact that Lee was arrested in the downstairs section of the theater. The official police record indicates that there was only one "arrest" at the Texas Theatre, but that may not be true. There may have been a second, unreported arrest in which a second man was taken out the rear of the theater and into the alley behind it.

Bernard J. Haire, who owned Bernie's Hobby House, two doors east of the Texas Theatre, had not yet heard about the assassination when he noticed police cars and a crowd gathering in front of his store. He walked outside onto Jefferson Boulevard and was standing there when Lee was brought out of the theater but did not know what was happening and could not see because of the size of the crowd. Haire walked back through his store and out into the alley, which was also filled with police cars. He walked toward the theater, and when he reached the rear door, the police were bringing out a young white man who was dressed in a pullover shirt and slacks. The man was flushed, as though he had been in a struggle, and appeared to be under arrest. He was put into a police car, which drove off. For a quarter-century, Haire thought that he had witnessed the arrest of Lee Oswald in the alley. He was amazed when he learned that, upon his arrest, Lee had been taken out the front door. He now says, "I don't know who I saw arrested."

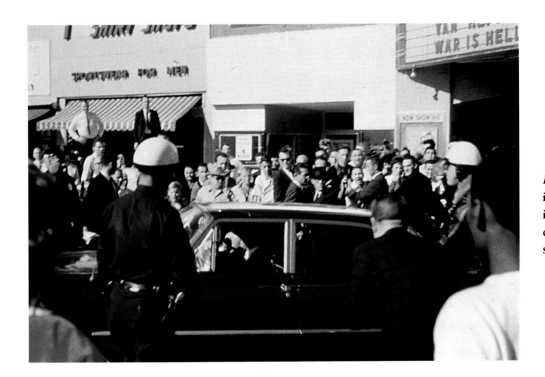

Left: Lee is shoved into the police car in front of the angry crowd. Then the car speeds away.

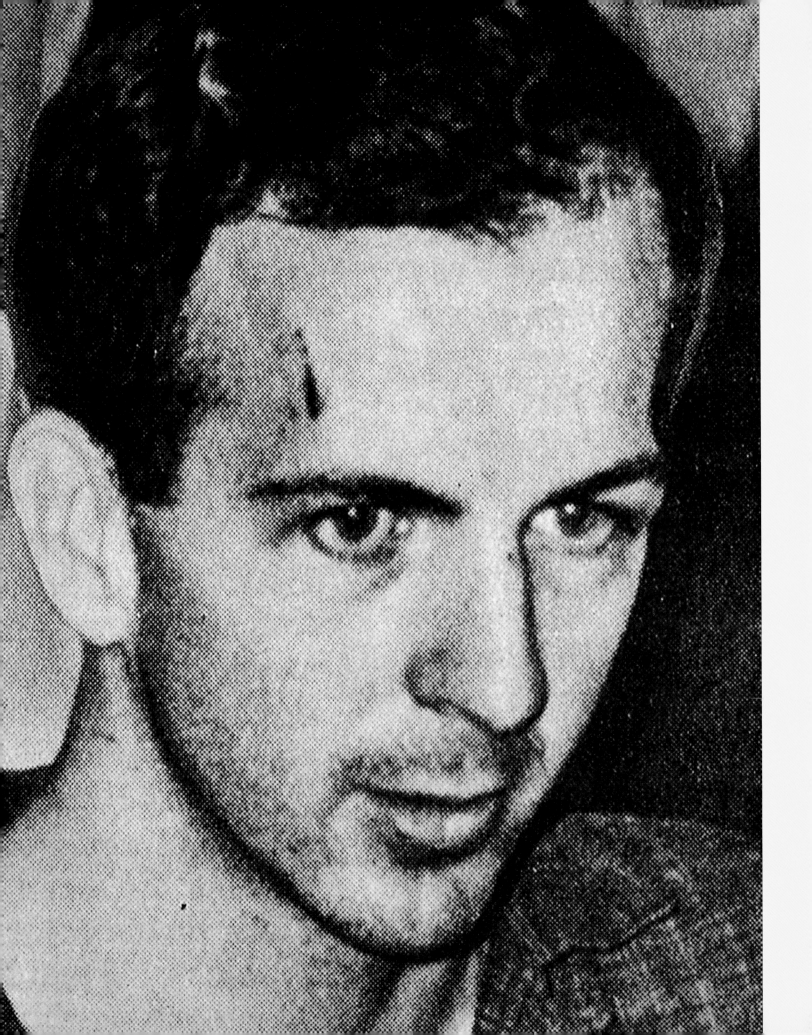

14

IN CUSTODY

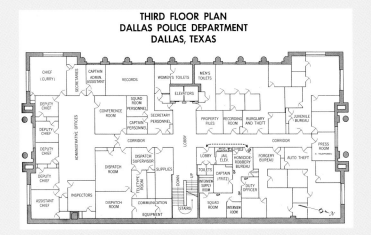

**THIRD FLOOR PLAN
DALLAS POLICE DEPARTMENT
DALLAS, TEXAS**

Above: **Third-floor plan of the Dallas police department. (Note the location of Captain Fritz's and Chief Curry's offices.)**

Left: **Lee Oswald under arrest.**

Interrogation

Between the time of his arrest on November 22 and his death on November 24, Lee Oswald was interrogated for a total of twelve hours. Captain Will Fritz, of the Homicide and Robbery Division of the police department, did the vast majority of the questioning. Officially, Fritz neither made nor kept any notes, and there were no stenographic or tape recordings made of the interrogation sessions. All we know of what Lee was alleged to have said has come from the recollections of those officials who were at the sessions.

From the moment of his arrest, Lee maintained that he hadn't shot anyone. He denied owning a rifle or storing weapons in Ruth and Michael Paine's garage. He said that he had seen Roy Truly showing some of his co-workers a rifle just a few days earlier. He admitted to owning a handgun but said that he had purchased it in Forth Worth.

He would not answer questions about the Alek J. Hidell I.D. card in his wallet and told Fritz, "You know as much about it as I do." Fritz said that Lee had told him he had started using the name Hidell while working in New Orleans the previous summer.

When asked which was his real name, Oswald or Hidell, Lee told a police officer, "You're the cop, you figure it out."

Oswald freely stated that he had rented post office box 2915 in Dallas, where the Mannlicher-Carcano rifle and the Smith & Wesson revolver were both allegedly shipped, but he stated that he (or Alek J. Hidell) had received no packages at the box. Questioned about box 30061 in New Orleans, he stated, "I don't know anything about that." He also declared that he never allowed anyone, except Marina, to have access to his post office boxes. When asked why he

Left: **Police Chief Jesse Curry, at his desk, concerned about his prisoner.**

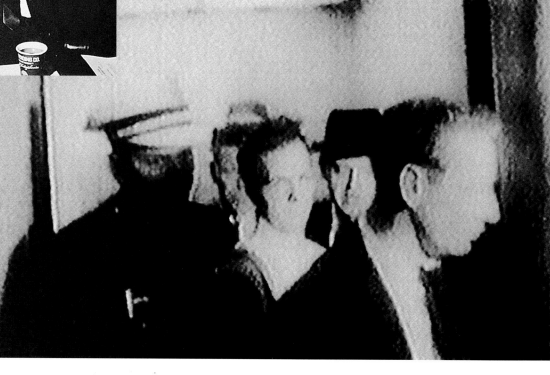

Right: **Lee arrives under arrest at the police station.**

Left: The first view most of the public got of the accused assassin.

Below: Oswald's lookalike and co-worker Billy Lovelady (seated) was at police headquarters for questioning in the assassination when Lee is led in.

Below Left: Lee, handcuffed and under arrest, at police headquarters.

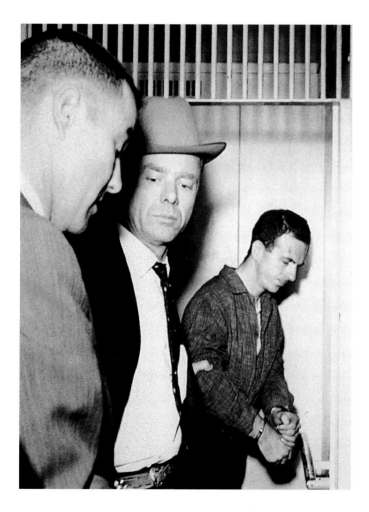

Below Right: The clock on the right reads 2:00 p.m. It has now been an hour and a half since the assassination.

had rented his room on North Beckley Avenue under the name O. H. Lee, he replied that his landlady, Gladys Johnson, had made a mistake on her records. He stated that he never told Buell Frazier anything about curtain rods and that the only bag he took to work with him on Friday morning was his lunch bag. He said that at the moment when President Kennedy was shot, he was eating his lunch in the depository lunchroom on the first floor. He spoke of the encounter with Roy Truly and Police Officer Marrion Baker about ninety seconds after the shooting on the second floor in the snackroom, stating that he had gone there to buy a bottle of Coca-Cola. He told the police that he walked out the front door of the depository and talked to co-worker Bill Shelley for five to ten minutes and that Shelley told him that there probably wasn't going to be any more work that day, so he went home. Shelley denied seeing Lee at all after the assassination, but he admitted to being in front of the depository building at the time Lee stated. Lee is supposed to have confirmed the story of the bus and cab rides that brought him to North Beckley Avenue on the day of the assassination. However, he said he went directly to the movies from the rooming house.

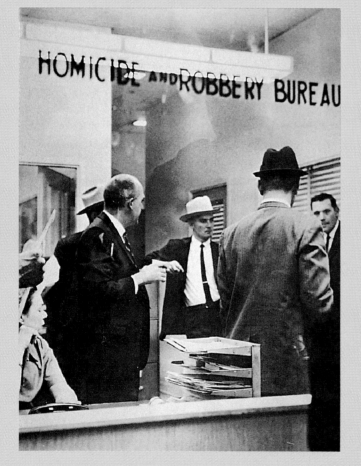

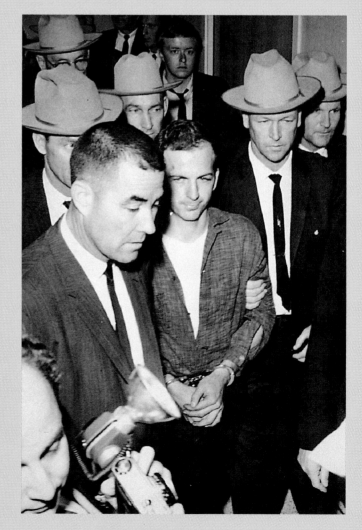

Left: **Deputy Sheriff Roger Craig in the Homicide Bureau the afternoon of the assassination.**

Right: **Lee in the police station hallway near the office of the Homicide Bureau.**

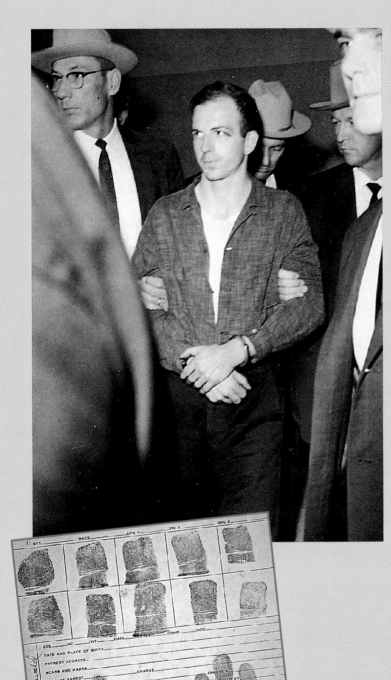

Left: Oswald in custody, waiting for legal representation which never came.

Right: The original arrest report on Lee Harvey Oswald for crimes against President Kennedy, Governor Connally, and Police Officer J. D. Tippit.

Above Left: Lee's fingerprint card. He refused to sign it.

Right: The only color booking photo of Oswald. He was booked after midnight, so the date is November 23.

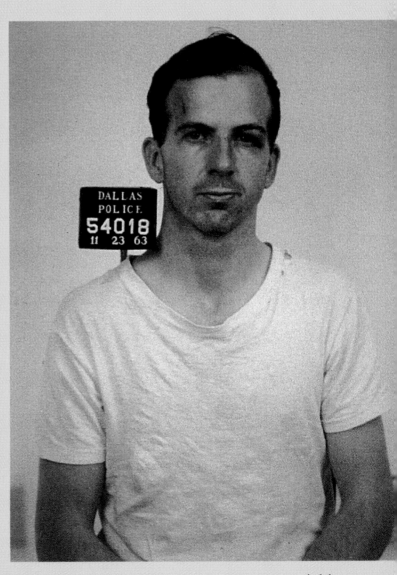

When asked his feelings about President Kennedy, Lee told the police, "My wife and I like the President's family. They are interesting people. I have my own views on the President's national policy. I have a right to express my views but because of the charges I do not think I should comment further. I am not a malcontent; nothing irritated me about the President." (Warren Report)

Lee remained relatively unflustered through the twelve hours of on-and-off interrogation, except when FBI Agent James Hosty joined the proceedings. At that time, Lee showed that he was visibly upset at Hosty, and he accused him of accosting Marina.

On Saturday, November 23, and again on the morning of the twenty-fourth, Lee was shown a copy of a photograph apparently of himself holding a rifle and wearing a handgun in a holster on his right hip. He told Captain Fritz and the others who were present that the photograph was a forgery. He further stated that he had been photographed several times the day before by the police and that the photograph was a composite. He asked to have John J. Abt, a New York City attorney known for handling political conspiracy cases, represent him. He was permitted to call Abt, but Abt was away and unavailable over the weekend. During his time in custody, no lawyer was present on behalf of Lee Oswald, and he died Sunday morning without having had legal representation.

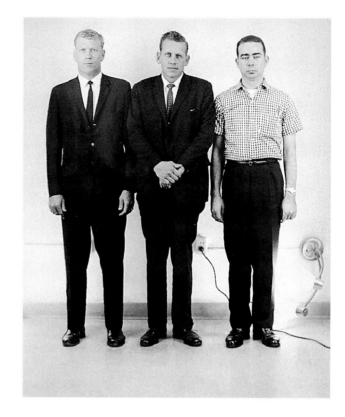

Above: **The men who stood in one of the line-ups with Lee. Lee was the only one wearing a torn T-shirt and was the only one with a long, deep gash on his forehead. He stuck out like a sore thumb.**

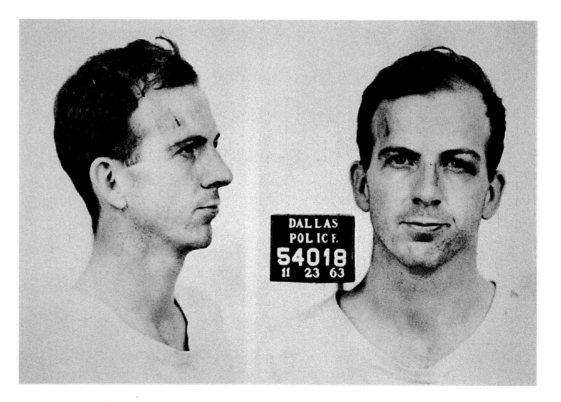

Right: **The mug shots for prisoner #54018. Lee was first booked for killing Officer Tippit, and then later charged with murdering President Kennedy.**

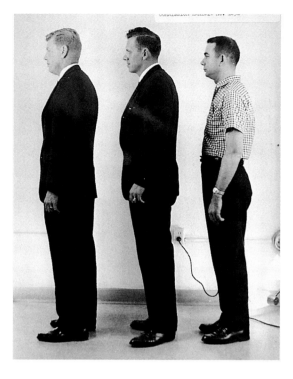

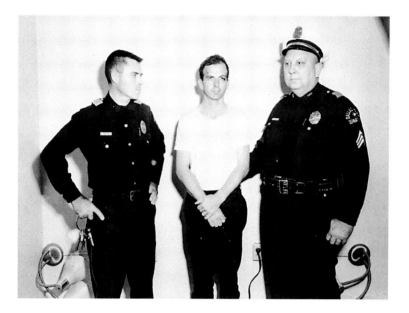

Below: Lee is posed for a photograph with Sergeant W. F. Warren and Officer T. V. Todd before processing.

Above Left: Some of the line-up men. A blind man could have picked Lee from this group, and he protested.

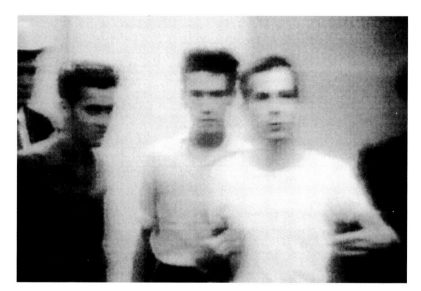

Left: Lee protesting being put in a line-up with just a T-shirt on. He asks for a clean shirt. He was not given one.

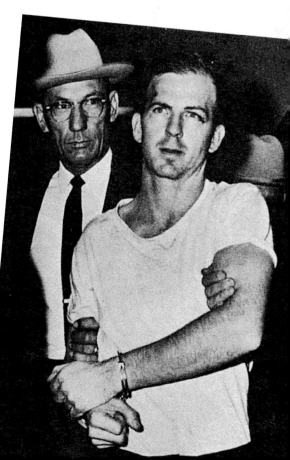

Left: Lee shouts, "I'm just a patsy."

Right: Lee was frequently handcuffed and was even denied the right to take a shower or change his shirt.

The Evidence

Lee was given a paraffin test on the night of November 22 to reveal whether he had fired either a rifle or a handgun during the twenty-four hours prior to the test. We are told that the results were positive for his hands but *negative for his cheeks*. When a rifle is fired, the gunpowder of the bullet leaves a pattern of nitrate deposits on the face, notably the cheek, of the marksman. If Lee had fired the rifle but then washed his face, the nitrate residue might have been washed off both his hands and his face. However, since it is virtually impossible to wash your face without using your hands, and Lee's hands tested positive, it is highly unlikely that he had fired a rifle on the day of the assassination. Traces of nitrates could have been left on his hands if he had not washed them after urinating. A positive result could also have been caused by ink from the book cartons he had been handling all morning. Since the results did not prove Lee's guilt but, rather, pointed to his innocence, the Warren Report said the test was unreliable.

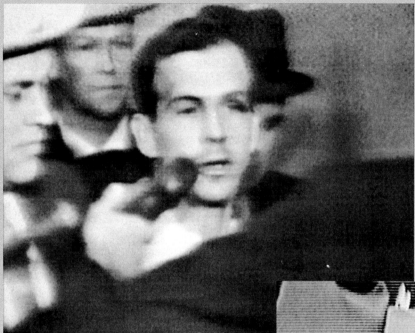

Left: Lee angrily states, "They've brought me in because I lived in the Soviet Union."

Right: Lee protesting his treatment. Compared to the detectives, he appears to be quite small in stature.

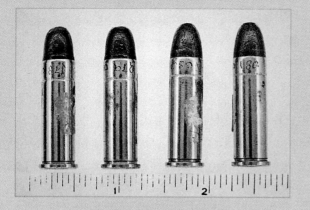

Above: Four bullets were removed from Lee's revolver after his arrest.

Below Right: The result of the paraffin test on Lee's cheeks shows that he did not fire a rifle that day. Meanwhile it can be shown that the positive test results for his hands could have been caused by the materials at his workplace.

Ex.# 2, left hand, paraffin cast showing nitrates.

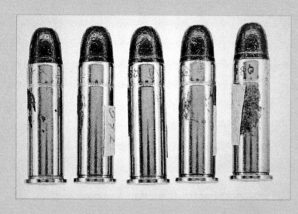

Above: Five .38 special bullets were found in Lee's pants pocket. Why would he have left two chambers in the revolver empty?

Below: Following the arrest, the police went to Ruth Paine's house to search it. They found the blanket that had supposedly been used to wrap a rifle and the backyard photographs.

Left: The blanket that the police claimed was used to store a rifle.

While Lee was alive, no fingerprints were found on the Mannlicher-Carcano rifle, though the police and the FBI both tested it. After Lee was murdered, the authorities brought the Mannlicher-Carcano to the funeral parlor where his body was being prepared for viewing. They requested that they be left alone with the body and were granted as much time as they wanted. Only after this visit was one of Lee's palm prints found on the rifle. The print was located on a part of the weapon that could only have been touched when the Carcano was disassembled. Lieutenant Carl Day, who was in charge of the fingerprint evidence, stated "that this print had been on the gun several weeks or months." If we concede that the print was legitimate in the first place, it only shows that Lee had touched the disassembled rifle at one time since it had arrived in Dallas on March 20. Given the funeral home visit, even that is in question. None of the bullet shells had a fingerprint; neither did the unfired bullet found in the rifle.

At 7:30 on the morning after the Kennedy assassination, a snub-nosed .38 Smith & Wesson revolver, serial number 893265, with the word "England" stamped on the cylinder, was found in a brown paper bag on or near the grassy knoll, described in a suppressed FBI memo as "in the general area of where the assassination of President Kennedy took place." The revolver was the same make and caliber as the handgun alleged to have been found in Lee's possession when he was arrested. The discovery of a second gun at the scene of the assassination was withheld from the public for more than thirty years, and the results of the FBI's investigation of the weapon still have not been released.

Above Left: **The original report and evidence showed that two, not three, empty rifle bullet shells were found on the sixth floor.**

Right: **Some of the possessions belonging to Lee found by the police at the Paine house on display on the floor at the police station. Note the large number of Russian-language books and pamphlets.**

Right: Among Oswald's possessions were more personal items. Note the photo of Major-General Walker's home carefully placed in the foreground. Note also that the license plate of the car in the photo has not yet been punched out.

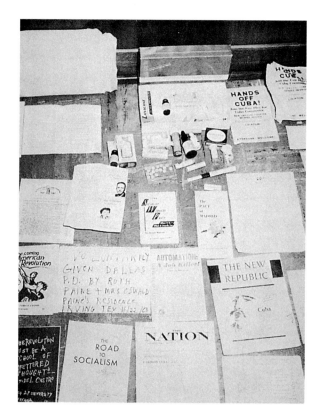

Above Left: More of Lee's possessions taken from the Paine home.

Below: Marina and Marguerite arrive at the police station.

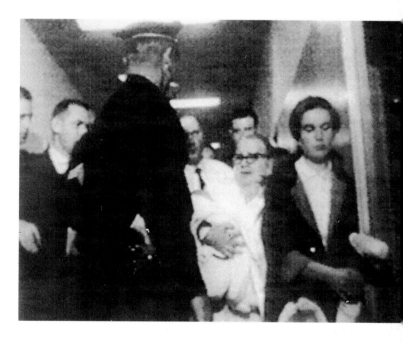

Above Left: Additional personal effects of Oswald's.

Right: Marina and Marguerite at the police station elevator, waiting to see Lee.

Lee was arraigned for the Tippit killing at 7:10 p.m. Friday, November 22, 1963, and for the assassination of President Kennedy at 1:35 a.m. on November 23. Both arraignments were before Judge David Johnston. The Dallas police station was in a state of utter confusion while Lee Oswald was a prisoner there. It was packed wall to wall with reporters and television and radio crews from around the world who directed inquiries to Lee whenever he appeared in the hallway as he was taken from one part of the building to another. He told the reporters and film crews that he hadn't shot anybody, that he was just a patsy, and he asked for someone to step forward and give him legal assistance. No one did. But waiting in the crowd throughout the entire weekend was Jack Ruby, who was carrying a Colt revolver in his pocket.

Below: **Marina, holding Rachel, and Marguerite.**

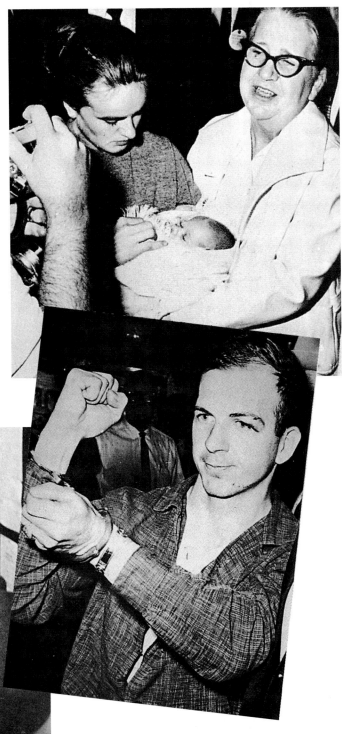

Below: **The prisoner, on one of many trips through the corridors of the police station.**

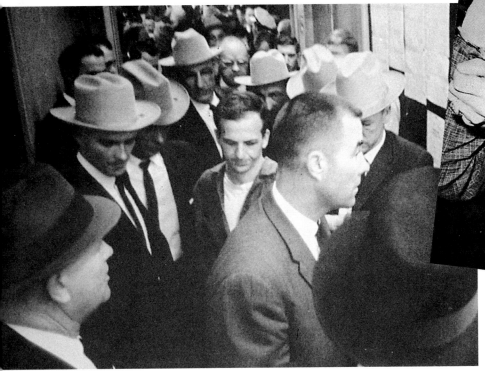

Above Right: **Lee is showing his handcuffs to reporters as the result of a question. Later, this would be referred to as a communist salute of solidarity by the press all over the world.**

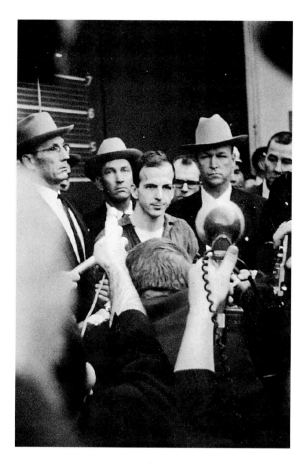

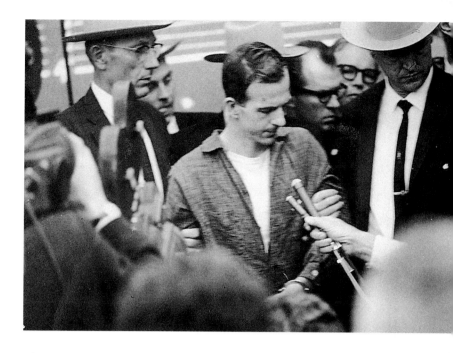

Above Right: Lee also stated for the record that he didn't shoot anyone.

Above Left: Lee meets the press at the "midnight press conference" where he declared his innocence and asked for legal help.

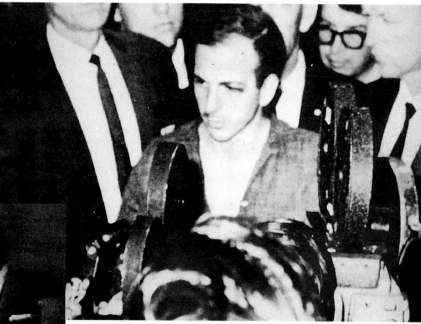

Above: Lee answers questions from reporters. Representatives of media organizations from around the world were present at the conference.

Left: Jack Ruby, top right, at the police station, Friday night, corrected D.A. Henry Wade when Wade stated that Lee had been a member of the Free Cuba Committee. Ruby called out the correct name, the Fair Play for Cuba Committee.

15
"SPARKY"

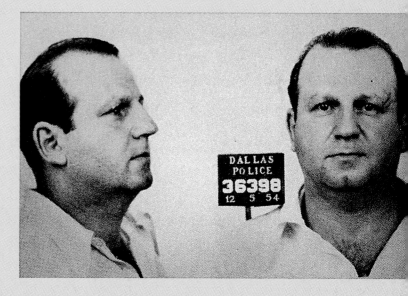

Above: Mug shots of Ruby from a 1954 arrest.

Chicago

Jack Ruby was born Jacob Rubenstein on or around March 25, 1911, in Chicago, Illinois, the fifth of eight children. His parents, Joseph and Fanny, were Orthodox Jews and quite poor. They were forced to move several times during Jacob's youth, always within the downtrodden, predominantly Jewish neighborhoods around Maxwell Street. Joe Rubenstein and his wife argued constantly and separated in 1921 when Jacob was ten.

At school, Jacob was ridiculed and picked on. Like Lee Oswald, he was a truant who preferred hanging around the streets of Chicago to facing his schoolmates. He failed and had to repeat the third grade. He never did finish school; Chicago school records show that he completed only through the sixth grade, while he himself said he had stayed through the eighth.

Left: Jack Ruby relaxes in his office with two of the strippers who worked at the Carousel Club.

Fanny Rubenstein had a long history of mental problems. In 1923, when he was twelve, Jacob and three of his siblings were removed from home and put into foster care by a Chicago juvenile court. Ruby recalled being in foster homes for as much as five years. When he was finally returned to his mother, he was a full-fledged hoodlum and, according to his brother Earl, "stronger than any professional fighter." As a teenager, Sparky (so named for his quick temper) terrorized his neighborhood but managed, somehow, to avoid too much involvement with the police. When he was twenty-six, in 1937, Fanny Rubenstein was finally committed to a mental institution.

Seeking his fortune, Jacob moved to California in 1933, first to Los Angeles and then to San Francisco. While he was in San Francisco, he fell in love with Virginia Belasco, but they eventually split up. In fact, Jacob found little success in California and, finally, returned to Chicago.

Ruby and the Mob

Ruby grew up around some of the most infamous mob figures in history. In his youth, he and his close friend Beryl David Rossofsky (who changed his name and became boxing champ Barney Ross) ran numbers for Al "Scarface" Capone, Frank "The Enforcer" Nitti, and Jake "Greasy Thumb" Guzik. Before he was a teenager, he was scalping sports tickets on the streets and to school friends.

In 1937 he became involved as an organizer and negotiator with Local 20467 of the Scrap Iron and Junk Handler's Union. He had been friends with Leon Cooke, the union's financial secretary. In December 1939, Cooke was shot. He died of his wounds the following month, and organized crime moved in and took over the union. Cooke had been one of the few opponents to this move, and when he was killed, it opened the door for the mob. When they came in, they forced Jacob out.

By 1941, Jacob's poor fortune had not changed. He and his brother Earl started the Spartan Novelty Company, which also soon failed. As World War II began, he and some of his other Jewish friends did their part by breaking up meetings of the anti-Semitic fifth columnists of the pro-Nazi German American Bund.

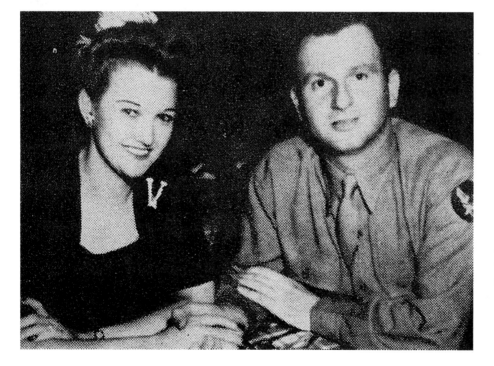

Left: **On leave from the air force, Jack relaxes with a friend in 1944.**

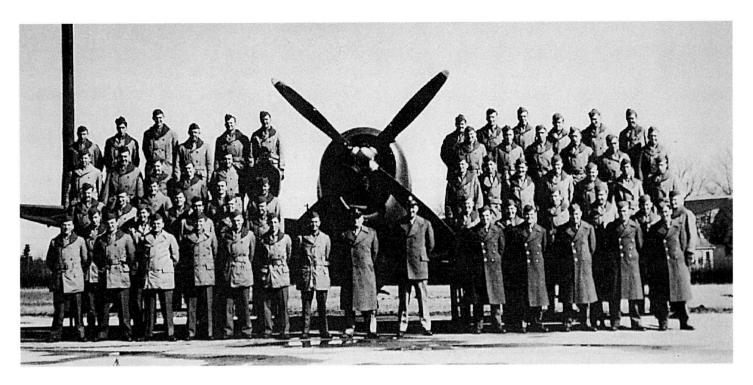

Above: Jack, front row, second from left, with his Army Air Force unit.

Left: Ruby was the manager for a young dancer, Ben Estes Nelson, who billed himself as Little Daddy.

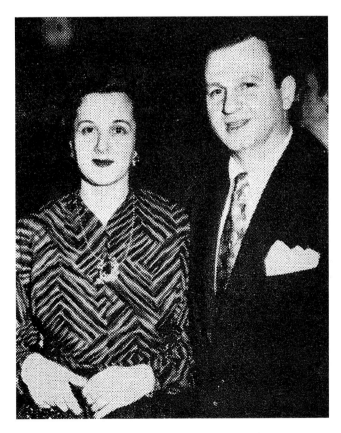

Above: Jack and his sister, Eva Grant.

Jack was not a very large man—5'9" and around 175 pounds—but he took meticulous care of himself. He was the 1940s equivalent of what would be called a health nut today.

Originally deferred from military service in 1941, he was reclassified 1-A in 1943. When he was thirty-two years old he was drafted into the 300th Army Air Force Base Unit and made private first class. He counted several fellow servicemen among his friends.

An anti-Semitic sergeant once made the mistake of calling him a Jew bastard, and Jack kicked the living daylights out of him. Despite this, he was honorably discharged on February 21, 1946. He returned to Chicago, where he became a partner in Earl Products with his brothers, Earl and Sam, selling small novelty items. He had several disagreements with his brothers, and they bought out his share in Earl Products for $14,000. He decided to go to Dallas, where his sister, Eva Grant, had moved in 1945. Eva had opened the Singapore Supper Club, and he would help her manage it.

On December 30, 1947, in Dallas, Jacob Rubenstein legally changed his name to Jack Leon Ruby, the middle name borrowed from his friend the late Leon Cooke. Life was no easier for Jack in Dallas. He tried and failed at several business ventures, including owning shares in a half-dozen nightclubs controlled largely by the Chicago underworld, the last of which was the Carousel Club, the only one to show a profit. Jack had a nervous breakdown in 1952, apparently caused by severe financial problems. His brother Sam lent him $5,500 to pay off a tax debt.

Jack continued to work with and for the Chicago underworld. He was friends with Jimmy Weisberg and Paul "Needle-Nose" Labriola, two gunmen who worked for Sam Giancana and who ended up as fatalities in two gruesome gangland murders. Their decapitated bodies were discovered stuffed in the trunk of a car. Sparky also had friends in Johnny Roselli's gang in Las Vegas and Mickey Cohen's in Hollywood.

Jack's capacity for violence was prodigious. He hit a musician with brass knuckles, punched out the teeth of a second, and gave another a concussion with a blackjack. In a fight with an

Right: An early version of Ruby's business card from the Carousel Club.

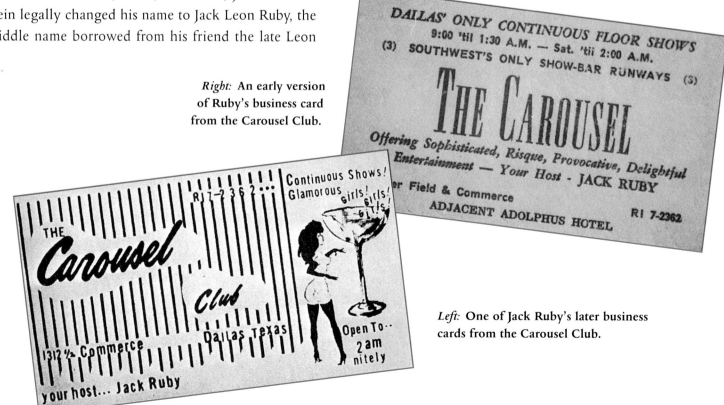

Left: One of Jack Ruby's later business cards from the Carousel Club.

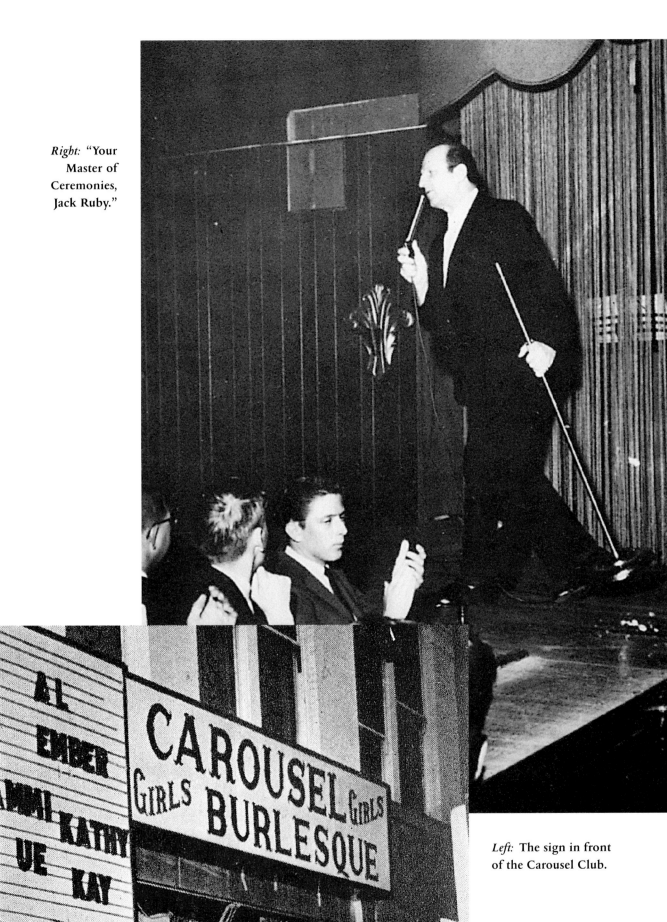

Right: "Your Master of Ceremonies, Jack Ruby."

Left: The sign in front of the Carousel Club.

employee, the tip of his left index finger was bitten off. A cigarette girl pressed him for fifty dollars in back salary and Jack told her he would throw her down the stairs of the Carousel Club if she didn't drop the subject. On more than two dozen occasions he attacked his own customers; his methods for doing so included pistol whippings and other gunplay. He once shot at another club owner.

Jack was well connected. He was personally acquainted with hundreds of Dallas law enforcement personnel; the Colt revolver with which he shot Lee was bought for him by Dallas Police Officer Joe Cody. He was friends, in Dallas and elsewhere, with a broad spectrum of the criminal element, including Lewis J. McWillie, Joe Bonds, Paul Roland Jones, Joe Campisi, and many others.

Ruby's connections to Sam Giancana, Johnny Roselli, Santos Trafficante, and Carlos Marcello were ignored by the Warren Commission. The members of the House Assassinations Committee knew that if anyone could expose his mob connections it would be Sam Giancana and Johnny Roselli, and so they were subpoenaed. Just before he was going to testify before the House Select Committee, Giancana was shot to death while cooking dinner in his apartment in Chicago. Roselli, who had already angered his mob cohorts for leaking details about Mafia involvement in the Bay of Pigs operation and assassination attempts against Fidel

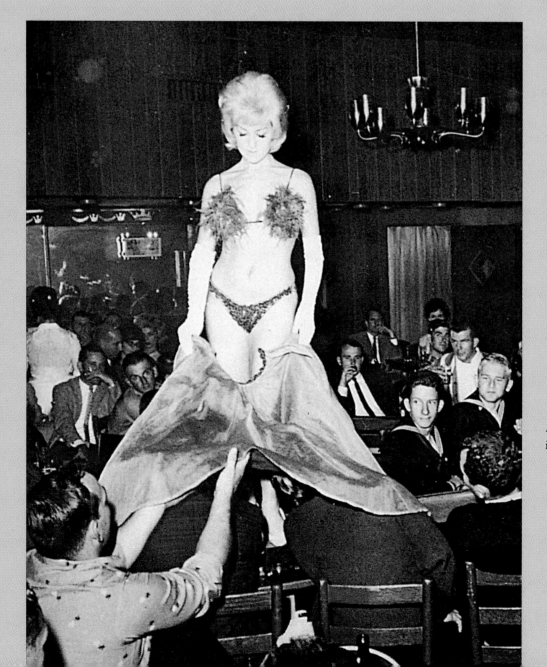

Left: **A stripper at work in the Carousel Club.**

Castro to journalist Jack Anderson, was found dismembered and floating in an oil drum off the coast of Florida in July 1976. Journalist Seth Kantor has observed that in Ruby's universe the guilty never reach trial. Key witnesses are regularly eliminated before they get a chance to testify. It should be noted that more than 300 witnesses in the Kennedy assassination investigation are now dead. The vast majority of these deaths were violent or highly questionable. (See the mysterious death project boxes in *The Killing of a President*.)

Johnny Roselli had referred to Jack Ruby as "one of our boys" and declared that Ruby had killed Lee Oswald to silence him. In the fall of 1963, Ruby met at least twice with Roselli in Miami, and it is believed that they may have known each other as early as 1933 in Los Angeles, California. (David Scheim, *Contract on America*, 1988)

Jimmy Hoffa, another mob-connected figure in Ruby's life, met a similarly untimely end. A few days before the assassination of President Kennedy, Ruby was in contact with at least two ranking men from Hoffa's inner circle, bodyguard Barney Barker and Murray "Dusty" Miller (who years later served as labor coordinator for George Bush's 1970 Texas senatorial race). Jack was out of money and facing labor problems in the autumn of 1963, and he may have been seeking assistance from his Teamster Union friends. The House Committee never got its opportunity to

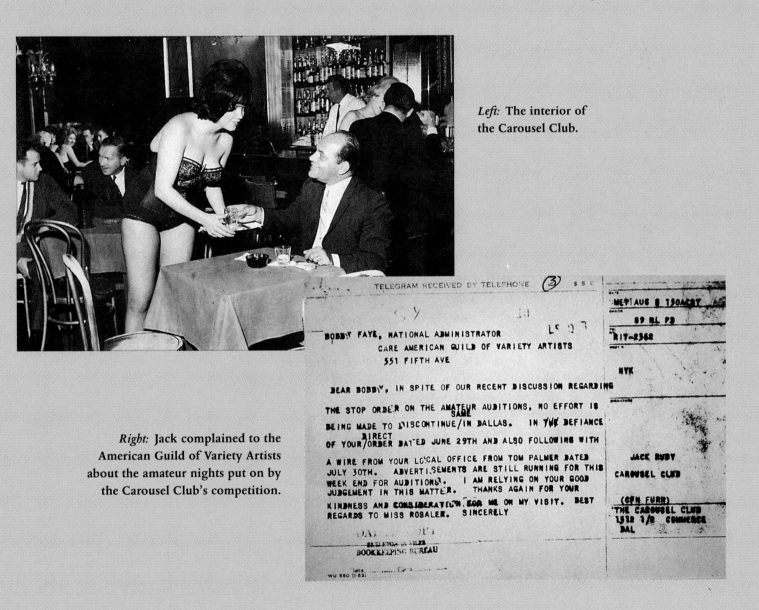

Left: The interior of the Carousel Club.

Right: Jack complained to the American Guild of Variety Artists about the amateur nights put on by the Carousel Club's competition.

speak to Hoffa; by the time hearings began, he had disappeared.

The underworld leaders Jack Ruby was most closely connected with were Santos Trafficante and Carlos Marcello, who ran all of the narcotics and gambling interests in the Southeast. When procuring strippers for the Carousel Club, Ruby engaged women from New Orleans clubs controlled by Marcello. Three weeks prior to the assassination, Ruby telephoned Nofio Pecora in New Orleans. Pecora was one of Marcello's lieutenants. Ruby might have been trying to contact Harold Tannenbaum, a club owner, who had been using Pecora's phone. Tannenbaum's club was also controlled by Marcello.

Ruby must surely have felt the control of Carlos Marcello in Dallas, where Marcello also controlled gambling and narcotics. A close Marcello associate, Joe Campisi, managed the business in Texas for Marcello. Ruby ate at Campisi's Egyptian restaurant on Mockingbird Lane in Dallas on many occasions. Campisi was one of the first visitors Ruby received in jail after his arrest for the Oswald shooting.

One of Ruby's closest friends was Lewis McWillie, who worked for both Havana gambler Norman "Roughhouse" Rothman and Santos Trafficante at the Tropicana before Castro came to power. McWillie and Ruby were close friends of Pat Kirkwood, who owned The Cellar, the nightclub where practically the entire Secret Service contingent assigned to protect the president had partied throughout the night prior to the assassination. (One can only wonder who picked up the tab for the party.)

Immediately following the Cuban revolution, Castro threw Trafficante in jail. Trafficante was, of course, severely angered by this. As was the case with most of the mob leaders, he had made a fortune by playing both ends against the middle selling arms to both Castro's and Cuban President Fulgencio Batista y Zaldívar's armies. Castro was aware of this. He wisely mistrusted Trafficante and incarcerated him in the minimum security prison at Trescornia, Cuba. Trafficante received visits from underlings Johnny Roselli, Sam Giancana, and Jack Ruby while there. Ruby seems to have was made so many

Left: **The Marsala Apartments on South Ewing, where Jack Ruby lived.**

trips to Cuba at this time that the House Assassinations Committee determined he had probably been working as a courier for the Trafficante organization. (Report of the House Select Committe on Assassinations)

Prior to shooting Lee Oswald, Ruby was arrested nine times during his fourteen years in Dallas. The offenses included assault, carrying concealed weapons, and disturbing the peace.

Like Trafficante, Ruby also played both ends against the middle. Apart from his friends in the police department and in the mob, he was also a paid informer for the FBI in 1959. He made contact with them on nine occasions between March 11 and October 2 of that year. This alone could easily have gotten him killed if it had been discovered by his mob associates. J. Edgar Hoover personally asked the Warren Commission to keep the FBI's connection with Ruby a secret. Once again, the Warren Commission suppressed evidence. They honored Hoover's request at the expense of another strong lead to the conspiracy.

Above: Jack and his beloved dogs. Sheba, on the left, was left in his unlocked car when Jack shot Lee.

Right: The bedroom in Jack's apartment.

Ruby's Problems

Up to the time of the assassination, Ruby was living with a roommate, George Senator, at 323 South Ewing Street in the Oak Cliff section of Dallas. He was in a financial vise. The corrupt American Guild of Variety Artists (AGVA) was apparently taking payoffs from his competition, Abe and Barney Weinstein, the owners of the Colony and Theater Clubs, to look the other way and allow the Weinsteins to have amateur strippers work along with professional union strippers. This was a clear violation of the union's rules and it was hurting the Carousel Club. Jack was furious at both the Weinsteins and AGVA. At the time of the assassination, Jack owed the IRS $40,000. He was in desperate need of money and needed favors from the mob in his fight with AGVA.

Was the mob involved in the assassinations of President John F. Kennedy and Lee Harvey Oswald? In all probability, yes. Most investigators and the leadership of the House Assassinations Committee believed that they were, as do the majority of experts on the assassination. But the mob could not have done it alone. There had to be help from some organization with the power and influence to continue the cover-up for more than three decades.

On November 20, 1963, *two days before* the assassination, thirty-one-year-old Melba Christine Marcades, whose professional name was Rose Cheramie, was pushed out of a moving 1957 two-tone Ford onto Route 190 near Eunice, Louisiana. Bruised, disoriented, and lucky to be alive, she was found by the side of the road and taken to a small hospital in Eunice, where she was briefly treated. Since she had "no financial basis," she was soon to be released. She appeared to be under the influence of drugs when admitted, and Louisiana State Police Lieutenant Francis Fruge was called. He took her to a jail cell to "sober up." She had been a nine-year mainlining heroin addict, and her last heroin fix had been at 2:00 p.m. When she started to display severe symptoms of drug withdrawal, Fruge called a doctor, who sedated her.

On November 21, Fruge took her to East Louisiana State Hospital, where Lee Oswald had applied for a job less than three months before. During the one- to two-hour ride, Fruge questioned Cheramie, who told him that she was going to Dallas to pick up some money, pick up her baby, and kill President Kennedy.

She was formally admitted to the hospital at 6:00 a.m. and diagnosed as being in heroin withdrawal and in clinical shock. The following day she began sobbing and was quite agitated. She told her doctors that she had been thrown out of the car by two Latino men who worked for her boss, a man by the name of Jack Ruby, a nightclub owner from Dallas. Ruby had sent her from Dallas to Miami to pick up a shipment of narcotics to be taken to Houston after the pick-up. A hospital attendant asked her why

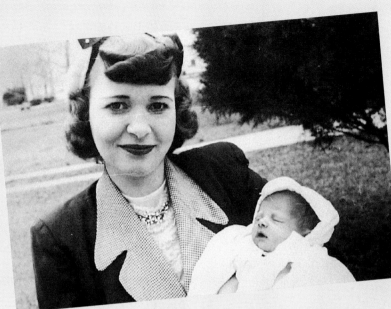

Above: **Rose Cheramie in younger, better days.**

she had been thrown from the car, and she replied that she didn't mind transporting narcotics but that she drew the line at murder. The attendant kept notes of his questioning. Cheramie told him that the president was going to be killed in Dallas within a few days.

When Fruge heard about the assassination, he called the hospital and told them not to release Cheramie until he arrived and could speak to her. The following Monday, Cheramie told Fruge that the two men who had traveled with her from Miami were going to Dallas to kill the president. Upon seeing a newspaper article stating that Ruby was quoted as saying that he had never known Oswald, she began to laugh and told Fruge that Ruby and Lee Oswald had known each other well. She told him that she had seen Lee in Jack's nightclub.

The story of Rose Cheramie stayed buried and didn't surface until the time of the Garrison investigation, but by that time it was far too late. On September 4, 1965, Cheramie was hit and killed by a car on the eastbound side of a highway between Texas and Louisiana near Big Sandy, Texas. The driver of the car told the police that she had been lying on the highway and that, in swerving to avoid hitting her, he ran over her head. Her autopsy revealed that she had a "deep punctate stellate" wound in her right forehead. In all probability, it was a gunshot wound. It is almost beyond question that the unidentified driver ran over her in an attempt to obliterate the preexisting wound in her head, the real cause of her death. Although the official records show that she was dead on arrival, hospital records show that she was on the operating table for eight hours after she was brought in.

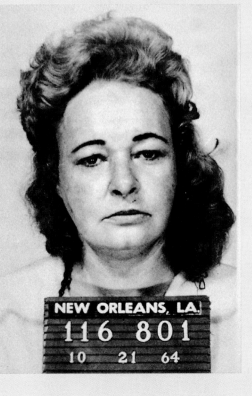

Left: **Rose Cheramie's mug shots from an arrest on October 21, 1964, one year after the assassination.**

Left: Ruby reached Lee and was about to pull the trigger of his revolver.

16

THE MURDER OF
LEE HARVEY OSWALD

On the day of the Kennedy assassination, Jack Ruby, according to his own recounting of the day's events, had gone to the *Dallas Morning News* to place his regular advertisement for the Carousel Club at approximately 11:10 A.M. Sometime around noon, he ran into a *News* employee and friend named John Newnam and talked to him for a few minutes. Thereafter he noticed several people assembled in front of a television set and joined them. He then learned of the assassination.

Left: The black-bordered newspaper advertisement that allegedly infuriated Jack Ruby. Bernard Weissman (below) was the person who commissioned the advertisement that questioned Kennedy administration policy.

According to his own statements, Ruby proceeded to go home and to call his sister Eva at her home. He related that, on telling her the news, she became hysterical. He told her that while he had been at the newspaper office, the phone was ringing constantly because people were complaining that the *Dallas Morning News* should not have run a black-bordered anti-Kennedy ad that had been placed in the newspaper that morning prior to the assassination. He said that John Newnam, whom Eva evidently also knew, agreed that the News should not have run the ad but said that his superiors had made the decision and that there was nothing to be done about it. Jack then called Andrew Armstrong Jr., the handyman at the Carousel Club, to tell him that he would soon be there. He then supposedly drove to the Carousel Club.

When Ruby arrived at the club, he told Armstrong to call the rest of the employees to tell them that they wouldn't be opening the club that night. He then returned to his sister Eva's, where he telephoned the Morning News composing room and instructed them to change his ad to announce the closing.

There is evidence that Jack Ruby went to Parkland Hospital instead of directly to his club on the day of the assassination. One of the best books about Ruby is Seth Kantor's *The Ruby Cover-up* (1978). Kantor worked for Scripps-Howard in Dallas in the early 1960s and had contacts among Dallas police as well as with local mobsters. He and Jack Ruby had a conversation at Parkland Hospital soon after the shooting. They discussed whether or not Jack should close the Carousel Club out of respect for the president. Kantor told Ruby that it would be a nice gesture to do so. He again spoke with Ruby at a press conference held by Dallas District Attorney Henry Wade, during which Jack corrected Wade when he referred to the Fair Play for Cuba Committee as the Free Cuba Committee. Kantor was also in the police department basement when Ruby shot Oswald. He testified about all of this to the Warren Commission, which made little of the revelations.

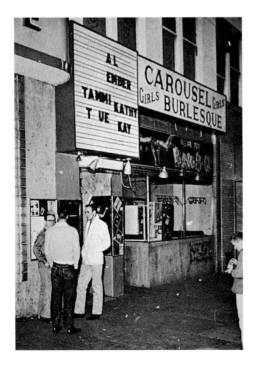

Left: **Jack Ruby's Carousel Club.**

Above: **Jack closed the club on the night of the assassination in deference to the president.**

Ruby called his synagogue and asked what time the evening Sabbath services were to start; he was told that there would be a special memorial service for President Kennedy that night. He went home to dress, arrived late for the service, but stayed afterward and spoke to Rabbi Hillel Silverman for a few moments. After the fact, friends and relatives noted that he expressed his sorrow about the death of President Kennedy.

At 11:15 p.m. he went to Phil's Delicatessen and told the counterman to make up sandwiches. While he waited, he called homicide detective Richard M. Sims at police headquarters and asked if he wanted a sandwich. Sims said they were winding everything up for the night.

Ruby went to the police station around midnight, took the elevator to the second or third floor, and asked some policemen if they had seen KLIF radio broadcaster Joe Long, whom he knew. As he stood in a hallway, Lee Oswald was brought out of a room. Jack later claimed that it was the first time he had ever seen Lee. "I don't recall if he was with [Police] Captain [Will] Fritz or [Police] Chief [Jesse] Curry or both," he added.

Rumors that Lee was being mistreated had been started by members of the press. Curry, wanting to show the world that Lee was alive and well, had arranged for the press to see him in a hallway around midnight of the day of the assassination. This was intended not as a press conference but as a viewing of the prisoner. When he was presented, several reporters asked if there was a roomier place they could gather. The authorities said they could go down to the assembly room in the basement. There Lee made his first post-assassination statement to the press. "Did you shoot the President?" he was asked. "I didn't shoot anybody, no sir!" he replied. All the while, Jack Ruby was hovering in the background.

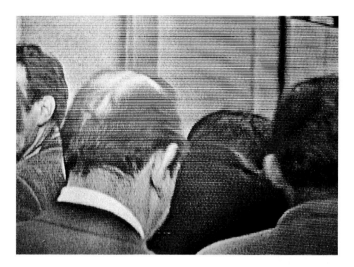

Above: **The back of Ruby's head as he walks through the hallway of the police station on Friday night.**

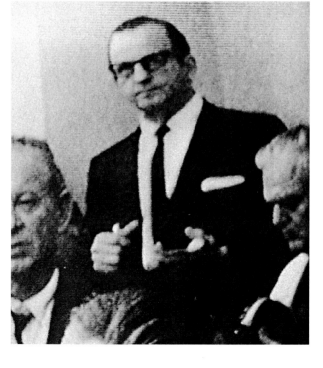

Left: **At a press conference on Friday night, Jack corrected District Attorney Henry Wade when he said that Lee was a member of the Free Cuba Committee, not the Fair Play for Cuba Committee. How did Ruby know what group Lee had belonged to?**

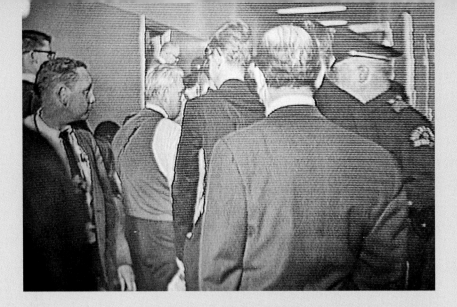

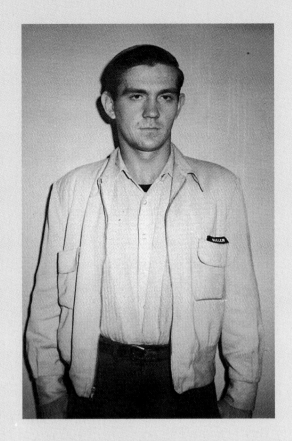

Above: Ruby was so well known to the press and the police that no one questioned what he was doing at the police station.

Above: The handyman at the Carousel Club was drifter Curtis LaVerne "Larry" Crafard.

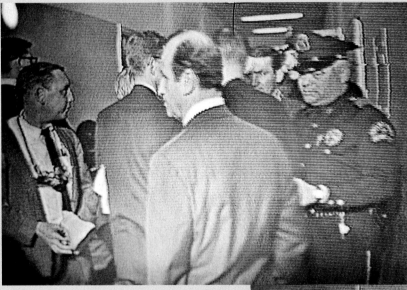

Above: Jack had been stalking Lee since Friday night, and continued to do so all weekend long.

Right: Jack Ruby in the third-floor hallway of the police station at about 11:30 p.m. Friday, November 22.

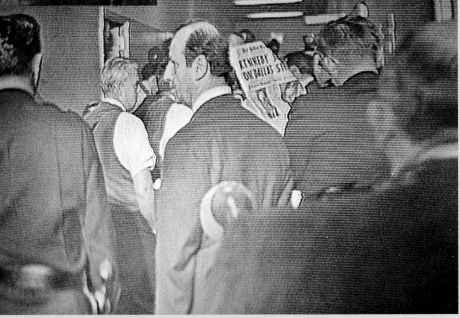

Ruby left the police station and drove to the KLIF offices to meet with disk jockey Russell "The Weird Beard" Knight. Approximately two hours later he went to the offices of the *Dallas Times Herald* to bring a twist board (a novelty item he distributed) to a friend, Pat Godosh. In the composing room he demonstrated the board to a few printers. The subject of the black-bordered *Morning News* ad came up, and the men discussed the rumor that the phones at the *News* were ringing off the hook, with people canceling their subscriptions and ads. Ruby took the elevator down and spoke to the nightwatchman at the door for a few minutes, then got into his car and drove home.

He awakened his roommate, George Senator, around 3:00 a.m. Senator said that he had seen Jack's *News* ad announcing that he was closing the club. They talked for a while about the assassination. Jack told Senator that he wanted him to go somewhere with him. He then called Curtis LaVerne "Larry" Crafard, a handyman at the Carousel Club, waking him up, and asked him if he knew how to use a Polaroid camera. Crafard said he did. At 4:00 a.m. Ruby, Senator, and Crafard drove to the junction of East Ross and Expressway and took pictures of a billboard that read:

SAVE OUR REPUBLIC

IMPEACH EARL WARREN

FOR IMFORMATION WRITE TO BOX 1757

BELTHAM MASS

It is unclear what motivated Ruby to photograph the billboard. We only know that he went out of his way to do it. Somehow, the action doesn't fit with the official version of events, which tells us that he was in mourning for the president.

Later on Saturday, Ruby drove to Houston Street just past Elm Street and parked his car. He walked down Elm Street into Dealey Plaza toward the triple railroad underpass and saw Patrolman James M. Chaney, whom he knew. (Chaney had been riding on a motorcycle a few feet to the president's right at the moment of the assassination the previous day.) Ruby asked Chaney which window was alleged to have been the sniper's nest. Chaney pointed toward the depository. Ruby walked up on the north side of Elm and looked at the memorial wreaths that had been placed in Dealey Plaza. At this point there is some evidence, never confirmed, that he again returned to the Dallas police station.

Above: **Ruby twice went to Dealey Plaza to look at the floral arrangements left as memorial.**

Above: **This is the sign that Jack went out of his way to photograph on the night of the assassination.**

Sunday, November 24

On Sunday at 10:18 a.m. Ruby allegedly received a call from Karen "Little Lynn" Bennett Carlin, one of his strippers. According to Jack, Lynn said she needed money for rent. Since the closing of the Carousel Club, she had not been paid by Ruby. Even though it was Sunday, her landlord had threatened to evict her if she didn't pay the rent immediately. Jack told her that, while all he was required to do was pay her salary when the club was open, he would advance her some cash by Western Union. He asked how to address her; he knew her only as Little Lynn. She gave him her address and full name, which he jotted down, misspelling it Karren Bennet. He asked her if she knew the Western Union office in Forth Worth and told her that $25.00 would be there in care of Will Call Western. George Senator was apparently a witness to the call.

Just before 10:45 a.m., Ruby left his apartment with his dachshund, Sheba, spoke to a neighbor for a minute, and drove off in his white two-door 1960 Oldsmobile. At around 10:50 he passed Dealey Plaza and the county jail (which overlooked the plaza), taking note of the crowd in the street. He continued on to the Western Union office, pulled into the Allright Parking Lot, by the Southland Hotel, at the corner of Main and Pearl Streets, and left his car, unlocked, with Sheba inside.

Right: Karen "Little Lynn" Bennett Carlin, one of Jack's strippers, was the "reason" he was near the jail.

Left: Ruby drove his car to the Western Union office.

He entered the Western Union office and, while waiting for a clerk, filled out the form to send the money to Little Lynn. From the Western Union office he headed west on foot to the police station. He later claimed that he simply walked past the guards there, unchallenged, and down into the basement via the car ramp on Main Street "just out of curiosity." Just as he arrived in the basement and mingled with the crowd, a car horn sounded four times: short . . . short . . . long . . . short.

That morning, Lee, handcuffed to Detective James R. Leavelle, was on his way from the police station to the county jail. He was being taken from the station through the basement parking lot when, at 11:21 a.m., Jack Ruby stepped through the crowd and fired one shot into Oswald's abdomen.

Leavelle's partner, Charles W. Brown, was driving the car that was to be used to transfer Oswald. The car was supposed to be in place at the bottom of the exit ramp that led up to Commerce Street. It wasn't. As Ruby was preparing to fire a second shot, Brown was backing up the car, and the rear bumper hit the back of Ruby's leg, knocking him off balance. Jack was wrestled to the ground by several law enforcement personnel, and his gun was taken from him.

Lee was taken via ambulance to Parkland Hospital, where President Kennedy and Governor Connally had gone two days before.

Above: **The receipt for Jack's money order to Karen Bennett Carlin.**

Below: **Newspapers in Jack's apartment were open to stories about the assassination.**

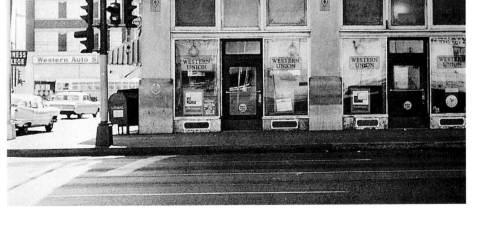

Right: **The Western Union office from which Jack sent a money order to Karen "Little Lynn" Bennett Carlin on the morning of Oswald's murder.**

Earlier in the morning, before 11:00 and possibly as early as 8:00, four technicians from WBAP-TV saw someone standing just outside the police station on the Elm Street side of the building by the top of the exit ramp. They were sure that it was Jack Ruby. If Ruby had been there it would have added weight to the issue of whether his murder of Oswald was premeditated—that is, whether he spent time specifically waiting for Oswald as opposed to merely acting on the spur of the moment. The Warren Commission determined that the man seen by the technicians was only someone who happened to appear on a section of videotape submitted as evidence and that this man was not Ruby. The man in question looks almost nothing like Ruby, and labeling him as a person mistakenly identified as Ruby was a desperate measure to squash the critical issue of premeditation. Ruby's premeditation in the murder of Oswald could only add weight to the notion of a conspiracy to kill the president.

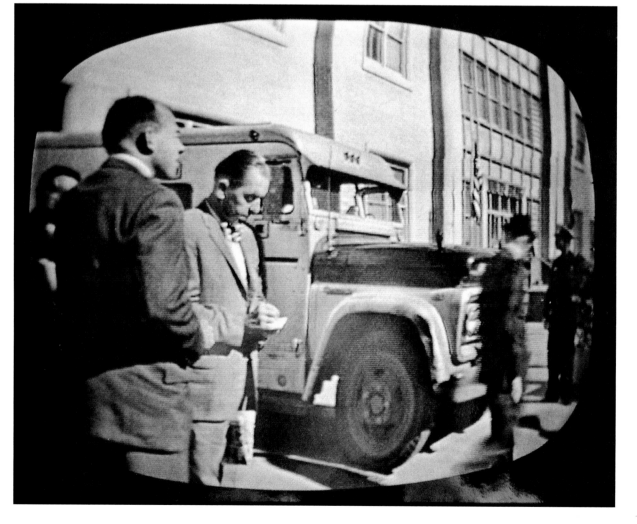

Left: The Warren Commission tried to say that it is the man pictured here who was the person thought to have been Ruby by four television crew members who were sure they saw him long before he was supposed to be near the jail. However, this man looks nothing at all like Ruby. Was Jack at the jail earlier than the official story says? If so, this adds credence to the idea that Ruby stalked Oswald.

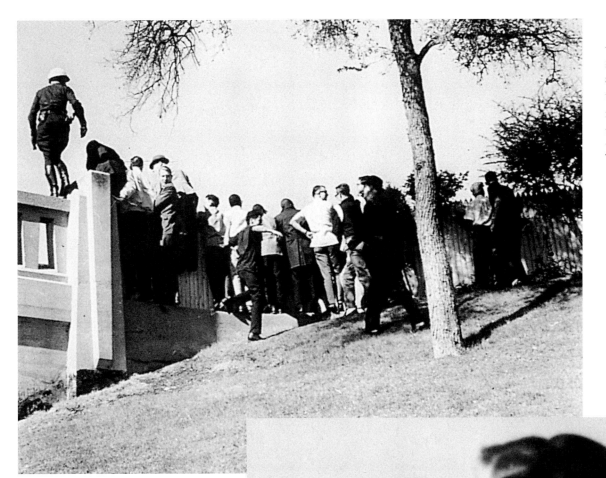

Left: Jack Ruby on the grassy knoll? Taken several minutes after the shooting, the man in this photograph of the knoll might be Jack Ruby.

Below: Jack Ruby two days later at the time he shot Lee. Notice the similar features and haircuts of the men in both photos.

Above: A number of people who knew Ruby have told the author that they feel strongly that this is him.

The Murder

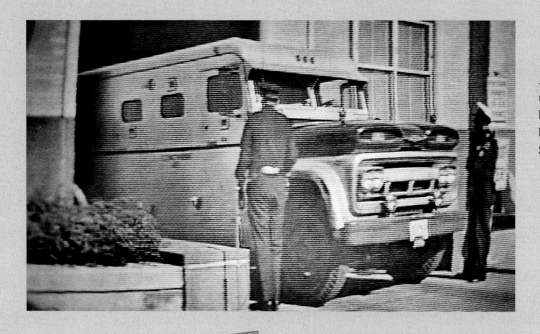

Left: The Commerce Street ramp to the jail's basement parking lot was blocked by a decoy armored car, but not the ramp on the Main Street side.

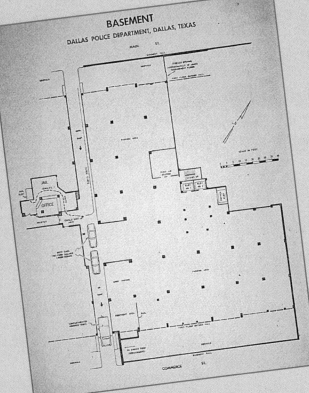

Left: The floor plan of the basement and garage of the Dallas police department.

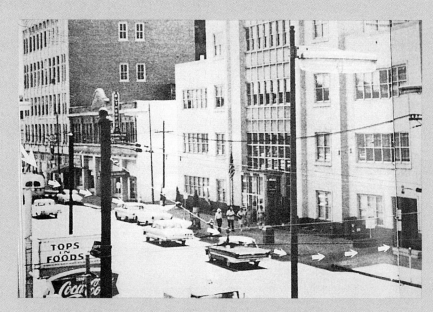

Right: After sending the money order from the Western Union office on the left, Jack walked east down Elm Street.

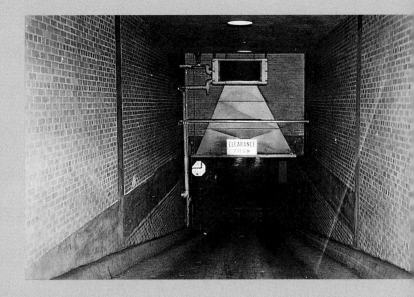

Above Left: The Main Street entrance to the jail basement that Jack was supposed to have used to gain access to Lee.

Above Right: The top of the ramp that Jack supposedly walked down in order to enter the basement garage.

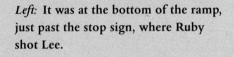

Left: It was at the bottom of the ramp, just past the stop sign, where Ruby shot Lee.

Right: Jack stood by the railing at the ramp and waited for Lee to be brought out.

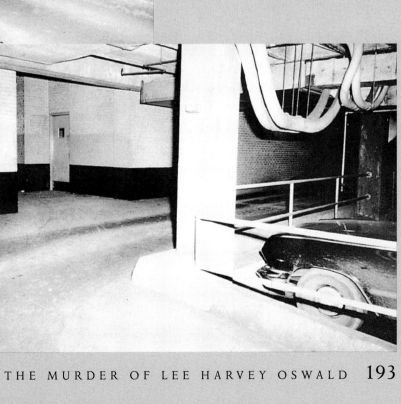

Below: It is possible that Ruby was led into the basement down the stairs on the right rather than having walked down the ramp completely unnoticed by anyone. This would mean that he had an accomplice, someone with access to police headquarters.

Above: Lee entered the garage through the doorway from the basement office.

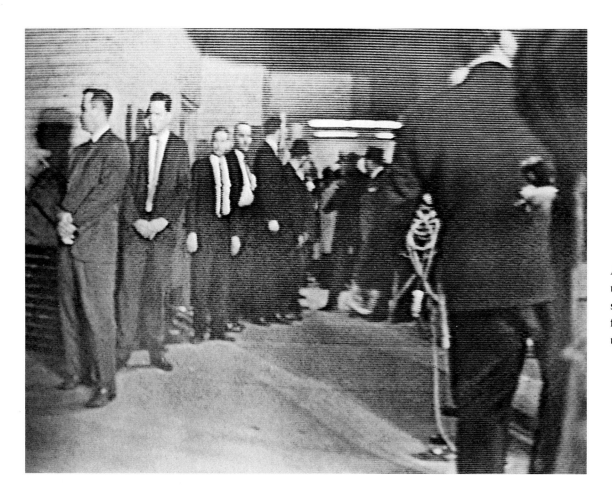

Left: The police and the press wait for the start of Lee's transfer from the city jail to the county jail.

Below: Jack Ruby (wearing a hat) had arrived in the basement, and waits for the arrival of Lee Oswald.

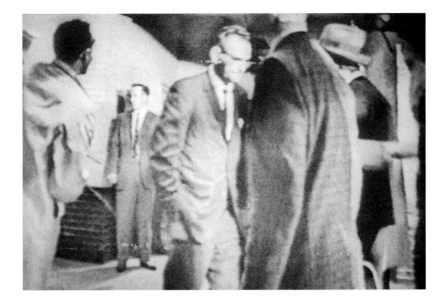

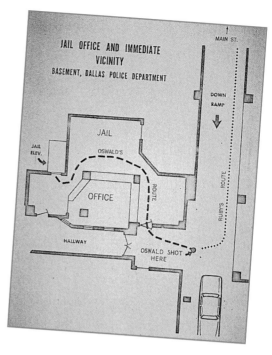

Above: The route through the basement office and into the garage where Lee was murdered.

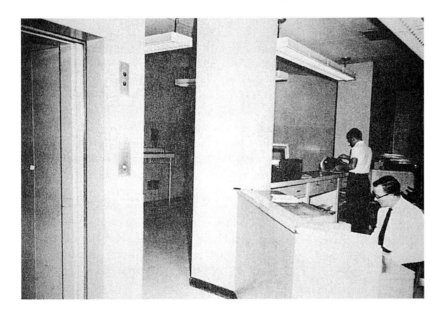

Above: The jail elevator on the left opened into the basement office of City Hall.

Right: Detective Jim Leavelle escorts his prisoner out of the elevator and through the basement office.

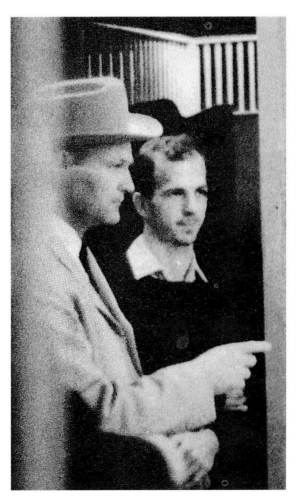

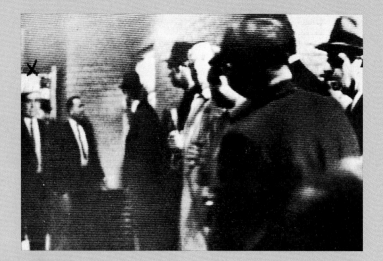

Above Left: The stalker awaits his prey.

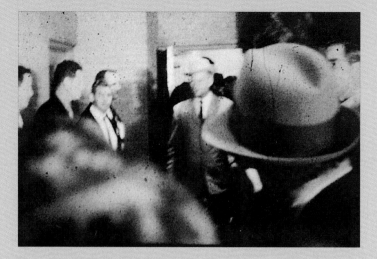

Above Right: Jack, on the right in the fedora hat, watches Jim Leavelle escort Lee into the garage.

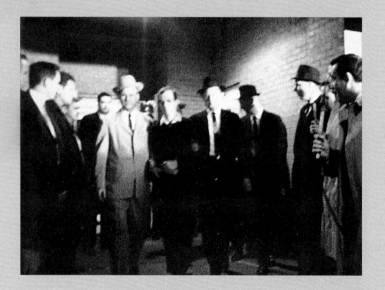

Above Left: Lee is led into the garage.

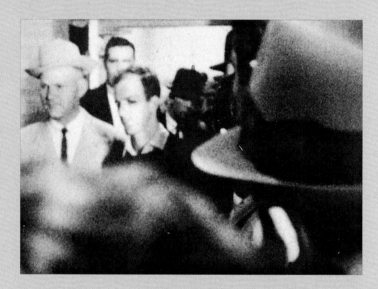

Above Right: Jack sees Lee, who had not yet seen him.

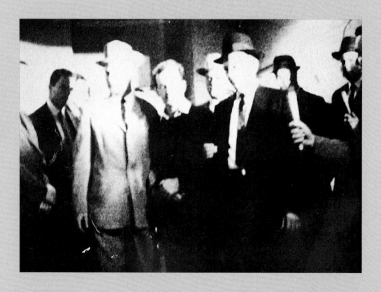

Above Left: Lee starts to turn to his left and looks toward Jack.

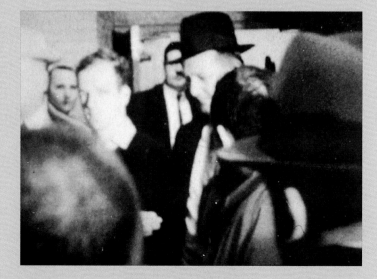

Above Right: Lee seems to recognize Ruby.

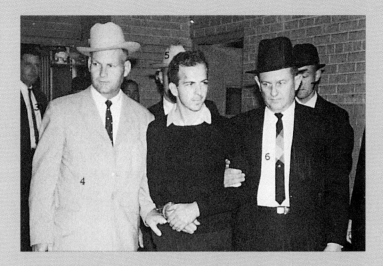

Above Left: Lee appears to stare at Ruby with a fixed gaze.

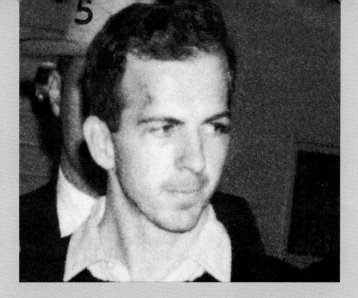

Above Right: He seems to be thinking, "What are you doing here, Jack?"

Above Left: Ruby pushes his way through the reporters.

Below: Ruby reaches Lee and is about to pull the trigger of his revolver.

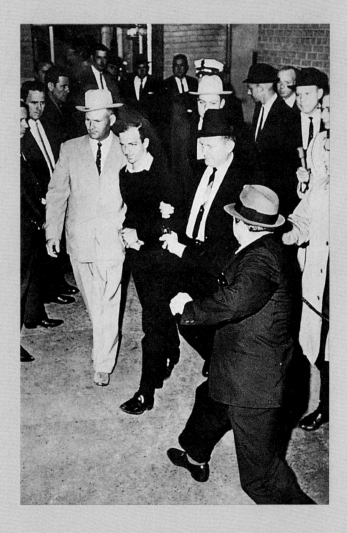

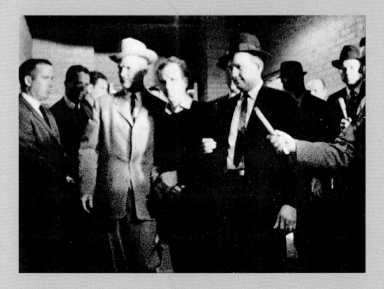

Above Left: As Lee turns forward, Jack races toward him, gun in hand.

197

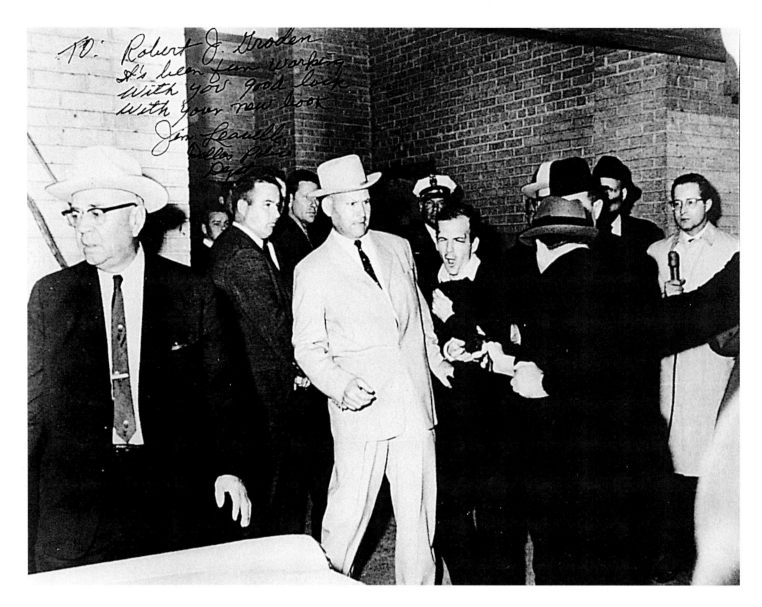

To: Robert J. Groden
It's been fun working
with you good luck
with your new book

Jim Leavelle
Dallas Police
Dept

Above: Ruby became part of history when he fired a single bullet into Lee's abdomen and silenced the patsy.

Right: Jack Ruby's .38 special Colt Cobra, serial no. 2744 LW.

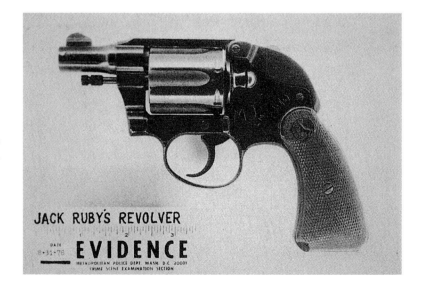

JACK RUBY'S REVOLVER
DATE
8-31-78
EVIDENCE
METROPOLITAN POLICE DEPT. WASH. D.C. 20001
CRIME SCENE EXAMINATION SECTION

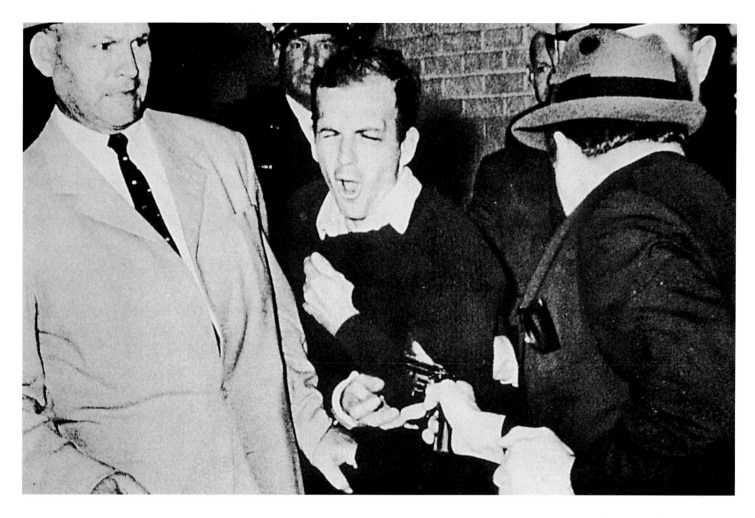

Above: Lee shouts in pain.

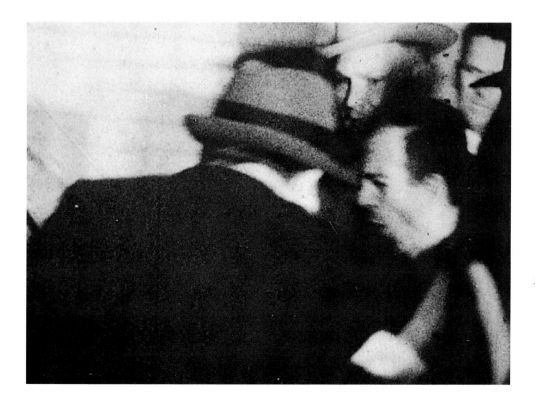

Left: Pain registers on Lee's face.

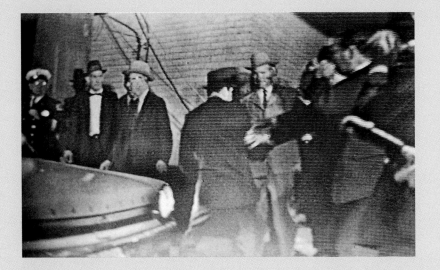

Above: The detectives seem to begin to realize what has happened.

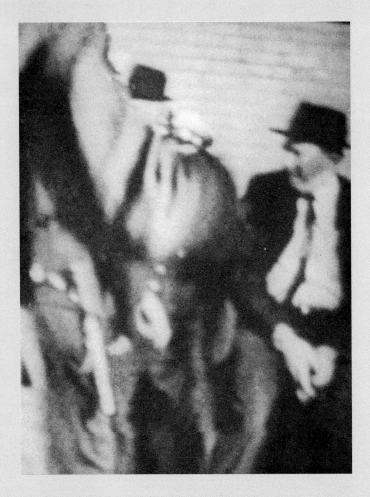

Above: Officer L. C. Graves wrestles Ruby's gun away from him as Jack is brought down.

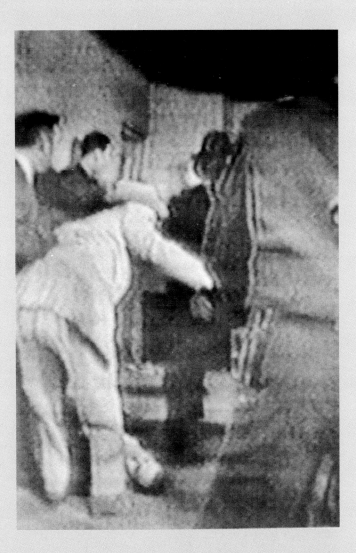

Right: Lee, losing consciousness, lies on the ground at Jim Leavelle's feet.

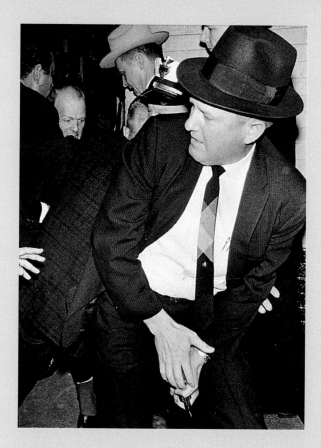

Left: Graves holds Ruby's revolver safely away from him.

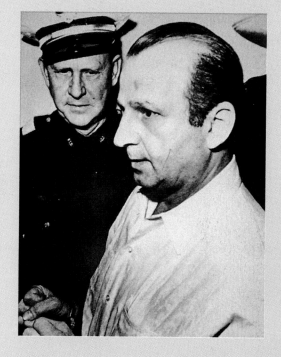

Right: Jack was handcuffed and brought, ironically, to the cell Lee had just vacated.

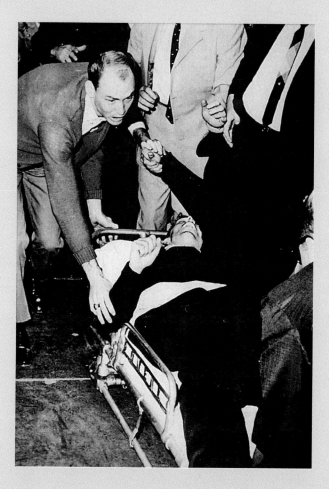

Left: An ambulance was called, the armored truck was removed, and Lee was placed on a stretcher and wheeled toward the ambulance.

Below: Lee lies still alive but unconscious on the stretcher on the basement floor.

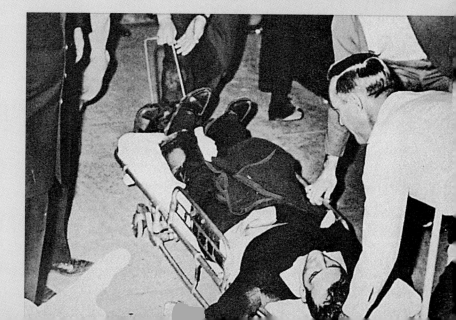

Lee Oswald's Last Moments

Charles Crenshaw was one of the first doctors to see Lee Oswald when he arrived at Parkland Hospital. A gifted surgeon and one of the men who had treated President Kennedy, he fought to save the life of his patient. Here, in an exclusive interview, are Dr. Crenshaw's recollections of the last moments of Lee Oswald's life.

"I suggested that we not treat Oswald in trauma room one in deference to the memory of President Kennedy, so we were waiting for Oswald to arrive in trauma room two, where Governor Connally had been."Oswald arrived on a cart. He was ashen, white. He had no blood pressure, no pulse, but he still had a heartbeat. He was breathing, and he was maintained on the cart nearly seven and a half minutes. The chief of anesthesia, Dr. [Marion T. "Pepper"] Jenkins, put a tracheal tube in place. Oswald was placed on 100 percent oxygen. Dr. Ron Jones, the senior resident, had come down, and he put in a chest tube on the left, because the bullet, even though it looks as though it went straight into the abdomen, went through part of the left lung.

"Oswald was catheterized by the urology resident, Dr. Bill Risk. After all of this was done, we got Oswald to the elevator and up to the operating room. We used the first operating room available. . . . Dr. Malcolm Perry, having stayed upstairs, started the operation twelve minutes after Oswald had arrived at Parkland. There was no delay in taking care of Oswald. We put Betadine on his abdomen, and he was operated on. The incision was made midline from the chestbone down. We found that almost his whole blood volume was in his abdomen. Dr. "Red" Duke had run and gotten all of the O-negative blood. So Oswald was receiving blood immediately. It was later found that he had A-negative, so it worked out very well. He didn't have type-specific blood. We were pumping the blood in and we started wiping all of the blood out of his abdomen.

Below Right: **The floor plan of Parkland Hospital's emergency area. Lee was taken to trauma room two.**

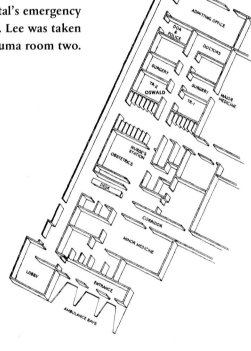

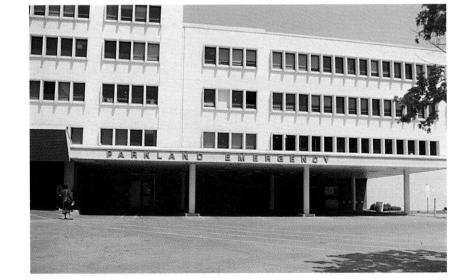

Left: **Lee was brought to the emergency entrance.**

"There were all these areas of the wound. The bullet went in on the left side, through the left lung, it hit the spleen, then hit the major artery in the abdomen, the aorta, and knocked part of the main artery to his intestines, then the bullet went through the major vein, called the vena cava, through the loops of the intestines, the upper part of the right kidney, and then completely through the liver, and the bullet was on the right side underneath the skin, what we call subcutaneous. In that one shot, as we sometimes say, Ruby hit all of the real estate in the abdomen, from left to right. It was the most woeful injury one could see.

"We took the spleen out, clamped that off, stopped the bleeding from the aorta, sewed the artery back on the aorta and got a flow there and were taking care of the different injuries.

"The injuries were amenable to surgery. I stood there at the end of the table watching, and I noticed a rather large fellow to my left, weighing at least two

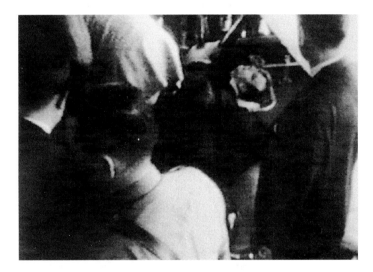

Above: An unconscious Lee Oswald was taken from the ambulance and wheeled into Parkland Hospital. This may be the last picture of him while he was still alive.

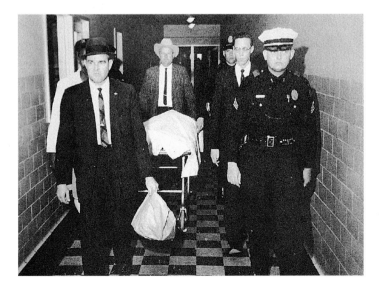

Above: Lee remained alive for one hour and fifteen minutes after he was shot, then his body was wheeled to the autopsy room.

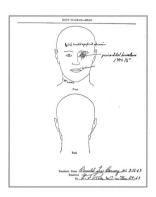

Right: The head drawing from Lee's autopsy report. It shows where he had been beaten.

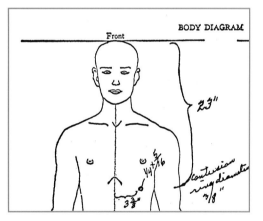

Above: The full-body diagram shows the entrance wound in the left side of the abdomen. The three-eights-inch wide entrance wound was twenty-three inches from the top of his head and three and three-eighths inches left of center.

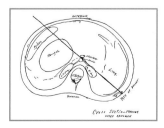

Right: The bullet damaged nearly every organ in Lee's abdomen.

hundred pounds. He was in a small scrub suit with a badge on his left upper pocket and a gun in a back small pocket of his scrub suit. He had no hat and no mask. He resembled Oliver Hardy.

"I was tapped on the shoulder and a nurse who I did not know asked me if I would take a call. I thought to myself, 'Well everything's happening at Parkland,' so I went to the nursing supervisor, Miss Audrey Bell. I picked up the phone, and immediately I heard this loud voice. It said, 'This is President Lyndon B. Johnson. How is the accused assassin doing?' I told him that he'd lost a lot of blood, but he was holding his own. And he said, 'Would you take a message to the chief operating surgeon?' It was more of an order than a request. And he said, 'There is a man in the room. I would like for him to be able to take a deathbed confession from Oswald.' So I thought, 'Yes sir,' but all of a sudden the phone stopped. So I went back to the room and I tapped

Dr. Tom Shires, the chief of surgery, on the shoulder and said, 'Guess who I have been talking to?' And he looked at me and said, 'What's gonna happen now?' And I said, 'That was the President, Lyndon Baines Johnson.' I said, 'He wants a deathbed confession.'

"Oswald was on oxygen and anesthesia, he wouldn't have been able to talk for two or three days even if he had survived, there would have been no way. The amount of time from when Oswald had been shot until the time he got to Parkland had been too long. He really died of pneumogastric shock, complications from all he had gone through, and aerobic metabolism. When his heart started fibrillating we tried all of the medications and procedures to re-start his heart.

"Dr. Perry did an incision for a right thoracotomy. We started a manual squeezing or pumping of the heart, direct injection of Adrenalin into the heart. Then we tried to use electrotherapy and shock. Dr. McClelland took out the paddle and, through a series of amps, went up until it was as high as it could go. And each time Oswald was shocked, there was no activity on the EKG. Dr. Gene Akin told Dr. Shires that Oswald's eyes were clouding over. It was obvious that Lee Harvey Oswald was dead."

Lee Harvey Oswald died at 1:13 p.m. on November 24, 1963.

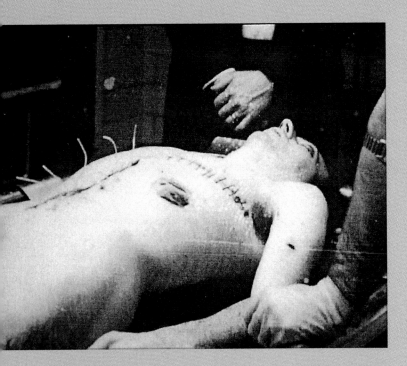

Above: **This previously un-published morgue photo of Lee shows the extent of the bullet's damage.**

Right: **Close-up of autopsy photo showing the damage done to Lee's left eye.**

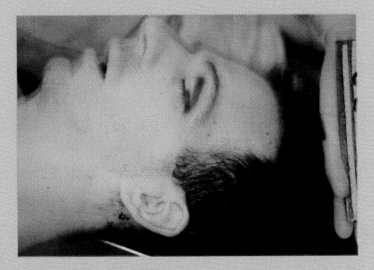

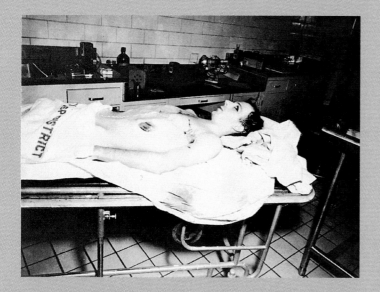

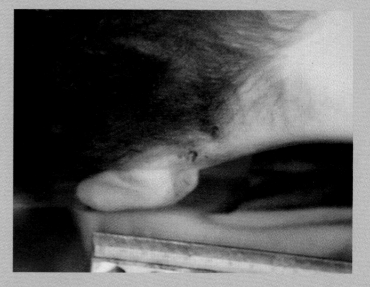

Above Left: The official morgue photo of Lee after the autopsy.

Above Right: Lee had had a mastoid operation as a child, but there is no sign of the scar in this autopsy photo.

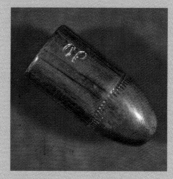

Left: This bullet, just like the one that killed Lee, was actually fired from Jack Ruby's gun.

Above: Lee had a scar on his left wrist from his "suicide attempt," but where is it in this autopsy photo? It was also not mentioned in the original autopsy report.

Right: This autopsy photo shows that Lee had been beaten. The bruising on his face shows this, but much of the damage was hidden by his hair.

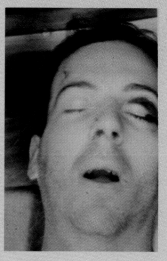

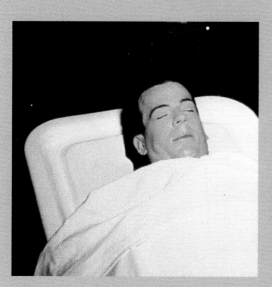

Left: Lee's body is prepared for the funeral.

Right: Lee in his coffin.

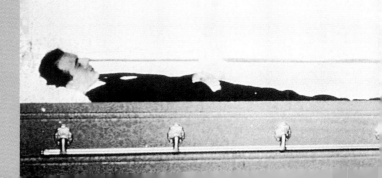

Burying Lee Oswald and the Truth

Oswald was buried the following day in Rose Hill cemetery in Fort Worth under the name of William Bobo, an itinerant cowboy who had just died. The false name was used to prevent vandalism of the grave; indeed, the original gravestone was eventually stolen. Although it was recovered, it was never returned to the gravesite.

Present at the funeral were Marina and her two daughters, Marguerite, Robert Oswald, and dozens of reporters and photographers. Seven reporters were pressed into service as pallbearers. Buried with Lee were the answers to the greatest mystery of all time. Who killed President John Fitzgerald Kennedy? And why?

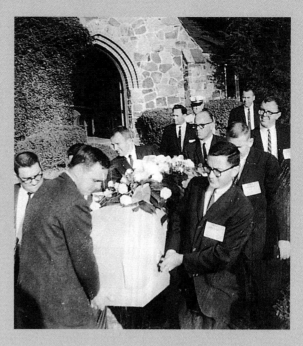

Above: **Lacking pallbearers, reporters were pressed into service to carry Lee's coffin.**

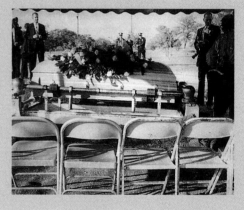

Right: **Lee's casket was put into position for the service to begin.**

Below: **Marguerite holds Rachel, and Marina holds June's hand as they leave the chapel.**

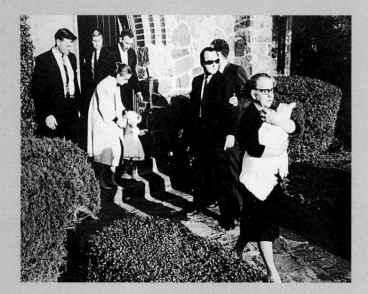

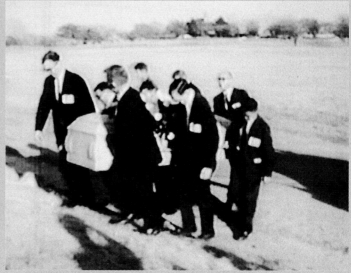

Above: **Reporters carry Lee's casket to the burial plot.**

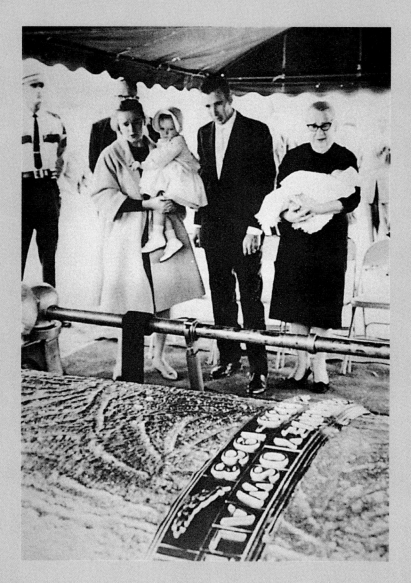

Left: Lee's death guaranteed that there would be no trial in the assassination of President Kennedy. No one would be able to challenge the official cover-up.

Below: The legacy of doubt has haunted Marina, June and Rachel Oswald for more than three decades.

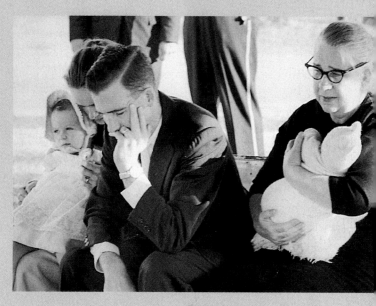

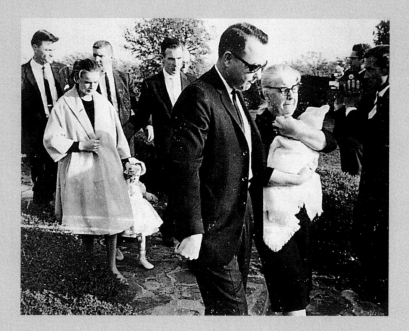

Left: The mourners leave the gravesite.

Below: The original marker stone on Oswald's grave, which was subsequently stolen.

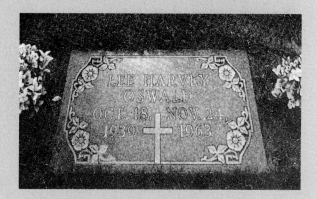

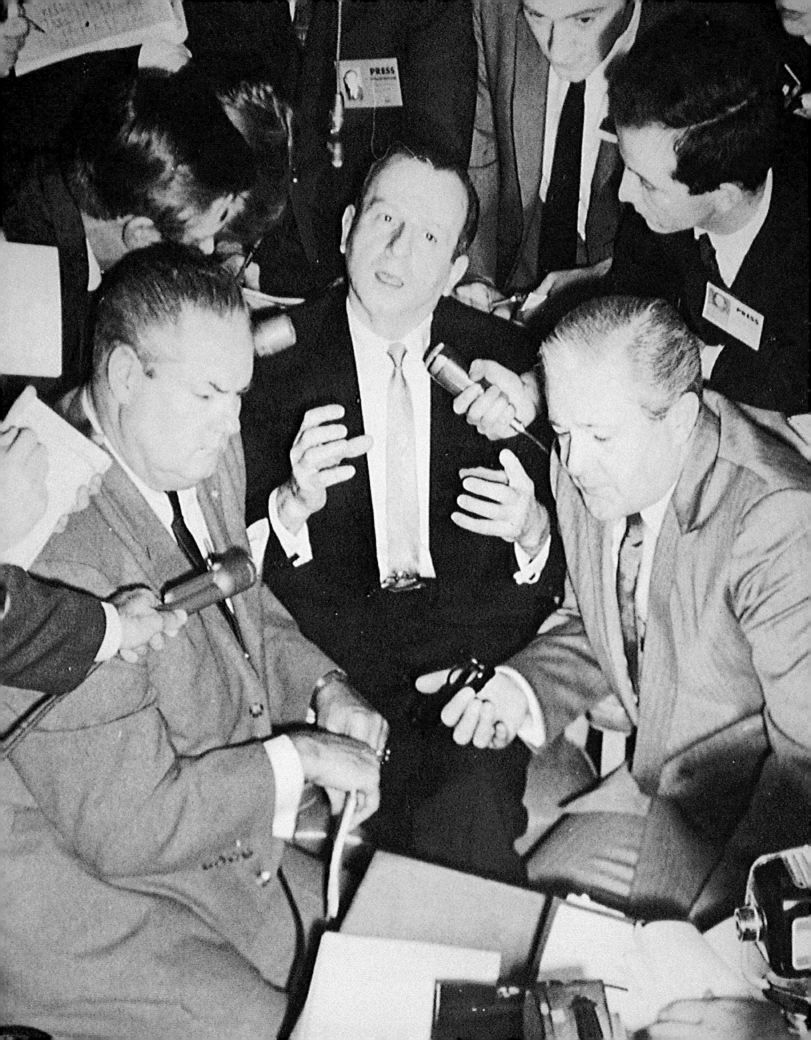

17

THE OSWALD/RUBY CONNECTION

Why Did Ruby Do It?

Ruby later told a reporter that he had consumed thirty Dexedrine and antibiotic tablets before he shot Oswald. "They stimulate you," he said. On the surface, it seems that he may have been trying to blame his actions on the drugs. However, the truth might be that he didn't want to commit the crime but was being pressured into the act and needed the stimulation of the drugs to back his motivation and help him pull it off.

When asked his motive for murdering Oswald, Ruby responded that he didn't want Mrs. Kennedy to have to return to Dallas to bear the pain of a trial. That story, it was later disclosed, had been suggested to him by one of his attorneys, Tom Howard. The story actually made sense to some people. "That's just like Jack," Diana Hunter, a Carousel Club stripper, stated. "He always looked after his dancers first. For one brief moment, in Jack's eyes, Jacqueline Kennedy must have become one of Jack Ruby's girls." (Bob Callahan, *Who Shot JFK?*, 1993)

Left: Jack, with his attorneys, surrounded by the press.

Events in Ruby's life may suggest a motive. For a long time prior to the assassination, he was deeply in debt and trying desperately to obtain money. His only possible source of cash was organized crime. According to Seth Kantor in *The Ruby Cover-up*, Ruby had met privately with syndicate payoff man Paul Rowland Jones hours before President Kennedy arrived in Texas. What arrangement was he making? According to researcher Penn Jones Jr., Ruby reportedly had $2,000.00 on him when he was arrested, and later the authorities allegedly found $10,000.00 in his apartment and money in the trunk of his car. On the afternoon of the Kennedy assassination, Bill Cox, a Dallas bank officer, observed him at the bank with several thousand dollars in his hands. However, he made neither a deposit nor a withdrawal that day.

Below: **The homicide report that charged Jack Ruby with Lee's death.**

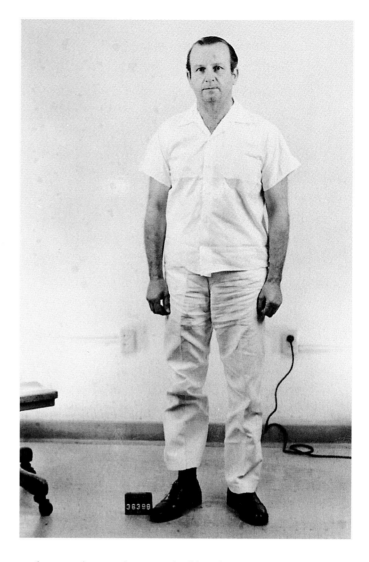

Above: **Jack was photographed by the police and processed. He was prisoner #36398.**

Right: **Jack's fingerprint card shows that his index finger, which had been bitten off in a fight, was missing.**

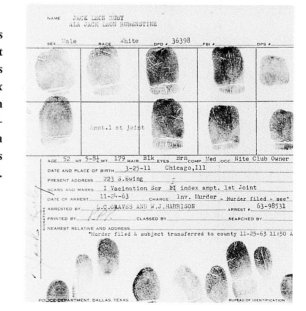

Oswald and Ruby

Less than two seconds before Jack Ruby shot Lee Oswald, Lee turned his head to his left and looked directly at Jack's face for a brief moment. Photographs seem to show a glimmer of recognition in Lee's eyes, raising the question of whether the two knew each other. Several people saw them together prior to the assassination, and there are other links.

Witnesses said that they saw Lee in the Carousel Club prior to the assassination. Beverly Oliver, who worked at the Colony Club, was friends with Jack Ruby and claims that she was introduced to Lee by Jack in the Carousel Club as "Lee Oswald of the CIA." Beverly also saw Lee's old buddy David Ferrie at the Carousel Club; she thought he was the manager. Rose Cheramie (see boxed text on page 180), who had prior knowledge of the assassination and who worked for Ruby, told Louisiana police that Jack and Lee were "bedmates."

Bertha Cheek, the sister of Earlene Roberts, Lee's housekeeper at 1026 North Beckley Avenue, visited Jack Ruby at the Carousel Club on November 18, 1963, four days before the assassination. Cheek had also been the landlady of Ruby's friend Harry N. Olsen, the only Dallas policeman who could not recall where he was at the time of the Kennedy assassination. Less than five years later, Cheek bought a Dallas hotel for $900,000.00.

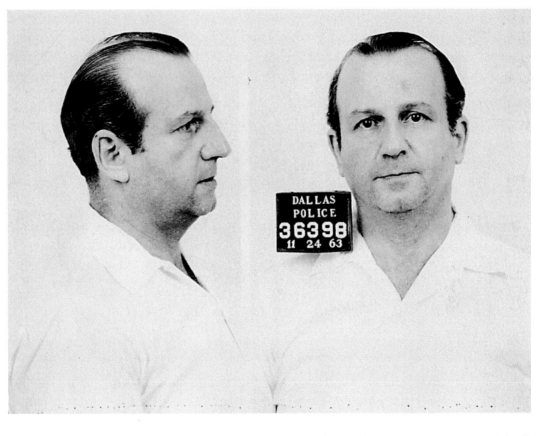

Above: **When Lee was pronounced dead, Jack was booked for murder.**

Ruby and the Police

Many argue that Ruby couldn't have planned the murder of Oswald in advance because no one knew the exact time Oswald was to be transferred. The planned time of the transfer was changed several times. However, organized crime was known to control elements within the Dallas police department. When Ruby emerged from the crowd outside the police station to shoot Oswald, he passed a policeman, W. J. "Blackie" Harrison. Harrison had had the opportunity at least twice that morning to let Ruby know, by phone, the plans for moving Oswald.

Later, during the investigation of Oswald's murder, Blackie Harrison and his partner, detective L. D. Miller, were reluctant witnesses. Miller acted as if he were a suspect himself, at first refusing to be a sworn witness, when all he had apparently done was have coffee with Harrison on the morning of the murder. What could Miller have been trying to hide?

Many believe that Ruby lied about how he had gained entrance to the Dallas police department basement. The idea that he walked down the entire length of the parking garage ramp unnoticed truly strains credulity. The generally accepted alternative is that he was brought into the basement down an unguarded staircase from the police department parking lot. It has long been suspected that his confederate in this was Assistant Police Chief Charles Batchelor. Batchelor had also been a key planner of security for the presidential motorcade route.

Penn Jones Jr. wrote, "Several high ranking telephone people in Dallas hurried to the police shortly after Jack Ruby killed Lee Harvey Oswald with phone company records proving that Ruby and Oswald knew each other. . . . At Dallas police headquarters, the men were told to go home and forget it. All the phone company men were hastily transferred out of Dallas." (*Who's Who in the JFK Assassination*)

Ruby tried to hide a conversation he had with Policeman Harry Olsen soon after Oswald was arraigned for shooting Officer Tippit. On the evening of the assassination, as he was leaving the police station on his way to the *Dallas Times Herald*, he stopped to talk for over an hour to Olsen and his girlfriend, twenty-seven-year-old British Kay Coleman, who worked under the name Kathy Kay Coleman. She told Jack that if the crime had been committed in England, Oswald would have been dragged through the streets and hanged. They both stated that Jack appeared upset and heard him refer to Lee as "a son of a bitch." Both Olsen and Coleman agreed that a trial was too good for the cop killer and that he should be cut to ribbons. Jack later refused to talk about the conversation because it pointed to the issue of premeditation in the shooting of Lee, and in fact the conversation was probably far more inflammatory than has been revealed. One of Jack's lawyers, Joe Tonahill, felt that Jack might have been maneuvered into shooting Lee by this sort of power of suggestion. Jack met with both Olsen and Coleman again Saturday night outside the Carousel Club. A month later Olsen and Coleman were married.

Ruby may very well have known Officer Tippit. A man named Harold Richard Williams, arrested in early November 1963 in an after-hours raid on the Mikado Club in Dallas, where he was working as a chef, was placed in the back of an unmarked police car driven by Tippit. Sitting on the front seat next to Tippit was Jack Ruby, whom Williams knew because he "used to furnish us with girls." Williams told researcher Mark Lane that Tippit called his companion "Rube." When, after both his release and the assassination, Williams saw published photographs of Tippit and started to talk about what he had seen, he was rearrested by the Dallas police and told to keep quiet.

Tippit was shot along the most direct route between Oswald's rooming house and Ruby's apartment.

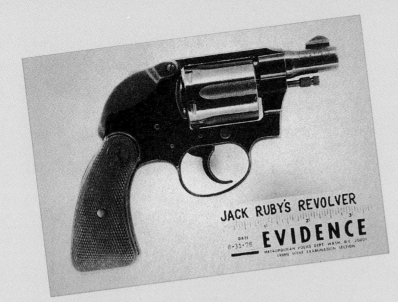

Above Left: Shown here is Jack's gun, which had been purchased for him by Joe Cody, a Dallas police officer.

Above Right: Roscoe White, who had the first known copy of the third backyard photograph, knew Ruby through his wife, Geneva, who had worked at the Carousel Club for a short time.

Left: Jack Ruby with Geneva White.

Ruby's Conviction

Jack Ruby's defense team included, besides Tom Howard and Joe Tonahill, San Francisco's Melvin Belli. The defense Ruby received has since been viewed as incredibly inept. The trial broke Jack psychologically and emotionally. He seemed to believe that he should be considered a national hero and set free. Instead, Belli presented him as a second-generation mental defective whose mother was committed to an insane asylum, with Jack only a heartbeat away from the same fate. He was tried for murder in the first degree. On March 14, 1964, ten days after the start of the testimony, a jury of eight men and four women, having deliberated for two hours, convicted him of Lee Oswald's murder. He was sentenced to death in the electric chair.

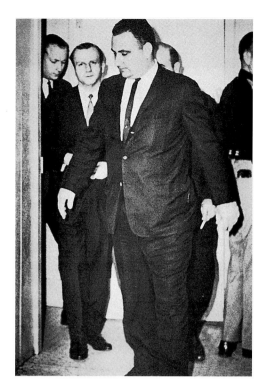

Above: **Not wishing for history to repeat itself, police carefully guarded Jack at the trial.**

Below: **Jack's sister, Eva Grant, at her brother's trial.**

Right: **Karen Bennett. Jack sent her money before shooting Lee. Was the issue of the money a cover to get Jack near the jail?**

Above: Eva Grant.

Below: Marguerite Oswald and Judge Joe B. Brown,
who presided at the Ruby trial.

Right: Since the defense plan relied
on Jack being judged insane, he
was given psychiatric testing.
Here he is taken for a test.

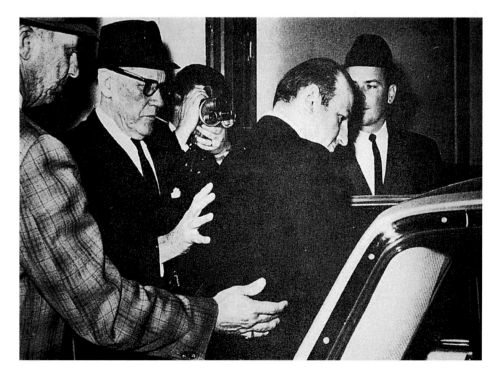

Ruby and the Warren Commission

Following his conviction, Ruby repeatedly asked to testify before the Warren Commission. Finally, in June 1964, Chief Justice Earl Warren and Congressman Gerald Ford, along with Leon Jaworski, who was representing the Texas State Attorney General's office, traveled to Dallas and "interrogated" Ruby in the county jail. During the questioning, Ruby urgently pleaded that the commission members take him to an environment where he could tell all he knew. He was beyond doubt in fear of losing his life:

"Is there any way to get me to Washington? [Warren tells him no. He did in fact have subpoena power and could easily have had Ruby taken or sent anywhere.] I don't think I will get a fair representation with my counsel, Joe Tonahill, I don't think so. I would like to request that I go to Washington and you take all the [lie detector] tests that I have to take. It is very important. . . . Gentlemen, unless you get me to Washington, you can't get a fair shake out of me. If you understand my way of talking, you have to bring me to Washington to get the tests. . . . I want to tell the truth, and I can't tell it here. I can't tell it here. Does that make sense to you? . . . Gentlemen, my life is in danger here. Not with my guilty plea of execution. . . . Do I sound sober enough to you as I say this? . . . I will tell you, gentlemen, my whole family is in jeopardy. My sisters, as to their lives . . . there is a certain organization here, Chief Justice Warren, if it takes my life at this moment to say it, and [Sheriff] Bill Decker said 'be a man and say it,' there is a John Birch Society right now in activity, and [Major-General] Edwin Walker [a ranking member of the society and the man whom Oswald had been accused of trying to kill in the rifle attack on April 10, 1963] is one of the top men of this organization. Take it for what it is worth, Chief Justice Warren. . . . Unfortunately for me, for me giving the people the opportunity to get in power, because of the act I committed, has put a lot of people in jeopardy with their lives. Don't register with you, does it? [Warren replied, "No, I don't understand that."] Would you rather I just delete what I said and just pretend that nothing is going on? . . . Well, I said my life, I won't be living long now. I know that my family's lives will be gone. . . . You can get more out of me. Let's not break up too soon. . . . Mr. Bill Decker said be a man and speak up. I am making a statement now that I may not live the next hour when I walk out of this room." (Warren Report, Volume 5)

Ruby was never brought to Washington.

In a suppressed television interview and in letters smuggled out of jail, Ruby said several times that Lyndon Johnson was the power behind the assassination:

"First you must realize that the people here want everyone to think I am crazy . . . isn't it strange that Oswald . . . should be fortunate enough to get a job at the [book depository] two weeks before. . . . Only one person could have had that information, and that man was Johnson . . . because he is the one who was going to arrange the trip. . . . The only one who gained by the shooting. . . . They also planned the killing, by they I mean Johnson and the others. . . . you may learn quite a bit about Johnson and how he has fooled everyone." (Letter reprinted in *Who's Who in the JFK Assassination*)

Ruby continued to request that he be able to make a statement and to take a polygraph test. The latter request was finally granted on July 18, 1964, when he was tested by Warren Commission expert S. A. Herndon. Among the witnesses was Arlen "Single Bullet" Specter, Warren Commission assistant counsel. Not surprisingly, the analysis of the test indicated results consistent with the lone assassin theory. However, in March 1979, three months after the House Assassinations Committee was disbanded, a report entitled "The Analysis of Jack Ruby's Polygraph Examination" was submitted to the committee. The

FBI Director J. Edgar Hoover wrote to Warren Commission General Counsel J. Lee Rankin on February 27, 1964, stating, "Ruby had been contacted nine times by the FBI in 1959, from March 11 to October 2, 'to furnish information.'" Hoover requested that the Warren Commission suppress this information. They honored this request and who knows how many others. (Hoover FBI memo, February 27, 1964)

analysis of the test was performed by three of the top polygraph experts in the country, Richard O. Arthur, Charles R. Jones, and Benjamin F. Malinowski.

The two most relevant questions and Ruby's answers were:

1. Did you know Oswald before November 22, 1963?
 Answer: No.
2. Did you assist Oswald in the assassination?
 Answer: No.

Herndon's conclusion that Ruby was telling the truth when he answered "no" was exactly what the Warren Commission and the FBI wanted to hear. However, the House Assassinations Committee report states, "In fact, Ruby's reactions to the preceding question (Did you assist Oswald in the assassination?) showed the largest valid GSR (galvonic skin response) reaction in [the] test series. In addition, there is also a constant suppression of Ruby's breathing and a rise in his blood pressure at the time of this crucial relevant question. In the second analysis of the test results, the panel concludes that Ruby was not being truthful when answering "no" to the question "Did you assist Oswald in the assassination?" This is contrary to Herndon's opinion. (House Select Committee on Assassinations, Volume 8, pp. 217–218)

Ruby's elevated skin-response reaction and suppressed breathing might be explained in another way, in relation to the incompetent manner in which the question was phrased. Implicit in the question is an assumption of Lee Oswald's guilt. Ruby must have known that Lee was innocent; therefore, it was impossible for him to give a black-or-white answer. The answer could only be a shade of gray. Hence the qualification in the panel's review of the test. In addition, although the house panel did not go into detail, it determined that Ruby was lying about knowing Lee Oswald before November 22, 1963, as well.

Jack Ruby's Death

Upon appeal in 1967, Ruby was granted a new trial. Among other things, it was discovered that Joe B. Brown, the presiding judge at the original trial, had been writing a book about the events. On January 3, 1967, before a new trial could begin, Ruby died of cancer. He had told family members he was convinced the authorities were murdering him via injection with live cancer cells to silence him.

Who was Ruby really working for when he murdered Lee Oswald?

Mobster Johnny Roselli said it best. Roselli told Jack Anderson that Ruby was just the kind of foot soldier the mob could call on at the spur of the moment to silence a witness. If organized crime and/or elements of the U. S. intelligence community were involved in the president's assassination, it would be extremely important for those guilty parties to have Oswald silenced whether Oswald knew who they were or not. There is every indication that Jack Ruby stalked and assassinated Lee to silence him, and that he acted on behalf of those above him in the mob.

Below: **Jack once again sat before Judge Brown during one of his many appeals for a new trial.**

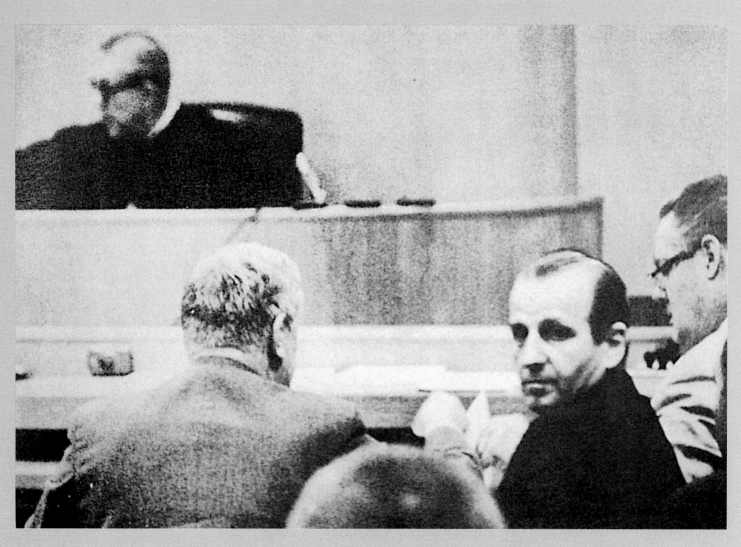

Left: Jack sitting in the courtroom during his trial.

Below: Jack Ruby's funeral in Chicago on Monday, January 9, 1967. Whatever Ruby may have known was buried with him.

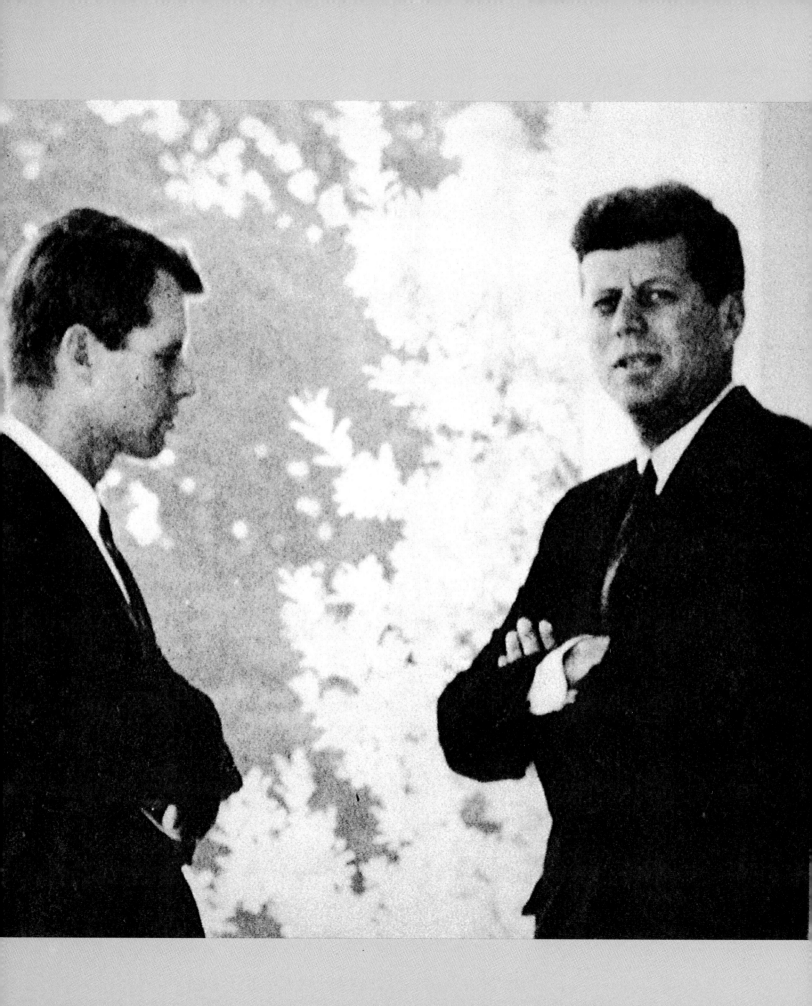

18

IF NOT OSWALD, THEN WHO?

Below: Senator Richard Russell, who stated, "We have not been told the truth about Oswald."

Left: Robert and John Kennedy. Few politicians created so many enemies in such a short time.

The Disbelievers

As early as two weeks after the death of President Kennedy, 52 percent of the American people already believed that the assassination was the result of a conspiracy. In the years that have followed, the figure has grown at times to well over 90 percent. No one who has studied the topic can fall prey to the propaganda that Oswald acted alone, but many don't know the facts and have been taken in by the theory of the lone assassin.

The list of people who, through the years, have not chosen to believe the myth of the lone assassin includes:

✛ Attorney General Robert F. Kennedy: "If anyone was involved, it was organized crime"; "Subject to being elected [president, in 1968], I would like to re-open the Warren Commission."

✛ Chief Justice Earl Warren said that we would never know the whole truth about the assassination.

✛ Warren Commission member Senator Richard Russell: "I'm not completely satisfied in my own mind that [Oswald] did plan and commit this act altogether on his own."

✛ Warren Commission member John McCloy: "I no longer feel we had no credible evidence or reliable evidence in proof of a conspiracy."

✛ The FBI's chief of domestic intelligence, William Sullivan: "There were huge gaps in the case, gaps we never did close."

✛ Dallas Police Chief Jesse Curry always believed that at least two assassins were involved. He also stated, "We don't have any proof that Oswald fired the rifle. No one has been able to put him in that building with a gun in his hand."

✛ In 1977, Dallas District Attorney Henry Wade told this author, "Of course I never did believe that Oswald acted alone."

✛ Secret Service agent Roy Kellerman, who rode in the front seat of the limousine, believed there was a conspiracy.

✛ Presidential aide Kenneth P. O'Donnell rode in the Secret Service follow-up car just behind the presidential limousine. He heard at least one shot come from the grassy knoll and knew that there was a conspiracy.

✛ John McCone, the director of the CIA, who had been appointed by President Kennedy to replace Allen W. Dulles, believed that there were two gunmen and expressed the belief to Robert Kennedy.

Lee Oswald's statement of his innocence—"I didn't shoot anybody, no sir"—has been tested by Psychological Stress Evaluators and Voice Stress Analyzers, which are lie detectors for recorded statements. His statements have passed the tests as truthful every time.

There has never been a shortage of suspects in the Kennedy case. The number of enemies John Kennedy amassed in his thousand-day presidency gives us a catalog of suspects, each of whom had a motive to participate in the assassination. None of the official investigations into the murder ever seriously considered any option except the lone assassin theory. The sole exception is the investigation of the House Assassinations Committee, which found a probable conspiracy backed by organized crime.

Below: **According to Representative Hale Boggs: "Hoover lied his eyes out...on Oswald, on Ruby, on their friends, you name it."**

Left: Senator Richard Schweiker predicted, "The Warren Report will fall like a house of cards."

Right: "The Pentagon has destroyed its Kennedy assassination file," said Representative Richardson Preyer.

Left: Senator John L. McClellan, Robert Kennedy, and John Kennedy investigate the Teamsters in 1957.

The Mob Alone

"The mob did it, it is a historical truth." These are the words of Professor George Robert Blakey, chief counsel of the House Select Committee on Assassinations. The view has been echoed by Kennedy assassination authors David Scheim (*Contract on America* 1989) and John Davis (*Mafia Kingfish*, 1989). In 1994, Frank Ragano, once a lawyer for Santos Trafficante, Carlos Marcello, and Jimmy Hoffa, confirmed in his autobiography, *Mob Lawyer*, written with Selwyn Raab, what the Kennedy research community had known for decades. His employers had been deeply involved in the planning, financing, and execution of the Kennedy assassination.

Ragano states that, in July 1963, Hoffa sent him to New Orleans with a request for Marcello and Trafficante to have President Kennedy assassinated. When Ragano gave the message to the gangsters, he could tell that they didn't need convincing. He felt that it was already being planned. According to Ragano, Hoffa, upon hearing the news of the assassination, happily stated, "I told you they could do it. I'll never forget what Carlos and Santos did for me." Marcello was quoted as saying, "When you see Jimmy, you tell him he owes me and he owes me big."

Ragano states that on March 13, 1987, four days before he died, the seventy-two-year-old Trafficante had a conversation with him in which he said in Italian, "That Bobby made life miserable for me and my friends. Carlos fucked up. We shouldn't have killed John. We should have killed Bobby." Blakey's opinion was that Ragano and Trafficante were telling the truth about what they each knew and remembered.

In September 1962, just slightly over a year before the assassination, Trafficante told associate José Aleman, "This man Kennedy is in trouble, and he will get what is coming to him. He's not going to make it to the election. He is going to be hit." At about the same time, Carlos Marcello was in constant fear of being deported. He had never bothered to become a United States citizen and had been kicked out of the country by Bobby Kennedy on April 4, 1961. He had returned to New Orleans, filled with hate for both Kennedys. Marcello was living in the shadow of permanent deportation. During a "business meeting," after a few too many drinks, he let it be known to undercover detective Ed Becker and others that he "was going to have President Kennedy murdered" and that he was "setting up a nut to take the blame."

Left: Joseph Civello, a Dallas Mafia boss, had a connection to Ruby, but the Warren Commission hid the link.

Above: Mob boss Santos Trafficante.

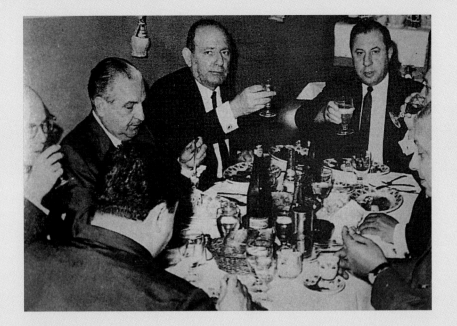

Above Left: Mob Lawyer Frank Ragano (right) linked his boss Jimmy Hoffa with Carlos Marcello (left) and Santos Trafficante (center) in the assassination conspiracy. The three mobsters all had the motive, opportunity, and means to kill the Kennedys.

Above Right: Chicago crime boss Sam Giancana was killed before he could testify about the assassination.

Left: Santos Trafficante.

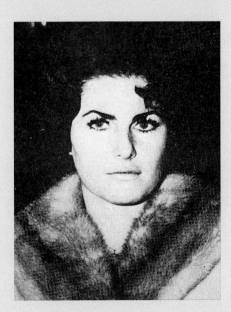

Right: Johnny Roselli was involved in the CIA/Mafia plots to kill Castro. He was murdered.

Above: Judith Campbell, a friend of Giancana, was introduced to JFK by Frank Sinatra in 1960.

It is highly probable that Lee was the "nut" Marcello was referring to and that he was being set up by Guy Banister, Clay Shaw, and David Ferrie. But were they working only for Marcello?

The Banister organization could have learned about Lee from either Lee's uncles Dutz Murret and John "Moose" Murret or Ferrie. After Lee had been arrested in New Orleans, it was Nofio Pecora, an associate of both the Murrets and Marcello, who bailed Lee out of jail. Telephone company records show that Jack Ruby called Pecora three weeks prior to the assassination.

In the final analysis, individual elements of organized crime were certainly involved in the assassination. But the Warren Commission, the national news media, and all of the other elements of the conspiracy almost certainly could not have been controlled by a handful of gangsters for the more than thirty years that have followed. It took more power and political influence than even Trafficante and Marcello had to pull that off.

To paraphrase Professor Blakey, "The mob did it, it's a historical truth"—but they were not alone.

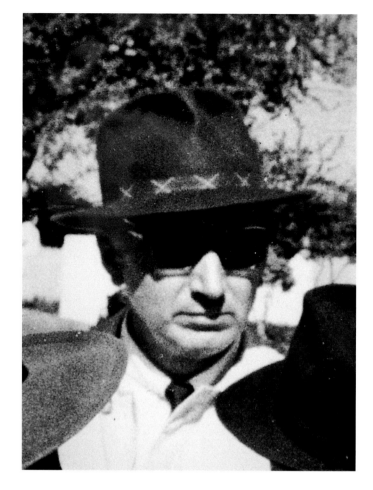

Above: Arrested in Dealey Plaza and questioned, Eugene Brading, a Mafia associate with thirty-five arrests, was present at both Kennedy assassinations.

Below Left: Teamsters President Jimmy Hoffa was the target of an investigation by the McClellan Committee that caused his mob ties to be exposed.

Below Right: Brading's file from the House Assassinations Committee remains suppressed.

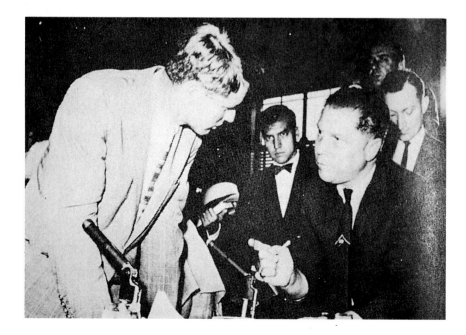

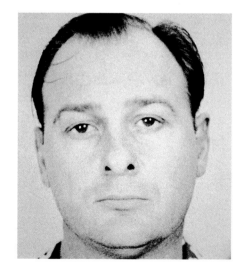

Anti-Castroites and the Ultra Right Wing

In New Orleans on the afternoon of November 22, 1963, the day John Kennedy was murdered, two men sat at a table in the Katz 'n' Jamer Tavern on the 500 block of Camp Street. One of them was Guy Banister; the other was Jack S. Martin, an investigator for Banister, part-time private detective, and police informant. Banister was being his usual aggressive, arrogant, and overbearing self.

They returned drunk to their office at 531 Lafayette Street, another entrance to the Newman Building at 544 Camp Street, the building where Oswald had set up his Fair Play for Cuba Committee headquarters. Banister accused Martin of having appropriated a file. Martin answered that he hadn't, but Banister, looking for a fight, kept pushing. Finally, Martin told his boss that he had noted several strange visitors recently at the office, including Lee Harvey Oswald, who had just hours before been arrested in Dallas. He enumerated the other visitors and told Banister he was aware of what it all meant. Banister drew his .357 Magnum revolver and proceeded to pistol whip Martin.

Martin was beaten so severely that he needed to be taken to Charity Hospital for medical assistance. A police report about the attack was filed. Angered and fearful after Banister's attack, Martin told a close friend that Banister and David Ferrie were involved in the conspiracy to assassinate President Kennedy. Martin said that Ferrie was the getaway man whose job was to fly the assassins away from Texas after the assassination.

Right: It was at the Katz 'n' Jamer that Guy Banister and Jack Martin discussed the assassination on the afternoon of November 22.

The Katz 'n' Jamer Tavern, lower left, which was a hangout for Guy Banister and his associates.

News of David Ferrie's trip to Houston, Texas, on the day of the assassination (flying through a violent thunderstorm, allegedly to go rollerskating) and the information that he had been an associate of Lee Oswald reached the New Orleans District Attorney's office through Jack Martin. Martin tipped off New Orleans Assistant District Attorney Herman Kohlman: "A former Eastern Airlines pilot named David Ferrie might have aided Oswald in the assassination." Martin had known Ferrie for more than two years. The two had done a job for Banister investigating a phony religious order in Louisville, Kentucky. Martin told Kohlman "that he suspected Ferrie might have known Oswald for some time and that Ferrie might have once been Oswald's superior officer in a New Orleans unit of the Civil Air Patrol." He also told Jim Garrison that Ferrie had instructed Oswald in the use of a rifle with a telescopic sight.

On November 25, Martin told the FBI that he thought he once saw a photograph of Oswald and other CAP members when he visited Ferrie's home and that Ferrie might have assisted Oswald in the purchase of a foreign firearm. He also told the FBI that Ferrie had a history of arrests and was an amateur hypnotist and possibly capable of hypnotizing Oswald.

In August 1968, Rev. Raymond Broshears, who had roomed with Ferrie in 1965, stated, "David admitted being involved with the assassin. There's no question about that. Ferrie was in Houston at the time Mr. Garrison has him in Houston, with an airplane waiting."

The FBI, probably through the intervention of Banister, instantly cleared Ferrie without investigation. Ferrie's name was never mentioned in the Warren Report.

Above: Jack Martin, who implicated Banister, Ferrie, and Shaw in the assassination.

Below: Martin gave the first lead to the New Orleans contingent of the conspiracy.

Left/Above/Right: The myth that Ferrie and Lee had never met was exploded when witnesses who were with them both at the same time came forward in 1992. This amazing photograph presented by John Ciravolo shows Ferrie on the left and Lee on the right. They were at a Civil Air Patrol picnic in 1955 when the picture was taken.

Left: David Ferrie, whose own death was suspicious, took the secrets of the Kennedy assassination to his grave.

Right: Ferrie's life and death still remain mysteries decades later.

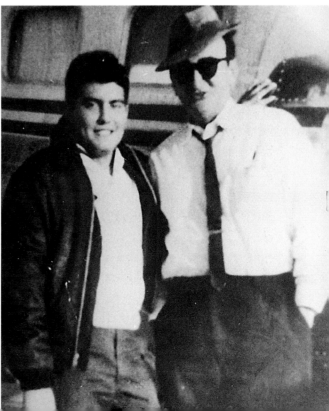

U.S. Intelligence and the Ultra Right Wing

In 1976, writer W. R. Morris broke the story of a man calling himself Harry Dean. Alleging to be a former agent of both the FBI and the CIA, Dean made a number of interesting accusations. Born in Cuba, Dean worked for both agencies from the late 1950s through the early 1960s and had been involved in the CIA's support of the overthrow of Fulgenio Batista by Fidel Castro in the days before the revolution. Dean joined Castro's guerrilla army and actively participated in Castro's "26th of July" movement, which succeeded in overthrowing Batista and bringing Castro to power. During this period, Dean was feeding information to the CIA about Castro's progress and activities. When he returned to the United States, he spied on the Fair Play for Cuba Committee for the FBI and the CIA. He became the secretary of local committees in Los Angeles, Chicago, and Detroit.

Dean stated, "Lee Oswald was definitely an undercover agent working for the United States. According to many reliable sources, Mr. Oswald knew Jack Ruby." Dean, who knew Oswald and said that he held the same position and did the same type of work for both the CIA and the FBI as him, had infiltrated the John Birch Society and learned of a plot to kill President Kennedy. Dean reported that the plot involved Major-General Edwin Walker.

If Dean was correct about Walker's involvement, which had been independently confirmed by Jack Ruby under oath in 1964, then the supposed April 1963 rifle attack on Walker could very well have been the sham it is believed to be by many researchers. It is known that Walker felt that President Kennedy was a communist.

Walker, a devout racist, was arrested as a civilian by federal officers in 1962 in Oxford, Mississippi, for conspiracy and for interfering with U.S. marshals in

Above: This letter to a "Mr. Hunt" from Lee Oswald remains a mystery. Was it E. Howard Hunt or Dallas oilman H. L. Hunt?

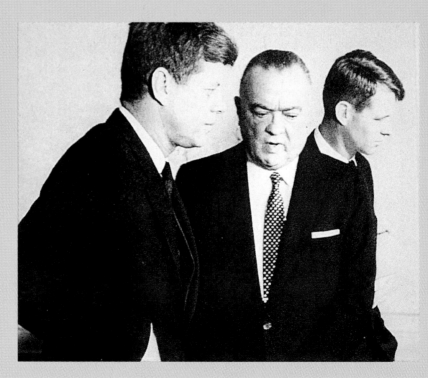

Below: J. Edgar Hoover hated the Kennedys. The president's death enabled Hoover to remain in his powerful job.

the performance of their duties when he attempted to block the enrollment of James Meredith as the first black student at the University of Mississippi. After his arrest he was placed on $100,000.00 bond and taken to a federal institution in Springfield, Missouri, where he was given a battery of psychiatric tests and found to be mentally incompetent. He blamed his arrest on President Kennedy and called it a "frame-up" instigated by the Kennedy administration.

Dean reported, "I attended many meetings of the John Birch Society prior to the assassination in 1963, and heard details of the Kennedy killing plan being discussed each time we met". Dean claimed that the right-wingers organized the murder plot and financed it. In addition Dean stated, "General Walker ramrodded and trained the hired guns. I was with a man in 1963 when he picked up $10,000...[that was to be taken] to Mexico City to help finance the murder of Mr. Kennedy. The assassination team worked out of Mexico City for several weeks before the President was shot in Dallas."

Dean stated, "Lee Harvey Oswald was not involved in the assassination of John F. Kennedy. Like myself, he worked for the FBI and the CIA and gathered information about the Kennedy murder plans. He was on the payroll of the United States Government when the President was shot to death on November 22, 1963. Oswald was framed by...Walker and other conspirators of the Kennedy assassination plot. Walker and two of his Army sharpshooters met regularly to discuss the plans for the actual shooting of Mr. Kennedy....The gunmen were being groomed under the personal hand of General Walker."

Lee, according to Dean, "was a U.S. spy for several years. While in the Marines, Oswald worked with the CIA to overthrow forces in Indonesia, [was working for] CIA operations in the Philippines, and was with the American undercover operations in Taiwan." Later he "defected to Russia where he was denouncing [sic] his American citizenship. This was a curtain to protect Oswald's real identity as an American undercover agent. When Lee returned from Russia, he worked

Left: The FBI's number three man, William Sullivan, believed in an Oswald-U.S. intelligence link. He died in a shooting incident in 1978.

Right: CIA man Gary Underhill investigated the assassination. He was killed, shot in the head.

closely with Guy Banister, a FBI-CIA agent, who operated a 'private detective' agency in New Orleans. Banister's office was actually a front for CIA operations."

Dean stated that Lee was completely innocent of the murder and was silenced to keep the lid on the crime. He has a great deal of sympathy for Lee and his family and sent flowers to his grave: "I often feel that I could be in a mound of clay somewhere instead of Lee Oswald. The same thing that happened to him could very well have happened to me."

Dean added that Lee was framed by the conspirators after they discovered that he had reported their assassination plans to government agencies. Lee had pretended to be a sympathizer with the conspirators and was present at several meetings where the impending assassination was being discussed. He gathered as much information as he could and turned it over to the FBI.

There are two known times Lee could have passed information he had obtained about the assassination conspiracy to the FBI. The first was after his arrest in New Orleans on August 9, 1963, when he requested and was granted an interview with FBI agent John Quigley. The second was when he brought his note to the FBI on November 5, just a little over two weeks before the assassination. The note could have been a report on the assassination conspiracy. If it wasn't, why did J. Gordon Shanklin order James Hosty to destroy it two hours after the murder of Oswald by Ruby on November 24, 1963? Dean stated that the note was in fact "a personal and confidential message from Oswald about the assassination plans."

According to Dean, the original plan called for the president to be shot at or near the Trade Mart, the motorcade's destination, where the president was to give a luncheon speech at the time of the assassination. He explained, "Oswald had attended several Birch Society meetings under a false name. He knew the assassins planned to kill John Kennedy at the Trade Mart Center and he passed the information on to the proper authorities. The Birchers found out about Oswald and were very angry. They considered him a devout Communist because he had defected to Russia and had been connected to the Fair Play for Cuba Committee. The Birchers were thrilled at the opportunity to frame a lousy little Communist."

Dean stated that after the conspirators realized Lee had revealed their plan, they changed the assassination site to the Texas School Book Depository in order to frame him: "If the assassins had attempted to shoot Mr. Kennedy at the Trade Mart, they would either have been killed or captured because the whole area was crawling with federal officers who were heavily armed. Lee Harvey Oswald, working as a federal security agent, had performed his job well."

Lee, according to Dean, would have been caught by surprise when the assassination took place in front of the book depository. He would have been convinced that his warning would have prevented the assassination, which as far as he knew was still set for the Trade Mart. Lee probably "realized that he was being framed when officers rushed into the book building and, for this reason, he quickly left the area. An agent, regardless of the situation, is on his own. The agency he is working for at the time will not come to his rescue. It would be too embarrassing for the agency."

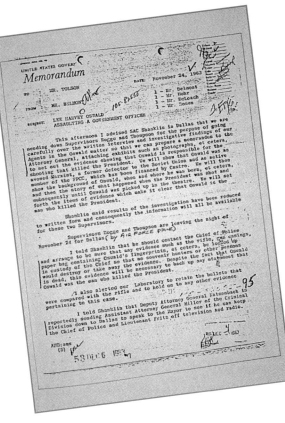

Left: This FBI report, dated November 24, the day Lee was murdered, lays out J. Edgar Hoover's plan...

Right: ...to have Lee named as the lone assassin before the investigation had even begun.

Below: James Hosty, the Dallas FBI agent assigned to Lee Oswald, was told by his boss, J. Gordon Shanklin, to destroy Lee's note to him.

Right: Even early FBI documents refer to Lee by the code name "IS - R."

Right: "IS - R" stands for Internal Security - R.

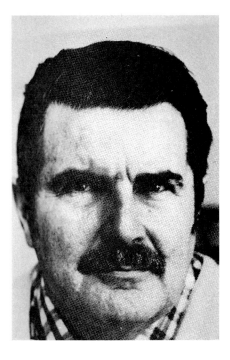

Because so much information and documentation about Lee has been withheld from public view, and since the national news media have never probed into his past, there is no way to verify all of Harry Dean's story, but it makes a great deal of sense. If Lee had been making a political statement or looking for a place in history, why would he deny killing Kennedy? When he was arrested in the Texas Theatre, he was reported to have said, "Now everyone will know who I am." Did he mean that his cover as an agent was blown?

Dean claimed to know the identities of two of the four triggermen. The names are not new to researchers of the Kennedy assassination but undoubtedly are new to the general public. One was Loran Eugene Hall, a Latin American who was jailed by Fidel Castro for plotting against him. Hall has a long criminal record in the United States. In 1963, as Lorenzo Pascillo, he founded the Anti-Castro Commando Group and worked with David Ferrie, whom he named to lead it. Hall was also a member of the paramilitary group "The Minutemen," along with Joseph Adams Milteer (see *The Killing of a President*).

Hall told Jim Garrison that he had attended several meetings of anti-Castro groups where people would discuss the need to murder President Kennedy. He was quoted by several witnesses as saying, "President Kennedy should have been assassinated after the Bay of Pigs and Cubans should have done that, because he was the one that was holding the freedom of Cuba in his hands."

Dean said that Hall had been a paid informant for both the CIA and the FBI. "Hall was never on the payroll, but he was paid for the information he gave to the FBI and the CIA about Castro's activities in Cuba."

Hall admitted to the FBI after the assassination that he had been in Dallas at the time of the murder but denied personal knowledge of the killing. He also admitted to investigators that it was he who had gone to Silvia Odio's apartment in Dallas in September 1963. He further stated that the two men who were with him were Lawrence Howard and William Seymour (see page 79). Hall used the name Leopoldo and and claimed that it was Billy Seymour he introduced as Leon Oswald.

The second of the four triggermen, according to Harry Dean, was Eladio Cerefine del Valle, nicknamed Yito. A congressman and city councilman in Cuba under Batista's regime, he had escaped from Cuba one week before Castro came to power on January 1, 1959, and was the leader of the Free Cuba Committee in Florida. He was a smuggling partner of Santos Trafficante and had hired his close friend David Ferrie to fly him into Cuba on several raids. Ferrie was paid $1,000.00 per trip if the mission was to fire-bomb sugarcane fields and $1,500.00 to land on a deserted road to pick refugees up and fly them back to America.

On February 22, 1967, as he was about to be arrested for conspiracy in the murder of President Kennedy, David Ferrie died in his apartment of what was termed a cerebral hemorrhage. There were two typed but unsigned suicide notes found at the scene, along with approximately fifteen empty pill containers. The postmortem photographs show fresh, deep abrasions inside Ferrie's lower lip, indicating severe force applied to his lower face just prior to death. It is believed that he was forced to ingest an overdose of Proloid, which could have easily induced a cerebral hemorrhage.

On the same day and almost at the same time, Eladio del Valle, whom David Ferrie had referred to as his CIA paymaster, was murdered, shot in the heart at point-blank range, his head split open by a blow from an axe, a hatchet, or a machete. His body was found sprawled inside his late-model Cadillac in a supermarket parking lot in Miami. A close friend of del Valle, Diego Gonzales Tendera, is convinced that del Valle was murdered because of his involvement in the conspiracy to kill President Kennedy.

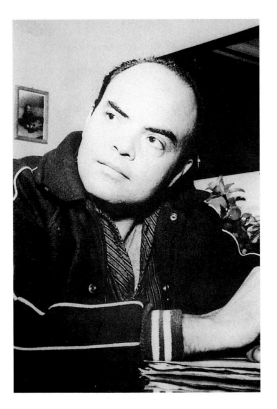

Left: Eladio del Valle, whom David Ferrie called his CIA paymaster, was murdered a few hours after Ferrie died. Jim Garrison was trying to find him for questioning at the time.

Above: David Ferrie's living room, with his pilot's cap on the coffee table.

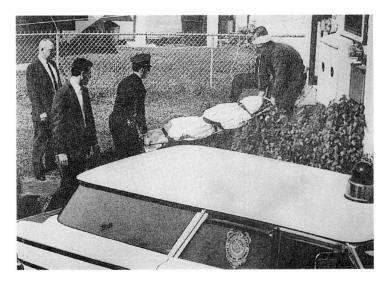

Right: The window in David Ferrie's bedroom.

Above: Ferrie's body being removed from his house on February 22, 1967, by coroner's office personnel.

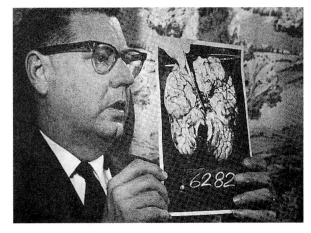

Right: Dr. Nicholas Chetta, the coroner of New Orleans, shows a photograph of David Ferrie's brain and the hematoma that was related to his death.

U.S. Intelligence and Anti-Castro Cubans

Antonio Veciana was a founder of the violently anti-Castro guerrilla group Alpha 66. In March 1963, Alpha 66 attacked Soviet vessels docked in Cuba, leading to President Kennedy's order to curtail Cuban exile activities. The action also followed on the heels of the Cuban missile crisis, when President Kennedy had agreed to stop invasion plans and attacks against Castro's Cuba in exchange for the removal of Soviet atomic warheads from Cuba. The attacks threatened to ignite an international crisis between the United States and the Soviet Union. In an attempt to curtail the problem, the Department of State voiced "strong opposition" to the actions of Alpha 66 and other anti-Castro groups. The president confirmed the position. However, on March 26, Commando L, a group from Alpha 66, struck again and attacked a Russian ship. The Soviets protested strenuously, as did Castro, and President Kennedy disavowed any connection with the attacks. Certain members of the exile leadership held a press conference in Washington, D.C., to advertise publicly what they had done, which made it appear, to some, that they had the backing of the government. Antonio Veciana and others were rounded up and placed in a confined area in Florida, where their movements were restricted. These passionate, angry, and frustrated nationalists were being prohibited from trying to regain their country, and the target of their anger was rapidly shifting from Castro to President Kennedy. In 1976, Veciana testified before the Senate Intelligence Committee and revealed that the true power behind the Cuban raids was the CIA, which had been instigating, training, and funding the activities of the exiles and deliberately sabotaging the president's attempts to end the cold war and to reach a mutual agreement with the Russians.

Veciana said that when Alpha 66 attacked the Russian boats in Cuban ports, they were acting under the instructions of a man called Maurice Bishop, the code name for the CIA handler who had been assigned to him—actually David Atlee Phillips, CIA chief of Cuban operations in Mexico City, according to Veciana. Bishop had also arranged the Washington press conference and was responsible for the exiles' program of defying the president's hands-off policy with their continued attacks. "It was my case officer, Maurice Bishop," Veciana said, "who had the idea to attack the Soviet ships. The intention was to cause trouble between Kennedy and Russia. Bishop believed that Kennedy and Khrushchev had made a secret agreement that the U.S.A. would do nothing more to help in the fight against Castro. Bishop felt—he told me many times—that President Kennedy was a man without experience surrounded by a group of young men who were also inexperienced, with mistaken ideas on how to manage this country. He said you had to put Kennedy against the wall in order to force him to make decisions that would remove Castro's regime. This is why we made the assaults on the Soviet ships and then called the press conference in Washington—to try to force Kennedy to take action. My case officer's function in the CIA was to perform dirty tricks." Veciana said that Bishop was "a man who did not leave tracks. He never did like to leave tracks and he taught me not to leave a trail."

The House Select Committee on Assassinations had a great deal of interest in Antonio Veciana, Maurice Bishop, and David Atlee Phillips. Phillips, who died of cancer in 1988, despised President Kennedy and was seen with Lee Oswald in Dallas shortly before the assassination by Veciana.

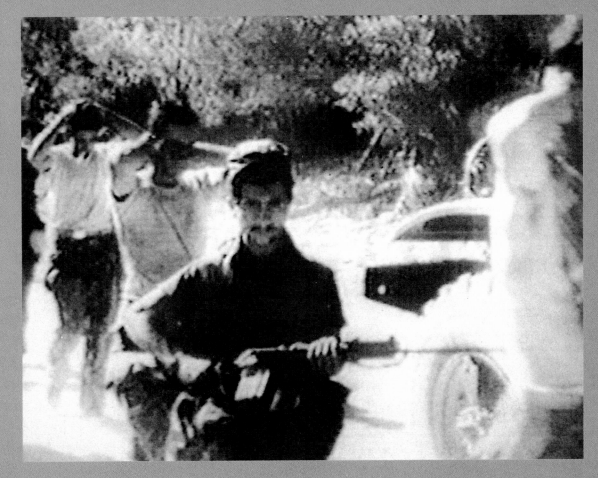

Right: The Bay of Pigs invasion and its failure angered both Fidel Castro and his enemies.

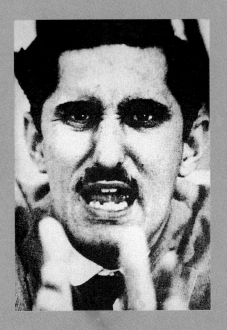

Above Left: Antonio Veciana said CIA man David A. Phillips was Maurice Bishop, Lee's CIA controller.

Above Center: A drawing of CIA intelligence officer Maurice Bishop based on Antonio Veciana's description.

Above Right: David Phillips.

The Cuban Connection

The April 23, 1976, publication of the Report of the Senate Select Committee to Study Governmental Operations with Respect to Intelligence Activities provided a greatly needed measure of hope for critics of the Warren Report. Its authors, the Church Committee, were a group of U.S. senators charged with investigating American intelligence excesses in the United States. The Church Report backed the notion that Fidel Castro, through infiltrators planted in the Cuban exile movement, had ordered the murder of President Kennedy in retaliation for attempts on Castro's life, and for the raids on Cuba originating from the United States. The report represented the first release of details concerning U.S. plots against Castro and his warnings of retaliation against President Kennedy, information that had been shown in 1963 to Lyndon Johnson and Earl Warren, who feared that, if the public was to become aware that Castro was the prime suspect behind the assassination, Johnson would have no other choice but to retaliate against Cuba. Castro would, as a matter of survival, have to request aid from the Soviet Union. Khrushchev could not possibly refuse after he had backed down at the Cuban missile crisis. The result could have been war. This is why the Warren Commission buried all evidence of a Cuban connection.

The Warren Report had declared that there had been no involvement by the Castro government in the assassination of President Kennedy. They did not, however, rule out the prospect that Lee had assassinated the president on his own, acting as a vigilante for Castro. The vigilante scenario was an attempt to provide a motive for a lone assassin.

During the Kennedy administration, the CIA had contracted with both the Mafia and Cuban exiles in waging a secret war against Fidel Castro. Both the president and Robert Kennedy had stayed away from these unholy alliances in the wake of the Bay of Pigs fiasco and the Cuban missile crisis. However, the CIA, with mob support, backed the Cuban exile paramilitary groups in their raids against Cuba, and the CIA had continued its assassination attempts against Fidel Castro, until the moment of John Kennedy's assassination.

The Kennedy brothers didn't know it, but the CIA's chief of special affairs, Desmond Fitzgerald, had arranged a meeting between CIA Officer Nestor Sanchez and Dr. Rolando Cubela (whose code name was AM/LASH) in Paris on the day of the assassination. Cubela was to give Castro a pen that would inject him with an undetectable and fatal poison. For two years, Cubela had offered to defect to America to help fight Castro, but the CIA asked him to stay in Castro's inner circle, where he could do the most good.

On September 7, Cubela had contacted the CIA and offered to assassinate Castro himself. Fitzgerald headed the station responsible for U.S. attempts to overthrow the Castro government, code named JM/WAVE. Castro was somehow tipped off to the plot, and on the same day, at the Brazilian embassy in Havana, he gave an interview to Associated Press reporter Daniel Harker. Commenting on Cuban exile activity against him, he warned, "We are prepared to fight them, and answer in kind. United States leaders should think that if they are aiding terrorist plans to eliminate Cuban leaders . . . they themselves will not be safe." Two and a half months later, John Kennedy was dead.

As the former CIA director, all of this information was known to Warren Commission member Allen Dulles. Unforgivably, Dulles did not reveal what he knew, and the Warren Commission published its report without the slightest notion that this motive for the assassination of President Kennedy as retaliation existed. There is also no mention, among the ten million words in the Warren Commission volumes, of CIA or Mafia plots to murder Fidel Castro. The Church Committee was the first to reveal these facts a dozen years later.

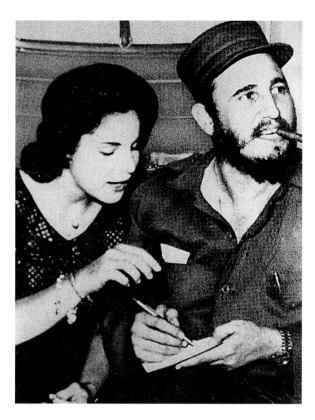

Left: Marita Lorenz with Fidel Castro.

Left: Marita Lorenz was recruited by the CIA to poison Castro, her former lover.

Right: Rolando Cubela, alias AM/LASH, who was to try to kill Fidel Castro for the CIA.

Above: Fidel Castro's September 1963 threat against President Kennedy's life, reported by Daniel Harker, of the Associated Press.

Below: Allen Dulles knew of the Castro connection but never told the other Warren commissioners.

THE EVOLUTION OF LEE HARVEY OSWALD

From age 2 to age 24, the face of "Lee Harvey Oswald" underwent many puzzling changes. The smiling freckled boy who evolved into an alleged presidential assassin was indeed a man of many faces...thick curly hair to receding straight hair...thick neck to thin neck...square chin to pointed chin. Who was Oswald? Why do some photos of him look so different than others? Several photos seem to be clever composites...why? Is the "birth Oswald" the same person as the "historical Oswald", or did one assume the identity of the other? How many "Oswalds" were there, and why? You be the judge.

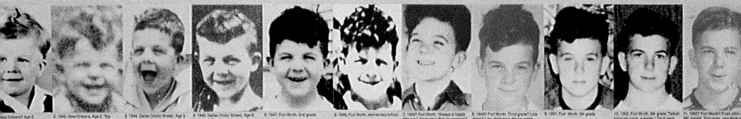

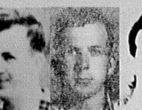

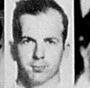

19

TOO MANY
OSWALDS

Lee Harvey Oswald's life story is almost too convoluted to be believed. We are told that he started out as a street kid with mob connections in New Orleans. Soon he was a Marxist-to-be suspended from that same class for refusing to salute the American flag. Later in his youth, he became a patriotic Civil Air Patrol cadet whose goal was to join the marines. As a marine radar operator he worked at a base that supposedly was an operating point for U-2 covert flights. Yet as a marine he espoused Marxism to mysterious women companions in expensive Japanese bars. He was, in all probability, an agent of the Office of Naval Intelligence who received Russian-language training at El Toro prior to being sent to Russia. Soon, he turned into a Soviet defector who was treated like a prince by the Russian bureaucracy, his wife, and the KGB. Yet as a repatriated American, he was welcomed with open arms by the Russian community in Dallas. As a militant activist he openly proclaimed his support for Fidel Castro; at the same time he was covertly involved with the most rabid anti-Castro paramilitary group in America. Finally, he was the silenced patsy in the plot to assassinate the president of the United States. There appears to have been more than one Lee Harvey Oswald. He seemed to possess a number of different personalities and lives, many working at cross-purposes.

Left: **This poster, created by assassination researcher Jack White, shows the many faces of Lee Harvey Oswald. It also suggests the very real possibility that there may have been more than one person using the name.**

Sightings

The idea that more than one person might have been using Lee Oswald's identity began years before the assassination with J. Edgar Hoover. Hoover's concern was that the Soviets might send a counterfeit Oswald back. This is but one possibility. There are others.

The Warren Commission's volumes of evidence and testimony are full of hints that not only were others using Lee's identity but that there may have been more than one Lee Oswald going all the way back to the 1950s.

When Lee and his mother moved back to New Orleans after leaving New York and Lee ran into his old friend Richard Warren Garrett, Garrett noticed a massive personality change in Lee, as well as unexplained physical changes (see chapter 1). Former marine Sergeant Godfrey "Gator" Daniels remembered, "When we were at Atsugi, Lee used to come back to the barracks sometimes late at night very drunk. He would wake us up by shouting at the top of his lungs, 'Save your Confederate money, boys! The South will rise again!'" In contrast, the only drink Lee is known to have taken in the time he and Marina were married was just after the birth of their first daughter. It is a Russian tradition to have a session of hard drinking to celebrate such occasions, but Lee's friends had to goad him into the traditional vodka-fest.

Many researchers believe the possibility that the "Oswald" who returned from the Soviet Union was a different man from the one who got the early discharge from the marines and pretended to defect to the other side. They point out the obvious changes in Lee's appearance. So obvious in fact, that members of his own family noticed as well. Robert Oswald observed that Lee had lost a lot of hair and that he was much thinner. There is also evidence that he was two inches shorter when he came back to the United States than when he departed. When he was arrested, he was measured by the Dallas police as 5'9", while his Marine Corps identification card, which he was

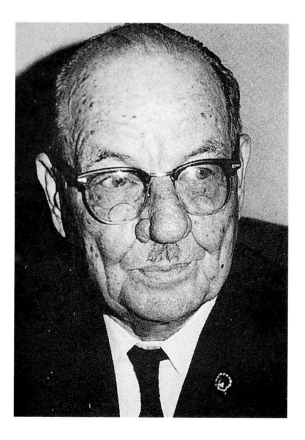

Above: Someone using Oswald's name while he was living in Russia ordered trucks for an anti-Castro group.

Right: Truck salesman Oscar Deslatte met with someone who tried to buy trucks in Oswald's name.

Left: Samples of Lee's signature from different documents. Some are the same, but many vary.

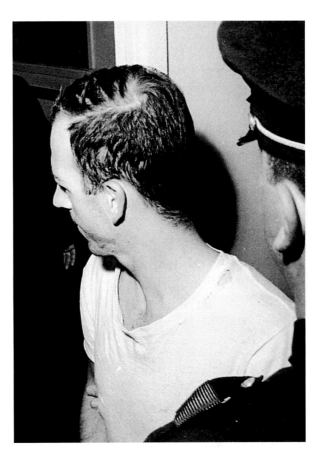

Above: Lee at police headquarters. Note the lack of a mastoid operation scar or depression.

Right: Lee had a three inch mastoid scar behind his left ear from a 1945 operation. His Marine Corps record reporting the mastoid scar.

carrying at the time of his arrest, lists his height as 5′11″. While many of the reported heights for Lee are 5′9″, just as many are 5′11″, and these descriptions alternate. This is one reason to believe that there may well have been more than one Lee Oswald.

There are numerous reports of Oswald "sightings" in and around Dallas during the weeks prior to the assassination, and in Oklahoma, Florida, and Mexico City as well. On January 20, 1961, at the time of the CIA-run and -financed Bay of Pigs invasion, an American accompanied by a Cuban exile negotiated a deal to buy ten pickup trucks from Bolton Ford on Canal Street in New Orleans. The manager of the dealership, Oscar Deslatte, recalled the name Oswald after the assassination and found the paperwork on the transaction in their files nearly three years later. The American originally gave his name as Joseph Moore but said that the paperwork should list his last name as Oswald. Written on the order form is the name Oswald. Joseph "Oswald" Moore asked Deslatte to give him a "good price [for the trucks] because we're doing this for the good of the country." He was representing the Friends of a Democratic Cuba, an anti-Castro, anticommunist organization. At this exact point in time, the genuine Lee Oswald was halfway around the world in Russia. Two leading members of the Friends of a Democratic Cuba were Lee Oswald's former employer Gerard Tujague and his probable future employer Guy Banister.

In 1975 the Senate Intelligence Committee took testimony from an unnamed former immigration inspector from New Orleans who said that he was certain he had interviewed Lee Harvey Oswald in a New Orleans jail sometime before April 1, 1963. Uncertain whether the prisoner was using the name Oswald, he was sure "Oswald" claimed to be a Cuban alien. He could tell that he was not in fact a Cuban alien and therefore ended the interview. The interview occurred prior to Lee's trip to New Orleans late in April 1963.

On September 25, 1963, someone identifying him-self as Harvey Oswald appeared at the Selective Service office in Austin, Texas, stating that he had been discharged from the marines under "less than honorable conditions" and wanted to have his discharge upgraded. He mentioned that he was registered as a serviceman in Florida, which was the center of anti-Castro Cuban exile operations in the United States. The real Lee was registered in California. Recall that on September 25, 1963, another Lee Oswald was ostensibly on his way to Mexico City by bus. This is the same day that Silvia Odio allegedly met "Leon Oswald" in Dallas (see boxed text on page 79).

In October, just as Lee had returned to Dallas from New Orleans, possibly via Mexico City, three men were discovered firing a rifle on private property outside Dallas owned by Mrs. Lovell Penn. Penn asked them to leave. One of the men resembled Lee, and another was "Latin, perhaps Cuban." The Cuban reference is interesting since it occurred more than a decade before the public was informed of a Cuban connection. Penn found a 6.5-millimeter Mannlicher-Carcano bullet shell on her land. After the assassination, she turned it over to the FBI. The FBI tested the cartridge case and found that it had not come from the rifle that was reportedly found in the Texas School Book Depository.

On October 13, a man "identical" to Lee appeared at a meeting of Directorio Revolucionario Estudiantil (DRE), a student revolutionary anti-Castro organization. At the same meeting was Major-General Edwin Walker, allegedly the assassination target of the real Lee back on April 10.

Hubert Morrow, the manager of the Allright Parking Lot at the Southland Hotel in downtown Dallas, remembered a man who called himself Oswald and asked about a job as a parking lot attendant. Morrow originally wrote the name down as "Lee Harvey Osborn" but was told by the job applicant that the name was Oswald. The real Lee rarely used the Harvey and referred to himself as Lee Oswald. The applicant asked Morrow an odd question. He wanted to know

Left: Deputy Sheriff Roger Craig saw this Oswald double get into the green station wagon on the right.

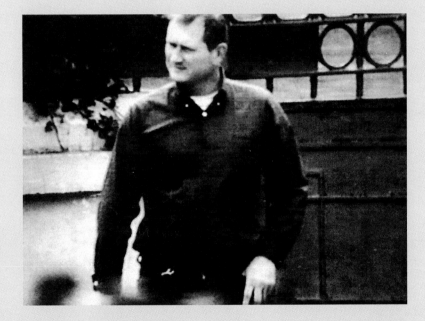

Above Left: The Oswald Mexico City impostor photographed by the CIA in October 1963.

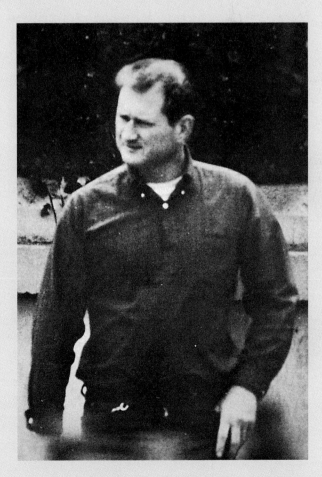

Above Right: The Mexico City Oswald photo, except, that in this version the background has been retouched. Why?

how high the Southland building was and if it had a good view of downtown Dallas.

At Morgan's gunshop in Fort Worth on November 1, a man who looked like Lee attracted a lot of attention by bragging about being an ex-marine while buying rifle ammunition. The real Lee was in Dallas the entire day.

In early November, a man resembling Lee showed up at a furniture store that had previously been a gunshop and still had the sign "Guns" displayed outside. With him were a wife and two children, one an infant. The wife never spoke. "Oswald" asked where he could get the firing pin of his rifle fixed. The Irving Sports Shop was suggested.

On November 4, Irving Sports Shop employee Dial Ryder waited on a customer who dropped off a rifle to have a telescopic rifle sight mounted and aligned. The name on the repair ticket, which the store retained, is Oswald. The Mannlicher-Carcano, Lee's alleged rifle and the only rifle linked to him, was shipped to him with the scope already mounted. When the rifle was found in the depository, the scope was hopelessly misaligned. Neither Ryder nor his employer could remember Lee. Someone else was using Lee's name to have work done on a weapon that was not Lee's. The rifle was picked up on November 8.

Starting on November 9, a man became the center of attention at the Sports Drome Rifle Range by firing at other people's targets. There were several such incidents, but the most important, and the first to be reported, occurred on November 16, 1963, six days before the assassination. Dr. Homer Wood and his thirteen-year-old son, Sterling C. Wood, were sighting their rifles at the Sports Drome when they struck up a conversation with the man in the booth next to theirs. The man—whom they later were sure was Lee, although he was a far better shot than Lee—volunteered that his gun was a 6.5-mm. Italian rifle with a 4-power scope. Sterling Wood remembered that the rifle projected a "ball of fire" when it was fired; he

also remembered a weapon different than the Carcano found in the depository.

On November 9, between 1:30 and 2:00 p.m., someone calling himself Lee Oswald entered the showroom of Downtown Lincoln-Mercury, a car dealership near the Texas School Book Depository in Dallas, and said he wanted to test drive a used Mercury Comet. The salesman, Albert Guy Bogard, was severely shaken by the test drive; the customer (who called himself Lee Oswald) drove the car recklessly at speeds up to eighty miles per hour on the Stemmons Freeway. Bogard recalled that "Oswald" said he didn't have the money to buy the car yet but that he would be getting "a lot of money in the next two or three weeks." Two of Bogard's co-workers confirmed his story, one adding that "Oswald" complained that the prices were too high and that he would probably need to go "back to Russia where they treat workers like men." One of the salesmen remembered that "Oswald" returned for a second time a few days before the assassination. The Warren Commission ignored this testimony. The real Oswald did not know how to drive and did not have a driver's license. The real issue, however, is that once again someone else was using Lee's identity and the Warren Commission chose not to pursue it as a topic of investigation.

After he testified to the Warren Commission, Al Bogard was severely beaten by a group of men and had to be hospitalized for quite a while. On February 14, 1966, at the age of forty-one, he was found dead in his car in a cemetery in Hallsville, Louisiana. A hose had been connected to the tailpipe and run into his car through a window. His death, like so many others related to the Kennedy assassination, was automatically ruled a suicide.

Two weeks prior to the assassination, Leonard Hutchinson, an Irving, Texas, supermarket owner, was asked to cash a check in the amount of $189.00 for someone identifying himself as Harvey Oswald. A barber whose shop was near Hutchinson's store gave a haircut to someone who looked like Lee and who

then went into Hutchinson's. The Warren Commission disregarded these sightings because Lee was not in Irving during the time mentioned by both men. Who, then, was calling himself Harvey Oswald?

Two employees of the Western Union Office in Dallas remember that someone using the name of Oswald had collected several money orders and had sent a telegram during the second week in November. He was accompanied by a man who appeared to be "Spanish." The money orders had been delivered to the YMCA. After the assassination, the FBI was unable to trace either the telegram or the money orders in Oswald's name. There is apparently no record of the amounts of the money orders.

On November 17, in Abilene, Texas, two hundred miles west of Dallas, photographer Harold Reynolds picked up a note that had been slipped under his apartment door. It had been intended for his neighbor, Pedro Valeriano Gonzalez, the president of a anti-Castro group, the Cuban Liberation Committee. The note read, "Call me immediately. Urgent." Two Dallas phone numbers were given. The note was signed "Lee Oswald." Reynolds gave the note to Gonzalez, who was quite nervous when he saw it. Although he had a phone in his apartment, Gonzalez proceeded to call Dallas from a street pay phone. Reynolds reported that he had seen a man who looked like Lee with an older man from New Orleans at Gonzalez's apartment. Gonzalez had a history of making anti-Kennedy statements. He left Abilene soon after the assassination and turned up in Venezuela. Could it have been Lee that Harold Reynolds saw in Abilene? If not, who was it? How could he have gotten there and back? Why would he have gone there? Who was the older American from New Orleans? David Ferrie? Clay Shaw? Guy Banister?

Another revelation of a false Oswald was reported on the first installment of the 1975 CBS television miniseries *The American Assassins*, during which an interview with ex-gunrunner Robert Ray McKeown by Dan Rather was shown. McKeown said he received a visit from "Lee Harvey Oswald" a few weeks before John Kennedy's murder. The man claimed that he was

Below Left and Right: **More shots of the Oswald Mexico City impostor photographed by the CIA in October 1963. This set of photographs, taken over a period of several days, was withheld from the Warren Commission by the CIA.**

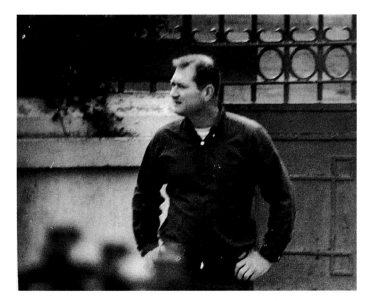

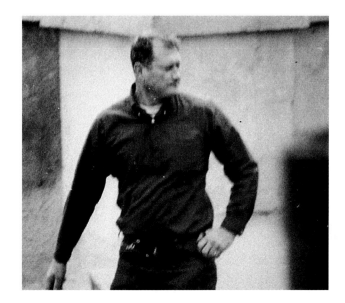

interested in buying bazookas and machine guns and intimated that he represented others. McKeown stated that a tall Latino named Hernandez accompanied "Oswald."

According to McKeown, "Oswald" was " . . . this little guy . . . small, blond-headed." Oswald was certainly not a small man. Nor did he have blond hair; it was brown. And what of his companion? Who was he? It is interesting to note that, on August 9, 1963, when Lee was arrested in New Orleans for fighting with three anti-Castro Cubans, one of these three men was a tall, Latin man with a mustache named Celso M. Hernandez.

It has long been believed that the New Orleans fight was staged to help establish Oswald's pro-Castroite cover story. If McKeown's Hernandez was the Hernandez arrested on August 9, it would either prove that Oswald and Hernandez were working together and that the New Orleans fight was staged for publicity value or that the McKeown "Oswald" was an impostor.

The former FBI and CIA agent known as Harry Dean stated that Oswald impostors were used by the conspirators to plant evidence against Oswald in Mexico, New Orleans, and Dallas. One was William Seymour, a man who looked enough like Lee Harvey Oswald to be his twin brother. Seymour may have posed as Oswald on countless occasions. Even after the assassination, many persons reported seeing Oswald at various places. Actually, according to Dean, the man parading around as Lee Harvey Oswald was "William Seymour."

The identification of Billy Seymour as one of the Oswald impostors surfaced during Jim Garrison's investigation of Clay Shaw in New Orleans in 1967–1968 and has never been properly investigated by any government body.

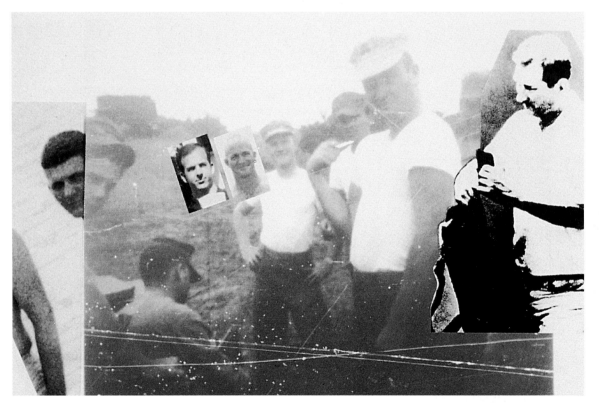

Left: **Dallas Policeman Roscoe White's chin is an exact match for the chin in the backyard photos.**

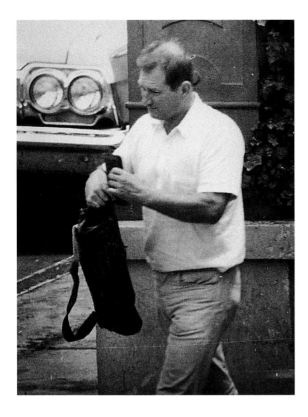

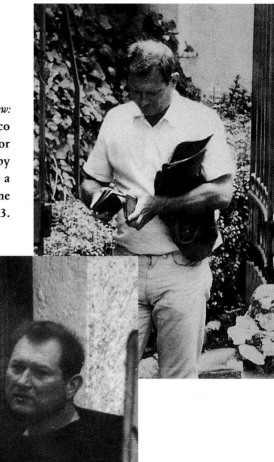

Left, Right, Below:
The Oswald Mexico
City impostor
photographed by
the CIA a
second time
in October 1963.

Left: The Oswald
Mexico City impostor
photographed on a
third occasion by the
CIA, October 1963.

The Manchurian Candidate

In 1978, Edward Jay Epstein, in his book *Legend: The Secret World of Lee Harvey Oswald*, published information given to him by CIA Chief James Angleton. Angleton believed in the KGB-controlled "Manchurian Candidate" scenario involving Oswald. He claimed to believe that Lee's communist beliefs were genuine but that, while living in Russia, Lee fell under the spell of the KGB and was trained by them as a double agent to be used when he returned to America. Angleton never claimed that the KGB was behind the assassination but rather that, in Dallas or New Orleans, Lee had cracked and had gone into business for himself.

Angleton's personal involvement in this story was quite deep. When Soviet defector Yuri Ivanovich Nosenko told the CIA that he had handled and read Lee's KGB file and that no records were in the file relating to any Soviet intelligence training of Lee, Angleton mistrusted Nosenko and believed that the defector was providing Lee (and the Soviets) with a cover story. Angleton put Nosenko under CIA house arrest, in the spring of 1964, for "intense interrogation," which lasted for four years. He was placed in what amounted to solitary confinement in a windowless, padded cell and was given and failed (undoubtedly due to the stress of his horrible situation) several polygraph tests. J. Edgar Hoover and Angleton's boss, Richard Helms, claimed to believe Nosenko, but Angleton and the entire counterintelligence section didn't. They were convinced that Lee was a Soviet-trained assassin and that Nosenko was sent to America to hand the Warren Commission false information regarding Lee's relationship to Soviet intelligence.

In light of the cruel treatment that Nosenko received, it is even more curious that Lee was officially ignored upon his return from Russia.

British attorney Michael Eddowes, in his 1977 book *The Oswald File*, expounded another theory about Oswald. Eddowes believed that the man who came back to America was a KGB agent who was a double for Lee Oswald. He proposed that this Oswald was a sleeper, a psychologically controlled assassin, and that the real Lee Harvey Oswald had never returned from the Soviet Union (if indeed the real Oswald had been the defector in the first place).

Based largely upon Michael Eddowes's scenario, Marina Oswald allowed Lee's body to be exhumed on October 4, 1981. The corpse was taken to Baylor University, where, based solely upon dental records, forensic pathologists pronounced that it was indeed the body of Lee Harvey Oswald.

Left: French Secret Army Organization terrorist and assassin Jean Souetre, a k a Michel Mertz and Michel Roux, was expelled from Dallas less than forty-eight hours after the assassination, according to CIA document #632-796.

Above: Lee introduced this man to Marina as "Alfred of Cuba." Was "Alfred" another alias for Jean Souetre?

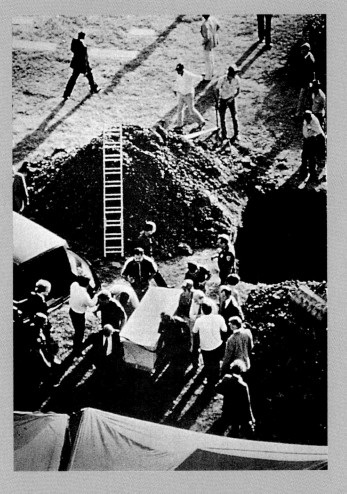

Left: Lee is exhumed. The body did not have a craniotomy, but the man shot by Ruby did.

20

THE LEGACY
OF DOUBT

Why has the Warren Commission version of Lee's life and death persisted as the official story, reported in history books and taught in schools? Why didn't this official version raise and investigate the questions that we have asked in this volume? And why do the government and the media, to this day, disdain the work of an important cadre of researchers on the conspiracy?

In retrospect, it seems that the conspirators achieved one of their two major goals. They eliminated the power of the Kennedys (but failed to eliminate Castro). They also gained two fringe benefits for which they hadn't bargained. First, even if the government, in its final analysis of the assassination, ignored any involvement on the part of Fidel Castro, it did ultimately go along with the account of Oswald's role that the conspirators had hoped to create. Thus the government had a vested interest in keeping this version of the events as gospel. Second, the governmental agencies involved ran scared that the possible involvement of some of their members with Oswald would be disclosed. These two benefits assured the conspirators protection and years of freedom to carry out whatever plans they had.

More than three hundred major witnesses are dead. A number of the deaths were certainly due to natural causes, but the vast majority were the result of violence. Among them are unsolved murders, so-called natural deaths without autopsies, deaths whose reported causes are highly suspect, and numerous "well-timed" suicides.

Although there is a long menu of suspected killers in these deaths, it would clearly be absurd to believe that any of the possible groups (the Central Intelligence Agency, the ultra right wing, anti-Castroites, Cuban exiles, the military, the mob, the FBI, or the Dallas Police Department) suspected of complicity in the Kennedy assassination and conspiracy were formally involved as entire organizations. But individual members of these groups *did* help plan and carry out

the killing of President Kennedy; some participated in the cover-up; some assisted in the murder of Oswald; and others eliminated many of the witnesses who are now dead.

Law-enforcement and intelligence officials frequently have no idea of what others within their organizations are doing, which could explain the convincing, self-righteous indignation that arises whenever a new piece of evidence surfaces, pointing a finger. Nonetheless, as Harry Dean has pointed out, "It would be embarrassing for the agencies to admit that Oswald was working for them, but it is time that the truth was told regardless of the consequence. They know that Lee Harvey Oswald did not kill John Kennedy."

Certainly, as the record shows, members of the Warren Commission and its staff stumbled upon countless elements of the truth, which they avoided or distorted. The American news media have helped allow the Warren Commission's monumental work of fiction to remain standing as the official story. There are four reasons why.

First, there are those who simply don't care who killed the president. Either they didn't like him or they feel that, since the man is dead and no one can bring him back, the subject should be left alone. Besides, as many discovered with the deaths of Dorothy Kilgallen (the only reporter to privately interview Jack Ruby after he shot Oswald) and Dallas assassination researcher Lou Staples, it can be very unhealthy to pry open locked doors in the Kennedy case.

Second, a few actually believe that Lee Oswald was the lone assassin. They tend also to believe that the government could not have been involved in sabotaging the 1967–1968 investigation of Clay Shaw conducted by Jim Garrison. Garrison was the only public official in the entire country who was doing what the government and the Warren Commission had never done: He tried to find out who killed the president of the United States. The CIA and the Justice Department actively mounted a ruthless campaign to destroy the Garrison investigation and, indeed, Garrison himself.

The third reason is the old adage "Once burned, twice cautious." After the CIA and the Justice Department successfully torpedoed the Garrison investigation, many in the news media who had reported on the investigation felt that they had been taken for a ride by Garrison and his group and would now disbelieve the most convincing of new evidence.

The fourth and most insidious reason was exposed in generalities in 1976 by the Schweiker-Hart Subcommittee when it finally revealed to the American people that many of this country's most famous and trusted news people were on the CIA's payroll and had been for many years.

The official assassination record has been one of cover-up from the moment President Kennedy was shot. The Warren Commission, the CIA, and the FBI conducted their own internal investigations. It wasn't until 1976 that the public was made aware of the cover-up practiced by the press. But the revelation that the nation's news media cooperated in suppressing information did not make the media any more honest or open. The cover-up continues.

And what of Lee? He remains a mystery wrapped in a riddle inside an enigma. Was he totally innocent—"just a patsy"—as he himself said? Did he have prior knowledge of the assassination? Who was Lee Harvey Oswald? We've searched for him. As Marina has said, "Lee was no angel." We've looked as hard as we can and have come up with one inescapable, undeniable fact: There is no conclusive proof that Lee Harvey Oswald assassinated President Kennedy. Did he know who did? That's the maddening question. We may never know these answers, but we have tried to find out.

The case is very far from closed.

SIGNIFICANT EVENTS IN THE LIFE OF LEE HARVEY OSWALD

October 18, 1939	Lee Harvey Oswald is born.
December 26, 1942	Lee is placed in the Evangelical Lutheran Bethlehem Orphan Asylum.
January 29,1944	Marguerite requests Lee's release from the Orphan Asylum.
May 1945	Marguerite marries Edwin Ekdahl and the family moves to Fort Worth.
Fall 1945	Lee starts the first grade at Benbrook Common School.
Summer 1946	Marguerite and Lee move to Covington, LA.
Fall 1946	Lee starts grammar school in Covington.
January 27, 1947	Lee enters the first-grade class at the Lily B. Clayton School in Ft. Worth.
January 1948	The Ekdahls permanently separate.
March 1948	Lee changes to the George Clark Elementary School to continue in the third-grade.
September 1949	Lee starts the fourth-grade at Ridglea West Elementary School, Fort Worth.
June 1952	Lee completes the sixth-grade at Ridglea.
August 1952	Marguerite and Lee move to New York City. That fall, Lee enrolls in Trinity Evangelical School, N.Y.
March 19, 1953	Lee is arrested for truancy in New York.
April 16, 1953	At Youth House for Boys, Lee is given a psychological evaluation.
May 7, 1953	Lee is released from Youth House.
January 1954	Marguerite and Lee move to New Orleans. Lee enters the eighth-grade at Beauregard Junior High School.
July 1955	Lee joins the Civil Air Patrol.
Fall 1955	Lee enters Warren Easton High and then drops out.
August 1956	Lee and Marguerite move back to Ft. Worth. Lee later enters Arlington Heights High School.

October 24, 1956	Lee joins the Marine Corps after attending high school for only 23 days. He is stationed in San Diego until April 1957.
May 2, 1957	Lee is promoted to private first class and, two days later, is sent to learn aircraft surveillance at Keesler A.F.B. in Biloxi, Mississippi. He receives a clearance of "confidential."
Summer 1957	Lee is stationed in El Toro, California.
September 1957	Lee is shipped to Atsugi Naval Air Station, Japan to act as as a radar operator. Oswald accidentally shoots himself.
November 1957	Lee's unit ships out for Subic Bay, Philippines.
March 1957	Oswald's unit returns to Atsugi.
April 11, 1958	For gun possession, Lee receives his first court-martial.
June 27, 1958	Oswald's second court-martial.
September 14, 1958	Lee is stationed on Taiwan for three weeks.
November 2, 1958	Oswald is sent back to the States. Lee takes a one month leave from the Marines.
December 21, 1958	Lee is reassigned to the Marine Base in El Toro, California.
February 25, 1959	Lee takes a Russian language proficiency test and applies to Albert Schweitzer College in Switzerland.
March 9, 1959	Lee is promoted to Private First Class.
March 23, 1959	Oswald receives his High School General Educational Development (GED) certificate.
August 17, 1959	Lee requests a hardship discharge from the Marines allegedly to help his mother.
September 4, 1959	Lee's early hardship discharge is approved and he applies for a passport.
September 10, 1959	Lee receives his first passport.
September 11, 1959	Lee is discharged from the Marine Corps.
September 20, 1959	On board the SS *Marion Lykes*, Oswald sets sail for England.
October 15, 1959	Lee arrives in Moscow and requests Russian citizenship.
October 21, 1959	Lee "attempts suicide" in a Moscow hotel room.
October 31, 1959	Just days after his release from a Moscow hospital, Lee tries to give up his U.S. citizenship at the American embassy.
January 7, 1960	Lee arrives in Minsk, Russia.

May 1, 1960	CIA pilot Francis Gary Powers is shot down in his U-2 spy plane by the Russians.
June 3, 1960	J. Edgar Hoover writes a memo stating that the FBI needs to be cautious about an imposter using Lee's birth certificate and identity.
September 13, 1960	Lee's discharge from the Marine Corps is downgraded to undesirable because of his "defection."
February 1961	Lee writes to the American embassy indicating his desire to return to the United States.
March 4, 1961	Lee meets Marina Prusakova.
April 15, 1961	The three-day Bay of Pigs invasion of Cuba begins.
April 30, 1961	Lee and Marina get married.
February 15, 1962	Marina gives birth to June Lee Oswald.
June 2, 1962	Lee, Marina, and June start the trip to America. They travel by train through Russia, Poland, Germany, and the Netherlands.
June 26, 1962	Lee's first known contact with the FBI. He is contacted by Special Agents John W. Fain and B. Thomas Carter who meet with Lee in the Ft. Worth FBI office.
August 16, 1962	FBI Special Agent Fain meets with Lee in the rear seat of Fain's car in front of Lee's home.
October 9, 1962	Lee allegedly rents Dallas post office box #2915.
October 12, 1962	Lee starts working for Jaggars-Chiles-Stovall, a photo-lithography firm.
October 22, 1962	The six-day Cuban Missile Crisis begins.
January 27, 1963	A.J. Hidell orders a Smith & Weston .38 revolver
March 12, 1963	A Mannlicher-Carcano rifle is ordered from Klein's sporting goods in Chicago by A. Hidell.
March 31, 1963	Marina takes some photographs of Lee in the backyard of the Neely Street house.
April 6, 1963	Lee is fired from from Jaggars-Chiles-Stovall.
April 24, 1963	Oswald departs for New Orleans by bus.
May 9, 1963	Lee is hired by the Reily Coffee Company in New Orleans.
June 4, 1963	1,000 Fair Play for Cuba leaflets are ordered from Jones Printing.
July 19, 1963	Lee is fired from the Reily Coffee Company.
August 5, 1963	Lee enters the Casa Roca store in New Orleans and talks to the owner Carlos Bringuier.

August 9, 1963	Lee hands out FPCC handbills and is arrested following a fight with Carlos Bringuier and two of his friends.
August 12, 1963	Oswald appears in court, is found guilty, and is fined $10.
August 16, 1963	Lee and three others hand out FPCC leaflets in front of Clay Shaw's Trade Mart. WDSU-TV is tipped off and films the event.
August 17, 1963	Lee appears on Bill Stuckey's radio show "Latin Listening Post".
August 26, 1963	Witnesses claim to observe Lee in Clinton, Louisiana, with both David Ferrie and Clay Shaw.
September 13, 1963	President Kennedy's trip to Texas is announced, but without any details.
Late September 1963	Sylvia Odio gets a visit in Dallas from three men. One of them is impersonating Lee Oswald.
September 26, 1963	Lee is supposed to have traveled from Houston, Texas to Laredo and crossed the Mexican border at Nuevo Laredo.
September 27, 1963	Lee or an imposter arrives at the Hotel Comercio, which is known as a meeting place for *anti*-Castro Cuban exiles, and visits the Cuban Consulate in Mexico City.
October 2, 1963	"O.H. Lee" leaves Mexico City for Laredo, Texas.
October 14, 1963	Lee moves to 1026 North Beckley Avenue in Dallas under the name of "O.H. Lee."
October 16, 1963	Lee starts working at the Texas School Book Depository for $ 1.25 per hour.
October 18, 1963	Lee's 24th birthday.
October 20, 1963	Rachel Oswald, Lee and Marina's second daughter is born.
November 1, 1963	FBI Agent Hosty visits the home of Ruth Paine and Marina writes down his license number.
November 6, 1963	Lee hand-delivers a note to the Dallas FBI office just blocks from the Book Depository. FBI office chief Gordon Shanklin orders agent James Hosty to destroy the note after the assassination.
November 22, 1963	The President is assassinated in Dallas. Oswald is arrested at the Texas theater and charged with the murder of J.D. Tippit.
November 23, 1963	Lee is charged with the assassination of President Kennedy.
November 24, 1963	Lee Harvey Oswald is murdered by Jack Ruby.

BIBLIOGRAPHY

Adelson, Alan. *The Ruby-Oswald Affair.* Seattle: Romar Books, Ltd., 1988.

Benson, Michael. *Who's Who in the JFK Assassination: An A to Z Encyclopedia.* New York: Citadel Press, 1993.

Blakey, George Robert, and Richard N. Billings. *The Plot to Kill the President.* New York: Times Books, 1981.

Callahan, Bob. *Who Shot JFK?: A Guide to the Major Conspiracy Theories.* New York: Fireside Books, 1993.

Crenshaw, Charles A., Jens Hanson, and J. Gary Shaw. *JFK: Conspiracy of Silence.* New York: Signet Books, 1992.

DiEugenio, James. *Destiny Betrayed: JFK, Cuba and the Garrison Case.* New York: Sheridan Square Press, 1992.

Eddowes, Michael. *The Oswald File.* New York: Clarkson N. Potter, 1977.

Epstein, Edward Jay. *Legend: The Secret World of Lee Harvey Oswald.* New York: McGraw-Hill, 1978.

Flammonde, Paris. *The Kennedy Conspiracy: An Uncommissioned Report on the Jim Garrison Investigation.* New York: Meredith Press, 1969.

Fonzi, Gaeton. *The Last Investigation.* New York: Thunder's Mouth Press, 1993.

Garrison, James. *On the Trail of the Assassins.* New York: Sheridan Square Press, 1988.

Groden, Robert J. *The Killing of a President.* New York: Viking Studio Books, 1993.

―――. *High Treason: The Assassination of President Kennedy and the New Evidence of Conspiracy.* New York: Berkley Books, 1989.

Hurt, Henry. *Reasonable Doubt: An Investigation into the Assassination of John F. Kennedy.* New York: Holt, Rinehart and Winston, 1985.

Joesten, Joachim. *Oswald: Assassin or Fall Guy?* New York: Marzani & Munsell, 1964.

―――. *Marina Oswald.* London: Peter Dawnay Ltd., 1967.

Kanter, Seth. *The Ruby Cover-up.* New York: Zebra Books, 1978.

McMillan, Priscilla Johnson. *Marina and Lee.* New York: Harper & Row, 1977.

Melanson, Philip. *Spy Saga: Lee Harvey Oswald and U.S. Intelligence.* New York: Praeger Publishers, 1990.

Miller, Tom. *The Assassination Please Almanac.* Chicago: Henry Regnery, 1977.

Model, F. Peter, and Robert J. Groden. *JFK: The Case for Conspiracy.* New York: Manor Books, 1976.

Morris, W. R. and R. B. Cutler. *Alias Oswald.* Massachusetts: GKG Partners, 1985

Nechiporenko, Oleg Maximovich. *Passport to Assassination: The Never-Before-Told Story of Lee Harvey Oswald by the KGB Colonel Who Knew Him.* New York: Birch Lane Press, 1993.

Noyes, Peter. *Legacy of Doubt.* New York: Pinnacle Books, 1973.

Oliver, Beverly, with Coke Buchanan. *Nightmare in Dallas.* Lancaster, PA: Starburst Publishers, 1994.

Oswald, Robert L., with Myrick and Barbara Land. *Lee: A Portrait of Lee Harvey Oswald by His Brother.* New York: Coward-Mcann, 1967.

Popkin, Richard H. *The Second Oswald.* New York: Avon Books, 1966.

Ragano, Frank, and Selwyn Raab. *Mob Lawyer.* New York: Charles Scribner's Sons, 1994.

Sauvage, Leo. *The Oswald Affair: An Examination of the Contradictions of the Warren Report.* New York: World Publishing Co., 1966.

Scheim, David E. *Contract on America: The Mafia Murder of President John F. Kennedy.* New York: Shapolsky, 1988.

Shaw, J. Gary, and Larry R. Harris. *Cover-Up: The Governmental Conspiracy to Conceal the Facts About the Public Exicution of John F. Kennedy.* Self published, 1976.

Sloan, Bill, with Jean Hill. *JFK: The Last Dissenting Witness.* Gretna, LA, 1992.

Summers, Anthony. *Conspiracy.* New York: McGraw-Hill, 1980.

―――, and Robbyn Summers. "The Ghosts of November." *Vanity Fair*, December 1994.

Thompson, Josiah. *Six Seconds in Dallas: A Microstudy of the Kennedy Assassination.* New York: Bernard Geis & Associates, 1967.

Weisberg, Harold. *Oswald in New Orleans.* New York: Canyon Books, 1967.

RECOMMENDED DOCUMENTARIES AND BOOK STORES

Documentaries

The documentaries below are recommended.

JFK: An Unsolved Murder
KRON-TV, San Francisco, California, 1988
Stanhope Gould, producer; Sylvia Chase, host.
This documentary presents an in-depth discussion of the medical and photographic evidence in the Kennedy case and includes statements from physician experts and witnesses who were attendant at the president's autopsy. Not available on home video.

The Men Who Killed Kennedy
Central Independent Television, Birmingham, England, 1988,
Nigel Turner, producer.
An essay that gives a good overview of all the collected evidence. Available in an extended five-part series from Time-Life Video.

Reasonable Doubt
C. S. Films, Inc., Baltimore, Maryland, 1988
Chip Selby, producer.
This film presents information that successfully refutes the single bullet theory, but focuses only on that aspect of the assassination.

JFK, The Director's Cut
Warner Home Video, Burbank, California, 1993
The director's cut of Oliver Stone's film *JFK* is seventeen minutes longer than the movie as shown in theaters. Also available in wide screen on laserdisc.

Who didn't Kill . . . JFK.
3-G Home Video, Montebello, California, 1990
Jack White, host.
This program contains extensive analysis of the backyard photographs of Lee Harvey Oswald.

JFK: The Case for Conspiracy
New Frontier Video, P.O. Box 2164, Boothwyn, PA 19061, 1993
A video documentary containing the most relevant available visuals relating to the assassination and the medical evidence. (143 mins.)

The Assassination Films
New Frontier Video, P.O. Box 2164, Boothwyn, PA 19061 (1995)
The first-ever collection of all of the relevant films of the assassination of President Kennedy, including optical enhancements of all of this priceless historical footage. (1 hour)

Many assassination-related video documentaries and a catalog are available from:
David Starks
P.O. Box 616
Glenside, PA 19038-0616
and
All That Video (ATV Films)
405 Hopkins Court
North Wales, PA 19454-1026

The Evolution of Lee Harvey Oswald (Poster)
JFK Educational Research,
Jack White, producer. 1994
704 Candlewood Road, Fort Worth, TX 76103
A poster showing seventy-seven portraits of Lee Oswald and how his features changed back and forth through the years. A strong arguement for the impostor theory.

Book Stores

The book stores below specialize in books on the assassination of President Kennedy and related subjects:

Almark & Company Booksellers
P.O. Box #7
Thornhill Ontario L3T 3N1
Canada
(905) 764-2665

The Last Hurrah Bookshop
937 Memorial Avenue
Williamsport, PA 17701
(717) 327-9338

The President's Box Bookshelf
P.O. Box 1255
Washington, D.C. 20013
(703) 998-7390

The JFK - Lancer Publications
332 N.E. 5th Street
Grand Prairie, Texas 75050
(214) 264-2007 (phone and fax)
(Also the publisher of *The Assassination Chronicles*, a quarterly assassination related newsmagazine).

Deep River Books
512 Santa Monica Blvd.
Santa Monica, California 90401
(310) 451-4353

M & A Book Dealer
P.O. Box 2422
Waco, Texas 76703

INDEX

Page numbers in *italics* refer to illustrations.

PHOTO CREDITS

Grateful acknowledgment for the use of photographs and other illustrative material in this volume is made to the following:

AP/Wide World: 223bl, 225tr, 225br, 230br.

Jack Beers: 143bl, 143cr, 146br, 168tr, 178bl, 182l, 191bl, 192br, 197br, 201tl, 208, 214tr, 215cr, 215br, 218b, 219tl.

The Bettmann Archive: 226bl.

Central Intelligence Agency: 47tl, 47cl, 47b, 89tr, 89br, 231br.

John B. Ciravolo, Jr.: 18, 20bl, 20br, 229cl, 229cr, 229t.

The Dallas Morning News: 158tl, 251b.

Dallas Municipal Archive and Records Center: 36bl, 61br, 62bl, 62cl, 62cr, 62br, 63tl, 63cr, 63tr, 63cl, 94bl, 94tr, 108br, 112tr, 115tl, 115bl, 115tr, 116tl, 116bl, 116tr, 119br, 125cr, 126, 129bl, 132bl, 133tr, 133br, 135cl, 135br, 136tl, 137b, 142br, 147bl, 149tl, 161tr, 161bl, 158tl, 161br, 162tr, 162br, 163tl, 163tr, 165br, 165bl, 166bl, 166br, 167tl, 167bl, 167tr, 171tr, 192cl, 193tr, 193br, 193cl, 194tr, 203bl, 210tr, 210br, 210bl, 211cr.

John Depew: 105b, 187tr.

FBI: 189br, 193tl, 231bl, 233bl.

Front Line: 41br, 42bl, 46bl.

The following photographs and illustrative material are part of The Robert J. Groden Collection (All Rights Reserved): 2cr, 22bl, 58bl, 58br, 59bl, 64tr, 65tr, 65cr, 68tl, 71tr, 71cr, 77cr, 77cr, 94br, 96tr, 97tl, 97tr, 97bl, 98br, 106cr, 112br, 115br, 120bl, 123tl, 124bl, 125tl, 128tl, 128bl, 128tr, 128br, 139tl, 143br, 144l, 145br, 147tl, 148br, 149cr, 149br, 156, 159tr, 159br, 174bl, 202bl, 202br, 204bl, 205c.

The House of Representatives: 223tr.

John Hurt: 33tr.

©1963 by Bob Jackson: 198t, 199t.

Penn Jones: 98tr, 230bl.

Kennedy Resource Group: 213bl, 213tr.

KGB/Soviet Intelligence: 47bl, 53bl, 53bc, 53r, 85br.

Marita Lorenz: 230tl.

John Marcyx: 32cl.

The National Archives: ixtl, xbl, 2tl, 2bl, 4bl, 4br, 5tl, 5tr, 5br, 6l, 7tl, 7cr, 7bl, 8l, 9tl, 9b, 10l, 10tr, 11br, 12, 16bl, 16br, 17tr, 19tr, 22tr, 23tr, 23br, 24, 25tr, 27br, 29b, 30br, 31b, 33cl, 33cb, 33cr, 34cl, 34br, 37tl, 37tr, 37br, 39tr, 40bl, 40br, 41c, 41bl, 43tr, 43br, 44tr, 44br, 45tl, 45tr, 45br, 46tl, 46br, 46br, 48tl, 48tr, 48bc, 49tl, 49cl, 49bl, 49tr, 49cr, 50t, 51tl, 51tr, 51cr, 51bl, 51br, 52tl, 52cl, 52bl, 52tr, 52cr, 52br, 53tr, 53cr, 53cr, 54tl, 54cl, 54bl, 54tr, 54c, 54cr, 54br, 55tl, 55bl, 55tr, 55br, 57c, 57br, 59tl, 60bl, 60c, 60tr, 60br, 61tl, 61bl, 61tr, 63cl, 63bl, 65b, 66tr, 66br, 67tl, 67cl, 67bl, 67tr, 67cr, 67br, 68tr, 68bl, 69tl, 77br, 78b, 78tr, 78cr, 81tl, 81cr, 81bl, 82tr, 82cr, 82br, 83tl, 83br, 84br, 85bl, 85bc, 85br, 86, 90bl, 90br, 91tl, 91tr, 91bl, 91br, 92tr, 92br, 93tr, 93cl, 93bl, 93cr, 93br,

95tl, 95cl, 95cl, 95bl, 99cl, 99bl, 100bl, 100br, 101tl, 101tr, 102br, 103tl, 104cr, 105tl, 107tl, 107bl, 107tr, 107br, 109tl, 109bl, 110br, 111cr, 111t, 111bl, 112tl, 116br, 117tr, 117br, 117cr, 117bl, 118tl, 118cl, 118bl, 118tr, 119bl, 121bl, 122bl, 123bl, 123cr, 124br, 130tl, 130br, 135tl, 138bl, 139, 140bl, 141br, 142bl, 143tr, 150b, 151tr, 151bl, 152bl, 153tl, 157l, 158br, 159tl, 163br, 164tl, 164br, 165tl, 165cl, 165tr, 167cr, 167br, 169bl, 169cr, 170, 172bl, 173bl, 173br, 174tr, 175bl, 175tr, 176bl, 177tl, 177br, 179tr, 179br, 183tl, 183bl, 184bl, 184br, 185bl, 185br, 186tl, 186cl, 186tr, 186br, 187br, 188bl, 188br, 189tl, 189tr, 190bl, 192tl, 194tl, 194bl, 195tl, 195bl, 195cr, 195br, 196tl, 196cl, 196bl, 196tr, 196cr, 196br, 197tl, 197cl, 197bl, 197tr, 198br, 199bl, 200tl, 200bl, 200tr, 200br, 201bl, 201tr, 201br, 203tl, 203tr, 203cr, 203br, 204br, 205tl, 205cl, 205bl, 205tr, 205cr, 205br, 206cr, 206cr, 206br, 206bl, 207tl, 207bl, 207tr, 213tl, 214bl, 215tl, 219br, 221l, 222br, 224bl, (224br), 225tl, 225bl, 225bc, 226br, 233tl, 233tr, 233cr, 233br, 237tr, 237bl, 237bc, 237br, 239tl, 239tr, 39bl, 239cr, 243tl, 243tr, 243br, 245bl, 245br, 247bl, 247br, 249bl, 249tr, 249tl, 249cr, 251tr.

New Orleans District Attorneys office: 69bl, 69tr, 72bl, 72tr, 72br, 235tl, 235bl, 235tr, 235cr, 235br, 242bl, 242br.

Marina Porter: 50br, 50cr, 99tl.

Stuart L. Reed: 101b, 120br, 121t, 153cr, 153bl, 154tl, 154br, 155bl.

J. Gary Shaw Collection: 19tl, 21tl, 21br, 68br, 69cl, 69br, 181tl, 181bl, 227tr, 227br, 228tr, 228br, 229br, 251tl.

The U.S. Army: 173t.

The U.S. Senate: 223tl.

United States Information Agency: 94tl.

Courtesy of WDSU TV Archive: 70bl, 70br, 71br, 73bl, 73tr, 73br, 74bl, 74tr, 74cr, 74br, 75tl, 75bl, 75tr, 75br.

Courtesy The Sixth Floor Museum Archives: 102, 104 br, 119tl, 119tr, 159bl, 160br, 161tl, 168bl, 169tl, 169tr, 239br.

Richard Sprague: 76tl, 76bl, 76tr, 77tr, 79tl, 79cl, 79bl, 104tl, 114b, 125bl, 127l, 131tl, 131bl, 131tr, 131br, 133bl, 136br, 146bl, 147tr, 160bl, 163cl, 163bl, 168br, 191tl, 191cr, 207br, 226tr, 229bl, 245tl.

The White House: 88br, 220.

Jack White JFK Educational Research, 704 Candlewood Road, Fort Worth, TX 76103: ii-iii, 26tr, 28cl, 240, 248bl.

Codes: *t:* top; *c:* center; *b:* bottom; *r:* right; *l:* left; *tr:* top right; *cr:* center right; *br:* bottom right; *tl:* top left; *cl:* center left; *bl:* bottom left.